Microphone Fiends

Microphone Fiends

Youth Music & Youth Culture

Edited by Andrew Ross & Tricia Rose

Routledge New York & London

Published in 1994 by

Routledge
29 West 35 Street
New York, NY 10001

Published in Great Britain by

Routledge
11 New Fetter Lane
London EC4P 4EE

Library of Congress Cataloging-in-Publication Data

Microphone fiends : youth music and youth culture / edited by Andrew
 Ross and Tricia Rose.
 p. cm.
 Essays and interviews.
 The essays originated in a conference held at Princeton
University, Nov. 1992, to commemorate the 50th anniversary of the
American Studies Program.
 ISBN 0-415-90907-4 (HB)—ISBN 0-415-90908-2 (PB)
 1. Music and youth. 2. Music and society. 3. Popular culture.
 4. Rock music—History and criticism. I. Ross, Andrew,
 II. Rose, Tricia.
 ML3795.M5 1994
 306.4'84—dc20 93-44005
 CIP

British Library Cataloguing-in-Publication Data.

Microphone Fiends: Youth Music and Youth
Culture
 I. Ross, Andrew II. Rose, Tricia
 306.4

ISBN 0-415-90907-4 (HB)
ISBN 0-415-90908-2 (PB)

Contents

ix Acknowledgments

1 Andrew Ross

Introduction

Histories and Futures

17 George Lipsitz

We Know What Time It Is: Race, Class and Youth Culture in the Nineties

29 Susan McClary

Same as it Ever Was: Youth Culture and Music

41 Lawrence Grossberg

Is Anybody Listening? Does Anybody Care?:
On Talking about 'The State of Rock'

59 Greg Tate

Excerpt from *Altered Spade: Readings in Race-Mutation Theory*

Locating Hip Hop

71 Tricia Rose

A Style Nobody Can Deal With:
Politics, Style and the Postindustrial City in Hip Hop

89 Juan Flores

Puerto Rican and Proud, Boyee!: Rap Roots and Amnesia

99 Jeffrey Louis Decker

The State of Rap: Time and Place in Hip Hop Nationalism

122 Tricia Rose

Contracting Rap: An Interview with Carmen Ashhurst-Watson

The Dance Continuum

147 Walter Hughes

In the Empire of the Beat: Discipline and Disco

158 Lady Kier Kirby

Hello

160 Willi Ninja

Not A Mutant Turtle

163 Tricia Rose

Nobody Wants a Part-Time Mother: An Interview with Willi Ninja

176 Sarah Thornton

Moral Panic, The Media and British Rave Culture

193 George Yúdice

The Funkification of Rio

Rock, Rituals and Rights

221 Robert Christgau

Rah, Rah, Sis-Boom-Bah:
The Secret Relationship Between College Rock and the Communist Party

227 Donna Gaines

Border Crossing in the U.S.A.

235 Robert Walser

Highbrow, Lowbrow, Voodoo Aesthetics

250 Joanne Gottlieb and Gayle Wald

Smells Like Teen Spirit:
Riot Grrrls, Revolution and Women in Independent Rock

275 Contributor Notes

Acknowledgments

The essays collected here originated in a conference organized at Princeton University in November 1992 to commemorate the fiftieth anniversary of the American Studies Program. The panelists included scholars, critics, journalists, performers and industry executives. All of the participants were invited to contribute to the volume. Most of the essays are longer versions of presentations made at the conference. Some participants based their papers on transcripts, others contributed substantially different papers. As for the conference, thanks are due to Arnold Rampersad, the program director, for his support; to Judith Ferzst, the program manager, who resourcefully devoted her energies to the tasks of organization and to the transcription of a number of the talks; to Barton Rouse, chef extraordinaire; and to Nick Fogler and the members of Terrace Club, who played hosts to the more festive events. Thanks, also, for the work of transcribing, to Nicole Torella at Rutgers University, and to David Serlin, Jonathan Levine, Alyssa Hepburn and Gina Diaz at New York University.

The editors gratefully acknowledge the permission of the following journals and publishers to reprint these essays in their revised form: *Centro,* Winter (1993) for " 'We Know What Time It Is': Race, Class and Youth Culture in the 90's"; *Critical Matrix,* Vol. 7, No. 2 (1993) for "Smells Like Teen Spirit: Riot Grrrls, Revolution and Women in Independent Rock"; Wesleyan University Press/University Press of New England for " 'A Style Nobody Can Deal With': Politics, Style and the Postindustrial City in Hip Hop," originally published in *Black Noise,* copyright © 1994 by Tricia Rose; *The Village Voice* for "In the Empire of the Beat: Discipline and Disco."

Introduction

Andrew Ross

In the fall of 1992, newsstands displayed the preview issue of *Vibe*, a new hip hop magazine produced jointly by Quincy Jones Entertainment and Time Publishing Ventures, Inc. With blue-chip backers like these, hip hop, it seemed, had found its ultimate commercial forum. The articles, features and photo spreads graced a lush, glossy setting that was a clear step up from the more rugged graphics of *The Source*, rap's "ghettocentric" house organ which, since its appearance in 1989, had presided over the period of hip hop's rise to prominence as an international cultural force. Not surprisingly, the first twelve lavish pages of ads comprised four for Levi's, five for Nike and one each for The Gap (with Latifah), Mossimo and Versus, Gianni Versace's new perfume. In one of those bone-crunching contradictions that have become a daily item in postmodern youth culture, the first feature page hosted a swinging assault by Greg Tate on hip hop commercialism, consciously spoken from within the belly of the Madison Avenue beast:

> A lifetime of Tarzan and John Wayne teaches us that when the drums fall silent, the pink man should really begin to know fear. Conventional wisdom would have us believe that hip-hop predicted all but the day and time of the Los Angeles rebellion. But what if hip-hop is not the expression of black folks' rage, but only another momentary containment of it, or worse, an entertaining displacement? During the gulf conflict, hip-hop's drums were deafeningly silent. They went on to the beat of the cash registers while the F-15s were taking out Baghdad's mothers and children until the break of dawn. . . . Cornel West has called rap visionless, but what it is, even at its most progressive, is agendaless. It reacts better than it proposes, and we who feebly wait for hip-hop nationalists to salve our rage and pain, hoping they will speak with us or for us, are to blame for not developing our own ways to radically speak above the fray. Hip-hop should be an invitation for everyone to break the silence around injustice, but it has become an invitation to party for the right to demagoguery. As a successful counter-cultural industry, whose style assaults have boosted the profits of the record, radio, junk food, fashion, and electronic industries, hip-hop's work is done. But as a harbinger of the black revolution, hip-hop has yet to prove itself capable of inspiring action towards bona fide social change. Now we'll see, like Bob Marley sang, who's the real revolutionary. After all, real bad boys move in silence.

Tate's brisk challenge was addressed to the arguably first black musical genre in which *anything could be said*, and for which testing the limits of free speech in a recognizably racist society had become a matter of conscious habit, if not necessity. Rap freestyling, after all, had given vent to a voice and a form that was capable of mainlining every arterial debate going, whether private or public; from searing revenge fantasies like Public Enemy's "By the Time I Get to Arizona" to the ribald body politics of Sir Mix-A-Lot's "Baby Got Back"; from protofeminist anthems like Queen Latifah's "Ladies First" to the psychological truth-or-dare of Cypress Hill's "Here is something you can't understand/ How I could just kill a man"; from TLC's savvy pop politics to KRS-One's agitprop preachiness to P.M. Dawn's blissed-out yearnings to Basehead's withering, dry dissonance. Nothing was off limits, and wrecking the mic had no end in sight. Despite this barrage of social commentary, hip hop had fallen short, in Tate's estimation, of "inspiring action toward bona fide social change." Let's face it, he asserts earlier in the piece, the music is "structurally incapable of becoming" what progressive black intellectuals ("those of us who aren't B-boys") want it to be. So cut your losses and apply the lessons of hip hop elsewhere.

Tate's dissatisfaction feeds off perceptions that have both long-term and short-term histories. At the very least, it recognizes the hugely expanded forum that hip hop, as a popular form, has made possible. At the same time, it acknowledges the limits placed upon the form by commercial dictates and by the ever more exacting decrees of style politics. When all is said and done, "real revolutionaries," he suggests, ought to know better than to expect from hip hop what it cannot provide. Tate's lesson therefore draws upon a perennial complaint among activist intellectuals, in this case, black nationalists, about the inability of cultural movements to deliver the masses. Notwithstanding the 1992 performance of "Rock the Vote" in boosting the youth vote by two and a half million (thirty-six percent of eighteen to twenty-four-year-olds voted in 1988 compared to forty-three percent in 1992, while MTV's Tabitha Soren secured her unlikely reputation as kingmaker), this complaint is based on an understanding of politics that has more to do with the active shaping of radical consciousness than with guaranteeing a voter turnout whose main purpose is to save face for the world's most prominent, electorally apathetic, liberal democracy.

But some readers might also hear in Tate's critique the particular, disillusioned voice of youth culture itself, giving up the anthemic refrain: "We won't get fooled again." Who was that fool again? It hardly seems necessary to review the conditions that saw the emergence in the 1960s of the idea of a rock counterculture, in which musicians with demonstrated organic ties to their vast audiences were asked to perform the powerful role of generational leaders. While that sense of leadership has long since eroded in the predominantly white communities and genres descended from rock, it has had a different career in the black musical tradition, where performers, in the historical absence of full social legitimacy, are nonetheless accountable to a long-standing community ethic that both honors and governs

their positions of cultural authority. Now with the rise of hip hop, a fully popular black musical form has been held up to the highest scrutiny for the integrity, authenticity and independence that was found wanting in the rock counterculture. It was only a matter of time before an organ of record, in this case *The Source*, announced the "death of rap," (after Ice-T's 1992 decision to pull "Cop Killer" from Warner's *Body Count* album) with the same sense of indignation that had accompanied countless previous declarations about the "death of rock," a genre in its own right, as Lawrence Grossberg describes in this volume. In his *Vibe* broadside against rap demagoguery Tate, of course, was not speaking from the hip hop source, but rather as a fellow traveler, ever willing to help steer the music's scratchy dynamism into some more pronounced social groove. And his challenge to the B-boy was on the level; it was issued in the spirit of masculine competition that rap has gloried in and to which rappers might feel they could respond.

Having established yet again that no musician, least of all the gangsta rapper, is in a position to shoot social justice direct from the hip, the more difficult question remains. What then is popular music good for? All too often, however, this is the question that comes first, to be followed by this or that coolness paean to the vox pop. For the majority of the contributors to this volume, it's the other way around; the question must be addressed only after assessments like Tate's have been recognized and agreed upon. Otherwise, we are mired forever in hand-to-hand combat on the muddy terrain of political correctness. For those who feel the need to assess the function of popular music, along with its associated youth cultures, the relevant criteria are more likely to be standards of cultural rather than social or economic justice. This is true even for those performers for whom career genre conventions ("rebel rock" genres) oblige them to make statements on a regular basis about social and economic justice. Such statements have more to do with semicontractual agreements with audiences about, say, the conventions of "keeping the faith," than they actually relate to those social and economic conditions responsible for the conventions of "selling out."

One of the aims of this collection is to take a closer look at the contractual nature of youth music, for the level of attention and meaning invested in music by youth is still unmatched by almost any other organized activity in society, including religion. As a daily companion, social bible, commercial guide and spiritual source, youth music is still *the* place of faith, hope and refuge. In the forty-odd years since "youth culture" was created as a consumer category, music remains the medium for the most creative and powerful stories about those things that often seem to count the most in our daily lives.

In the interim, youth as a term has accumulated a wide range of associations that can be evoked at will: "change," "alienation," "hope," "social flight," "immaturity," "idealism," "creativity," "insubordination," "apathy," "dissent," "naiveté." Many of these terms are largely interchangeable. The Clinton ascendancy, for example, was widely championed as a new generational spring to sweep away the long, seasonal rule of the gerontocratic

guardians of the Cold War, both in the West and in the old Communist bloc. The generation that had invented the idea of youth politics had come to power, and they had the (bad) music of idealism to prove it. Four months into a "rudderless" presidency, Clinton and his staff were being universally lambasted as "the teenagers in the White House," and were pressured to introduce some paternalistic faces into their fresh-faced ranks. In politics, youth has always been a double-edged sword, but there was an especial irony attached to this manipulation of the value of youthful caliber by Washington hacks. The sugary, anthemic futurism of Fleetwood Mac's "Don't Stop Thinking About Tomorrow" (the Clinton campaign song) just as surely could be transmuted into a fatal innocence about the past, with echoes of an earlier Sam Cooke lyric: "Don't know much about history. . . ." Clinton's Elvis affinity was just as likely to bear ominous, death-wish connotations as it was to evoke Southern, white, hipster charm. Generational maxims of the sixties, like never trusting anyone over thirty, were not slow in coming home to roost.

Everywhere else, the meaning of youth was up for grabs. With the cessation of Cold War antagonisms and an uneasy interregnum in effect, the full force of media punditry had come to be trained upon the new postboomer sensibilities. Youth, in this context, would be analyzed as a symptom of this or that prophetic comment about the near future. In the course of 1992 and 93, feature journalism hosted a glut of articles about the twentysomething "Generation X," in which baby busters were cited as evidence of every kind of social, cultural and economic trend, from apocalyptic malaise to promise of a brave new order. Not since the late fifties had American youth been scrutinized in such a frankly exploitative way. As always, the journalistic voices that spoke so confidently on behalf of a generation contrasted with the protective reticence of the subjects under investigation. Despite token inclusions, the model subjects remained those postadolescents who were temporarily confused but most likely to succeed in the long run, and thus to fill the target consumer demographic with high-end disposable incomes. In the media image-world, for example, the gilded white youth of *Beverly Hills 90210* won hands down in the contest for representing vagueness (notwithstanding Julie Brown's matchless Madonna parody—"Come on, get vague"—in her film spoof *Medusa: Dare to Be Truthful*: "ladies with no point of view, fellas who don't have a clue/ if they're stars, then you can do it/ just be vague, there's nothing to it").

Vagueness could well be taken to reflect the postmall angst of a youth cohort permanently set on cruise control, but it was more crucially a contentless set of emotional energies for the teen cultural industries to plug into and channel directly into acts of consumerism. Separated by less than six degrees of preppiness, with their well-scrubbed butts and pearly-toothed grins, scowls and smirks, the 90210 crew registered a consistent high on the scale of peer loathing, ultimately embodied in the movement that produced the *I Hate Brenda* newsletter. TV's more ethnically diverse versions of *90210*, like *The Heights*, drew disappointing ratings. In the meantime, the domestic TV environments represented in

Roseanne, The Simpsons, Married With Children and *Roc* provided a genuinely critical response to the simple functionality of the American family.

As a scourge upon the impossibly sanitized, aerobicized world of *90210*, the politics of dirt reasserted itself within music culture in the shape of grunge, an invitation for white, middle-class kids to do some style slumming with a vengeance. Perhaps as a result of their poor employment prospects, there was little of the guilt-tripping usually attached to the class spectacle of dressing down. In British rave culture, a conscious aversion to cleanliness—for which the tabloid press invented the moniker of "the crusties"—offered an alternative to the deodorized climate of the eighties, while the seminomadic, hippy, traveler culture lived out a loving, utopian parody of Thatcherite social mobility. In all the genre communities of noize music—industrial, postpunk hardcore, thrash, grind-core, speed metal, nosebleed techno, grunge, and bring-the-noise rap—high decibel levels and maximum distortion ranges conspired to maintain the sonic faction of the antihygiene program.

Thirty miles southeast of Beverly Hills one of the new alternative capitals of youth culture registered its own defiance on this semiotic landscape when the Compton zip code 90221 appeared on T-shirts. Responses like this demonstrate the ceaseless two-way dialogue, conducted through style and cultural appropriation, between hardcore, hip hop youth and their upper-middle-class, white peers. Home of the hardest, ghettocentric gangland rap, Compton shared this youth territory with areas of South Central, Watts and Pico that hosted the 1992 L.A. riots. Compton *attitude*, first embodied in the local homeboy posse, N.W.A., became a stylized repertoire for significant sectors of hip hop youth, in which street cool machismo spliced with race anger generated no end of running-scared public debate about the black male menace to society. Although it was only one of the many semitribal formations within the hip hop nation, gangsta rap became a highly visible forum for debating the limited roles and opportunities available to working poor African-American youth. The fantasy and theatricality associated with the gangbanger role was a dramatic space for reconciling the tension between public enemy stereotypes and masculine images of strength and agency for ghetto youth. Among other things, the overwrought sexism and homophobia associated with this theater was an intrinsic product of the physically threatened conditions under which black male youth negotiated their social survival.

Acting out the gangbanger on stage or on the street was one thing, but the hardcore contract with audiences ran much deeper than the wannabe role-playing implied. Consider Ice-T's comments about his own view of the relationship:

> I'm talking about the hardcore, the kids who come out with shotguns, and the motherfuck-
> ers that are looking like they'll jump off the stage and jack motherfuckers. That don't
> work. It's like, if you do not believe that I'm capable of doing any of that shit on the
> records, then it sounds like a joke. And you gotta remember, when I came out, me

saying that I was in a gang and all that, I didn't look at it as an image. I looked at it as coming clean so that I could make it in the business.[1]

The kind of belief that Ice-T describes here is a necessary component of most fan cultures, especially those within musical genres that demand conventions of "authenticity" from performers. Fans employ such convictions about their favorite musicians to reinforce the many uses that music has in their lives. This belief is a complex phenomenon, however, and quite removed from the model of audience impact deferred to by mainstream media accounts of rap's violently mimetic influence upon youth. Nothing has a longer (and more dismal) history in Western tradition, as Susan McClary reminds us in this volume, than the paternalist concern about music's all-too-powerful sway over the minds and bodies of youth. What this concern sadly misconstrues is that the stories and fantasies recounted in music, as in all art forms, are often powerful precisely *because* they are outlawed in daily life, or have no chance of being enacted there. "Believing" that some rappers are, or were, outlaws in no way invalidates this power; it only reinforces the rapper's authority to circulate the outlawed fantasies for an audience. Nowhere is this more evident than in the appeal of hardcore rap to white hip hop junkies, for whom no music is "too black, too strong," a reflection of the fact that the culture industries have come to depend upon the existence of a mass market of millions of white negroes. The long tradition of female hardcore rappers with street credentials has not changed this equation, but it has yielded an additional reserve of revenge fantasies directed against sexist male gangstas. As dream hampton argues, of the more recent visibility of female gangsta rappers:

> On wax we are placed inside the violence that characterizes gangsta rap. We are cast recipients of the beatdown, bullet or broken neck. "Niggas talking about how they shot the bitch, killed the bitch, raped the bitch," lists self-proclaimed gangsta bitch, Boss. "It's '93 and bitches got gats too. A nigga can take a bullet just like a bitch." Young Black women die at the hands of Black men who may or may not have claimed to love them, more often than they die at the hands of white men, police or otherwise. In her gangsta revenge fantasies Boss takes great pride in knocking niggas off. Nothing new to the genre, only she doesn't have a dick to grab. Nor does she want one.[2]

But for all the infamy of rap's vérité associations with gangsta rituals and realities, it should be remembered that hip hop emerged in the Bronx as an explicit alternative to gangland culture, and that its growth into a full-blown social movement has depended upon the coexistence of ghetto realism with a whole spectrum of social consciousness—from deep Afrocentric nationalism to New Age positivity—while maintaining an important dialogue with black intellectual and political leadership. On the other hand, the huge successes of its independent record industry have encouraged the growth of an entrepreneurial sector

that exploits social prejudice—as nasty as they wanna be—as unscrupulously as the lords of narcotraffic exploit poverty and social despair.

As a result, black youth in the recording business stand to get "paid in full" (a concept that is not only economic but which includes full recognition of musical integrity) or else sink back into poverty or a precarious career in the informal economy; that is, if they can avoid the fate of the one black males in four aged twenty to twenty-nine who are currently incarcerated under the U.S. criminal justice system, or the tens of thousands of others who become homicide statistics each year. In other words, they can rise to the top or crash to the bottom. In this respect, the gap in opportunity between youth of color and white youth is not as wide as it used to be. The hemorrhaging of stable manufacturing jobs and the steady disappearance of an inheritable parent culture organized around industrial labor have entrapped the "forgotten half" of noncollege youth of whatever color in the service and retail economies (if they are lucky enough to be employed), with little hope of bridging the gulf that divides dead-end jobs in fast-food eateries from semiskilled positions in the information and knowledge producing sectors. As for the unemployed, the youth population of runaways, drifters and throwaways is on the rise.

While the juvenile justice system reaped a harvest of rejects all over the deindustrialized heartlands, the growth of private mental hospitals has taken its toll on suburbia. In *Teenage Wasteland*, her milestone study of turnpike town burnouts, Donna Gaines suggests that the white suburban equivalent of inner-city gangsta rap is metal/hardcore's anthems about teenage imprisonment in psychiatric hospitals, such as Suicidal Tendencies's "Institutionalized," Metallica's "Welcome Home (Sanitarium)," and The Ramones's endless riffs about going mental.[3] In this musical culture, psychotropic drugs and lobotomies substitute for crack pipes and drive-bys in the landscape of the netherworld. The upshot of the massive increase in teenage institutionalization and loss of geographical and job mobility is a drastic decline in the social status of youth as a whole.

Indeed, it is Gaines' thesis that the civil rights of youth have been eroded to such an extent—with the exception of animals and inmates of total institutions, their lives are the most controlled and the most regulated in our society—that the only power they enjoy is that of consumers; "they get the lowest pay, have fewer rights, and suffer more structural regulation than anyone." Suicide, or attempted suicide (since most are intended to fail), is one typical response, for which Gaines provides an extended case history in her book. Infantile withdrawal and avoidance is another. Neither is an especially articulate reaction, since they are expressed through peer languages and subcultures that are often unintelligible to adults. While the vast majority of kids do not belong to the spectacular subcultures that attract so much attention from the press and from cultural studies scholars, most share to some extent in the activities and sensibilities that find high symbolic visibility in these subcultures.

If thrash, speed metal and their gothic variants remain the home of choice for the death

trip and the suicide tendency, rave culture became an open theater for infantilist imagery: whistles, pacifiers, sleepy, stripey, stocking knot-top caps, tent-sized, understyled clothing that simulates hand-me-downs from older siblings, fairy-tale Magic Kingdom garb, with Goofy-scale platform sneakers, comic-book and toon graphics, and a sexually indeterminate vibe of Ecstasy-induced euphoria. The rave, techno, and ambient club scenes are complex social spaces, part extension of high school, part fantasy spaceship, ravers either squatting in circles like nomadic travelers in a children's refugee camp, or else navigating or free-styling, with the aid of torches and glow-in-the-dark collars, through artificial, dry ice-filled, dance zones like parentless, gas-masked survivors of some near-future environmental disaster, for which cyber-pagan space travel is the favored escape route. Traveling light with miniature knapsacks fully equipped for the night's activities and the ultimate rendezvous with dawn, the ravers undertake their journey accompanied by music that often only sounds good on drugs—trancey sequences whose braindraining bpm intensity is irregularly punctuated, like jungle clearings, by spacey intervals of ambient sound. As a dance culture, the restless flight patterns of the raver contrast with the fierce endurance of the house clubster, whose performance stamina on the dance floor is often linked, and most especially in gay circles, to long workouts in the gym.[4]

It has long been a staple of subcultural theory that cultural formations like rave offer "magical" solutions to problems collectively experienced by youth. Subcultural theory views this solution as a response on the part of the subcultural group to the fragmentation or loss of status of a parent culture, for which the role-playing of their children is a symbolic recovery of a meaningful community. Thus, certain hip hop styles, like the recent adoption of workwear, might be seen as creative responses to the culture of parental occupations that are no longer guaranteed to unemployed youth. Alternately, the southern-fried-chicken funk of a band like Arrested Development might be seen as recovering the feel of rural lifeways available to ghettocentric urban hip hoppers only as a historical romance (rather than as a direct response to Southern, rural, black youth). According to this same theory, the psychedelic assemblies of rave (especially the "Summers of Love" in the late 1980s in Britain which generated the acid house/rave parties) would be analyzed as a semiparodic version of the trippy, utopian festivities of raver parents' own youth in the late sixties and early seventies, perhaps even an attempt to magically recover some of the lost cohesion of that moment. (The revival of hallucinogens in rave and marijuana in hip hop goes at least as far).

But how much of this interpretation is an act of projection on the part not only of subcultural theorists, but also of an entire parental generation still caught up in the fantasy that they are still themselves youthful, or at least more culturally radical, in ways once equated with youth, than the youth of today? It is not just Mick Jagger and Tina Turner who imagine themselves still to be eighteen years old and steppin' out; a significant mass of baby boomers partially act out this belief in their daily lives, and the cultural critics,

some of them stretching into middle age, who contributed to this volume are ever so conscious practitioners. On the other hand, it is also true that many kids listen obsessively to exactly the same music that their parents did: the Grateful Dead, Led Zeppelin, Jimi Hendrix, Eric Clapton, Bob Marley. Who is holding the mirror here? The elder or the youth? As retro consciousness rumbles, like a seismic impulse, along the whole cultural continuum from the youth underground to the fashion runway (where the impossibly childlike waif or gamine female figure has made a controversial return), the fantasy of youth has imploded upon itself, transforming delinquency into a luxury, in accord with the voracious demands of a consumer society. It may be that a new kind of social domination, with the fantasy of lost youth at its center, has come into being. The cultural and political forms of that domination are rooted in a middle-aged, regressive nostalgia that youths have no alternative but to recognize and resist under conditions not of their own choosing.

Their resistance (an overused term, for sure) is often lodged against a generation who claim to have invented the "politics of youth." That generation now wields the power to misunderstand and deride contemporary movements for their failure, as George Lipsitz reminds us here, to correspond to an anachronistic definition of youth culture and politics established in the 1960s and 1970s. Baby boomers often consider their experience of youth to have been uniquely definitive, and consequently have made this experience into an object of both envy and resentment for their children. One of the results is the kind of crazy mirror that throws up the current seventies style revival. Sometimes the response is more articulate and strategic. For example, in their article, Gayle Wald and Joanne Gottlieb discuss how and why the Riot Grrrls have reappropriated the term "girl," in the face of two decades of feminist aversion to its infantilizing associations. Similar attempts to reappropriate epithets like "queer" and "nigger," that were anathema to the gay liberation and mainstream civil rights movements, have transformed the entire sensibility of identity politics. That these terms are now *positively* infused with anger and activism on the part of Queer Nation, the Lesbian Avengers, WHAM, and black nationalist youth groups is an unsettling development to older activists, for whom these expressions belonged to the language of acquiescence and subordination. While it is true that Black Power activists never ceased to use the "nigger" word as a scourge against the acquiescence of the black bourgeoisie, the difference today lies in the rapidity with which such terms have become normalized and transmuted into daily cultural currency.

At other times, the responses are less articulate. They are often manifest in the explicit avoidance of social responsibility—an aversion to being taught by parents about how to be politically correct. MTV's *Beavis and Butthead* (drawn by Mike Judge) are the latest meathead characters to represent this studied avoidance of qualities associated with the responsible behavior of apprentice citizens. Their appeal, of course, even to adult fans, stems precisely from some fantasy of adolescent "stupidity" impenetrable to civil reason. Whether this is a refusal or a social incapacity is moot. When these charmers are asked

questions that demand adultlike responses, they simply pretend they haven't heard the question. In some instances, an entire musical genre elects the spirit of avoidance as its chief organizing principle. Such a case could be made for dance music in the period since disco went underground, after the late 1970s media overkill of *Saturday Night Fever*, and the "DISCO SUCKS" movement that was partly homophobic, partly racist, and partly an expression of the counterculture's distaste for studio-produced synth music. The survival and ultimate triumph of disco—at the Paradise Garage, in Chicago house, Hi-NRG, London acid, Detroit techno and rave (with hybrid variants like acid jazz and hip house, and with crossover excursions into funk, dub, ragga, dancehall, bhangra, salsoul and new jack swing)—has been the story of the persistence of a (black) gay underground that now stands in the forefront of youth culture.

The dance floor has always offered a safe haven for the socially marginalized, as both George Yúdice and Walter Hughes point out in their respective essays on Brazilian funk and gay disco, and as Willi Ninja's career demonstrates. In the last decade, it has become a liberating sanctuary for ever greater numbers and an ever more diverse youth constituency. Lamentably undocumented (AIDS has taken its toll upon the cultural memory) and underreported, for reasons of snobbery, in the music press, club dance music has been a focus for community that often matches the commitment claimed by the most devoted fandoms, like the Deadheads, or the most politically pure musical communities, like postpunk hardcore. It is difficult to do justice to the full meaning of a club track like "Last Night a DJ Saved My Life," except to say that there is more gospel truth attached to the song's title than there is irony. The cult of the DJ attained priestly proportions, with remarkable powers of crowd empathy and technical sorcery attributed to spinners and mixers like Larry Levan, Frankie Knuckles, Junior Vasquez, Andy Weatherall, Todd Terry, Derrick May, Kevin Saunderson, Marshall Jefferson, David Morales, Juan Atkins, Moby, Blaze, Dmitri, Little Louie Vega, and Frankie Bones. The intensities associated with dance music are extreme, reaching highs and lows that are unusual in popular music. Nothing can be more vapid and wearisome than a lame-ass disco beat, nothing can be more deeply sublime than a good DJ working a crowd through a prolonged cathartic release.

On the face of it, club music, as a genre with "something to say," appears to have no redeeming social potential—no one ever said anything too clever or quotable on a dance mix—and yet its congregationist ethic and its glamor-struck devotion to sonic rapture has earned it a unique set of neospiritual credentials that has put to rest disco's earlier equation, unearned or not, with mindless, metronomic pap. Indeed, if there is a cultural and sexual politics to dance music then it has come about through revaluing those very associations once employed to put it down: out-of-mind experience, the ecstatic power of repetition, a crowd hell-bent on appreciative hedonism, and speech that has all but stopped making sense. When Lady Kier Kirby insists, again and again, "I just wanna hear a good beat," you can hear all too clearly the constant craving for rhythm that is experienced as an

intimate impulse but which draws people together as if by instinct. The appeal is deeply autoerotic, but the feeling has to be shared by like-minded souls, who congregate for reasons of social survival as much as anything else. Another way of putting this is to say that rhythm-dominant dance music draws some part of its power from its fiercely conscious evacuation or refusal of the mentality claimed for more politically correct forms of music: rebel rock, roots reggae, ghetto soul, protest folk, and hardcore rap. Instead of yielding to a music that is always more or less identity-affirming, the sensual activity of losing oneself and regaining something else on the dance floor opens up a social space that is quite different from the public and private boundaries that hold our identities all too tightly in place. The demand for more "realness," that issued from Harlem vogueing culture, was a call to treat the floor to some fiction, or make it a gender-free zone at least.

Clubs come and go, often at the decree of a mogul owner, as venal as any record company executive. During their often brief life cycle, they can be governed by exclusive door policies so racist and looksist that they would be subject to civil rights suits in most other areas of commercial life. In general, however, since the club scene depends more upon underground status than upon record-buying consumerism it has escaped some of the worst effects of regulation, moral, social and economic, exacted upon music communities more directly affected by the gravitational pull of the culture industries. At times, the regulation is issued in a semiofficial way from institutions like the BBC (where, as Sarah Thornton reminds us here, a ban is a virtual guarantee of success for a record), or an organization such as the PMRC, which not only propelled popular music into the culture wars, but also pulled the record industries into the business of self-regulation. Aside from the moral flap over record labeling, and the eternal debate about co-optation (what happens when indie music is no longer indie?), the music industry's primary form of regulation is cultural, and is evident in the strict management of taste cultures that still correspond to racial and class divisions in society. This is why attempts at genre fusion and genre crossover are politically significant, in music coalitions like punk/reggae (and two-tone ska), hardcore/metal, acid house/jazz, rave/indie rock, rap/metal, metal/classic (see Robert Walser's essay), dub/disco, and even the mix of R & B and country that engendered rock 'n' roll. Difficult to market for an apartheid-based industry, and difficult to police as a social phenomenon, such fusions are not institutionally encouraged anymore than are events, like the Lollapalooza tours, that bring together different musical communities (or, at least, that bring together guitars *and* samplers) or the tradition of spontaneous parties in the British countryside, where the government has cracked down hysterically on the right to travel to or near rave sites that are increasingly attracting mixed congregations of hippies, indie rockers, metalheads and ravers.

On a different note, the economic regulation of music technology would require a lengthy history in its own right in any chapter of youth culture. Two of the more visible features of this history would include the legal brouhaha over sample clearance, and the desire of

the electronics giants to establish a consumer product standard that stamps out the copyright delinquency of the audiocassette revolution for once and for all. While the regulation in these instances is primarily economic, its cultural effect is to compromise if not threaten a whole range of liberties associated with cheap, creative musical alternatives (rap would not exist otherwise) in the age of the sample. There is no doubt that technology has most recently been in the frontline of the long-term battle over the means of production and the rights of possession of youth music and youth culture.

The category of youth seems inseparably tied, then, to the twin mechanism of rebellion and regulation. There are many ways, of course, in which that connection is itself a form of regulation, and so it is important to examine how this mechanism functions in the West, where youth culture has its modern, commercial origins, and in other parts of the world, where it has been exported to varying ends. In the West, we know that the youth industries have long learned to market the language of rebellion. A recent MTV station identification featuring a McCarthyite hearing at which youth are questioned by gerontocrats as part of an investigation into MTV's subversive potential is a typical example. In the old Communist bloc and in the Third World, images of Western youth subcultures and sounds of Western youth music are often used to challenge local, state definitions of youth culture. Jim Riordan has described the scenario in the Soviet Union just before the demise of Communist rule:

> Today, *glasnost* is helping to reveal a whole range of phenomena that just a few years ago were repressed: hippies and punks, night bikers and drug addicts, soccer hooligans and muggers, Buddhists and Hare Krishna followers, even swastika-sporting young neofascists. They may be abhorrent to "polite society," and have been condemned by leaders from Gorbachov to Archbishop Mikhail of Vologda and Velikoustyug. Gorbachov has spoken of "a certain section of young people enclosed in its own narrow little world, out of step, or trying to get out of step, with the swift onrush of life," while the Archbishop has written in *Pravda* of the "moral decay" among teenagers.[5]

Internal regulation of the imagery of "decadent" Western youth played a large role in the definition of Communist youth, and so its countercultural role was a significant one, encouraged, no doubt, by officials of Western states that condemned the same imagery at home. The youth movement in Tiananmen Square chose symbols of Western democracy that would appeal to Western powers and their media organs—the same symbols, like that of Lady Liberty, which would be anathema to dissident Western youth in a domestic context. Similar stories (George Yúdice tells one about the importation of funk in Brazil) could be told about the use of Western pop in Third World countries to subvert the traditional cultures assigned to youth. They are reminders that the profile of "youth culture" as rebellious has different uses in different contexts, and that it does not always correspond to what youths actually want to be or do. The fantasy of youth is not just a generational game, it also plays a highly charged role in the theater of international relations.

Even if, and perhaps because, their meaning differs from context to context, there is an immense significance still attached to those everyday activities, constantly being reinvented, which remain a medium for predominantly youthful energies: dressing up, dressing down, hanging out, zoning out, overindulging, tripping, stripping, street-posing, slamdancing, cruising, low riding, steppin' out, grossing out, chillin', gangbanging, dissing and the like. Whether personally customized or more uniformly induced by the high barometric pressure of peer group formation, these activities and the musical loyalties around which they are organized continue, as the contributors to this volume attest, to attract serious debate about the fantasy and the reality of youth culture. Aside from being part of a peer culture of display and spectacle, they openly invite the scrutiny of adults, and are part of a dialogue with adult practices. At the same time, they remain autonomous activities, offering a course of schooling in the arts of socialization on terms not wholly governed by adult sensibilities. Youth culture craves recognition but does not necessarily want to be understood by adults. Indeed, all the evidence suggests that it thrives upon being misunderstood, a fact that may have compromised, but has not deterred, the contributors to this volume.

Notes

1. "T-ing off: This Time It's Personal," Interview with R. J. Smith, *Village Voice* (April 13, 1993), p. 67.

2. dream hampton, "Hard to the Core," *The Source*, 45 (June 1993), p. 34.

3. Donna Gaines, *Teenage Wasteland: Suburbia's Deadend Kids* (Pantheon, 1991).

4. See Angela McRobbie, "Shut Up and Dance: Youth Culture and Changing Modes of Femininity," *Cultural Studies*, 7, 3 (October 1993) pp. 406–26.

5. Jim Riordan, "Teenage Gangs, 'Afgansty' and Neofascists," in Riordan, ed. *Soviet Youth Culture* (Bloomington: Indiana University Press, 1989), p. 122.

Histories & Futures

We Know What Time It Is
Race, Class and Youth Culture in the Nineties
George Lipsitz

In Public Enemy's music video "Fight the Power," Flavor Flav, the group's free-spirited trickster, displays a stopped alarm clock pinned to his shirt and explains that "this means we know what time it is." He does not elaborate on how the broken clock conveys this information, but from the context of the video his meaning is clear. The group believes that time has stopped, that progress is not being made, that the need for social change is so urgent that it obscures everything else about our time.

Public Enemy's sense of urgency about the present contains an important lesson for investigations into youth music and youth culture. Our time is a time of crisis for youth, a time of unprecedented damage and danger to young people. Since the 1970s, deindustrialization, economic restructuring and a resurgence of racism have created fundamentally new realities for young people. Yet too often we talk about "youth" as a transhistorical and timeless entity. We use categories borrowed from other eras, without realizing how little relevance they hold for the new realities of the 1990s.

Contemporary discussions of youth culture seem particularly plagued by memories of the 1960s—as if nothing significant has happened over the past twenty years. To be sure, the 1960s deserve recognition as a decade when young people active in the civil rights movement, in student protest groups, in antiwar activity, and in the emergence of women's liberation took history into their own hands and provoked substantive changes in society at large. But the enduring hold of the 1960s on the imagination of the present has been pernicious.

For both the right and the left, many of the political battles of the 1970s and 1980s have been a kind of referendum on the cultural changes of the 1960s. This preoccupation with the past has become so suffocating that it is hard not to sympathize with those two men in Pennsylvania a few years back who started an organization to end all nostalgia about the 1960s. They called their group the National Association for the Advancement of Time. If we are to understand, address and redress the conditions facing young people today, we have to acknowledge the new realities that confront them, and we have to reject analyses of youth that rely on outdated and obsolete concepts.

We live in revolutionary times. The powder keg that exploded in Los Angeles in 1992 after the acquittal of the police officers who brutalized Rodney King only made more visible the perpetual powder keg of race and class polarization created by twenty years of neoconservative economics and politics. This apocalypse on the installment plan hurts people of all ages, but it has exacted particularly high costs from young people, leaving them with little hope for a better future. In a society that subsidizes the rich and powerful by stealing from those least able to defend themselves, youths from so-called "minority" communities have fared particularly badly during these decades. But their resistance to that treatment has been the source of many of the most visible manifestations of contemporary youth culture. Our discussions of youth culture will be incomplete if we fail to locate them within the racialized social crisis of our time, but our understanding of that crisis will also be incomplete if we fail to learn the lessons that young people are trying to teach through their dance, dress, speech and visual imagery.

In Los Angeles at the time of last April's rebellion, some forty thousand young people (almost twenty percent of the city's sixteen to nineteen-year-olds) had no jobs and were not in school. Nationwide, the number of children living in poverty increased by 2.2 million between 1979 and 1989. Child poverty among European-Americans increased from 11.8 percent to 14.8 percent, among Latinos from 28 percent to 32 percent, and among blacks from 41.2 percent to 43.7 percent.[1] While youth music and youth fashions fare very well in the marketplaces of postindustrial America, young people are faring very badly. Despite endless rhetoric about "family values" and "protecting our children," the wealthiest and most powerful forces in our society have demonstrated by their actions that they feel that young people do not matter, that they can be our nation's lowest priority. From tax cuts that ignore pressing needs and impose huge debts on the adults of tomorrow in order to subsidize the greed of today's adult property owners, to systematic disinvestment in schools, the environment and industrial infrastructure, the resources of the young are being cannibalized to pay for the irresponsible whims and reprehensible avarice of a small group of wealthy adults.

The United States has one of the worst infant mortality rates among industrialized nations. Out of every thousand babies born in the U.S., 9.8 die in infancy—a rate worse than that of sixteen other nations. Black children die at almost twice the national average— 18.2 per thousand births, while twenty-two black and Latino infants per thousand in South Central Los Angeles die shortly after birth.[2] Black men in Harlem and South Central Los Angeles have a shorter life expectancy than men in the impoverished "Third World" country of Bangladesh.

These dire health statistics stem directly from continuously worsening economic deprivation. Deindustrialization has destroyed the blue-collar jobs that used to give young workers a start in life. Twenty-three percent of male workers between the ages of eighteen and twenty-four received wages below the poverty line in 1979, but by 1990, forty-three percent

of these young workers earned poverty wages. For those workers between the ages of twenty-five and thirty-four, six percent of full-time male workers received below poverty wages in 1979, but by 1990 this number had increased to fifteen percent.[3] The percentage of all full-time workers earning less than a subsistence wage increased from twelve percent of the work force in 1979 to eighteen percent by 1990. Between 1965 and 1990, black family income fell by fifty percent, while black youth unemployment quadrupled and white youth unemployment remained static.[4]

Unwanted as workers, underfunded as students, and undermined as citizens, minority youth seem wanted only by the criminal justice system. In Los Angeles, more than fifty thousand youths have been arrested in a misguided and counterproductive antigang initiative named "Operation Hammer."[5] Harvard University economist Richard Freeman estimates that thirty-five percent of all black men between the ages of fifteen and thirty-five were arrested at some point in 1989. Black Americans make up only twelve percent of the nation's drug users, but account for forty-three percent of felony offenders convicted for drug offenses.[6] A study for the National Center on Institutions and Alternatives in 1992 reported that seventy percent of black men under the age of thirty-five in Washington, DC had been arrested, and it estimated that as many as eighty-five percent of black males in that city would be arrested some time in their lives.[7] Since the 1970s, a series of moral panics about gangs, drug use, teenage pregnancy and "wilding" assaults have demonized inner-city minority youths, making them scapegoats for the chaos created in national life by deindustrialization and economic restructuring.[8]

Demonized images of inner-city youths serve the strategic purposes of neoconservatives who have fashioned a countersubversive electoral coalition against affirmative action, enforcement of civil rights laws and help for the poor. As Michael Rogin points out, countersubversives need demonized enemies to justify their own repressive and authoritarian desires. They also need a smoke screen to divert attention away from the dire consequences of their own policies, from the evisceration of the welfare state and from the depletion of the nation's social capital engendered by twenty years of direct and indirect subsidies to the wealthy.[9]

Young people and their culture play a particularly important role in the neoconservative strategy. Images of "gang members" and "unwed mothers" mistake the effects of poverty for its causes, and discursively create a middle class absolved of responsibility for the systematic redistribution of wealth and life chances over the past two decades. By presenting the inner-city urban poor as a threat to the middle-class family, neoconservatives win support for even greater repression, segregation and privatization. Middle-class young people increasingly face illegal searches, invasions of privacy, suppression of free speech and suspensions of civil liberties, all in the name of protecting them from bad influences.

For poor youths, programs like Operation Hammer and the national "Weed and Seed" initiative create a two-tiered definition of citizenship, depriving inner-city youth of basic

rights in the name of fighting crime. But of course, these measures only increase crime by institutionalizing brutality and the rule of force in the inner city, and by recklessly and irrevocably designating as "criminals" hundreds of thousands of noncriminal youths who live in neighborhoods dominated by gangs. By burdening as many young people as possible with arrest records and identification as gang "members," these repressive programs bring about the exact results they purport to prevent. They make noncriminal employment all but impossible for many, and they place young people in jails where joining gangs for protection and learning from experts how to commit crimes are the only real options. They give citizens a relationship to the Bill of Rights which differs according to the neighborhood in which they live. Over the past decade, the state of California has tripled its prison population; nationwide, one out of every four black males under the age of twenty-five is either in jail or prison, or under some kind of supervisory probation.

Yet for all this mistreatment, indeed in no small way *because* of this mistreatment, young people from aggrieved communities have been the creators of the most dynamic and innovative forms of youth culture in the postindustrial era. Of course, young people from every strata of society have produced some distinctive culture, and middle-class and working-class cultural forms also play an important role in expressing the perspectives and views of young people. But one of the most important (and certainly one of the most unexpected) developments of the 1980s and 1990s has been the emergence into the mainstream of cultural forms emanating from some of the country's most aggrieved populations. Materially deprived and culturally despised youths have seized the most advanced forms of modern technology to present their experiences and aspirations to a wider world. They ironicize and invert the iconography of countersubversive demonization.

Answering a culture of surveillance with a counterculture of conspicuous display, they constitute their own bodies, ghetto walls and city streets as sites for performance and play. As Tricia Rose explains about the emergence of hip hop culture in the South Bronx in the early 1970s, young people being trained in vocational high schools in obsolete technologies for jobs that no longer existed responded to their marginalization by mastering modern new technologies like digital samplers. They combined some of the oldest African-American oral traditions with some of the newest creations of electronic, digital, fiber-optic and computer-chip mass-media technology. Defamed and despised by countersubversive stories, they found a way to contest their erasure, to reintroduce themselves to the public by "throwing out" a new style that made other people take notice.[10]

People resisting domination can only fight in the arenas open to them; they often find themselves forced to create images of themselves that interrupt, invert or at least answer the ways in which they are defined by those in power.[11] In the face of neoconservative narratives longing for the stability of the pre-civil rights "golden age," young people embrace cultural forms that celebrate change and evoke endless and relentless movement. Graffiti writers make the monumental appear ephemeral by altering the visual landscape of the

city with their tags and *placas*. Samplers reconfigure time by inserting music from the past into the present, and by rediscovering historical figures (like Malcolm X) and making them a part of contemporary culture. "We love . . . change," proclaims Lady Kier Kirby of Deee-Lite, celebrating the ways in which mastery over technology creates new social and cultural spaces for artists and audiences.[12]

In embracing change, youth culture celebrates movement as well. Hemmed in by urban renewal, crime and police surveillance, young people write graffiti on subway trains and buses so that their names and images can travel all over the city and be seen by strangers. In hip hop, as Tricia Rose emphasizes, movement, flow, repetition and rupture provide the ruling aesthetics. Dancing calls attention to the movements of the body as metaphors; a dance step like "the running man" aestheticizes the danger of being chased by the police, while electric boogaloo "robot" moves and "vogue" gestures build dramatic tension through continuities and ruptures in movement.[13] Cyborg-like effects in dancing and music enable people whose oppressions are inscribed on their bodies (because of racism, sexism and homophobia) to imagine their bodies as flexible technologies with prosthetic properties. Large car speakers adjusted to pump-up-the-bass "jeep beats" of rap music travel freeways and city streets, claiming space by projecting out sound, while boom boxes similarly reconfigure street corners and subway cars through the invasive properties of amplified sound. It is no accident that while heavy metal videos tend to privilege stadium and arena concerts as ideal spaces of representation, hip hop videos more often take place on the streets of postindustrial urban inner-city neighborhoods, reclaiming them as sites of self-affirmation.[14] Queen Latifah's "Ladies First" presents abandoned urban slag heaps as sites for celebration and dancing; in "Paper Thin" MC Lyte dismisses her two-timing boyfriend before an "audience" of subway train passengers.

In Los Angeles, the poet/performance artist Marisela Norte has attracted a large following among young Chicanas (among others) through the sale of spoken-word casette tapes and compact discs that relate her experiences negotiating the physical and cultural spaces of the city. At one point Norte wrote all of her poems on the bus while riding to work, incorporating the people and signs she passed on her journey into her verses. Her movements across town force her to face race and class differences, but she concentrates on gender, on *las vidas de ellas* (the lives of the women), on the experiences of the women she sees every day whose struggles against suffocating male authority, the demands of home and family, romantic myths and sexual harassment engage her own hopes and fears.[15]

Public Enemy's Chuck D engineers his music for its reception in urban spaces. As he explained in a 1990 interview in *Keyboard*:

> One thing that's helped us is that we study different regions in rap. Rap has different feels and different vibes in different parts of the country. For example, people in New

York City don't drive very often, so New York used to be about walking around with your radio. But that doesn't really exist any more. It became unfashionable because some people were losing their *lives* over them, and also people didn't want to carry them, so now it's more like "Hey, I've got my Walkman." For that reason, there's a treble type of thing going on; they're not getting too much of the bass. So rap music in New York City is a headphone type of thing, whereas in Long Island or Philadelphia, where in order to get anywhere you gotta drive so people have cars by the time they're sixteen or seventeen years old, rap is more like "Well, I got my speakers in my car and I'm turning my sound all the way up." It's more of a bass type of thing. In some cities, they're into low riders—big cars you can put a four-way system in, with speakers in the front doors and in back, so that it becomes more of a wraparound sound.[16]

The emphasis on movement that emerges within hop hip reflects the ways in which race determines experience with urban space in contemporary U.S. cities. Los Angeles police officers beat Rodney King because of his movement—driving near a white neighborhood along the Foothill Freeway, moving on the ground while he was being beaten instead of freezing into motionless submission, and, according to a manuscript by Sergeant Stacy Koon (one of two officers convicted for the assault) because of the officer's revulsion for the movement of King's body.

He grabbed his butt with both hands and began to shake his fanny in a sexually suggestive fashion. As King sexually gyrated, a mixture of fear and offense overcame Melanie [Highway Patrol Officer Melanie Singer, who testified that she was not afraid and did not understand why the officers attacked King]. The fear was of a Mandingo sexual encounter.

Koon explained that King's "gyrations" justified his beating because:

In society there's this sexual prowess of blacks on the old plantations of the South and intercourse between blacks and whites on the plantation. And that's where the fear comes in, because he's black.[17]

Koon's frank description illustrates how domination rests on repression of the black body; in that context the movement of black bodies in hip hop talks back to domination, just as rap lyrics themselves elevate "talking back" into a form of art.

Rap music, graffiti writing and car customizing turn consumers into producers, and they contest prevailing definitions of property and propriety. They provide opportunities for people defamed by others to tell their own stories. Although always engaging with dominant values, they also invert, subvert and ironicize them. In a society that claims to valorize "family values," young people engaged in these activities often drop their family names

and adopt sobriquets that mock the world that generally disdains them, as evidenced by the rappers who call themselves Special Ed, Arrested Development, Public Enemy, Above the Law, and N.W.A. They accept the centrality of consumption and commodities in contemporary culture, but their own prestige hierarchies often hinge on the originality of their own imaginative appropriation and bricolage with brand names and fashion hierarchies.

Youth culture also displays a documentary zeal about representing the effects of deindustrialization that appear rarely, if ever, in dominant media and advertising outlets. To a mass media that generally divides the mass audience only into market segments, the frankness about inner-city life in hip hop culture reveals ways that the audience is already divided by history, culture and power.

Although images and icons of black nationalism and Chicano nationalism freely circulate inside those communities, pan-ethnic antiracist coalitions based on culture rather than on color also maintain a visible presence among young people. In Los Angeles, a group of graffiti writers call themselves ALZA, a *calo* slang word for "rise up," but also an acronym that means Asian, Latino, Zulu and Anglo. These efforts have served as a model for middle-class youths as well. At the University of California, San Diego (where I teach), a group of Asian-American students broke out of their traditional separation into Chinese-American, Japanese-American, Vietnamese-American, Filipino-American, and Korean-American groups to start a newspaper emphasizing their common experiences. But as they tried to define what it means to be Asian-American, they increasingly realized that what united them was opposition to anti-Asian racism. Yet once they began to organize themselves around antiracist principles, they soon saw they could not be against only anti-Asian racism, that they had to stand against racism against Latinos, Native Americans and African-Americans as well. Their newspaper has sparkled with the energy of pan-ethnic antiracism. In one issue an officer of the African-American Student Union contributed a column on Black History Month; in another, discussion of the fiftieth anniversary of the internment of Japanese-Americans led to an impassioned critique of anti-Arab violence during the Gulf War. In still another issue, a Japanese-American rap music fan wrote sensitively about his mixed feelings about Ice Cube's music after the singer employed anti-Korean references in what the student saw as an otherwise admirable exposé of power relations in U.S. society.

Similarly, intercultural rap music, built upon a base of "prestige from below" originating in African-American culture, has produced Latino rappers including Kid Frost, A Lighter Shade of Brown, Funky Aztecs, Mellow Man Ace, and Puerto Rock. European-American rappers with credibility among black artists and audiences include 3rd Bass and House of Pain, while the interracial group Cypress Hill attracts a broad-based audience united by symbols of urban alienation. Pacific Islander and Asian-American rappers include the Samoan-American Booya Tribe, and the Korean-American rappers from Seattle who make a bicultural pun by taking their name from the capital of South Korea and calling themselves

the Seoul Brothers. Both Kid Frost and A Lighter Shade of Brown have paid tribute to James Brown's "Say It Loud, I'm Black and I'm Proud," by declaring themselves "brown and proud." Unfortunately, we don't yet have a white group farsighted enough to "say it with a mumble, I'm white and I'm humble," but perhaps that is on the way.

In an increasingly segregated and polarized society, youth culture's ability to imagine coalitions across racial and ethnic lines has been exemplary. Yet on issues of gender, the picture is less encouraging. Sexism and misogyny permeate youth culture (as they permeate all culture in the U.S.), exerting important influence on its prestige hierarchies and exclusionary practices. It is perhaps excusable, in a culture that values property more than people, that aggrieved youths would make sport out of the destruction of property—that graffiti writers would deface walls, that hip hop "engineers" would create sounds designed to break speakers, and that car customizers might do permanent damage to cars by making them "hop" and throw sparks. But less understandable are the ways in which a diminished sense of self among inner-city males has often led to contemptuous attitudes toward women. One ugly aspect of the popularity enjoyed by hip hop among suburban youth has been its symbolic value to them as a franchise on an imagined male power created through the degradation of women. In addition, throughout U.S. culture, advertising messages that "hail" people as consumers lead inevitably to a needy narcissism, a pre-Oedipal preoccupation with pleasure that finds its ultimate expression in the macho fantasies of boys celebrating their sadism for the approval of other boys. From 2 Live Crew to Rambo, from the Gulf War to the revenge fantasies of Charles Bronson, much of contemporary culture revolves around what one critic has aptly termed "sadism in search of a story." Of course, interventions by young women have often played an important role in forms of popular culture claimed by young males as their own: graffiti writers Lady Pink in New York and Omega in Los Angeles have challenged male writers on their own turf, while rap artists Yo-Yo, Salt-N-Pepa and Queen Latifah have inverted, subverted and ironicized dominant masculine images in hip hop. Despite their successes, street art forms designed to celebrate difference and heterogeneity still truncate their emancipatory possibilities when they produce new binary oppositions and hierarchies based on gender and sexual preference.

When young people who have been demonized for their race or class turn around and demonize others—even members of their own groups, they divide communities that need to be united, and they replicate the ways of seeing the world that make class rule and racial oppression operative in the first place. Binary oppositions like those dividing men from women or heterosexuals from gays and lesbians turn "different from" into "better than." They betray the instincts of intersectionality and conjuncture that inform the most constructive creations of youth culture. Most important, they leave people longing for real or imagined domination over others as a kind of psychic reparation for their own pain. But they offer no way to change society so that mutuality, reciprocity and justice can replace

exploitation and hierarchy. They make it impossible to build the kind of organized political struggle necessary to redeem youth culture's emancipatory promises.

The beat poet Bob Kaufman described Charlie Parker as "an electrician," because the saxophonist "went around wiring people."[18] Kaufman no doubt meant that Parker's performances had an "electricity" about them—in the sense of being exciting and perhaps shocking. But an electrician also connects people to currents of energy and power. Just as the toasters, MCs and DJs in the South Bronx in the 1970s wired their turntables and speakers by stealing power from street lamps (lamping), youth culture in general has diverted power away from mainstream culture toward a culture in touch with the present and eager to build a different future. Yet it remains to be seen exactly what kind of political change can or cannot emerge from today's youth culture.

Revolutionary politics and oppositional art have traditionally been rooted in a transcendent critique whereby activists and artists attempt to stand outside their society in order to change it. Transcendent critiques draw strength from teleology—from their utopian vision of the future. But these utopian visions have too often obscured the realities of the present, leaving artists and activists addressing people as they wish them to be rather than as they actually are. Because transcendent thinkers believe their society to be completely corrupt, they too often distrust the people in them—even those they hope to persuade to become agents of social change. Today's youth culture proceeds from a different premise. Instead of standing outside society, it tries to work through it, exploiting and exacerbating its contradictions to create unpredictable possibilities for the future.

In their embrace of commercial culture, in their emphasis on exposing the contradictions of contemporary life and in their enunciation of indirect and ironic commentary, youth music and youth culture offer an immanent rather than a transcendent critique. While this approach has many advantages, it also often threatens to mimic rather than transform the dominant society. Young people in these subcultures often cynically give back measure for measure the treatment they have received from others, aggressively asserting their own interests against those of anyone who happens to get in their way. As Mike Davis notes in his memorable comparison between gang youths and suburban property owners' associations, the *homeboys* and *home owners* both maximize their interests by banding together around the protection of territory to make gains at the expense of others.[19]

Although preoccupations with power, emphasis on surface appearances and celebrations of property are often voiced ironically within youth culture, sometimes it is hard to tell the difference between critique and collaboration. As Greg Tate has shown repeatedly in his exemplary journalism, even among performers who are clearly cultural and political radicals in some ways, sexism, homophobia and materialism still loom large. It is difficult to imagine how all the insight, energy and inspiration flowing through youth culture can become a part of social change rather than a commodified substitution for it.

Without some kind of collective political movement attempting to redistribute wealth

and power, youth culture may well degenerate into simply another way for capitalists to sell back to people a picture of the life that has been stolen from them. Yet it would be foolish to dismiss youth culture simply because it has not yet produced an organized political movement. If we had the ability to transport ourselves back to moments in history when revolutionary change was about to occur, we would find relationships between politics and culture that resemble those of our own time. Certainly we would find little in the slave South in 1859, or in industrial cities in 1931, or on college campuses in 1959 that prefigured massive social upheaval in the years ahead. Yet when opportunities for change presented themselves, previously "apolitical" slaves, workers and students drew upon cultural stories from the Bible, from ethnic culture and from mass media to propel themselves into egalitarian movements against exploitation and hierarchy.

Similarly, the connections between youth culture and commercial culture should not lead us to believe that mere market considerations determine the reach and scope of these cultural practices. Graffiti writing and sampling are both based on problematizing prevailing notions of private property, while car customizers often spend enormous sums to render expensive commodities all but inoperable. It is not so much that youth cultures are under the "thrall" of commodities, but rather that the power of commodities inevitably shapes the contours of personal and collective identity. In societies where control of the state or control of the factory proves crucial to deciding individual and group identity, oppositional movements logically focus on politics or class struggle. Politics and class struggle certainly remain crucial to resolving the tensions exposed by contemporary youth culture. But at a time when consumer culture and media representations play a more powerful role than ever before in defining individual and group identity, it should come as no surprise that young people—whose identities have been defamed through cultural representations—would address cultural symbols as sites for contestation.

During the 1963 March on Washington, A. Philip Randolph noted that it fell to black people to expose America's elevation of property rights over human rights, because their ancestors had been transformed from human personalities into property by slavery. Consequently, African-Americans knew better than anyone else the deadly consequences of the confusion between people's rights and the rights of property. Similarly, young people who have been demonized by cultural representations logically address the terrain of culture as a crucial site for creative confrontation.

In *The Wretched of the Earth*, Frantz Fanon talks about times when communities experience a restlessness and uncontrollable energy in their songs. Even before they are able to channel their critiques into disciplined collective action, their culture articulates what Fanon calls the wisdom of the future.[20] It is this energy in youth culture that contains great import for the politics of tomorrow. The great, late, British historian E. P. Thompson (who in this context, I guess, should be called "EPMD Thompson"[21]), helps us understand the possibilities of the present moment through his conceptualization of class formation as

the lived reality and collective activity of the people, the ways in which they make meaning for themselves. In their challenge to dominant modes of representation, in their appropriation of consumer culture to fashion a new public sphere, and in their impatience with cultural representations that distort the realities of the present and the possibilities for the future, young people have created cultural forms that speak powerfully to the loneliness, exclusions and injustices of U.S. society.

The same Bob Kaufman who called Charlie Parker an electrician also wrote that "way out people know the way out."[22] It may seem strange to quote Kaufman so much, since he is best known for honoring a ten-year vow of silence, interrupted only occasionally by turning to acquaintances and asking "anybody got any speed?" But perhaps the power of Kaufman's poetry might help us understand how the massive silences about race and class within the dominant culture make representations like his, and those of contemporary youth culture, all that much more important. At a time when oppressive social hierarchies preserve parochial interests by controlling access to discursive and physical space, young people who don't "know their place" might be the very people most suited to letting us know what time it is.

Notes

1. Maxine Waters, "Testimony Before Senate Banking Committee," in Don Hazen, ed. *Inside the L.A. Riots* (New York: Institute for Alternative Journalism, 1992), pp. 26, 27.

2. Cynthia Hamilton, "The Making of an American Bantustan," in Don Hazen, ed., *Inside the L.A. Riots*, p. 20.

3. Noel J. Kent, "A Stacked Deck," *Explorations in Ethnic Studies* vol. 14 no. 1 (January 1991), 12, 13. Richard Rothstein, "Musical Chairs as Economic Policy," in Don Hazen, ed., *Inside the L.A. Riots*, p. 143. The identification of full-time male wages as the norm does not connote a judgment on my part that men's wages are more important than women's. The gender designation comes from assumptions by economists that greater continuity in the work force among men makes their work histories a more reliable index of the economy's performance.

4. Noel J. Kent, "A Stacked Deck," p. 13.

5. Lynell George, *No Crystal Stair* (New York and London: Verso, 1992). Marc Cooper, "L.A.'s State of Siege," in Don Hazen, ed., *Inside the L.A. Riots*, p. 15.

6. Jonathan Marshall, "Shattered Cities," in Don Hazen, ed. *Inside the L.A. Riots*, pp. 137, 138.

7. Jason DeParle, "Young Black Men in Capital Study Finds 42% in Courts," *New York Times* (April 18, 1992), A1, quoted by Thomas Dumm, "The New Enclosures: Racism in the Normalized Community," in Robert Gooding-Williams, ed. *Reading Rodney King: Reading Urban Uprising* (New York and London: Routledge, 1993), p. 190.

8. See Hazel Carby, *Critical Inquiry* (Summer 1992).

9. Michael Rogin, *Ronald Reagan, the Movie and Other Studies in Demonology* (Berkeley: University of California Press, 1987).

10. Tricia Rose, "A Style Nobody Can Deal With," oral presentation, Youth Music—Youth Culture conference. Princeton, New Jersey, November 20, 1992, published in this volume.

11. See James C. Scott, *Domination and the Arts of Resistance* (New Haven, Connecticut: Yale University Press, 1991).

12. Lady Kier Kirby, "The Music Writer," oral presentation, Youth Music—Youth Culture Conference. Princeton, New Jersey, November 20, 1992, published in this volume as "Hello."

13. I thank Herman Gray for calling my attention to the importance of "the running man." Willie Ninja presents an excellent introduction to the emergence of "voguing" within black gay drag culture in Jennie Livingston's 1992 film "Paris is Burning."

14. Rob Walser, *Running With the Devil* (Hanover: Wesleyan/University Press of New England, 1993), p. 114. Relevant hip hop videos include Queen Latifah's "Ladies First," MC Lyte's "Paper Thin," Gangstarr's "Manifest," Naughty By Nature's "Ghetto Bastard," Kid Frost's "La Raza."

15. Marisela Norte, "Word," New Alliance Record Company, 1992.

16. Mark Dery, "Public Enemy: Confrontation," *Keyboard* (September 1990), p. 90.

17. Richard Serrano, "Koon's Blunt Book on Life in LAPD Describes King Beating in Detail," *Los Angeles Times* (May 17, 1992), p. B6. See also Thomas Dumm, "The New Enclosures: Racism in the Normalized Community," in Robert Gooding-Williams, ed. *Reading Rodney King*, pp. 178–195.

18. Bob Kaufman, *Solitudes Crowded With Loneliness* (New York: New Directions, 1965), p. 12.

19. Mike Davis, *City of Quartz* (London and New York: Verso), 1991.

20. Frantz Fanon, *The Wretched of the Earth* (New York: Grove Press, 1968), pp. 225, 243.

21. As in EPMD, who recorded "You Gots to Chill" on the Fresh record label in 1988. The Long Island rappers Erick Sermon and Parrish Smith allegedly named themselves EPMD as an acronym for Erick and Parrish Making Dollars.

22. Bob Kaufman, *Solitudes Crowded With Loneliness*, p. 80. See also Maria Damon, *The Dark End of the Street: Margins in American Vanguard Poetry* (Minneapolis: University of Minnesota Press, 1993).

Same As It Ever Was
Youth Culture and Music

Susan McClary

As a historian who regularly studies the whole gamut of Western music, I am tempted to mutter David Byrne's refrain "same as it ever was" whenever some new scandal concerning youth music explodes onto the pages of, say, *Newsweek*. For diatribes against the music produced by or for the young pockmark the historical record back as far as Plato, whose ancient prohibitions rose again like the vengeful dead when the late Allan Bloom used them to attack the musical tastes of his students in the 1980s.[1]

Plato's apprehensions about music cluster around two principal issues, both of which are reproduced virtually every time a controversy concerning youth culture appears. First is the matter of authority. In his *Laws* he explains that

> our once silent audiences have found a voice in the persuasion that they understand what is good and bad in art; the old "sovereignty of the best" in that sphere has given way to an evil "sovereignty of the audience." Music has given occasion to a general conceit of universal knowledge and contempt for law, and liberty has followed in their train. To be unconcerned for the judgment of one's betters in the assurance which comes of a reckless excess of liberty is nothing in the world but reprehensible impudence. So the next stage of the journey toward liberty will be refusal to submit to the magistrates, and on this will follow emancipation from the authority and correction of parents and elders.[2]

Plato fears that unsanctioned music will instill a thirst for liberty (clearly not a good thing in his estimation). Such music, he claims, encourages the populace to value its own judgments and to resist authority, whether familial or governmental. As he puts it most direly in the *Republic*, "a change to a new type of music is something to beware of as a hazard of all our fortunes. For the modes of music are never disturbed without unsettling of the most fundamental political and social conventions."[3]

Plato's second set of anxieties involves the sensuous body as it can be aroused by the musics of women or ethnic groups noted for their "laxness," such as the Lydians. What

remain suitable for the Republic, then, are genres of music dedicated either to the martial discipline of the Spartans or to the moderate exchange of ideas through rhetoric. Plato tolerates music only when it serves as a vehicle toward some hegemonic political end. Left to its own devices (or to the dreaded "sovereignty of the audience"), music's ability to appeal to the body will wreak havoc on society.

Denouncements of these twin threats—subversion of authority and seduction by means of the body—recur as constants throughout music history. Saint Augustine, who indulged prodigiously in the pleasures of the flesh when he was young, is inclined to abolish music not only for himself but for his entire flock. He writes concerning the effects of music in the context of the liturgy:

> I realize that when they are sung, these sacred words stir my mind to greater religious fervor and kindle in me a more ardent flame of piety than they would if they were not sung. . . . But I ought not to allow my mind to be paralyzed by the gratification of my senses, which often lead it astray. For the senses are not content to take second place. Simply because I allow them their due, as adjuncts to reason, they attempt to take precedence and forge ahead of it, with the result that I sometimes sin in this way.[4]

Thus, even when serving to amplify holy words, the mere presence of music can distract the attention from the spiritual realm and direct it back to the sensual body. Note especially the slippage between the body and sin in Augustine and elsewhere in Christian writings, in which the most innocuous of sensory responses seem to raise immediately the specter of unbridled sexuality.

If authorities regard as suspect even the music that submits to official guidelines, their reactions often verge on the hysterical when musicians depart from tradition to introduce novelties into the mix. During the course of the Middle Ages, the church hierarchy assailed most of the innovations now treasured as the glories of Western music. For instance, twelfth-century polyphony (the practice whereby several voices in the all-male choir sing different parts simultaneously) is attacked thus by theologian John of Salisbury:

> Music sullies the Divine Service, for in the very sight of God, in the sacred recesses of the sanctuary itself, the singers attempt, with the lewdness of a lascivious singing voice and a singularly foppish manner, to feminize all their spellbound little followers with the girlish way they render the notes and end the phrases. Could you but hear the effete emotings of their before-singing and their after-singing, their singing and their counter-singing, their in-between-singing and their ill-advised singing, you would think it an ensemble of sirens, not of men; indeed, such is their glibness that the ears are almost completely divested of their critical power, and the intellect, which pleasureableness of so much sweetness has caressed insensate, is impotent to judge the merits of the

things heard. Indeed, when such practices go too far, they can more easily occasion titillation between the legs than a sense of devotion in the brain.[5]

And finally, John Calvin:

> We might be moved to restrict the use of music to make it serve only what is respectable and never use it for unbridled dissipations or for emasculating ourselves with immoderate pleasure. There is hardly anything in the world that has greater power to bend the morals of men this way or that, as Plato has wisely observed. And for this reason we must be all the more diligent to control music in such a way that it will serve us for good and in no way harm us.[6]

One of the themes running through these citations is the fear of emasculation. In a culture rigidly structured in terms of a mind-body split, music's appeal to the body predisposes it to be assigned to the "feminine" side of the axis. John of Salisbury's harangue (with its before-singing, counter-singing, and in-between-singing) even presents a scarcely veiled depiction of illicitly intertwining male bodies.[7] For Plato, Saint Augustine, John of Salisbury and Calvin, nothing less is at stake than masculinity itself and, by extension, the authority of church, state and patriarchy.

Up against this rigid history, we might expect the political Left to side with the liberties evidently afforded by music as it escapes the restraints of hegemonic circumscription. And so it has been in some cases. But as often as not, the same apprehensions show up in the rhetoric of critics identified with the Left as well, for anxieties over masculinity and mind-body dilemmas are not the exclusive preserve of conservatives. Like Plato or Augustine, the Left has often tried to harness music and channel its energies toward pragmatic ends—most obviously in pseudo-folk styles, which work by implying an unmediated link with traditional roots while minimizing the interference of the music itself. The political folk song is the Left's version of the Calvinist hymn: words foregrounded to control "the meaning," music effaced to the status of vehicle, all untoward appeals to the body eliminated.

Occasionally (most obviously in the writings of the Frankfurt School critics) the music itself is analyzed as a terrain upon which social tensions are enacted. Adorno's music criticism—which is unmatched as long as he sticks to the German canon—traces the ill-fated metanarrative of Enlightenment ideals as they collapse along the lines of their own internal contradictions. For him the only game left in town by the 1930s is modernism, which forswears beauty (now hopelessly complicit with commodification) and resigns itself to inhabiting a thorny, dissonant style that flaunts the agonies of alienation. Accordingly, he reacts with extraordinary vehemence against jazz, which he regards little more than a product of the culture industry—one that has the effect of luring the heirs of the idealist

tradition from their habits of critical interrogation to mindless, hedonistic revelling in the body. His extraordinary choice of tropes at the climax of one of his jazz essays makes clear how much is at risk—the loss not only of intellectual and cultural prestige, but also of virility itself—in this voluntary fall from grace:

> The aim of jazz is the mechanical reproduction of a regressive moment, a castration symbolism. "Give up your masculinity, let yourself be castrated," the eunuchlike sound of the jazz band both mocks and proclaims, "and you will be rewarded, accepted into a fraternity which shares the mystery of impotence with you."[8]

To be sure, Adorno is arguing in his vituperations against jazz for the continued preeminence of high art over popular culture. Yet those who purport to speak for popular culture have often reproduced his fear of the feminine, the body and the sensual. Recall, for instance, the erasure of women—whether the blues queens of the 1920s or girl groups of the early sixties—from historical narratives, or the continuing devaluation of dance music as a pathetic successor to the politically potent music of the sixties—especially in the "DISCO SUCKS" campaign, where an underlying homophobia is quite obvious, but also in the blanket dismissals of the many African-American genres (including disco) that are designed to maximize physical engagement.

Something of this suspicion of music is also discernible in the attempts by many scholars of popular culture to marginalize the music itself, the better to focus on lyrics, explicitly political concerns, ethnographic research on reception or issues involving the culture industry. Simon Frith, for example, has recently claimed that the musicological study of popular music (rap, in this case) "is more corrupting than its commercialisation."[9]

I would argue that there are at least two crucial reasons why the music itself and its imagery have to be figured into the cultural studies project. First, given the tendency in cultural studies to stress the radical idiosyncrasy of each listener's musical perceptions, we need to find ways of understanding the socially grounded rhetorical devices by means of which music creates its *intersubjective* effects; otherwise, the medium remains privatized and mystified, impervious to cultural criticism. Second, without some sense of shifting musical strategies and priorities, we cannot adequately address issues of power or history as they involve music: we cannot account for how musical styles, genres, conventions, artists or songs participate in social formation, nor for why battles over musical preferences frequently are so bitter (see again the quotations from Plato and others above).[10]

From my perspective as a music historian, it seems to me that the music itself—especially as it intersects with the body and destabilizes accepted norms of subjectivity, gender and sexuality—is precisely where the politics of music often reside. Without doubt, music's energies may be yoked occasionally (as they were in the sixties) to a more explicitly

political agenda. Yet such moments count, I believe, as anomalous. For theorists of popular music, the sixties may have been the worst thing ever to have happened: because some small percentage of the music produced during those few years articulated protests against the Vietnam War or class oppression, our attention has been distracted from the issues more consistently fought over in popular music—even during that paradigmatic decade. More than that, in positioning the physicality of the music in opposition to whatever the political substance of the "real stuff" was supposed to be, such theories reinscribe the polemics against the body that have characterized attempts at policing music throughout Western history.

A more productive approach to music—not just pop, but all music, including the ostensibly cerebral classical canon—would be to focus on its correspondences with the body. Teresa de Lauretis has used the term "technologies of gender" to refer to the ways in which film and other such media participate in the cultural construction of what it means to be male or female: she argues, in other words, that gender—far from being determined by nature or biology—is produced and shaped by social discursive practices.[11] I want to propose that music is foremost among cultural "technologies of the body," that it is a site where we learn how to experience socially mediated patterns of kinetic energy, being in time, emotions, desire, pleasure and much more.[12]

These patterns inevitably arrive already marked with histories—histories involving class, gender, ethnicity; music thus provides a terrain where competing notions of the body (and also the self, ideals of social interaction, feelings and so on) vie for attention and influence. An emergent group often announces its arrival first and most intensely in the ways its music constitutes the body.[13] In predictable reaction, devotees of entrenched genres frequently decry the heresy of the new as fiercely as did Plato, and for similar reasons: to identify strongly with a particular style is to take it as representing, quite simply, the way the world is; and people typically do not relish having their world and its attendant values—especially aspects as fundamental as perceptions of the body—pushed to the side as so much debris. Yet for better or worse, this is how the ever-changing history of Western music unfolds.

Although musical technologies of the body are frequently mediated commercially, their commercial status in no way diminishes their impact. Quite the contrary. Anxieties concerning music's relationship to money appear at least as far back as the attempts by city officials to regulate the urban minstrels who congregated in twelfth-century Paris in a special ghetto—the Tin Pan Alley of yesteryear.[14] Then as now, the problem is that what feels so intensely authentic can be purchased for a price: we pay professional musicians to push our buttons, which puts the enterprise dangerously close to prostitution. And yet it has very often been the music unleashed through and sustained by the commercial market—and largely through appeals to the body—that has succeeded in altering Western

culture, whether the erotic madrigal that emerged with the printing press in the 1500s or the public opera of seventeenth-century Venice that established codes for depicting— better, *constructing*—what we take to be our own most private feelings.

As Adorno's diatribe indicates, the most powerful musical influence in the twentieth century worldwide has come from African-American musicians, whose cultural traditions celebrate physicality without the terrorism of the mind-body split that has so plagued European culture. Ever since Okeh Records was persuaded to release Mamie Smith singing "You Can't Keep a Good Man Down" in 1920, the music of African-Americans has been bought and sold until it has permeated the entire globe. Without question, the treatment of black musicians by the commercial media has often been more than usually exploitative— artists have regularly been denied their share of the fortunes made by others from the sale of their music; and the reception of African-American music sometimes have bordered on the prurient—white audiences have often come to black music to experience vicariously the body they otherwise deny themselves; then have castigated black muscans for indulging in physicality. But if we reflect on twentieth-century culture, it seems undeniable that, during this period, African-Americans took over the making of images, the shaping of bodies and subjectivities through music. Despite the industry, even with all its rip-offs, the commercial process has also contributed to the creation of musical forms we know and love, and to the sensibilities that now seem so natural to most of us, black or white.

The important question is: What qualifies as political? If the term is limited to party politics, then music plays little role except to serve as cheerleader; if it involves specifically economic struggle, then the vehicle of music is available to amplify protest and to consolidate community. But the musical power of the disenfranchised—whether youth, the underclass, ethnic minorities, women or gay people—more often resides in their ability to articulate different ways of construing the body, ways that bring along in their wake the potential for different experiential worlds. And the anxious reactions that so often greet new musics from such groups indicate that something crucially political is at issue.

For the disenfranchised, one of the values of the culture industry is that it will peddle a groove if it thinks that groove will sell, regardless of whatever else is at stake. This is not at all to suggest that artists or fans control the scenario—the ability of the industry to absorb and blunt the political edge of anything it touches must not be underestimated. And cultural visibility (or audibility) does not translate automatically into social power. Yet it has frequently been by virtue of the market and its greed-motivated attention to emergent tastes that music has broken out of officially prescribed restrictions and has participated as an active force in changing social formations—formations that Plato and his followers saw as the very core of the political.

I would like to turn now to a couple of examples—one relatively recent, the other nearly four hundred years old—that illustrate music's impact on the body and the cultural reactions

to that impact. The first can be documented with unusual precision. On May 12, 1965, producer Jerry Wexler approached some studio musicians during a recording session and said, "Why don't you pick up on this thing here?" He then executed a brief dance step for the musicians. Guitarist Steve Cropper later explained:

> [Wexler] said this was the way the kids were dancing; they were putting the accent on two. Basically, we'd been one-beat-accenters with an afterbeat, it was like "boom dah," but here this was a thing that went "un-chaw," just the reverse as far as the accent goes. The backbeat was somewhat delayed, and it just put it in that rhythm, and [drummer] Al [Jackson] and I have been using that as a natural thing now, ever since we did it. We play a downbeat and then two is almost on but a little bit behind, only with a complete impact. It turned us on to a heck of a thing.[15]

The resulting tune, Wilson Pickett's crossover hit "In the Midnight Hour," is significant for several reasons. As Cropper's testimony indicates, it gave rise to a new style of soul music and provided Stax Records with the boost it needed to make it a viable presence within the industry. Thus whatever it was that was invented during that session quickly became a hot commodity that was exploited for all it was worth. But "Midnight Hour" also introduced into the broader public sphere a new way of experiencing the body, and it soon became part of a widely shared vocabulary of physical gestures and expressions. If you know this recording, its rhythms are indelibly engraved in your kinetic memory. At the mere mention of its title, your muscles coil up in eager anticipation of its groove.

As Cropper says, it soon turned into "a natural thing" for him and other musicians; it became virtually transparent. Yet Cropper's own account of how it came into being indicates how very constructed this "natural thing" was. He reveals with stunning clarity the historicity of musical grooves and, consequently, the historicity of the body. Moreover, he bears witness to the circularity between physical gestures and musical imagery, as the band seized a motion already practiced by one set of kids (predominantly African-American), figured out how to simulate that motion in their rhythms, and sent it out through the mass media to millions of others of all racial backgrounds who responded enthusiastically in their turn. Music depends on our experiences as embodied beings for its constructions and its impact; but our experiences of our own bodies—our repository of proper or even possible motions and their meanings—are themselves often constituted (to a much greater extent than we usually realize) through musical imagery.

The classic response of fans to a tune like this is: "It's got a good beat. You can dance to it." Critics often dismiss such statements as evidence of the mindlessness, the lamentable absence of discrimination in pop music reception. However, if you watch fans dance to "Midnight Hour," you will find that they have (in Wexler's words) "picked up on this thing here": those microsecond delays translate—as though without mediation or

consultation with the higher faculties—into a very specific set of gestures highlighting the butt, known as the Jerk. For the duration of the song at least, the body and even subjectivity itself are organized by its rhythmic impulses.

The fact that music can so influence the body accounts for much of music's power. But its power is not restricted to the activity of dance: the ability of music to mold physical motion often has ramifications that extend much further. Recall Plato's warning: "For the modes of music are never disturbed without unsettling of the most fundamental political and social conventions."[16]

To be sure, "Midnight Hour" does not address social issues at all. Yet its success on the American pop charts counts as a triumph of African-American countermemory. For what was unleashed with "Midnight Hour" is a form of physicality that is indispensable to African-American dance and music, but that mainstream America in 1965 still regarded as shameful: Peter Guralnik, for instance, writes in *Sweet Soul Music* about how White Citizen's Councils responded to this music by warning of "sex, barbarism, and jungle rhythms."[17] Under the influence of its groove, many white listeners started experiencing their own bodies in terms of an African-American sensibility. The impact of this and similar tunes on white Americans contributed to the political climate of cultural crossover in the sixties, the civil rights movement, as well as what came to be called "sexual liberation."[18]

This is not to deny the commodity dimension of "Midnight Hour": the lure of commercial success obviously motivated Wexler, and it likewise inspired Cropper, Jackson and Pickett (Guralnik's book deals in depth with the economic dimensions of soul). Yet the fact that a tune is constructed to maximize its ability to make money—as this one clearly was— does not mean that its social effects are negligible. Without question we need to attend closely to how those who profit manipulate our reactions. But students of popular culture who hasten to trash all commercial music betray how little they know about Western music history.

As improbable as it may seem at first glance, the early 1600s yielded a close parallel to Wilson Pickett's later impact on the elite Western body through marginalized and racially marked musical practices. For among the trophies acquired through the plunder of the New World was a style of dance music called the *ciaccona*.

Historical sources differ a bit with respect to the origin of the *ciaccona*: some attribute it to Peruvian Indians, while others suggest the input of African slaves.[19] Both possibilities seem musically plausible: the tunes played by Peruvian street musicians today still resemble the *ciaccona*, and the genre's characteristic cross-rhythms survive in African-based dance music throughout the Americas. Of course, a cultural fusion of this sort could not have taken place without the violent displacement of these two populations by the same colonial taskmasters who also exported the *ciaccona* back to Spain. Thus, while admiring the

power of this music and its impact on Western culture, we should not forget the vast human suffering and injustice it represents by virtue of its very existence.

We are able to reconstruct something about this music by means of the many seventeenth-century attempts at capturing it in Western notation, which functioned both to preserve it and to domesticate it for purposes of European appropriation. The process of the *ciaccona* is a relatively simple one: it involves a very short pattern, sometimes as brief as four seconds, that is simply repeated as long as the dance goes on. What compels the repetitions is a groove of jazzy cross-rhythms that engages the entire body.

When the *ciaccona*'s infectious rhythms hit Europe, it sparked a dance craze that inspired a familiar set of reactions: on the one hand, it was celebrated as liberating bodies that had been stifled by the constraints of Western civilization; on the other, it was condemned as obscene, as a threat to Christian mores. But most sources concurred that its rhythms—once experienced—were irresistible; it was banned temporarily in 1615 on grounds of its "irredeemably infectious lasciviousness."[20] Nor was social pedigree a sure defense against contamination: even noble ladies were said to succumb to its call. Like soul music at a later historical moment, the *ciaccona* crossed over cautiously guarded class and racial boundaries. Whatever the *ciaccona* signified in its original contexts, it quickly came to be associated in Europe (by friends and foes alike) with forbidden bodily pleasures and potential social havoc.

Many literary sources bear witness to the effects of the new dance. For instance, the lyrics for one extended *ciaccona* describe a funeral at which the priest slips during his Latin prayer and sings out "vida bona"—the signal for the *ciaccona* to begin—to which the officiating clergy, the nuns and even the corpse respond by wiggling and leaping with uninhibited glee. When they go afterward to beg forgiveness, the bishop asks (strictly as a point of legal information) to hear one refrain and spends the next hour gyrating with his skirts raised; his congregation continues to shake the house for another six. At the conclusion of this carnivalesque fantasy, the bishop forgives his flock.[21]

Not surprisingly, versions of the *ciaccona* quickly flooded the market, helping to expand the emerging industry of commercial music publication.[22] Even high art composers scrambled to get in on the action (a sure way of defusing the trickle-up effect of lower-class fads), and *ciaccona* patterns and rhythms resounded through both secular and religious repertories during the first half of the seventeenth century. Its energies, in fact, contributed to the quality of motion that characterizes early tonality: one could argue, in other words, that the procedures we like to regard as proof of Western musical supremacy bear traces of the West's encounter with Native American and African-American dance rhythms.

The most famous *ciaccona* setting to come down to us is Claudio Monteverdi's *Zefiro torna* (1632), an accompanied duet for two tenors. The poetic text hails the return of spring and spins out verse after verse enumerating the season's delights; but toward the end, the anguish and alienation of the poet's inner self suddenly erupt into the text, setting

up a stark Petrarchan contrast with the splendor of the natural world. For most of the duet, the *ciaccona* proliferates its dance pattern with reckless abandon, each temporary conclusion breeding only the desire for yet another repetition. The performance by Nigel Rogers and Ian Partridge, for instance, infuses the opening sections with a physicality that makes it quite obvious what the fuss over the *ciaccona* was about: one truly does not want that groove to stop, even if civilization itself is at risk.[23]

As the lines concerning the poet's emotional state appear, however, the music swerves into a concentrated passage featuring some of the most chromatic, dissonant writing available to the mannerist avant-garde. The duet ends pivoting between the overwrought agony that guarantees the "authenticity" of the subject's inner feelings and the carefree, seductive *ciaccona* rhythms of "nature," of the body. Note that this "body" is no longer the body of color from which the *ciaccona* was taken; it now stands for the "universal" (i.e., white) body—albeit a body yoked explicitly in binary opposition with the tortured, deeply feeling mind.[24]

To return to my refrain; "same as it ever was." In the aftermath of the sixties a number of jaded critics turned away from music because its impact seemed finally to have been but temporary; the criterion appears to have been that if music had not changed the world once and for all, then its potency had been illusory, its authenticity a sham. And a kind of cynicism replaced the utopian euphoria of the previous years, as fans traded in rebel rock for the bodily pleasures of disco. "Same as it ever was" could be heard as referring to that return to dance, that return to bodily expression.

Yet what I want to imply by this refrain is that this struggle over the body and the music that incites it has always been a central site of cultural contestation in Western music— not just since Elvis gyrated his hips on the Ed Sullivan Show. And while any given version of the transgressive body creates its effects for only a short while before being absorbed, it is imperative for critics to acknowledge and examine that struggle as it occurs *within the music*—even in the face of those from the Left or the Right who would "save" music from its own worst impulses: its ability to affect the body. To assess music from the outside as though it were but one commodity among many, or as though its meanings resided solely within its lyrics, is to fail to locate its pleasures, its means of manipulation and therefore its politics. In short, the study of popular music should also include the study of popular music.

Notes

1. Allan Bloom, *The Closing of the American Mind* (New York: Simon & Schuster, 1987).

2. Plato, *Laws*, 700a–701c, *The Collected Dialogues of Plato*, ed. Edith Hamilton and Huntington Cairns (New York: Pantheon, 1961); as quoted in Piero Weiss and Richard Taruskin, eds. *Music*

in the Western World: A History in Documents (New York: Schirmer Books, 1984), p. 7. Many of the quotations in this paper are taken from this collection (hereafter, Weiss/Taruskin), which I recommend as a convenient source of documents that reveal the cultural debates surrounding the Western high art musical tradition throughout its history.

3. Plato, *Republic*, 424b–c; quoted in Weiss/Taruskin, p. 8.

4. Saint Augustine (354–430), *Confessions*, trans. R. S. Pine-Coffin (Harmondsworth: Penguin Classics, 1961), p. 191; quoted in Weiss/Taruskin, p. 29.

5. John of Salisbury, *Policratus* (1159); trans. William Dalglish, "The Origin of the Hocket," *Journal of the American Musicological Society*, 31 (1978), p. 7; quoted in Weiss/Taruskin, p. 62.

6. John Calvin, Preface to the Geneva Psalter (1543), in *OEvres choisies* (Geneva: Chouet & Ciel, 1909), pp. 173–76; quoted in Weiss/Taruskin, p. 108.

7. Medieval historian Bruce Holsinger has suggested that these new textures may have given voice *quite deliberately* to homoerotic forms of expression, especially in the thirteenth-century secular motet. See his "The Bodies and Desires of the Early Polytextual Motet," paper delivered at the conference *Feminist Theory and Music II*, Eastman School of Music, June 1993.

8. Theodor W. Adorno, "Perennial Fashion—Jazz," *Prisms*, trans. Samuel and Shierry Weber (Cambridge, Mass.: MIT Press, 1981), p. 129.

9. Simon Frith, "I Am What I Am," *Village Voice* (Aug. 3, 1993), p. 82.

10. For a similar defense of the textual analysis of films (which has also been dismissed by some proponents of cultural studies), see Tania Modleski, "Some Functions of Feminist Criticism; or, The Scandal of the Mute Body," in her *Feminism Without Women: Culture and Criticism in a "Postfeminist" Age* (New York & London: Routledge, 1991), pp. 35–58.

11. Teresa de Lauretis, *Technologies of Gender* (Bloomington: Indiana University Press, 1987).

12. See my *Feminine Endings: Music, Gender, and Sexuality* (Minneapolis: University of Minnesota Press, 1991). The term "technologies of the body" is originally Michel Foucault's. See his *Discipline and Punish: The Birth of the Prison*, trans. Alan Sheridan (New York: Vintage Books, 1979), p. 24. My use of the term is strongly informed by de Lauretis's reworking of Foucault's models of both disciplinary and sexual technologies.

13. For a theory of why music registers social changes more rapidly than other media, see Jacques Attali, *Noise: The Political Economy of Music*, trans. Brian Massumi (Minneapolis: University of Minnesota Press, 1985).

14. See Christopher Page, *The Owl and the Nightingale: Musical Life and Ideas in France 1100–1300* (Berkeley and Los Angeles: University of California Press, 1989).

15. Steve Cropper, quoted in Ed Ward, Geoffrey Stokes, and Ken Tucker, *Rock of Ages: The Rolling Stone History of Rock & Roll* (New York: Rolling Stone Press, 1986), pp. 293–94.

16. See Note 2.

17. Peter Guralnick, *Sweet Soul Music: Rhythm and Blues and the Southern Dream of Freedom* (New York: Harper & Row, 1986), p. 11.

18. For more on the sociopolitical impact of soul, see Guralnik. For more on how popular music contributes to social formation, see George Lipsitz, *Time Passages: Collective Memory and American Popular Culture* (Minneapolis: University of Minnesota Press, 1990), and " 'Ain't Nobody Here But Us Chickens': The Class Origins of Rock and Roll," in his *Class and Culture in Cold War America: "A Rainbow at Midnight"* (South Hadley, Mass.: Bergin & Garvey Publishers, Inc., 1982), pp. 195–225. See also Susan McClary and Robert Walser, "Start Making Sense: Musicology Wrestles with Rock," in Simon Frith and Andrew Goodwin, eds., *On Record: Rock, Pop, & the Written Word* (New York: Pantheon, 1990), pp. 277–92; and Walser, *Running With the Devil: Power, Gender, and Madness in Heavy Metal Music* (Hanover, N.H.: Wesleyan University Press, 1993).

19. See Richard Hudson, *Passacaglio and Ciaccona: From Guitar Music to Italian Keyboard Variations in the 17th Century* (Ann Arbor: UMI Research Press, 1981), p. 4.

20. Lorenzo Bianconi, *Music in the Seventeenth Century*, trans. David Bryant (Cambridge: Cambridge University Press, 1982), p. 101.

21. These anonymous lyrics appear in Hudson, *Passacaglia*, pp. 7–8. Marino wrote an extensive account as well. See also the account in Cervantes' *La ilustre fregona*, partly reprinted in Bianconi, *Music in the Seventeenth Century*, pp. 101–2.

22. For more on the subsequent history of the *ciaccona*, see Hudson, *Passacaglia*, 11 and Bianconi, *Music in the Seventeenth Century*, pp. 103–4.

23. *Virtuoso Madrigals*, Archiv 2533 087, under the direction of Jürgen Jürgens.

24. Eventually, after but a few decades in European captivity, the *ciaccona* lost its rowdy qualities altogether. Its French spin-off, the *chaconne*, was used for static [i.e., "timeless"], formal rituals at ends of ballets. Even in Italy and Germany, it came to serve merely as a technique whose repetitive qualities made it ideal for depicting obsessive states of mind, as in Bach's anguished *chaconne* for solo violin.

 If the court of Louis XIV absorbed and sanitized the *ciaccona*, however, his legacy did not escape African-Americanization. At the conclusion of a paper linking modes of representation in the spectacle at Versailles and France's interactions with the slave populations in its colonies, Joseph Roach argues that "the Sun King's more profound and long-lasting contribution to the performing arts, though it is a monument to the law of unintended consequences, was made through his role in expanding the French 'body politic' to embrace the Afro-Caribbean world, including Louisiana. In Louisiana, the state which still bears his name, Louis XIV rocked the cradle of American popular music, and with all due respect to the genius of Monsieur Lully, most of the world now prefers jazz." Joe Roach, "Body of Law: The Sun King and the *Code Noir*, paper delivered at the conference *Performing the Body*, UCLA (May 1993).

Is Anybody Listening?
Does Anybody Care?
On 'The State of Rock'

Lawrence Grossberg

In this paper, I want to address some questions about the current state of the rock formation in the U.S., and about the possibility not so much of the death of rock as of rock becoming something else. Or in other words, in what sense is it meaningful—and in what sense could it be true—to talk about the death of rock. Let me begin by explaining my use of the phrase "the rock formation." In this context, "rock" refers to the entire range of postwar, "youth"-oriented, technologically and economically mediated, musical practices and styles. By describing it as a formation, I want to emphasize the fact that the identity and effect of rock depends on more than its sonorial dimension. Speaking of rock as a formation demands that we always locate musical practices in the context of a complex (and always specific) set of relations with other cultural and social practices; hence I will describe it as a cultural rather than as a musical formation. Finally, using the singular "the" signals my desire to operate at a certain level of abstraction, a level at which there is some unified sense to "rock." I don't mean to deny that this unity is always locally rearticulated, but the overemphasis on locality and specificity often leads us away from important generalities, as well as from the fact that such generalities are part of the reality of the local articulations (for instance, there is a history of this broad use of the term within the formation itself).

Rock as a cultural formation is a historical event, a historical production and organization of particular practices, activities, sounds, styles and commitments, of particular kinds of pain and fun. It emerged at a particular moment, determined by specific conditions of possibility, conditions to which rock responded. These conditions not only enabled rock, but also constrained it, setting limits on its shapes and effects. But if the rock formation had a beginning, it is also possible that it has an end or at least, a trajectory of disappearance. If it has a history of its own transformation (and it most certainly does), then presumably that history can be understood as its attempt to respond to changes in its conditions of possibility. But then we have to acknowledge at least the possibility that, as the conditions

41

themselves become so radically transformed so as to be in some sense unrecognizable, then the transformations of the rock formation may similarly become significant enough that we can no longer credibly speak about the resulting formation as rock, as if its continuities were more powerful than its discontinuities.

These reflections are motivated in part by my own personal political dilemma. In a book I published in 1992,[1] I treated the rock formation as an allegory for a kind of politics which, I argued, has been increasingly appropriated to construct a new conservatism in the U.S. In a sense, then, the reflections in this paper are the beginning of an attempt to ask what a new popular politics might look like, and how it might be culturally constructed. The paper's (unearned) optimism—trying to find that possibility in an emergent cultural formation—is a perhaps premature effort to balance the pessimism of my earlier argument.

I

Of course, talk about the end or death of rock is not a new theme. There is a long history of such discourses which goes back almost to the emergence of rock in the 1950s. Traditionally such arguments are about the power of rock to change its audience and the world, a power which, it is assumed, can be measured in the sounds themselves, in the audience's social marginality or in the imagined uses made of the music. This rhetoric assumes a binary, hierarchical and cyclical map of the musical terrain. It is built upon a strategy of differentiation: always distinguishing between the authentic and the co-opted. This distinction, then, easily and often slides into a narrative war between authentic youth cultures and corrupting commercial interests. Rock is judged dead to the extent that the commercial interests, the co-opted music, seem to be in control, not only of the market, but of the music and the fans as well (leaving only a few die-hard fans on the margins, fanning the embers of authentic rock). In a sense then, in this rhetoric, rock is never dead, but it is constantly in the process of dying or of being killed. This rhetorical strategy still has a powerful presence among both fans and critics. For example, Simon Reynolds has recently described the present situation as one which which rock has become "a reflection of straight aspirations, a normative agent. The dreams of youth culture have been excluded from the center stage, outflanked and outmoded."[2]

In fact, this rhetoric dominates much of the discussion about the relationship between rock and rap, taking two different forms. Some locate rap within rock, positioning it as the new internal site of authenticity (reproducing the structure of rock versus pop). Others, claiming that rap is not part of the rock formation (usually by drawing a sharp distinction between white and black musical formations) nevertheless position rap as the heir to rock's vitality and potential as a nascent act of resistance. Rap replaces rock, even as it reproduces the logic of its effects. I would argue, alternatively, that it is necessary to avoid arguments about whether rap has merely replaced rock as the new authentic music, for

this merely relocates rap in the logic of the rock formation. At the same time, we have to remember that the rock formation has, after all, encompassed various black sounds, apparatuses and scenes. At times, it has acknowledged them, at times it has appropriated them and at times it has given them the space within which to develop. For example, we might point to the positive importance of rap's white audience to its commercial success, as well as to the perplexing fact that its popularity seems to increase as it becomes "more black," even as it becomes "more black" in response to that white popularity. Of course, at other times and places, various rock alliances have "expelled" and even silenced those apparatuses and scenes which they judged to be "too black" (for instance, funk, disco and so on).

But I think that the contemporary rhetoric of the death of rock is different; something has changed, rhetorically at least:

> The question of the death of rock comes up again and again these days, and not just because of falling record sales, a collapse of the concert market, major labels consolidating to the point of monopoly, or desperately profligate, rear-guard superstar contracts. . . . It isn't even that the music is empty. . . . The question of the death of rock comes up because rock 'n' roll—as a cultural force rather than as a catchphrase—no longer seems to mean anything. . . . *There is an overwhelming sense of separation, isolation: segregation.*[3]

A number of other rhetorical strategies or organizing figures have gained an important and prominent place within the discourses of the death of rock. I will describe these as indifference, fragmentation and Babel.[4] For the sake of space, I will only give one illustration of each, although it is easy enough to find many examples of them all. Indifference claims that the differences according to which judgments of taste, authenticity and co-optation have been organized no longer works. The differences can no longer sustain the weight demanded of them for rock to continue functioning as rock. Consider the following example:

> The pop versus rock debate that has organized . . . musical taste since *Sgt. Peppers'* is now played out. There is no longer any point in attacking pop silliness in the name of rock truth or denouncing rock stodginess in the name of pop flair.[5]

The second figure, fragmentation, speaks as if the entire musical field is now so fragmented that there can no longer be a center or an organizing principle which can bind the music and fans together into the unity of rock. For example:

> Rock is slowly fading as tastes in music go off in many different directions . . . the age of rock as a prevailing cultural form is over. The music business as a whole is far bigger

than it was when rock reigned supreme, but no unifying musical movement has taken rock's place. . . . *We've never seen this kind of fragmentation before.*[6]

The third figure constructs the contemporary rock culture as the latest appearance of Babel, without the necessary common language or experience. For example, Greil Marcus refers back to the diverse sounds of the 1950s and "the new spirit they seemed to share." He identifies this spirit as a certain "myth of wholeness . . . a myth less of unity or even rebellion, than of a *pop lingua franca*." And he continues: "There is no central figure to define the music or against whom the music could be defined."[7]

Perhaps paradoxically, I want to take these three figures, not as diagnoses of the death of rock (to be judged true or false) but, rather, as evidence for a significant transformation in the rock formation, and of our inability to describe it. All of them seem to share a certain common assumption: namely, that the fields of rock music and taste are structured in some predictable and stable way (as organized differences, as center-margin or as a unified whole). They all evince something like a common "terror" or mourning at the collapse of such structures. But what is it that these various assumed structures actually describe? And what is their status? I want to suggest the obvious: that they are abstractions—from the broad terrain of postwar popular musics and from the complex relations between musical practices, social relations and the practices of daily life.

It is in fact necessary for the very practice of critical interpretation that one abstracts structures—unities-in-difference—from these dense and dispersed configurations. And these abstractions can and often do have a reality of their own, not only for the critic, but within the field that is being described (for instance, the appeal to an abstraction like "rock" has real power and effects in the lives of its fans and in the practices of the music industry). Moreover, the reality of such a structure ("rock" or my own "the rock formation") does not depend on any claim that the field of popular music is limited to a single formation, or that such a formation is homogeneous in any single or simple (for instance, musical) way. In fact, even what we may think of as "the particular" or "the concrete" is simply another—lower or more overdetermined—level of abstraction. Critical work always involves moving between different levels of abstraction, constructing the network of determinations that connect them. Consequently, analysts constantly need to "measure the distance" between different levels of abstraction, between "the abstract" and "the concrete."

Thus it is important to distinguish how such abstractions operate within the field of rock music, and how they operate within a critical-analytic discourse about that field, and the distance between them. In the following brief discussion, I want to describe three dimensions of this distance: empirical, structural and conceptual. This can be quite a problem if one is both a fan and a critic. Confusing the two contexts can often lead to serious misunderstandings in which critical and everyday categories slide into each other. For

example, taste is never as neatly organized as critical abstractions suggest, especially when we are considering the overdetermined way people respond to particular texts. For, at one level, I can argue that people respond neither to individual songs nor individual performers, but to sounds and images within larger contexts and logics. It is also true, at another level, that particular songs and performers can have a powerful impact, even outside one's apparent taste:

> We were committed to rock and roll, but that doesn't mean that we tuned out the opposition—what makes a hit a hit is that it penetrates your defenses. Nor did our pop tastes boil down to simple like and don't like. We respond to pop artist's individually— for how they sounded, or who they seemed to be.[8]

Thus, whatever our tastes may be "generically," we often cannot help but respond to other texts (for example, the popularity of romantic "make-out music" like Johnny Mathis' in the 1950s, or the ability of various AM "bubble gum" songs to insert themselves into our minds, our memories and our tastes).

A second confusion that frequently results from conflating the different levels at which our abstractions (structure, unities-in-difference) operate is the reduction of the field of popular music to some predetermined set of texts: sometimes to best-selling records or the records we know and/or like (there are a lot of records out there no one ever talks about), and sometimes to particular "genres" (often ignoring not only particular genres within rock but also everything from country and western and jazz to Las Vegas pop to Broadway show tunes to film music).

A third consequence is that the field of popular music is often reduced to its commercial face, to recorded (professional) music. This ignores the density of musical practices in daily life. It ignores all the music made outside of the vector of commodity production (for example, local bands and parties). It ignores all the music consumed in contexts other than commodity purchases, concerts, radio, and music videos. And it ignores all of the activities associated with musical life.

These three problems might be described as "empirical"; but there are also what might be called "structural" problems that arise from the ways we misuse various abstractions. These problems exist independently of the particular structures, but for the sake of simplicity, I will take two reasonably similar examples: the models of center/periphery and mainstream/margin. Most attempts to describe the terrain of popular music in such terms, while useful in particular contexts (for instance, fans' self-representation) oversimplify the relations between the center and the periphery, the mainstream and the margin. They ignore the fact that there have always been multiple centers or mainstreams. This diversity, more than anything else, has its most powerful impact in the always fragmented and incoherent nature of the Top 40. These models also ignore the varied forms of "traffic"

among the different centers and margins. The real question is less what or where a particular sound is, than how it travels.[9] What kinds of sounds travel? From where to where? What are the enabling and constraining conditions of such mobilities and stabilities? Let me give just two examples. Recently, some critics have observed that the success of one group does not seem to necessarily bring similar groups (or the entire subgenre) with it: consider R.E.M., Nirvana, Metallica, Guns N' Roses, or Garth Brooks. It seems increasingly difficult to describe a general movement into a center. Yet this situation may not be particularly unique to the present. On the other hand, what may be unique is the existence of a "hip mainstream," whether it be filled by grunge, house music, Lollapalooza, college rock, or simply, as one radio station put it, "Less music by dead White men."

There is, finally, a third—"conceptual"—set of problems with the ways critics use the abstractions they have constructed out of or taken from the dense configurations of musical practices in daily life. For such abstractions often move, without much self-reflection, between three different strata or fields of analysis. Within each of these strata, the configuration of popular music looks significantly different. And although "rock" appears in all three, one cannot assume any equivalence (or synonymity) between its three appearances. I want now to describe these strata, remembering that each one is always internally complex and contradictory. I will describe these fields as (1) the logic of production and/or commercialization (apparatuses); (2) the logic of consumption (scenes); and (3) the logic of effects or the operational logic (a space of alliances).

The logic of production and/or commercialization, which produces "apparatuses" of music, describes the largely industrial attempt to market music by segmenting it, usually according to "generic" distinctions supposedly grounded in "objective" sonorial features. Two recent examples of logics operating in this strata are worth pointing to: first, the recent attempt to organize taste via the marketing of scenes; and second, the recent collapse of rock into guitar-based music as a new marketing strategy, which can be traced back at least to the "success" of the racist attacks on disco in the name of "rock." It is also important to point out that music criticism, as part of the economic logic of marketing, is often complicitous with the construction of apparatuses.

The logic of consumption describes the organization of taste-cultures according to particular configurations or scenes. Reinterpreting a recent argument by Will Straw,[10] a scene is characterized by a particular logic which may, in a sense, transcend any particular musical content, thus allowing the scene to continue over time, even as the music changes. This also means that very different musics may exist in very similar scenes. The logic of a scene can be described along a variety of dimensions. For example, we can describe different taste-cultures according to their sense of history: Is there a "canon" which is incorporated into the present, thus denying a sense of change? What is the role of covers? We can also look to the various sorts of practices that are valorized: What is the meaning

of "authenticity"? What is the perceived relation between recording and performance? Between music and lyrics? What is the status of lip synching? What sorts of instruments and performances are tolerated or required? We can also differentiate scenes according to the ways particular sounds and practices are articulated to different structures of social differences: for example, the perceived relations between race and hard rock, or gender and heavy metal.

Straw, in his important article on rock scenes, distinguishes between alternative rock and dance music; whatever Straw's intentions, I want to read his description of these as logics of consumption. While such labels certainly operate in the logic of production describing different apparatuses, we cannot assume that they would refer to precisely the same structures, since both their boundaries and their specific characteristics would be significantly different. According to Straw, the logic of alternative rock is canonical (the past is constantly present); it places great emphasis on the individual career (earning your way); it has little sense of progress (rather, there is a lateral expansion through what Straw describes as "generic exercises"); and the local scene is always at the center, where it functions to reproduce the logic of the scene in its entirely. On the other hand, Straw characterizes the dance scene as polycentric, emphasizing spatial diversity, so that each local scene is a unique part of the whole rather than merely a repetition of the larger whole. Moreover, this geographically based sense of musical diversity is represented as a teleological temporal sequence. The result is that, while there may be a canon of sorts, it does not exist as part of the present except insofar as its songs can be covered and reworked into this narrative of movement.

But while Straw only describes these two logics, it is reasonable to assume that there are other logics of consumption, defining other scenes. And these logics need not correspond to critical genres or the apparatuses of production. For example, in a list of the logics of consumption of the rock formation, we might want to include the following: Top 40, oldies, hard rock, underground, hip mainstream, avant-garde and world music.

Operational logics, or logics of effects (which are always made manifest in specific alliances) describe the place of musical practices and relations in people's lived realities *understood socially (as a context of determination and power) rather than psychologically (as a context of experience).* Within this strata, rock's history cannot be reduced to that of its sonic register. There is no necessary identity between particular musical practices and the identity of rock as a cultural formation. That is, rock cannot be defined in purely musical terms, although we cannot ignore its musical textuality, its sonorial presence. Rock is more than just a conjuncture of musical and lyrical practices. Moreover, the identity, meaning and effect of rock—as a singular cultural formation, or in its various local articulations (alliances)—is always contextually produced. Rock's musical practices always already exist in specific and complex sets of relations which articulate their meanings and

effects. Consequently, rock's musical and lyrical practices, while often taken from other traditions and cultural formations, are almost always received as if they were already part of rock's conventionality.

Operational logics involve more than just the relationships between logics of production and logics of consumption. They define particular ways of navigating the spaces and places, the territorializations of power, of daily life. That is, they define the empowering and disempowering possibilities of the rock formation or at least of its different alliances. They articulate rock's political possibilities, its effectivities.

II

The following remarks, then, are meant to describe something about the changing operational logics of the rock formation. I will begin by briefly describing the conditions under which rock emerged, and the ways rock was shaped by its attempt to respond to those conditions, but always within the constraints they imposed. This will lead me to an equally brief discussion of some of the basic characteristics of the operational logic that defines the rock formation as a specific, determined, cultural event.

I want to identify four of the historical conditions of rock's possibility. First, rock emerged within a particular social and economic context. The postwar years were a time of economic prosperity and relative affluence, although this was unequally distributed. This prosperity was funded through a continuing war economy (increasingly funded through deficit spending) and an exploding consumer economy. Whatever redistribution of wealth took place was funded through taxation and government spending, rather than through real economic restructuring.

At the political level, the postwar years embodied a powerful ideological contradiction. On the one hand, a particularly American version of liberalism took shape, which celebrated America's difference from the rest of the world based on its acceptance of an internally differentiated society (although these internal differences were assumed to have no political significance). On the other hand, it was a time of political quietism: America had won its well-deserved place as leader of the free (capitalist) world and it was no time to rock the boat. Any protest or even criticism was taken as a threat to America's sense of its own uniqueness and identity. Thus, this quietism was itself articulated to a celebration of America, whether a conservative celebration in the 1950s or a utopian one in the 1960s. These two conflicting impulses—liberalism and quietism—were reconciled in an ideology of mobility and ameliorism; the trajectory of this mobility was defined by its supposed universal access (through hard work) and its speed (or more accurately, its gradualness).

The second condition of rock's emergence was sociological: the emergence of a large youth population distributed broadly throughout the population (the so-called baby boom). This youth population had to be disciplined, which called forth new investments, institutions

and strategies to shape youth, to police and control youth's practices and mobilities, its places and spaces. Yet at the same time, youth, first as a generation and increasingly as an attitude, was privileged and even celebrated. In a sense, youth itself was identified as the embodiment and the potential realization of the American dream.

The third condition was the appearance of a certain structuring of experience, the emergence of a "postmodern" structure of feeling. By this, I mean the disarticulation, at specific sites, of the relationship between affect and ideology, of investment and meaning, as two intertwined constitutive dimensions of human experience. Affect here refers to the quality and quantity of energy invested in particular places, things, people, meanings and so forth. It is the plane on which we anchor and orient ourselves into the world, but it is neither individualistic nor unstructured; it is not some pure psychological energy erupting through the social structures of power. Moreover, it is complexly articulated and structured, producing configurations not only of pleasure and desire (through economies of repression and satisfaction) and of emotion (through narrative economies), but also of volition (or will), of moods and passions. These latter describe the organization of what matters; they point to the fact that people experience things, live different identities, practices, relations, to different degrees and in different ways.

The postmodern structure of feeling describes the partial but increasing lack of fit between mattering maps and maps of meaning, between the organization of what matters and the social languages of signification, representation and value. The result is that, at particular sites, it is apparently impossible to invest in those meanings that supposedly make sense of life. And similarly, it is apparently impossible to find a structure of meaning that makes sense of what matters. For the most part, during the immediate postwar years, this postmodern disarticulation, always and only local, partial and temporary, was lived privately, as a psychological experience of alienation. It was lived with a very real sense of seriousness and *resentiment* (negativity). And it increasingly became a signifier of a generational difference which separated the baby boomers from their parents.

The fourth condition of possibility involved a series of developments in the cultural domain. Technological developments changed musical practices at every point in the cycle of production: amplification in performance; magnetic tape in recording (allowing sophisticated intervention between production and recording); and transistorization in consumer reception. The result was the increasingly sophisticated manipulation of both the sound and the musical commodity. At the same time, the music industry was undergoing serious changes and reorganizations: the "majors," reorganized as multinational corporations centered in the U.S. and Britain, gained substantial control of the market. And the market itself changed, as the major source of profits for the music industry shifted, from the sale of sheet music and the stocking of juke boxes, to the sale of records to individual consumers. In this context, a particular structure of relations developed between these major corporations and the so-called independents: on the one hand, the independents

were left to service markets deemed too small or too marginal by the majors; and on the other hand, there was a good deal of hostility between them, as the majors simply outbid and outdid the independents whenever one of the latter's markets suddenly seemed significant enough for serious exploitation.

This cultural context was also characterized by what might be called a particular "media economy," that is, a particular relationship or ratio between sight and sound, between visual and aural discourses. More concretely, for the postwar years, this is a question of the relative weight and impact of the two relatively new media of entertainment: television (and here I would include film) and music (records and radio). The former belonged largely to an industrial-domestic set of relations, especially within the lives of youth, so that the latter (music) was naturally constructed as the locus of authenticity. This implied a particular relationship between fandom and participation (for instance, the importance of concerts), one which was very different from what existed around Tin Pan Alley sounds and styles.

Finally, the cultural context made available particular images of rebellion. For the most part, these were images of alienation in the form of the beat poet (via the black hipster) and the juvenile delinquent or punk (largely through myths of urban and motorcycle gangs). These images defined a particular relation to marginality and, I would argue, in particular to black culture. There was no assumed identity between being black and being young, or even necessarily between black and white youth, but there was "a structure of imaginary desire" between them. (One can think of the appropriation involved in the 1960s slogan, "student as nigger"). This may help to explain the unique relation between rock and African-American sounds and rhythms, a crucial relation that nevertheless often occludes rock's relations to other sources, including country and western, swing, Tin Pan Alley, folk, and Latino sounds. It also helps to explain rock's constant tendency to both appropriate and reject black musical practices.

Having laid out some of the parameters of the context of rock's emergence and existence, let me try to describe the operational logic that rock defined and that, in turn, defined rock. First, rock is an affective machine. It operates on the plane of affect and its primary effects are affective. Rock is about the production of moods and passions and the organization of will. It constructs temporary mattering maps. For the most part, and most of the time, rock simply ignores ideology. Or to put it another way, it remains within the broad terms of the ideological mainstream. It does not (or only rarely) challenge the major dimensions of American ideology; it is largely liberal and ameliorist.

Second, rock is a differentiating machine. It continually separates Us (those within the space of its logic) from Them (those outside the space of its logic). A generational difference (a matter of the logic of consumption) becomes a social difference. And the differentiation continues even with the space of rock, for that is the nature of differentiating machines: they proliferate differences. But unlike liberalism, rock's logic says that differences do matter. In the terms of rock, this becomes a struggle over authenticity (where authenticity

must be understood as an affective term). The history of rock is marked by a continuous struggle over what is really authentic rock and which groups are really invested in it. To be clear here, I am not saying that there really is such a difference; rather it is an effect of rock's differentiating work, the operational logic's construction of the relations between different scenes, different apparatuses and, most importantly, different alliances. In this way, rock is continually restructuring itself as a field, reconstituting its "center" or actually, its centers (since there are always competing definitions of and investments in "authentic" rock).

Third, rock defines a politics of fun (where fun is not the same thing as pleasure, nor is it a simple ahistorical experience). In privileging youth, rock transforms a temporary and transitional identity into a culture of transitions. Youth itself is transformed from a matter of age into an ambiguous matter of attitude, defined by its rejection of boredom and its celebration of movement, change, energy; that is, fun. And this celebration is lived out in and inscribed upon the body—in dance, sex, drugs, fashion, style and even the music itself.

Finally and most importantly, rock is a deterritorializing machine which defines a politics of everyday life. Let me begin to explain this by elaborating on my use of "everyday life" here, which I take from Henri Lefebvre.[11] Everyday life is not the same as daily life. It is a particular historical organization of the space of daily life, an organization based on principles of repetition and recurrence. It is daily life becoming routinized, without any principle which can define its unity and meaningfulness. Everyday life is predictable, and, paradoxically, that predictability is itself a kind of luxury and privilege. At the same time, as Lefebvre points out, everyday life is a form of control: in Foucault's terms, a kind of disciplinization or, in Deleuze's terms, a politics of territorialization.[12] I think it is safe to assume that in postwar America, everyday life had already been or was rapidly being put into place.

In this context, it is important to begin by admitting the obvious but painful truth that rock rarely challenges the political and economic institutions of society (and when it does, it is usually either marginal, utopian or hypocritical). It does not even challenge or attempt to negate the political and economic conditions of everyday life. It remains largely within the privileged space of everyday life, although it often imagines its romanticized Other— its image of alienated rebellion, its black musical sources—as living outside everyday life.

Rock's politics are defined by its identification of the stability of everyday life with boredom. Consequently, it can only operate as a deterritorialization. It draws or produces "lines of flight" which transform the boredom of the repetition of everyday life into the energizing possibilities of fun. It creates temporary and local places and spaces of mobility and deterritorialization. It challenges the particular stabilities or territorializations of the everyday life within which it exists by producing and celebrating mobilities. Thus all rock can do is change the rhythms of everyday life. It restructures everyday life by articulating

its lines of flight into new mattering maps. Although it cannot break out of everyday life, the trajectory of its mobilities at least points to (even if it cannot define) a world beyond, an alternative to, everyday life. It is as if it imagined that Saturday night was outside the discipine of territorialization, and projected a world in which every moment could be lived as Saturday night.

As I have said, rock's lines of flight have rarely led to other planes of political, social and economic existence. When it does connect to such issues (for example, Vietnam), it is usually because political or economic realities (the draft) have suddenly appeared within the everyday lives of its fans. But rock does articulate the possibility of investing in a universe of diminishing opportunities. If it cannot offer transcendence, it can at least promise a kind of salvation. If it does not define resistance, it does at least offer a kind of empowerment, allowing people to navigate their way through, and even to respond to, their lived context. It is a way of making it through the day.

III

Hopefully, by this point, it is clear that there is at least a sense in which it might be empirically meaningful to talk about the death of rock, without merely reproducing the logic of the rock formation (that is, without confusing the level on which such a claim is operating). It is also possible that some of the same musical practices which existed within the rock formation might be relocated in a new, emergent, popular formation, also organized largely around popular music, with a different operational logic. It is in light of this possibility that I want to rethink the nature and effects of popular music in the 1990s.

In order to make sense of the current state of popular music, we have to make sense not only of what differences make a difference, but of how they make a difference. I propose to continue, then, by considering the context of contemporary popular music, and by looking at how rock's conditions of possibility have been transformed so radically as to suggest that rock's operating logic might no longer be either effective or possible.

I think most people would agree that the political and economic context of the U. S. has been drastically restructured. Not only have liberalism and the liberal state been methodically eroded, but the "quietist" construction of conservatism has given way to active, even aggressive, fundamentalist and popular conservatisms. Consequently, the reconcilation afforded by the ideology of mobility has become unnecessary, allowing the very notion of mobility to be refigured, so that it is increasingly signified by images of criminality and chance.

Similarly, even the appearance of economic prosperity has disappeared into an increasingly visible and publically accepted disparity of wealth, resulting in the impoverishment of significant portions of the population, both nationally and globally. That has gone hand in hand with the transformation of the military/consumer economy into a global corporate

economy aimed increasingly at privileged enclaves around the globe, willing to resort to the most exploitative sorts of practices to extract profit at any cost.

Given the havoc and pain that has been wrought by more than twelve years of conservative rule (and one year of neoliberal rule), it is not surprising that the optimism and faith in progress that characterized postwar America through most of the 1970s has all but collapsed. Nor is it surprising that the celebration of America has been inflected into an empty and sometimes fanatical patriotism.

Sociologically, I want to point to the changing presence, power and status of youth, the result in part of the ageing of the baby boomers who, continuing to invest in their own "youth"-fulness, are engaged, with the complicity of the Right, in an ideological struggle over the meaning of youth. At the same time, they are increasingly involved in and supportive of explicitly repressive policies aimed at policing and controlling the activities and practices of young people (for example, attacks on music and drugs, use of medical incarceration, depriving youth of civil rights and of a public voice). And in many instances, at the very least, they tolerate the very real material impoverishment of young people.

All of this has further depended on the fragmentation of "youth" as a chronological and social category into multiple generations, crossed by class and race, in complex relations. Two of these fractions have become the object of rather intense scrutiny: first, a generation of preadolescents who apparently do not want to grow up to be teenagers because they perceive adolescence as too dangerous. And second, a fraction that has come to be called, in an unprecedented debate over their identity or more accurately, their lack of identity, Generation X (or alternatively, the baby busters, the Brady boomers, and so on).[13] These names refer to those born between 1961 and 1981; they are the children of the pre-baby boom silent generation and the earlier parts of the baby boom. And they are presented as marking a new generation gap, one defined against the baby boomers. Their identity crisis seems to be defined not within their experience (for within their experience they have no identity crisis) but rather within the experience of the baby boomers, who seem to have a desperate need and a total inability to identify them. Generation X seems to exist in a space of a common terror at the inability to name, to understand the next generation. This is the Reagan youth, but it is also the grungers, the rappers and the American punks!

What I earlier called the postmodern experience has become a *dominant* structure of feeling, especially for the post-baby boomers. Now everything has come under the antiaura of the inauthentic, everything is already co-opted, already an act. The result is that one's responsibility is only located within a realm of affective sovereignty and individual choices where it does not matter what you invest in, as long as you invest in something. Consequently there is a tendency to keep everything at a distance, to treat everything ironically, with no investment in one's investment. Moreover, this structure of feeling is now lived publicly, on the surfaces of popular culture, not as an alienation but as a taken-for-granted

context of everyday life. The often noted rise in the acceptance and practice of dishonesty can be seen as based in a postmodern redefinition of ideology:[14] from "they don't know what they are doing but they are doing it anyway" to "they know what they are doing but they are doing it anyway." Students cheat (and feel guilty) because, after all, no one—even those who demand honesty—is honest.

Regarding the cultural domain, the transformations have been even more remarkable. There has been a technological revolution in the past ten years as great as that of the postwar years, and it has affected every site of musical and popular cultural practices (as well as inventing new ones); and the "revolution" is accelerating. From synthesizers and samplers to digital recording to laser disks and CD-ROMs. But already the music industry is investing in digital distribution systems (using the new "information highways") that will not even require the mediation of prerecorded commodities.

Similarly, the music industry has been and continues to be reconfigured. The majors have become multinational media and leisure corporations no longer based on North Atlantic capital. The relations between these transfigured majors and independent record companies have become less hostile (even while it has become more difficult for the latter to survive economically) as the majors increasingly come to view the independents as their own "minor" league. At the same time, the source of profits is shifting: at the moment, it still depends heavily upon the sale of CDs, but that is largely because of the trade practices that have attempted to increase their price even while the actual cost of production decreases. On the other hand, a greater share of the profit depends on selling secondary rights across media, and on secondary merchandising. All of this is, of course, taking place in the context of the shifting distribution of the market for music across age and geography, and the changing relative importance of different media (from radio to television) for introducing new music.

Similarly, the particular media economy, the particular structured relationship between aural and visual imagery which characterized the rock formation is changing. As Tony Parsons has recently written:

> Pop culture [read here the rock formation], though it lives on in the hearts of those of us between the ages of 30 and 50, has largely been replaced by game culture. But any industry that still generates around [twenty-five billion dollars] worldwide every year is alive and kicking. Pop as culture is dead. Pop as industry is thriving.[15]

Leaving the question of game culture aside, I do want to suggest that the ratio of sight and sound has already changed significantly. The visual (whether MTV, or youth films or even network television, which has, for the first time since the early 1960s, successfully constructed a youth audience) is increasingly displacing sound as the locus of generational identification, differentiation, investment and occasionally even authenticity. The result is

that new visual formations of youth culture speak, often in the space of rock and sometimes, even against rock, of a kind of salvation without the necessity of authenticity. As a result, the rhythms of both visual imagery and music have changed, the music as it were having adapted to television's beat.

Finally, I would suggest that there is almost a complete absence of any compelling, viable images of rebellion. All that is left is the fact of marginality and the struggle for identity. This has resulted, I think, in a kind of deromanticization of blacks, who are no longer imagined to exist outside of everyday life, and a more immediate and affective identification between whites and blacks (consider the images of various white rappers). One interesting result of this transformation is that, while the popular formation is still strongly linked to national identity, it is no longer involved in a celebration of America.

Now it is perhaps possible to speculate—and I emphasize that, at the moment, that is all it is—about the operational logic of the popular music formation that is emerging in this context. I am not claiming that the rock formation has disappeared, only that we may be witnessing its transformation; or perhaps it is better to say that the rock formation is giving ground to something else. Once again, it is necessary to emphasize that this new formation cannot be defined in purely musical terms. This new formation cannot simply be identified with, for example, rap or house/dance, although these are clearly central to it. But so is the experimentation so powerfully illustrated by rap's relation to other forms of music (including heavy metal and jazz). The new formation would certainly include a lot of techno-pop and even hard rock, especially some alternative scenes and apparatuses. And these may all be brought together around apparatuses and scenes like the Lollapalooza tours. But it would also include, more centrally than the rock formation, televisual and filmic texts and practices (as well as a wide range of other cultural imageries).

While I believe that the operational logic of this new formation is still affective, the other three features of rock's logic seem to be significantly different. While the new formation still manifests an obsessive self-referentiality which somehow equates the music with the identity of its audiences and producers, making the visual signs of marginality the condition of authenticity, there is a change, not only in the way scenes and alliances are formed, but also in the forms of mobility between them. In other words, differentiation—the produc-tion of differences—seems not less important or less effective but, rather, to have a different sort of effectivity and a different sort of importance. Such differences have become the crucial markers (billboards) of certain kinds of investment. Consequently, apparatuses, scenes and alliances are proliferating and, more importantly, the relations between them are becoming more fluid and temporary, and less exclusionary. If rock responded to the assumption of 1950s liberalism that differences do not matter precisely by making them matter, the pluralism of contemporary music seems to echo the 1950s image of differences without any power. But this is not quite accurate, for they do matter, as the public face of the last site of individual affective agency. There is a new tolerance

across differences, and the only exclusionary function of these differences seems to be to exclude those for whom the music matters too much (those still in the rock formation?). As Simon Frith puts it, "the rules of cult exclusion no longer apply—there is no musical taste that guarantees distinction."[16] This doesn't mean that fans do not still make judgments about authenticity, but that such judgments are not invested in the same ways. Nor do I mean to deny that there are still fractions that invest in rock, and continue to articulate its differentiating power, but even those investments are no longer capable of totalizing themselves across the entire field.

All of this can be interpreted as pointing to the changing place of the music, not only in the social formation, but in people's lives as well. It reflects a change in the quality and quantity of people's investment in the music—a change not only regarding its place on their mattering maps, but also in its ability to articulate mattering maps for them. Again, to quote from Simon Frith (while he is describing British youth, I am confident that similar trends are observable in American youth):

> A new Gallup survey of Britain's 14-to-16-year-olds found that the average teenager now listens to pop music for 4 hours a day, 3 times more, it's claimed, than teens spent listening to pop in the mid-1970s. The poll also reveals that pop is "very low" on a list of "the most important things in life" (after, in order, education, home, friends, money, sex, appearance, work, going out, sport, hobbies and football). . . . This is the postrock generation gap. The young listen to more and more, and it means less and less. The old listen to less and less, but it means more and more. The young are materialists; music is as good as its functions. The old are idealists, in search . . . of epiphany.[17]

Thus, the various post-baby boomer generations seem barely able to use the music to mark any generational difference, and totally unable to mark intragenerational differences. While the music matters, it matters in not quite the same way. Rather than being the affective center and agency of people's mattering maps, music's power is articulated by its place on other mattering maps, by its relation to other activities, other functions. Rather than dancing to the music you like, you like the music you can dance to. Thus, the music's popularity depends less on its place within specific alliances than on the construction of hyperalliances as venues for other sorts of affective relations and activities.

Similarly, while this new logic continues to foreground fun and the body, sexuality and dance, fun has been "depoliticized," since it is not longer defined by its antagonism to boredom, and no longer built upon a vision of the permanent celebration of fun embodied in youth. Rather, fun is apparently celebrated for its own sake, as the party due (not just) youth before the responsibility of the rest of their lives, before the likelihood of an early death. Fun is no longer defined against adulthood. To return to Parsons' image of a game culture, we now see that the games, mediated through computers, are matters of skill

that define a new and different difference from adults. And yet these games prepare youths for adulthood (sometimes a particularly vicious kind) and sometimes even define them as already more adult than the adults.

Let me now come to my moment of optimism, for I do not think that the politics of this new formation remain constrained to deterritorializing the spaces of everyday life, which is not to say that it escapes the "prison" of everyday life. In a way, in fact, it no longer has the power to restructure everyday life. So its politics are, to borrow a phrase from de Certeau, polemological,[18] predicated on the constant reassertion of the fact that we (they) are getting screwed. In this sense, it is more ideological than rock, and this may be reflected in the reemphasis on lyrics (almost always only in relation to the rhythm[19]). This new formation keeps trying to name the power, to identify those who are doing the screwing, so to speak, and thus its lines of flight constantly take it to the boundaries of everyday life. The real question is, can or will such a polemological politics take it own conditions, the conditions of everyday life, into account as the enemy, or will it constantly return to everyday life, reinscribing its own privilege? If we can "fabricate" the future, the answer may be ours—fans, critics and academics—to give.

Notes

1. Lawrence Grossberg, *We Gotta Get Out Of This Place: Popular Conservatism and Postmodern Culture* (New York and London: Routledge, 1992).

2. Simon Reynolds, "Dazed and Confused," *Village Voice* (January 1, 1991), p. 71.

3. Greil Marcus, "Notes on the Life and Death and Incandescent Banality of Rock 'n' Roll," *Esquire* (August 1992), p. 68 (emphasis added).

4. Actually, it may be less a matter of how "new" such rhetorical figures are in discourses about rock—certainly fragmentation has been around since the 1970s—than of their increasingly central and dominant role in the discourses of the death of rock.

5. Simon Frith, "End of an Ear," *Village Voice* (May 19, 1987).

6. Meg Cox, "Rock is Slowly Fading as Tastes in Music Go Off in Many Directions," *Wall Street Journal* (August 26, 1992), pp. 1 and 4 (emphasis added.)

7. Greil Marcus, *op. cit.*, pp. 68–69. (emphasis added).

8. Robert Christgau, "His Hit Parade," *Village Voice* (March 31, 1992), p. 87.

9. It would be interesting to consider here the question of the relative ease with which certain forms of practices travel: e.g., food travels more easily than music, which still travels more easily than language. Of course, we would then have to go on to acknowledge significant, determined variations within each of these forms. Moreover, ultimately it may not simply be a question of how culture travels, but how travel produces culture. See James Clifford, *The*

Predicament of Culture: Twentieth Century Ethnography, Literature and Art (Cambridge, Harvard University Press, 1988).

10. Will Straw, "Systems of Articulation, Logics of Change: Communities and Scenes in Popular Music," *Cultural Studies*, 5 (1991), pp. 368–388.

11. Henri Lefebvre, *Everyday Life in the Modern World*, trans. Sasha Rabinovitch (New Brunswick: Transaction, 1984).

12. See Henri Lefebvre, *Everyday Life*; Michel Foucault, *Discipline and Punish: The Birth of the Prison*, trans. Alan Sheridan (New York: Pantheon, 1977); Gilles Deleuze and Felix Guattari, *A Thousand Plateaus: Capitalism and Schizophrenia*, trans. Brian Massumi (Minneapolis: University of Minnesota Press, 1987).

13. For examples of this discussion, see: Douglas Coupland, *Generation X: Tales for an Accelerated Culture* (New York: St. Martin's Press, 1991); Richard Linklater, *Slacker* (New York: St, Martin's Press, 1992); and Neil Howe and Bill Strauss, *13th Gen: Abort, Retry, Ignore, Fail?* (New York: Vintage, 1993).

14. Andrew Ross (personal correspondence) has pointed out that this distinction has been used to distinguish between "the masses" (who operate from ignorance) and "the intellectuals" (who operate from knowledge). Yet in this "traditional" reading, knowledge was supposed to lead to or call for changed behavior. In its postmodern articulation, no such change of behavior is involved, because irony has replaced the understanding supposedly constructed through knowledge.

15. Tony Parsons, "Time To Make Music Not Headlines," *The Daily Telegraph* (January 1, 1993), p. 14.

16. Simon Frith, "End of an Ear," *Village Voice* (May 19, 1987).

17. Simon Frith, "He's the One," *Village Voice* (October 29, 1991), p. 88.

18. Michel de Certeau, *The Practice of Everyday Life*, trans. Steven F. Rendall (Berkeley: University of California Press, 1984).

19. For a discussion of the relation between rhythm, existence and power, see Gilles Deleuze and Felix Guattari, *A Thousand Plateaus: Capitalism and Schizophrenia*, trans. Brian Massumi (Minneapolis: University of Minnesota Press, 1987), pp. 310–350.

Excerpt from *Altered Spade: Readings in Race-Mutation Theory*

Greg Tate

Introduction

I'm writing a novel which explores four intellectual obsessions: black music, black national-ism, black women and science fiction.

The novel is set in the twenty-first century. The main character is an academic and cultural anthropologist named Babylonia Ain't Free. She's writing a history of a social and political movement which was initiated by her grandfather about twenty-five or thirty years before the novel begins. Her grandfather, who adopted the name Mandela Ain't Free, was originally named Bono Pruitt.

Mandela Ain't Free is a charismatic figure—a cross between Amiri Baraka, Victor Von Frankenstein and Jean-Michel Basquiat. The seeds of his political and social vision began to take shape while he was a student at Rhode Island School of Design (RISD). During college, he became interested in a genetic development program at Howard University spearheaded by Dr. Camelot Drexel. Dr. Drexel's research was based on the theory that black people's consciousness and social condition could be transformed through genetic mutation, rather than religious or ideological conversion. He wanted to transform a select group of black folks into amphibious creatures who would assist him in leading an exodus of black people to the Sirius B system.

While at RISD Mandela Ain't Free became intrigued with Drexel's ideas, and began using his techniques in an artistic context. He developed a whole body of work around the notion of mutating subjects. Using his charismatic personality, Mandela would draw people to him, and then alter them. In the novel, Mandela describes his mutation exhibitions. In one exhibit, he shows a film in which it appears as if there are twins of different races in the same womb—one twin is black, the other is white. It seems as if he has sped up and altered the evolutionary process so that the black twin looks as if he is crowding the white one out of the womb.

Eventually, Mandela decides that he does not want to confine his explorations to the

art world, he wants to do this *for real*. So, he creates a street-based revolutionary movement called the "Quantum Black Movement," founded on Drexel's ideas. He brings together a group of serious geneticists who develop techniques designed to increase black brain power and other skills. His main motivation is a sort of genetically based racial uplift plan. Mandela then initiates this revolutionary-action phase, called the "Race Wars," which is similar to the Black Power movement and the Black Panthers in its political aims and its historical trajectory: "Race Wars" is eventually crushed, infiltrated and dispersed into warring splinter factions.

Babylonia's best friend is Geza Sphinx, a DJ who embodies my idea of how DJs will "perform" music in the future. Instead of manipulating turntables or CD players to play prerecorded music, Geza has shards of laser-responsive material woven into her clothing, which—when she steps into an arena of cross-firing laser beams—catch the musical sounds, and produce an ever-shifting musical collage.

Besides Geza's first-person narrative there are texts from the other sources—biographies, manifestos, timecharts, letters—all written by various characters.

Excerpt from "Notes Toward A Comprehensive Quantum Black Timeline," compiled by the Babylonia Free Memorial Research Group, Spelman College, Atlanta, Georgia, 2103.

1998

Nebraska-Minnesota BloodsCrips announce peace treaty with the Aryan Nation. Congressional Black Caucus holds first hearings on the Black Genocide question. Camelot Drexel escapes from an orphanage in Free Roxbury, Massachusetts.

2004

Drexel, now sixteen, begins work at Howard University Medical Center on his All-African People's Melanocyte/Gene-mapping project. Meets Mandela Ain't Free (then Bono Pruitt), a transfer student from Rhode Island School of Design doing course work in the center's reconstructive surgery software lab.

2009

Drexel goes public with his Japan-São-Paulo-backed African Space Program. Begins soliciting sperm donors for The Brotherhood of Sleeping Star Spermatozoa. Mandela Ain't Free's first exhibition, "Reparations 1–3," held at New York's Spinoza Gallery.

2013

On June 19, Drexel and an armed band of followers hijack a Japanese space station project and leave earth, presumedly headed for Sirius B. On June 23rd, rumors circulate that the ship was destroyed by a U.S. space-based laser satellite at the request of the Japanese government. In protest, major insurrections break out in Brazil, U.S.E. and the U.S.A. Now based in Los Angeles, Mandela Ain't Free forms a theoretical terrorist sect known as the Young Black Hegelians, later the Quantum Black Movement. Drexel's brother, Rahman Ibn Hassan, signs contract with Warner Galactica to write *Black Star Fucker*, a biographical account of Drexel's mystery-shrouded childhood years.

2015–2020

Soft Target phase of the Quantum Black Movement's Race Mutation Wars.

2057

From her loft at the former St. Elizabeth's Mental Hospital in Washington DC, Babylonia Ain't Free self-publishes *Preface To A Proper Historiography of Quantum Black Theory*.

Excerpt from a conversation between Babylonia Ain't Free and Black Snake Dick Head, originally published in *Artforum, May 2055*.

BAF: You left the Quantum Black Movement at a critical juncture, just prior to the transition from Style Wars to Race Wars. Mandela Ain't Free himself threatened you with assassination. Did he think you would betray the movement to the state?

BSDH: Click bang what a hang, your grandaddy just shot poor me. Well by that time the question wasn't who Mandela wanted dead but who he thought was fit to live. Everyone was a traitor or a coward from his perspective. He tried to quarantine me in Harlem until certain of his operations were completed. I wasn't having it. I saw the handwriting on the wall and did not want to be there when the state swept through Harlem like Sherman had swept through Atlanta. Of course, Mandela beat them to it, but my escape still proved to be a prescient move. I do want to say one thing though. In those days I openly accused Mandela of being a revolutionary wannabe and history has proven me incorrect. He was as much of a military genius as he was an artistic one.

BAF: What brought you two together initially?

BSDH: Oh, his artwork, no doubt about that. I was there at his first exhibition, like everybody else in Gotham in the know, black, white or indifferent. Hysteria had been mounting for months about his work. No one but his assistants and his dealer had seen

it. His dealer, not usually a man given to hyperbole or hysteria, claimed it was the most radical formal break in the plastic arts since Cubism. He said that, like Cubism, the work was shocking more because of its formal and perceptual implications than its content, though that's still debatable.

Information kept coming out in dribs and drabs, deliberately leaked, of course. We discovered Mandela was a former geneticist and plastic surgeon who'd gone into art, and that his politics were a throwback to twentieth-century black radicalism. It was rumored he'd once wanted mount a piece utilizing his own castrated penis, and had been expelled from Chicago Art Institute because of it. This was all mildly intriguing stuff.

We didn't know for certain he was a black man until the gallery noticed photographs were published in *Artforum*. You've seen them, I'm sure, those blurry black and whites after Joel-Peter Witkin. Mandela standing over a table teeming with maggots, microsurgical instruments in hand, a smudgy pile behind him, suggestive in retrospect, I suppose, of the mass graves discovered by the Allies in Hitler's death camps. The title of the show was properly provocative and oblique: "Reparations 11–3."

Physically speaking, I've always though Mandela was strikingly ugly. That shaved and bony cadaverous head and ratty hair implants topping his broad barrel chest. Anatomically, everything about him was out of proportion, like he'd been stitched together from several men. He had the thick forearms of a dock worker bizarrely tapering into spidery fingers more appropriate on, oh, I don't know, an effete sitarist. Those demonic eyebrows prepared you for eyes angrily shooting out at the world from narrowed slits. His were twinkling and jolly instead, just like old St. Nick.

So the day of the opening comes, lines stretching down West Broadway from Prince to Broome. Only fifteen people at a time were going to be allowed in to view the work. You can imagine how long the process took. Also, no one who had seen the work would be allowed back out until all the invited guests had seen it. Obviously, they wanted to maintain the element of surprise. Special arrangements had been made with the other galleries in the building to house each consecutive group of viewers after they'd exited.

There was a squad of security people dressed in outfits Mandela had designed himself, very Afghani, right down to the curved scimitars they carried. I came in with maybe the fourth group. The windows out front were blackened and it was also pitch black on the inside except for some luminous strips on the floor. They functioned as an illuminated footpath. We were led to a roped-off, white, curtained area that glowed from within with ultraviolet light. When the curtains parted, what stood between us and the work was a thick wall of fiberglass.

There were three exhibits or specimens there. The one he later titled "Cubist-Faced Bitch," but then called "Cultural Properties," came up first. She was blonde, Nordic, half seated, half standing on an operating table with her back to the audience. I remember her body line as lithe and stately. Just as I got used to the gloom a small spotlight became

trained on her back. The flesh on it had been ripped to shreds, by what instrument I didn't know, but we're talking a mass of scars, welts and bruises, highlighted by turned-back rolls of dessicated flesh. A hologram came into view, a nineteenth-century portrait of an elegant and aquiline-featured black man in his mid-forties. He was posed in exactly the same way as the woman, and his back had been mutilated in exactly the same formations as hers. Clearly he was the model for the work done on her. There was no longer any mystery as to what reparations referred to.

A plethora of things shot through my mind at once. I was struck by the exactitude of the scar-tissue work, and then by how noble and dignified the black gentleman looked. It was as if all the suffering that had gone into destroying his back had only heightened his sense of regality. There was no way of knowing what was happening on the woman's face. It was still turned away from us and shrouded by her hair.

I thought of Toni Morrison's statement—do you know who Toni Morrison was? Yes of course you've obviously had a very thorough education—that the most amazing thing about slavery was that bestial treatment had not produced beasts. And I reflected, no, it would take commodity fetishism to accomplish that deformation on the African. What centuries of the yoke, the lash and the chain hadn't been able to effect, the magical belief that goods conferred status upon their owners had done in less than a generation. Looking at Mandela's work in that white, art-world context, you knew you were seeing the culmination, as well as as a critique, of the total Americanization of the African soul.

The light dimmed over the woman's back, and from the sides another blinked on, brightening the area of her head. Slowly she turned, revealing a face with a nose scraped in homage to Napoleon's work on the Sphinx, and instead of two normal-sized eyes, there was one humongus and flattened Egyptian-style one, cartoonishly designed but clearly made of flesh, inset into her forehead. Neither side- nor the flat-perspective effect changed when she stood up and faced us, exhibiting a brass breastplate whose facade was modeled after some multiple-pyramid archaelogical site.

Following the full unveiling of that spectacle the curtains closed rapidly, and we were all made aware of our silent, shaken selves, shuddering in the darkness. When the drapes parted again we saw what appeared to be a mixed, I mean Negroid and Caucasian, couple in togas. The pose they held suggested they were preparing to toast guests at a salon fête. As an overhead sliced light between them, you saw that the woman was black as night, her partner a ruddy pink, and that they were joined like Siamese twins from the hipbone to the shoulders. On the fiberglass shield, cursive lettering begin emulsifying like invisible ink, spelling out the title "Integration Leads to Miscegenation." As that was occurring the couple began doing ritualized serving movements in perfectly coordinated tandem, toasting a ghost audience in every direction. Finally, they poured each other drinks, toasted our assembly and faded to black.

This time, instead of the curtains closing, the back wall of the exhibition space lit up in

blinding white. Mandela stood in a doctor's smock and pointer before a screen. A film came on the screen. The opening titles read "Mirror, Mirror." The images came from inside the womb of a white woman in late-stage pregnancy who was carrying twins. As the film progressed, one began transforming from a small white child to an increasingly larger black one, who threatened to crowd his brother out or crush him along the way. We prepared for a horror show, but the film ran out unexpectedly, thrusting us back into the scarier regions of our own overwrought imaginations.

To say we were shocked, outraged, angered by this work would be an understatement. We were terrorized. More by the how than the what. This was living flesh we had been looking at. It had been transformed by state-of-the-art surgery and the vision and violence of a race-obsessed lunatic into monstrosities. Was it done under threat of terror or with the consent of the subjects? Were they subjects or victims? How had he found them? Was the work reversible? Was it for sale and in what form? Then there was the vengefulness and blind fury of the whole project, its nihilistic denial of innocence as a human possibility.

I knew then that your grandfather was the most evilly brilliant black man I would ever meet, and that I wanted to spend the rest of my life documenting his working methods, procedures and artifacts. Believe it or not, I've had crazier ideas since. You see, I was young then, and just getting started.

Excerpt from a prison letter written by Mandela Ain't Free to his daughter Nada Ain't Free while awaiting execution on Rikers Island, 2020.

We kept waiting for *Childhood's End*, but the extraterrestrials never showed up flapping their forked tails. When the show got running their speaking parts weren't dubbed in. Too late for that little sister. Jonah and the whale was a closed chapter, no man from Mars coming to play Messiah and we blew our chance at Black Moses back in 1929.

We told the old guard: astral traveling can't save your ass and the tenth Pan-Afrikan Congress ain't never gonna happen. Our options narrowed to guerilla warfare and weaponry for the body. We converted our Brooklyn garment factories to munitions plants. Had bionic SWAT teams shooting up everywhere like poison mushrooms, microcosmic Hiroshimas. We inducted the apathetic through sheer terror. Airports began belching hand grenades, bodies splayed in the terminals like crippled umbrellas. We blew up the Brooklyn Bridge and burned Harlem to the ground. Said gentrify this, motherfuckers, move your leisure classes into ashes and rubble.

Your generation makes me laugh. You lean left and then duck for cover. Make tracks for the underground railroad. You'll learn. Never mind that you're no apologist for random slaughter. Never mind you hold onto the concept of innocent bystanders. The white

bodypolitic doesn't distinguish, so why should we? You might as well be Mandela Ain't Free as one more freak nigger caught straddling the fence. They'll bring the rabid packs of cybernetic dobermans down on your ass quick as they will mine. Clamp on those hydraulic incisors with a bent towards evisceration. Now go appeal that in the World Court. Make a case for the Geneva Convention under suspension of your right to bear genitals. When we came on the scene they were in the process of making blackness the legal definition of madness and disease—of making blackness synonymous with insanity and the plague. We were the ones who stood up and said, you want to see sick, black and crazy, we'll give it to you in spades.

Excerpt from Babylonia Ain't Free's *Preface To A Proper Historiography of Quantum Black Theory*, 2057, Black Baby's Press.

Only the naive or the duplicitous will tell you that the wars hadn't been fought over race and power. They'll try to convince you they were once nothing more than an intellectual game played by two opposing systems of signification—the Quantum Blacks and their theoretical soft targets, the white bodypolitic. Only after the dialogue left the academy, so the story goes, did things degenerate from the eloquently figurative to the crudely and brutally literal: an escalation from debates over matters of interpretation to disputes that could only be settled by bloodshed, bombings and assassinations. The fact of the matter is that race war was the inevitable course of the Quantum Black Movement from the moment of its inception. What movement for black self-determination could not end up at war with the state?

. . . the Quantum Blacks defined themselves as super-niggers, even if they'd acquired their ultra-blackness through copious studies rather than street knowledge. A black and learned breed of übermensch apart who pronounced that, since they did not know their place relative to the white bodypolitic, they would find it by bearing their sign of negation to a *reductio ad absurdum*, a theoretical black hole. Not to a collapse in the fabric of space-time, dimension or gravity, but to a fold in the curtain of race memory. In practice, this meant adhering to the belief that the white bodypolitic did not exist, could not exist and had never existed. That this negation returned the whites as a critical presence by absenting them as a thing to be voided was less a contradiction in terms than the trope which commenced the psychological phase of the wars. In effect, the Quantum Blacks were signifying that, since they did not believe in the white bodypolitic, that bodypolitic could not impose its definitions of blackness upon them or the world, leaving the Quantum Blacks free to define blackness for themselves and the world, as opposed to having it defined by the Other-man.

Excerpt from DJ Geza's memoir of Babylonia Ain't Free, *My Baby Left and Took My Best Jams With Her,* 2069, Kitchen Table Press.

The game of love is never called off because of darkness.

—Pepe Le Poo

You can call me Geza or you can call me Skeeza. I answer to both, knowing, as my grandmother believed on her deathbed, that I've lived the life of a queen and have no regrets. Unlike grandmother, I'm not on my deathbed and my memoirs are a work in progress, a never-ending saga that will forestall closure and go on after this body has given up the ghost. This is not my story.

This is the story of Babylonia Ain't Free, Baby Ain't Free to those who loved her and the Womb-For-Hire homegirls who always gave her a hard way to go, even after she'd saved them from her evil stepmother, Nada, the last mayor of Gotham.

The homegirls used to call Babylonia freak to her face. It ain't bother her none. She loved them more than she loved life itself.

She did not think she was so different from them. She used to say she was living her dream life just like the homegirls were living theirs. In her dream life she was Isis to Black Snake Dick Head's Osiris, a tragic goddess doomed to wander the earth until she turned up her murdered lover's missing body parts. The homegirls were artificially inseminated black-market baby factories who'd farmed themselves out to an infant-mercenary trade running between Bahia and Angola. Ranging in age between seventeen and forty-five, they'd been carrying their pregnancies for five years. This was nobody's science fiction to them, this was their lives. In their minds they were the last down sisters in the struggle, heroines on a mission, the breeders of tomorrow's African revolutionaries. Baby believed that, all things being equal, she carried on after a dead man's dick and so did the homegirls.

The homegirls used to see Baby up in the 'hood looking for the dick and the head, and laugh, like, look that girl she tripping ain' she, yup, she ain't lookin' for no man, she lookin' for chopped meat, ha ha ha.

The homegirls had taken to dressing shabby the winter Baby moved into the 'hood with me. Over the summer their fashion had been hooded black leather warm-up suits. By February, I was mourning their sacrifice of style in favor of signification. Snowbanks six feet high in Harlem and the wombies were draping themselves in billowing expanses of burlap, trails of razor-slit maternity gowns gilled to ventilate the spine and tummy. Baby took their fashion statements as ironic gestures rather than demented ones.

I saw the homegirls' whole lives as self-induced victimization. Baby saw a banged gang of urban bushwomen. In her mind they were mocking expectant motherhood as a form of martyrdom. Crocus sacks, crown of thorns, the whole nine yards.

Through winter winds the troops barreled across the drifts, moving down Harlem's white-capped boulevards like a platoon of chipper tumbleweed, bare asses flapping through the

breeze like it wasn't no thing. Stepping smart, these rag-ass fashion girls hung together, any kind of weather. Out on maneuvers they wore their weaves knotted into a ropetrain thirty mamas-to-be long. Baby saw a sisterhood of sidewalk mountaineers scaling the streets along cable-lengths of artificial hair. I saw a chain of patriarchy's fools.

Whenever the homegirls spoke it was en masse, singing, cursing and chanting in rude harmony, a cacophony of bad-mouthing that announced the arrival of a Babel of marching feet, much attitude and enough artillery to even the odds in the people's favor if the pigs ever showed up again.

A rough and riotous black noise was their sound, and it screened out the ears of the curious. Outside their circle we in the 'hood took them for a clarion of idle chatterboxes, talking loud and saying nothing.

Of course Babylonia thought differently. She believed that what went on inside their cabal was an exchange of information rivaling Wall Street. In her romance the homegirls were sisters clear on the power of the word and the womb to organize the world.

We frequently went to town over this bullshit, to my mind, line of thinking. Arguments Baby geeked on 'cause they cracked my legendary cool. Every body got their buttons, you just got to know how to push em. Baby made mine go mad red when she professed her love for the homegirls.

Bitch never tired in her faith that each homegirl's vagina was a mouth of God, a sacred jawbone seamed to their monkey-asses to deliver the messages of pro-black radical prophets. At first I thought she was trying to shit the bullshitter, but Baby kept her sarcasm in check more than her tongue. She could've just been fucking with me. I never could tell.

Baby always said she wanted to join the homegirls and carve out a new identity for herself among their muttering cult of merchandised fertility. She said if nothing else they had style and a sense of mission missing from most young sisters uptown. Style or no style, woman-cult or cargo-cult, I did not buy into the wombies mission or their mystique. I had come up in the streets same as them, and much to Babylonia's faux-feminist chagrin, I had no problem calling them hos, cows, women of low intelligence, willing victims of reactionary masculinism, a reduction of black womanhood to the status of commodity uterus for yet another male-dominated master race plan.

We had this same argument so many times you'd think we'd have wanted a new script, but you know how those games are, you don't want nobody getting new on you.

When I went critical on Baby's idolatry, she would ask: Didn't my dislike derive from how many ass-whippings homegirls had given my light-skinned, long-haired cat-eyed ass when I was coming up? She would ask: Didn't I think the homegirls pointed up how race-consciousness as a measure of blackness paled besides being able to bring real black babies into the world? Didn't the homegirls definition of what it meant to be a black woman carry more weight than my own?

And I'd go off, screaming how only a rich and pampered Ivy League bitch like Babylonia

would confuse black womanhood with being a raggedy-ass, knocked-up, barefoot and ignorant ho. I'd rant how my self-respect alone made me more of a real black woman than they'll ever be. I don't care how many mud-puppies they litter up and down the street. And so on.

At which point Baby would try and change the subject, talking about had I ever noticed how race-conscious sisters with light, bright, damn-near white complexions always think of themselves as nine shades darker than their true colors? I'd say: Kiss my ass wench, and she'd say: Hey, you know, nobody does it better, and shit like that. Then we'd make love, all night long, going on and on, like hot buttered soul and candy popcorn, beat don't stop until the break of dawn, you know the beat don't stop until all the freaks are gone. Yeah, Baby. Once we was girls together.

Locating
Hip Hop

A Style Nobody Can Deal With
Politics, Style and the Postindustrial City in Hip Hop

Tricia Rose

Life on the margins of postindustrial urban America is inscribed in hip hop style, sound, lyrics and thematics.[1] Emerging from the intersection of lack and desire in the postindustrial city, hip hop manages the painful contradictions of social alienation and prophetic imagination. Hip hop is an Afro-diasporic cultural form which attempts to negotiate the experiences of marginalization, brutally truncated opportunity and oppression within the cultural imperatives of African-American and Caribbean history, identity and community. It is the tension between the cultural fractures produced by postindustrial oppression and the binding ties of Black cultural expressivity that sets the critical frame for the development of hip hop.[2]

Worked out on the rusting urban core as a playground, hip hop transforms stray technological parts intended for cultural and industrial trash heaps into sources of pleasure and power. These transformations have become a basis for digital imagination all over the world. Its earliest practitioners came of age at the tail end of the Great Society, in the twilight of America's short-lived federal commitment to black civil rights, and during the predawn of the Reagan-Bush era.[3] In hip hop, these abandoned parts, people and social institutions were welded and then spliced together, not only as sources of survival, but as sources of pleasure.

Hip hop replicates and reimagines the experiences of urban life and symbolically appropriates urban space through sampling, attitude, dance, style and sound effects. Talk of subways, crews and posses, urban noise, economic stagnation, static and crossed signals leap out of hip hop lyrics, sounds and themes. Graffiti artists spray-painted murals and (name) "tags" on trains, trucks and playgrounds, claiming territories and inscribing their otherwise contained identities on public property.[4] Early breakdancers' elaborate, technologically inspired, street-corner dances, involving head spins on concrete sidewalks, made the streets theater-friendly, and turned them into makeshift youth centers. The dancers'

electric, robotic mimicry and identity-transforming characterizations foreshadowed the fluid and shocking effect of morphing, a visual effect made famous in *Terminator 2*. DJs who initiated spontaneous street parties by attaching customized, makeshift turntables and speakers to streetlight electrical sources revised the use of central thoroughfares, made "open-air" community centers in neighborhoods where there were none. Rappers seized and used microphones as if amplification was a life-giving source. Hip hop gives voice to the tensions and contradictions in the public urban landscape during a period of substantial transformation in New York, and attempts to seize the shifting urban terrain, to make it work on behalf of the dispossessed.

Hip hop's attempts to negotiate new economic and technological conditions, as well as new patterns of race, class and gender oppression in urban America, by appropriating subway facades, public streets, language, style and sampling technology are only part of the story. Hip hop music and culture also relies on a variety of Afro-Caribbean and Afro-American musical, oral, visual and dance forms and practices in the face of a larger society that rarely recognizes the Afro-diasporic significance of such practices. It is, in fact, the dynamic and often contentious relationship between the two—larger social and political forces and black cultural priorities—that centrally shape and define hip hop.

The tensions and contradictions shaping hip hop culture can confound efforts at interpretation by even the most skilled critics and observers. Some analysts see hip hop as a quintessentially postmodern practice, while others view it as a present-day successor to premodern oral traditions. Some celebrate its critique of consumer capitalism, while others condemn it for its complicity with commercialism. To one enthusiastic group of critics, hip hop combines elements of speech and song, of dance and display, to call into being through performance new identities and subject positions. Yet to another equally vociferous group, hip hop merely displays in phantasmagorical form the cultural logic of late capitalism. I intend to demonstrate the importance of locating hip hop culture within the context of deindustrialization and to show how hip hop's primary properties of flow, layering and rupture simultaneously reflect and contest the social roles open to urban inner city youth at the end of the twentieth century.

In an attempt to rescue rap from its identity as postindustrial commercial product, and situate it in the history of respected black cultural practices, many historical accounts of rap consider it a direct extension of African-American oral, poetic and protest traditions to which it is clearly and substantially indebted. This accounting, which builds important bridges between rap's use of boasting, signifying, preaching and earlier, related, black, oral traditions, produces multiple problematic effects. First, it reconstructs rap music as a singular oral poetic form which appears to have developed autonomously (outside hip hop culture) in the 1970s. Quite to the contrary, rap is one cultural element within the larger social movement of hip hop. Second, it substantially marginalizes the significance of rap as *music*. Rap's musical elements and its use of music technology are crucial

aspects of the use and development of the form, and are absolutely critical to the evolution of hip hop generally. Finally, and most directly important for this discussion, it renders invisible the crucial role of the postindustrial city on the shape and direction of rap and hip hop and makes it difficult to trace the way hip hop revises and extends Afro-diasporic practices using postindustrial urban materials. Hip hop's styles and themes share striking similarities with many past and contiguous Afro-diasporic musical and cultural expressions; these themes and styles, for the most part, are revised and reinterpreted using contemporary cultural and technological elements. Hip hop's central forms—graffiti, breakdancing and rap music—developed, in relation to one another, within Afro-diasporic cultural priorities, and in relation to larger postindustrial social forces and institutions.

What are some of the defining aesthetic and stylistic characteristics of hip hop? What is it about the postindustrial city generally, and the social and political terrain in the 1970s in New York City specifically, that contributes to the emergence and early reception of hip hop? Even as today's rappers revise and redirect rap music, most understand themselves as working out of a tradition of style, attitude and form which has critical and primary roots in New York City in the 1970s. Substantial postindustrial shifts in economic conditions, access to housing, demographics and communication networks were crucial to the formation of the conditions which nurtured the cultural hybrids and sociopolitical tenor of hip hop's lyrics and music.

The Urban Context

Postindustrial conditions in urban centers across America reflect a complex set of global forces which continue to shape the contemporary urban metropolis. The growth of multinational telecommunications networks, global economic competition, a major technological revolution, the formation of new international divisions of labor, the increasing power of finance relative to production, and new migration patterns from Third World industrializing nations have all contributed to the economic and social restructuring of urban America. These global forces have had direct and sustained impact on urban job opportunity structures, have exacerbated long-standing racial-and gender-based forms of discrimination and have contributed to increasing multinational corporate control of market conditions and national economic health.[5] Large-scale restructuring of the workplace and job market has had its effect upon most facets of everyday life. It has placed additional pressures on local, community-based networks of communication, and has whittled down already limited prospects for social mobility.

In the 1970s, cities across the country were gradually losing federal funding for social services, information service corporations were beginning to replace industrial factories, and corporate developers were buying up real estate to be converted into luxury housing, leaving working-class residents with limited affordable housing, a shrinking job market and

diminishing social services. The poorest neighborhoods and the least powerful groups were the least protected and had the smallest safety nets. By the 1980s, the privileged elites displayed unabashed greed as their strategies to reclaim and rebuild downtown business and tourist zones with municipal and federal subsidies exacerbated the already widening gap between classes and races.

Given New York's status as hub city for international capital and information services, it is not surprising that these larger structural changes and their effects were quickly and intensely felt in New York.[6] As John Mollenkopf notes, "during the 1970s, the U.S. system of cities crossed a watershed. New York led other old, industrial metropolitan areas into population and employment decline."[7] The federal funds that might have offset this process had been diminishing throughout the 1970s. In 1975, President Ford's unequivocal veto to requests for a federal bail out to prevent New York from filing for bankruptcy made New York a national symbol for the fate of older cities under his administration. The New York *Daily News* legendary headline, "Ford to New York: Drop Dead," captured the substance and temperament of Ford's veto and sent a sharp message to cities around the country.[8] Virtually bankrupt and in a critical state of disrepair, New York City and State administrators finally negotiated a federal loan, albeit one which accompanied an elaborate package of service cuts and carried harsh repayment terms. These dramatic social service cuts were felt most severely in New York's poorest areas and were part of a larger trend in unequal wealth distribution and were accompanied by a housing crisis which continued well into the 1980s. Between 1978 and 1986, the people in the bottom twenty percent of the income scale experienced an absolute decline in income while the top twenty percent experienced most of the economic growth. Blacks and Hispanics disproportionately occupied this bottom fifth. During this same period, thirty percent of New York's Hispanic households (for Puerto Ricans it is forty percent) and twenty five percent of black households lived at or below the poverty line. Since this period, low-income housing has continued to disappear, and blacks and Hispanics are still much more likely to live in overcrowded, dilapidated and seriously undermaintained spaces.[9] It is not surprising that these serious trends have contributed to New York's large and chronically homeless population.

In addition to housing problems, New York and many large urban centers faced other major economic and demographic forces which have sustained and exacerbated significant structural inequalities. While urban America has always been socially and economically divided, these divisions have taken on a new dimension. At the same time that racial succession and immigration patterns were reshaping the city's population and labor force, shifts in the occupational structure, away from a high-wage, high-employment economy grounded in manufacturing, trucking, warehousing and wholesale trade, and toward a low-wage, low-employment economy geared toward producer services, generated new forms of inequality. As Daniel Walkowitz suggests, New York has become

sharply divided between an affluent, technocratic, professional, white-collar group managing the financial and commercial life of an international city and an unemployed and underemployed service sector which is substantially black and Hispanic.

Earlier divisions in the city were predominantly ethnic and economic. "New York," according to Mollenkopf, "has been transformed from a relatively well-off, white, blue-collar city into a more economically divided, multi-racial, white-collar city." This "disorganized periphery" of civil service and manufacturing workers contributes to the consolidation of power among white-collar, professional, corporate managers, creating the massive inequalities in New York.[10]

The commercial imperatives of corporate America have also undermined the process of transmitting and sharing local knowledge in the urban metropolis. Ben Bagdikian's study, *The Media Monopoly*, reveals that monopolistic tendencies in commercial enterprises seriously constrain access to a diverse flow of information. For example, urban renewal relocation efforts not only dispersed central-city populations to the suburbs, they also replaced the commerce of the street with the needs of the metropolitan market. Advertisers geared newspaper articles and television broadcasts toward the purchasing power of suburban buyers—creating a dual "crisis of representation" in terms of whose lives and images were represented physically in the paper, and whose interests were represented in the corridors of power.[11] These media outlet and advertising shifts have been accompanied by a massive telecommunications revolution in the information processing industry. Once the domain of the government, information processing and communication technology now lie at the heart of corporate America. As a result of government deregulation in communications via the break up of AT&T in 1982, communication industries have consolidated and internationalized. Today, telecommunications industries are global data transmittal corporations with significant control over radio, television, cable, telephone, computer and other electronic transmittal systems. Telecommunication expansion coupled with corporate consolidation has dismantled local community networks, and has irrevocably changed the means and character of communication.[12] Since the mid-1980s, these expansions and consolidations have been accompanied by a tidal wave of widely available communications products which have revolutionized business and personal communications. Facsimile machines, satellite-networked beepers, cordless phones, electronic mail networks, cable television expansions, VCRs, compact discs, video cameras and games and personal computers have dramatically transformed the speed and character of speech and of written and visual communication.

Postindustrial conditions had a profound effect on black and Hispanic communities. Shrinking federal funds and affordable housing, shifts in the occupational structure away from blue-collar manufacturing and toward corporate and information services, along with

frayed local communication patterns, meant that new immigrant populations and the city's poorest residents paid the highest price for deindustrialization and economic restructuring. These communities are more susceptible to slumlords, redevelopers, toxic waste dumps, drug rehabilitation centers, violent criminals, mortgage redlining and inadequate city services and transportation. It also meant that the city's ethnic- and working-class-based forms of community aid and support were growing increasingly less effective against these new conditions.

In the case of the South Bronx, which has been frequently dubbed the "home of hip hop culture," these larger postindustrial conditions were exacerbated by disruptions considered an "unexpected side effect" of a larger, politically motivated, "urban renewal" project. In the early 1970s, this renewal [sic] project involved massive relocations of economically fragile people of color from different areas in New York City into parts of the South Bronx. Subsequent ethnic and racial transition in the South Bronx was not a gradual process that might have allowed already taxed social and cultural institutions to respond self-protectively; instead it was a brutal process of community destruction and relocation executed by municipal officials, under the direction of legendary city planner Robert Moses.

Between the late 1930s and the late 1960s Moses executed a number of public works projects, highways, parks and housing projects which significantly reshaped the profile of New York City. In 1959, city, state and federal authorities began the implementation of his planned Cross-Bronx Expressway, which would cut directly through the center of the most heavily populated working-class areas in the Bronx. While he could have modified his route slightly to bypass densely populated working-class ethnic residential communities, he elected a path that required the demolition of hundreds of residential and commercial buildings. In addition, throughout the 1960s and early 1970s, some sixty thousand Bronxites homes were razed. Designating these old blue-collar housing units as "slums," Moses's Title I slum clearance program forced the relocation of 170,000 people.[13] These "slums" were in fact densely populated stable neighborhoods, comprised mostly of working- and lower-middle-class Jews, but they also contained solid Italian, German, Irish and black neighborhoods. Although the neighborhoods under attack had a substantial Jewish population, black and Puerto Rican residents were disproportionately affected. Thirty-seven percent of the relocated residents were non-white. This, coupled with the subsequent "white flight," devastated kin networks and neighborhood services. Between the late 1960s and mid-1970s the vacancy rates in the southern section of the Bronx skyrocketed. Some nervous landlords sold their property as quickly as possible, often to professional slumlords, others torched their buildings to collect insurance payments. Both strategies accelerated the flight of white tenants into northern sections of the Bronx and into Westchester. Equally anxious shopkeepers sold their shops and established businesses elsewhere. The city administration, touting Moses's expressway as a sign of progress and modernization, was

unwilling to admit the devastation that had occurred. Like many of his public works projects, Moses's Cross-Bronx Expressway supported the interests of the upper classes against the interests of the poor, and intensified the development of the vast economic and social inequalities which characterize contemporary New York. The newly "relocated" black and Hispanic residents in the South Bronx were left with few city resources, fragmented leadership and limited political power.

The disastrous effects of these city policies went relatively unnoticed in the media until 1977, when two critical events fixed New York and the South Bronx as national symbols of ruin and isolation. During the summer of 1977 an extensive power outage blacked out New York, and hundreds of stores were looted and vandalized. The poorest neighborhoods (the South Bronx, Bedford Stuyvesant, the Brownsville and Crown Heights areas in Brooklyn, the Jamaica area in Queens and Harlem) where most of the looting took place were depicted by the city's media organs as lawless zones where crime is sanctioned, and chaos bubbles just below the surface. The 1965 blackout, according to the New York Times, was "peaceful by contrast," suggesting that the blackout which took place during America's most racially tumultuous decade was no match for the despair and frustration articulated in the blackout of the summer of 1977.[14] The 1977 blackout and the looting which accompanied it seemed to raise the federal stakes in maintaining urban social order. Three months later, President Carter made his "sobering" historic motorcade visit through the South Bronx, to "survey the devastation of the last five years," and announced an unspecified "commitment to cities." (Not to its inhabitants?) In the national imagination, the South Bronx became the primary "symbol of America's woes."[15]

Following this lead, images of abandoned buildings in the South Bronx became central popular cultural icons. Negative local color in popular film exploited the devastation facing the residents of the South Bronx and used their communities as a backdrop for social ruin and barbarism. As Michael Ventura astutely notes, these popular depictions (and, I would add, the news coverage as well) rendered silent the people who struggled with and maintained life under difficult conditions:

> In roughly six hours of footage—*Fort Apache, Wolfen* and *Koyaanisqatsi*—we haven't been introduced to one soul who actually lives in the South Bronx. We haven't heard one voice speaking its own language. We've merely watched a symbol of ruin: the South Bronx [as] last act before the end of the world.[16]

Depictions of black and Hispanic neighborhoods were drained of life, energy and vitality. The message was loud and clear: to be stuck here was to be lost. And yet, while these visions of loss and futility became defining characteristics, the youngest generation of South Bronx exiles were building creative and aggressive outlets for expression and identification. The new ethnic groups who made the South Bronx their home in the 1970s

began building their own cultural networks, which would prove to be resilient and responsive in the age of high technology. North American blacks, Jamaicans, Puerto Ricans and other Caribbean people with roots in other postcolonial contexts reshaped their cultural identities and expressions in a hostile, technologically sophisticated, multiethnic, urban terrain. While city leaders and the popular press had literally and figuratively condemned the South Bronx neighborhoods and their inhabitants, their youngest black and Hispanic residents answered back.

Hip Hop

Hip Hop culture emerged as source of alternative identity formation and social status for youth in a community whose older local support institutions had been all but demolished along with large sectors of its built environment. Alternative local identities were forged in fashions and language, street names and most importantly, in establishing neighborhood crews or posses. Many hip hop fans, artists, musicians and dancers continue to belong to an elaborate system of crews or posses. The crew, a local source of identity, group affiliation and support system, appears in virtually all rap lyrics and cassette dedications, music video performances and media interviews with artists. Identity in hip hop is deeply rooted in the specific, the local experience and one's attachment to and status in a local group or alternative family. These crews are new kinds of families forged with intercultural bonds which, like the social formation of gangs, provide insulation and support in a complex and unyielding environment and may, in fact, contribute to the community-building networks which serve as the basis for new social movements.

The postindustrial city, which provided the context for creative development among hip hop's earliest innovators, shaped their cultural terrain, access to space, materials and education. While graffiti writers' work was significantly aided by advances in spray-paint technology, they used the urban transit system as their canvas. Rappers and DJs disseminated their work by copying it on tape-dubbing equipment and playing it on powerful, portable "ghetto blasters." At a time when budget cuts in school music programs drastically reduced access to traditional forms of instrumentation and composition, inner-city youth increasingly relied on recorded sound. Breakdancers used their bodies to mimic "transformers" and other futuristic robots in symbolic street battles. Early Puerto Rican, Afro-Caribbean and black American hip hop artists transformed obsolete vocational skills from marginal occupations into the raw materials for creativity and resistance. Many of them were "trained" for jobs in fields that were shrinking or that no longer exist. Graffiti writer Futura graduated from a trade school specializing in the printing industry. But since most of the jobs for which he was being trained had already been computerized, he found himself working at McDonald's after graduation. Similarly, African-American DJ Red Alert (who also has family from the Caribbean) reviewed blueprints for a drafting company until computer automation

rendered that job obsolete. Jamaican DJ Kool Herc attended Alfred E. Smith auto mechanic trade school while African-American Grand Master Flash learned how to repair electronic equipment at Samuel Gompers vocational high school. (One could say Flash "fixed them alright"). Salt-N-Pepa (both with family roots in the West Indies) worked as phone telemarketing representatives at Sears while considering nursing school. Puerto Rican breakdancer Crazy Legs began breakdancing largely because his single mother could not afford Little League baseball fees.[17] All of these artists found themselves positioned with few resources in marginal economic circumstances, but each of them found ways to become famous as entertainers by appropriating the most advanced technologies and emerging cultural forms. Hip hop artists used the tools of obsolete industrial technology to traverse contemporary crossroads of lack and desire in urban Afro-diasporic communities.

Stylistic continuities were sustained by internal cross-fertilization between rapping, break-dancing and graffiti writing. Some writers, like black American Phase 2, Haitian Jean-Michel Basquiat, Futura and black American Fab Five Freddy produced rap records. Others writers drew murals that celebrated favorite rap songs (for example, Futura's mural, "The Breaks," was a whole car mural that paid homage to Kurtis Blow's rap of the same name). Breakdancers, DJs and rappers wore graffiti-painted jackets and T-shirts. DJ Kool Herc was a graffiti writer and dancer first, before he began playing records. Hip hop events featured breakdancers, rappers and DJs as triple-bill entertainment. Graffiti writers drew murals for DJ's stage platforms, and designed posters and flyers to advertise hip hop events. Breakdancer Crazy Legs, founding member of the Rock Steady Crew, describes the communal atmosphere between writers, rappers and breakers in the formative years of hip hop:

> Summing it up, basically going to a jam back then was (about) watching people drink, (break) dance, compare graffiti art in their black books. These jams were thrown by the (hip hop) DJ . . . it was about piecing while a jam was going on.[18]

Of course, sharing ideas and styles is not always a peaceful process. Hip hop is very competitive and confrontational; these traits are both resistance to and preparation for a hostile world which denies and denigrates young people of color. Breakdancers often fought other breakdance crews out of jealousy; writers sometimes destroyed murals, and rapper and DJ battles could break out in fights. Hip hop remains a never-ending battle for status, prestige and group adoration which is always in formation, always contested and never fully achieved. Competitions among and cross-fertilization between breaking, graffiti writing and rap music was fueled by shared local experiences and social position, and similarities in approaches to sound, motion, communication and style among hip hop's Afro-diasporic communities.

As in many African and Afro-diasporic cultural forms, hip hop's prolific self-naming is a form of reinvention and self-definition.[19] Rappers, DJs, graffiti artists and breakdancers all

take on hip hop names and identities which speak to their role, personal characteristics, expertise or "claim to fame." DJ names often fuse technology with mastery and style: DJ Cut Creator, Jazzy Jeff, Spindarella, Terminator X Assault Technician, Wiz and Grand Master Flash. Many rappers have nicknames which suggest street smarts, coolness, power and supremacy: L.L. Cool J (Ladies Love Cool James), Kool Moe Dee, Queen Latifah, Dougie Fresh (and the Get Fresh Crew), D-Nice, Hurricane Gloria, Guru, MC Lyte, EPMD (Erick and Parrish Making Dollars), Ice-T, Ice Cube, Kid-N-Play, Boss, Eazy-E, King Sun, and Sir Mix-A-Lot. Other names serve as self-mocking tags, or critique society, such as Too Short, The Fat Boys, S1Ws (Security of the First World), The Lench Mob, N.W.A. (Niggas With Attitude) and Special Ed. The hip hop identities for breakdancers like Crazy Legs, Wiggles, Frosty Freeze, Boogaloo Shrimp, and Headspin highlight their status as experts known for special moves. Taking on new names and identities offered "prestige from below" in the face of limited legitimate access to forms of status attainment.

In addition to the centrality of alternative naming, identity and group affiliation, rappers, DJs, graffiti writers and breakdancers claim turf and gain local status by developing new styles. As Hebdige's study on punk illustrates, style can be used as a gesture of refusal, or as a form of oblique challenge to structures of domination.[20] Hip hop artists use style as a form of identity formation which plays on class distinctions and hierarchies by using commodities to claim the cultural terrain. Clothing and consumption rituals testify to the power of consumption as a means of cultural expression. Hip hop fashion is an especially rich example of this sort of appropriation/critique via style. Exceptionally large, "chunk," gold and diamond jewelry (usually "fake") mocks yet affirms the gold fetish in Western trade; fake Gucci and other designer emblems cut up and patch-stitched to jackets, pants, hats, wallets and sneakers in custom shops, work as a form of sartorial warfare (especially when fake Gucci-covered B-boys and B-girls brush past Fifth Avenue ladies adorned by the "real thing.") Hip hop's late 1980s fashion rage—the large plastic (alarm?) clock worn around the neck over leisure/sweat suits suggested a number of contradictory tensions between work, time and leisure.[21] Early 1990s trends—super-over-sized pants and urban warrior outer apparel, as in "hoodies," "snooties," "tims" and "triple fat" goosedown coats, make clear the severity of the urban storms to be weathered and the saturation of disposable goods in the crafting of cultural expressions.[22] As an alternative means of status formation, hip hop style forges local identities for teenagers who understand their limited access to traditional avenues of social status attainment. Fab Five Freddy, an early rapper and graffiti writer, explains the link between style and identity in hip hop and its significance for gaining local status:

> You make a new style. That's what life on the street is all about. What's at stake is
> honor and position on the street. That's what makes it so important, that's what makes

it feel so good—that pressure on you to be the best. Or to try to be the best. To develop a new style nobody can deal with.[23]

Styles "nobody can deal with" in graffiti, breaking and rap music not only boost status and elevate black and Hispanic youth identities, they also articulate several shared approaches to sound and motion which are found in the Afro-diaspora. As black filmmaker and cultural critic Arthur Jafa has pointed out, stylistic continuities between breaking, graffiti style, rapping and musical construction seem to center around three concepts: *flow, layering* and *ruptures in line.*[24] In hip hop, visual, physical, musical and lyrical lines are set in motion, broken abruptly with sharp angular breaks, and yet sustain motion and energy through fluidity and flow. In graffiti, long winding, sweeping and curving letters are broken and camouflaged by sudden breaks in line. Sharp, angular, broken letters are written in extreme italics, suggesting forward or backward motion. Letters are double- and triple-shadowed in such a way as to illustrate energy forces radiating from the center—suggesting circular motion—and yet the scripted words move horizontally.

Breakdancing moves highlight flow, layering and ruptures in line. Popping and locking are moves in which the joints are snapped abruptly into angular positions. And yet, these snapping movements take place in one joint after the previous one—creating a semiliquid effect which moves the energy toward the fingertip or toe. In fact, two dancers may pass the popping energy force back and forth between each other via finger-to-finger contact, setting off a new wave. In this pattern, the line is both a series of angular breaks, and yet sustains energy and motion through flow. Breakers double each others' moves, like line-shadowing or layering in graffiti, intertwine their bodies into elaborate shapes, transforming the body into a new entity (like camouflage in graffiti's wild style) and then, one body part at a time, revert to a relaxed state. Abrupt, fractured, yet graceful footwork leaves the eye one step behind the motion, creating a time-lapse effect which not only mimics graffiti's use of line-shadowing, but also creates spatial links between the moves which gives the foot series flow and fluidity.[25]

The music and vocal rapping in rap music also privileges flow, layering and ruptures in line. Rappers speak of flow explicitly in lyrics, referring to an ability to move easily and powerfully through complex lyrics, as well as to the flow in the music.[26] The flow and motion of the initial bass or drum line in rap music is abruptly ruptured by scratching (a process which highlights as it breaks the flow of the base rhythm), or the rhythmic flow is interrupted by other musical passages. Rappers stutter and alternatively race through passages, always moving within the beat or in response to it, often using the music as a partner in rhyme. These verbal moves highlight lyrical flow and points of rupture. Rappers layer meaning by using the same word to signify a variety of actions and objects; they call out to the DJ to "lay down a beat," which it is expected will be interrupted, ruptured. DJs

layer sounds literally one on top of the other, creating a dialogue between sampled sounds and words.

What is the significance of flow, layering and rupture as demonstrated on the body and in hip hop's lyrical, musical and visual works? Interpreting these concepts theoretically, it can be argued that they create and sustain rhythmic motion, continuity and circularity via flow; accumulate, reinforce and embellish this continuity through layering; and manage threats to these narratives by building in ruptures which highlight the continuity as it momentarily challenges it. These effects at the level of style and aesthetics suggest affirmative ways in which profound social dislocation and rupture can be managed and perhaps contested in the cultural arena. Let us imagine these hip hop principles as a blueprint for social resistance and affirmation: create sustaining narratives, accumulate them, layer, embellish and transform them. But also be prepared for rupture, find pleasure in it, in fact, *plan on* social rupture. When these ruptures occur, use them in creative ways which will prepare you for a future in which survival will demand a sudden shift in ground tactics.

While accumulation, flow, circularity and planned ruptures exist across a wide range of Afro-diasporic cultural forms, they do not take place outside capitalist commercial constraints. Hip hop's explicit focus on consumption has frequently been mischaracterized as a movement *into* the commodity market (hip hop is no longer "authentically" black if it is for sale). Instead, hip hop's moment(s) of "incorporation" are a shift in the already existing relationship hip hop has always had to the commodity system. For example, the hip hop DJ frequently produces, amplifies and revises already recorded sounds, rappers prefer high-end microphones, and both invest serious dollars for the speakers that can produce the phattest beats. Graffiti murals, breakdancing moves and rap lyrics often appropriate and sometimes critique verbal and visual elements and physical movements from popular commercial culture, especially television, comic books and karate movies. If anything, black style through hip hop has contributed to the continued blackening of mainstream popular culture. The contexts for creation in hip hop were never fully outside or in opposition to commodities; they involved struggles over public space and access to commodified materials, equipment and products. It is a common misperception among hip hop artists and cultural critics that during the early days, hip hop was motivated by pleasure rather than profit, as if the two were incompatible. And it would be naive to think that breakdancers, rappers, DJs and writers were never interested in monetary compensation for their work. The problem was not that they were uniformly uninterested in profit, rather, many of the earliest practitioners were unaware that they could profit from their pleasure. Once this link was made, hip hop artists began marketing themselves wholeheartedly. Just as graffiti writers hitched a ride on the subways and used its power to distribute their tags, rappers "hijacked" the market for their own purposes, riding the currents that are already out there, not just for wealth but for empowerment. During the late 1970s and early 1980s, the market for hip hop was still based inside New York's black and Hispanic communities.

So while there is an element of truth to this common perception, what is more important about the shift in hip hop's orientation is not its movement from precommodity to commodity, but the shift in control over the scope and direction of the profit-making process, out of the hands of local black and Hispanic entrepreneurs and into the hands of larger, white-owned, multinational businesses. And, most importantly, while black cultural imperatives are obviously deeply affected by commodification, these imperatives are not in direct opposition to the market, nor are they "irrelevant" to the shape of market-produced goods and practices.

Hebdige's work on the British punk movement identifies this shift as the moment of incorporation or recuperation by dominant culture, and perceives it to be a critical element in the dynamics of the struggle over the meaning(s) of popular expression. "The process of recuperation," Hebdige argues, "takes two characteristic forms . . . one of conversion of subcultural signs (dress, music and so on) into mass-produced objects and the 'labelling' and redefinition of deviant behavior by dominant groups—the police, media and judiciary." Hebdige astutely points out, however, that communication in a subordinate cultural form, even prior to the point of recuperation, usually takes place via commodities, "even if the meanings attached to those commodities are purposefully distorted or overthrown." And so, he concludes, "it is very difficult to sustain any absolute distinction between commercial exploitation on the one hand and creativity/originality on the other."[27]

Hebdige's observations regarding the process of incorporation and the tension between commercial exploitation and creativity as articulated in British punk are quite relevant to hip hop. And hip hop has always been articulated via commodities and engaged in the revision of meanings attached to them. Conversely, hip hop signs and meanings are converted and behaviors relabeled by dominant institutions. Graffiti, rap and breakdancing are fundamentally transformed as they move into new relations with dominant cultural institutions.[28] In 1994, rap music is one of the most heavily traded popular commodities in the market, and yet it still defies total corporate control over the music, its local use and incorporation at the level of stable or exposed meanings.

These transformations and hybrids reflect the initial spirit of rap and hip hop as an experimental and collective space where contemporary issues and ancestral forces are worked through simultaneously. Hybrids in rap's subject matter, not unlike its use of musical collage and the influx of new, regional and ethnic styles, have not yet displaced the three points of stylistic continuity to which I referred earlier: approaches to flow, ruptures in line and layering can still be found in the vast majority of rap's lyrical and music construction. The same is true of the critiques of the postindustrial urban America context and the cultural and social conditions which it has produced. Today, the South Bronx and South Central Los Angeles are poorer and more economically marginalized than they were ten years ago.

Hip hop emerges from complex cultural exchanges and larger social and political conditions

of disillusionment and alienation. Graffiti and rap were especially aggressive public displays of counterpresence and voice. Each asserted the right to write[29]—to inscribe one's identity on an environment which seemed Teflon-resistant to its young people of color; an environment which made legitimate avenues for material and social participation inaccessible. In this context, hip hop produced a number of double effects. First, themes in rap and graffiti articulated free play and unchecked public displays, and yet the settings for these expressions always suggested existing confinement.[30] Second, like the consciousness-raising sessions in the early stages of the women's rights movement and Black Power movement of the 1960s and 1970s, hip hop produced internal and external dialogues which affirmed the experiences and identities of the participants, and at the same time offered critiques of larger society which were directed to both the hip hop community and society in general.

Out of a broader discursive climate in which the perspectives and experiences of younger Hispanic, Afro-Caribbeans and African-Americans had been provided little social space, hip hop developed as part of a cross-cultural communication network. Trains carried graffiti tags through the five boroughs; flyers posted in black and Hispanic neighborhoods brought teenagers from all over New York to parks and clubs in the Bronx and eventually to events throughout the Metropolitan area. And characteristic of communication in the age of high-tech telecommunications, stories with cultural and narrative resonance continued to spread at a rapid pace. It was not long before similarly marginalized black and Hispanic communities in other cities picked up on the tenor and energy in New York hip hop. Boom boxes in Roxbury and Compton blasted copies of hip hop mix tapes made on high-speed, portable, dubbing equipment by cousins from Flatbush Avenue in Brooklyn. The explosion of local and national cable programming of music videos spread hip hop dance steps, clothing and slang across the country faster than brushfire. Within a decade, Los Angeles County (especially Compton), Oakland, Detroit, Chicago, Houston, Atlanta, Miami, Newark and Trenton, Roxbury and Philadelphia have developed local hip hop scenes which link (among other things) various regional postindustrial urban experiences of alienation, unemployment, police harassment and social and economic isolation to their local and specific experience via hip hop's language, style and attitude.[31] Regional and, increasingly, national differences and syndications in hip hop have been solidifying and will continue to do so. In some cases these differences are established by references to local streets and events, neighborhoods and leisure activities, preferences for dance steps, clothing, musical samples and vocal accents. At the same time, cross-regional syndicates of rappers, writers and dancers fortify hip hop's communal vocabulary. In every region, hip hop articulates a sense of entitlement, and takes pleasure in aggressive insubordination. Like Chicago and Mississippi blues, these emerging, regional, hip hop identities affirm the specificity and local character of cultural forms as well as the larger stylistic forces that define hip hop and Afro-diasporic cultures.

Developing a style nobody can deal with—a style that cannot be easily understood or

erased, a style that has the reflexivity to create counterdominant narratives against a mobile and shifting enemy—may be one of the most effective ways to fortify communities of resistance and simultaneously reserve the right to communal pleasure. With few economic assets and abundant cultural and aesthetic resources, Afro-diasporic youth have designated the street as the arena for competition and style as the prestige-awarding event. In the postindustrial urban context of dwindling low-income housing, a trickle of meaningless jobs for young people, mounting police brutality and increasingly demonic depictions of young inner-city residents, hip hop style *is* black urban renewal.

Notes

This essay is excerpted from *Black Noise: Rap Music and Black Culture in Contemporary America* (Wesleyan Press, 1994).

1. I have adopted Mollenkopf's and Castell's use of the term postindustrial as a means of character-izing the economic restructuring that has taken place in urban America over the past twenty-five years. By defining the contemporary period in urban economies as postindustrial, Mollenkopf and Castells are not suggesting that manufacturing output has disappeared, nor are they adopting Daniel Bell's formulation that "knowledge has somehow replaced capital as the organizing principle of the economy." Rather Mollenkopf and Castells claim that their use of postindustrial "captures a crucial aspect of how large cities are being transformed: employment has shifted massively away from manufacturing toward corporate, public and nonprofit services; occupations have similarly shifted from manual worker to managers, professionals, secretaries and service workers." John Mollenkopf and Manuel Castells, eds., *Dual City: Restructuring New York* (New York: Russel Sage Foundation, 1991), p. 6. Similarly, these new postindustrial realities, entailing the rapid movement of capital, images and populations across the globe, have also been referred to as "post-Fordism" and "flexible accumulation." See David Harvey, *Social Justice and the City* (Oxford: Basil Blackwell, 1988). For an elaboration of Bell's initial use of the term, see Daniel Bell, *The Coming of Post-Industrial Society* (New York: Basic Books, 1973).

2. My arguments regarding Afro-diasporic cultural formations in hip hop are relevant to African-American culture as well as Afro-diasporic cultures in the English- and Spanish-speaking Carib-bean, each of which has prominent and significant, African-derived, cultural elements. While rap music, particularly early rap, is dominated by English-speaking blacks, graffiti and breakdancing were heavily shaped and practiced by Puerto Ricans, Dominicans and other Spanish-speaking Caribbean communities which have substantial Afro-diasporic elements. (The emergence of Chicano rappers took place in the late 1980s in Los Angeles.) Consequently, my references to Spanish-speaking Caribbean communities should in no way be considered inconsistent with my larger Afro-diasporic claims. Substantial work has illuminated the continued significance of African cultural elements on cultural production in both Spanish- and English-speaking nations in the Caribbean. For examples, see Herbert S. Klein, *African Slavery in Latin America and the Caribbean* (New York: Oxford Press, 1986); Ivan G. Van Sertima, *They Came Before Columbus*

(New York: Random House, 1976) and Robert Farris Thompson, *Flash of the Spirit* (New York: Random House, 1983).

3. See Allen J. Matusow, *The Unravelling of America: A History of Liberalism in the 1960s* (New York: Harper and Row, 1984).

4. In hip hop, the train serves both as means of inter-neighborhood communication and a source of creative inspiration. Big Daddy Kane says that he writes his best lyrics on the subway or train on the way to producer Marly Marl's house. See Barry Michael Cooper, "Raw Like Sushi," *Spin* (March, 1988), p. 28. Similarly, Chuck D claims that he loves to drive; that he would have been a driver if his rapping career had not worked out. See Robert Christgau and Greg Tate, "Chuck D All Over the Map," *Village Voice, Rock n Roll Quarterly*, vol. 4, no. 3 (Fall 1991).

5. See John H. Mollenkopf, *The Contested City* (Princeton, NJ: Princeton U. Press, 1983), especially pp. 12–46 for a discussion of larger twentieth century transformations in U.S. cities throughout the 1970s and into the early 1980s. See, also, John Mollenkopf and Manuel Castells, eds., *Dual City: Restructuring New York* (New York: Russell Sage Foundation, 1991); Michael Peter Smith and Joe R. Feagin, eds., *The Capitalist City: Global Restructuring and Community Politics* (London: Basil Blackwell, 1987); Michael Peter Smith, ed., *Cities in Transformation: Class, Capital and the State* (Beverly Hills: Sage Publications, 1984); and Saskia Sassen, *The Mobility of Labor and Capital: A Study in International Investment and Labor Flow* (Cambridge: Cambridge University Press, 1988).

6. I am not suggesting that New York is typical of all urban areas, nor that regional differences are insignificant. However, the broad transformations under discussion here have been felt in all major U.S. cities, particularly New York and Los Angeles—hip hop's second major hub city— and critically frame the transitions that, in part, contributed to hip hop's emergence. In the mid-1980s very similar postindustrial changes in job opportunities and social services in the Watts and Compton areas of Los Angeles became the impetus for Los Angeles' gangsta rappers. As Robin Kelley notes: "The generation who came of age in the 1980s, under the Reagan and Bush era, were products of devastating structural changes in the urban economy that date back at least to the late 1960s. While the city as a whole experienced unprecedented growth, the communities of Watts and Compton faced increased economic displacement, factory closures, and an unprecedented deepening of poverty. . . . Developers and city and county government helped the process along by infusing massive capital into suburbanization while simultaneously cutting back expenditures for parks, recreation, and affordable housing in inner city communities." Robin D. G. Kelley, "Kickin' Reality, Kickin' Ballistics" forthcoming in Eric Perkins, ed., *Droppin' Science: Critical Essays on Rap Music and Hip Hop Culture* (Philadelphia: Temple, 1994). See, also, Mike Davis, *City of Quartz: Excavating the Future of Los Angeles* (London: Verso, 1989).

7. Mollenkopf, *Contested City*, p. 213.

8. Frank Van Riper, "Ford to New York: Drop Dead," New York *Daily News* (October 30, 1975), p. 1.

9. Philip Weitzman, " 'Worlds Apart': Housing Race/Ethnicity and Income in New York City," *Community Service Society of New York* (CSS), 1989. See, also, Terry J. Rosenberg, "Poverty

in New York City: 1980–1985" (CSS), 1987; Robert Neuwirth "Housing After Koch" *Village Voice 7* (November 7, 1989) pp. 22–24.

10. Daniel Walkowitz "New York: A Tale of Two Cities" in Richard M Bernard ed., *Snowbelt Cities: Metropolitan Politics in the Northeast and Midwest Since World War II* (Bloomington: Indiana Press, 1990); Mollenkopf and Castells, eds., *Dual City* p. 9. See, also, parts 2 and 3 *Dual City*, which deal specifically and in greater detail with the forces of transformation, gender and the new occupational strata.

11. Ben Bagdigian, *The Media Monopoly* (Boston: Beacon Press, 1987). Despite trends towards the centralization of news and media sources, and the fact that larger corporate media outfits have proven unable to serve diverse ethnic and racial groups, a recent study on New York's media structure in the 1980s suggests that a wide range of alternative media sources serve New York's ethnic communities. However, the study also shows that black New Yorkers have been less successful in sustaining alternative media channels. See Mitchell Moss and Sarah Ludwig, "The Structure of the Media," in *Dual City*, pp. 245–265.

12. See Tom Forester, *High-Tech Society* (Cambridge, MIT Press, 1988) and Herbert Schiller, *Culture, Inc.: The Corporate Takeover of Public Expression* (New York: Oxford Press, 1989).

13. Similar strategies for urban renewal via "slum clearance" demolition took place in a number of major metropolises in the late 1960s and 1970s. See Mollenkopf, *Contested City*, especially ch. 4, which describes similar processes in Boston and San Francisco.

14. Robert D. McFadden, "Power Failure Blacks Out New York; Thousands Trapped in Subways; Looters and Vandals Hit Some Areas," *New York Times* (July 14, 1977) p. A1, col. 5; Lawrence Van Gelder, "State Troopers Sent Into City as Crime Rises," *New York Times* (July 14, 1977) p. A1, col. 1; Charlayne Hunter-Gault, "When Poverty is Part of Life, Looting is Not Condemned," *New York Times* (July 15, 1977) p. A4, col. 3; Selwyn Raab, "Ravage Continues Far Into Day; Gunfire and Bottles Beset Police," *New York Times* (July 15, 1977) p. A1, col. 1; Editorial, "Social Overload," *New York Times* (July 22, 1977) p. A22.

15. Lee Dembart, "Carter Takes 'Sobering' Trip to South Bronx," *New York Times* (October 6, 1977) p. A1, col. 2, B18, col. 1; Richard Severo, "Bronx a Symbol of America's Woes," *New York Times* (October 6, 1977) p. B18, col. 1; Joseph P. Fried, "The South Bronx USA: What Carter Saw in New York City is a Symbol of Complex Social Forces on a Nationwide Scale," *New York Times*, (October 7, 1977) p. A22, col. 1.

16. Michael Ventura, *Shadow Dancing in the USA* (Los Angeles: J. P. Tarcher Press, 1986) p. 186. Other popular films from the late 1970s and early 1980s which followed suit included *1990: The Bronx Warriors* and *Escape From New York*. This construction of the dangerous ghetto is central to Tom Wolfe's 1989 best-seller and the subsequent film *Bonfire of the Vanities*. In it, the South Bronx is constructed as an abandoned, lawless territory from the perspective of substantially more privileged, White outsiders.

17. Rose interviews with all artists named except Futura, whose printing trade school experience was cited in Steve Hager, *Hip Hop: The Illustrated History of Breakdancing, Rap Music, and*

Graffiti (New York: St. Martin's Press, 1984), p. 24. These artist interviews were conducted for my book on rap music, entitled *Black Noise: Rap Music and Black Culture in Contemporary America* (Wesleyan Press, 1994).

18. Rose interview with Crazy Legs, November 1991. "Piecing" means drawing a mural or master-piece.

19. See Henry Louis Gates, Jr., *The Signifying Monkey: A Theory of Afro-American Literary Criticism.* Gates's suggestion that naming be "drawn upon as a metaphor for black intertextuality" is especially useful in hip hop, where naming and intertextuality are critical strategies for creative production. See pp. 55, 87.

20. Dick Hebdige, *Subculture: The Meaning of Style* (London: Methuen, 1979). See, especially, pp. 17–19, 84–89.

21. For an interesting discussion of time, the clock and nationalism in hip hop, see Jeffrey L. Decker's article in this collection.

22. Hoodies are hooded jackets or shirts, snooties are skull caps and tims are short for Timberland brand boots.

23. Nelson George, et al., eds., *Fresh: Hip Hop Don't Stop* (New York: Random House, 1985) p. 111.

24. While I had isolated some general points of aesthetic continuity between hip hop's forms, I did not identify these three crucial organizing terms. I am grateful to Arthur Jafa, black filmmaker and cultural critic, who shared and discussed the logic of these defining characteristics with me in conversation. He is not, of course, responsible for any inadequacies in my use of them here.

25. For a brilliant example of these moves among recent hip hop dances, see "Reckin' Shop In Brooklyn" directed by Diane Martel (Epoch Films, 1992). Thanks to Arthur Jafa for bringing this documentary film to my attention.

26. Some examples of explicit attention to flow are exhibited in Queen Latifah's *Ladies First*: "Some think that we can't flow, stereotypes they go to go"; in Big Daddy Kane's *Raw*: "Intro I start to go, my rhymes will flow so"; in Digital Underground's *Sons of the P*: "Release your mind and let your instincts flow, release your mind and let the funk flow." Later, they refer to themselves as the "sons of the flow."

27. Hebdige, *Subculture* pp. 94–95.

28. Published in 1979, *Subculture: The Meaning of Style* concludes at the point of dominant British culture's initial attempts at incorporating punk.

29. See Duncan Smith, "The Truth of Graffiti" *Art & Text* 17, pp. 84–90.

30. For example, Kurtis Blow's "The Breaks" (1980) was both about the seeming inevitability and hardships of unemployment and mounting financial debt, and the sheer pleasure of "breaking it up and down," of dancing and breaking free of social and psychological constrictions. Regardless of subject matter, elaborate graffiti tags on train facades always suggested that the power and presence of the image was possible only if the writer had escaped capture.

31. See Bob Mack, "Hip-Hop Map of America" *Spin* (June, 1990).

Puerto Rican And Proud, Boyee!
Rap, Roots and Amnesia

————

Juan Flores

————

MC KT (Tony Boston) of Latin Empire commented recently on a television special:

> There's a lot of Puerto Ricans out there that don't speak Spanish and aren't into the Spanish music, a lot of them, and they're still proud to be Puerto Rican. But if you don't know nothing about it, if you don't try to learn about it, then you're gonna be lost in the sauce.[1]

Writing and performing for a wide range of audiences while projecting "a Puerto Rican perspective" has keyed Latin Empire, the best-known Nuyorican rap group, into the dynamics of cultural identity. Many of their own raps are about who they are and where they come from, and their experience as rappers, both in the streets and in the "business," has been a constant struggle to uphold that self-representation in the face of strong pressures to re-do their act so that it fits into more familiar, preestablished categories.

In his brief comment, KT is actually setting forth a view of culture and identity. First he disengages cultural belonging and pride from any necessary attachment to the recognized markers or traditions of the culture, thus freeing the young Puerto Ricans raised here from the weight of having to "prove themselves" and compensate for their remove from familiar roots and life-ways. But leaving them room does not mean letting them off the hook: addressing his fellow Nuyoricans directly, KT reminds them that if one pitfall is the straitjacket of fixed codes and canons, the other is "the sauce," the undifferentiated hodgepodge of contemporary cultural blending under the sway of the commercial media and pluralist ideology.

If you want to draw lines and mark yourself off, you have to be willing to reconnect; if you want to celebrate borders, you have to learn how to build bridges and know about the alternatives. Culture as a source of identity does need to be understood as a flexible, open-ended process grounded in lived experience; but it is also a process in the sense

that it is constituted by people on the basis of action and choice. KT and Puerto Rock (Rick Rodríguez), his cousin and partner in Latin Empire, like to tell about how they used to reject, or at least not relate to, the boleros and plenas and Puerto Rican Spanish they were surrounded by growing up, and how exposure to the larger public has taught them to appreciate this background, and incorporate it into their rhymes and beats. The challenges of cultural expression and representation have amounted not so much to a professional "career," as to a process of growth and learning, a shift in their sense of cultural inheritance, from something imposed and exclusionary to a force of self-assertion and historical contestation.

The experience of Puerto Ricans in rap has been the story of intense cultural negotiation, of jostling for a place within an ever-broadening field of expressive practices, without relinquishing the particularities of their own community and heritage. It is a story of special interest to the study of contemporary youth culture because of its unmatched historical depth: Puerto Ricans have been involved in hip hop since the beginning, since it first emerged in the streets of Harlem and the South Bronx nearly twenty years ago.[2] Along with their African-American counterparts, "Puerto Rocks" (as Puerto Rican hip-hoppers came to be called) were an intrinsic part of the forging of expressive styles which have become the hallmark of an entire generation, and have diffused throughout the country and worldwide. While the relation of other cultural groups to rap has been one of adoption and rearticulation, Puerto Ricans have been present as initiators and co-creators, such that their recent history as a community can be tracked by way of reference to their participation in the trajectory of the genre.

It is necessary to emphasize this point of historical origination, because the dominant construction of rap in the media and most narrative accounts has tended systematically, or at least symptomatically, to elide precisely the Puerto Rican role and dimension in staking out this preeminent field of contemporary youth sensibility. For, in terms of ethnic composition, that construction has proceeded in three main directions, all of which have had the effect of omitting the many Puerto Rican breakers, rappers and graffiti writers who were such a conspicuous part of the hip hop scene when it was still in the streets and schoolyards, and as it began to find exposure among a broader public. According to the prevalent images and definitions, rap is either particularized as a "black thing," generalized as a multicultural "youth thing," or variegated into a set of subcategories ("gangsta rap," "message rap," "female rap," and so on) which in the last few years has come to include "Latino rap." None of these versions allows for a reconstruction of rap which would account for its formation and original social function.

Of course rap has traveled far and wide since back in the days, and there is no particular gain to be had from privileging origins or some presumed authenticity as a means of stemming the levelling, deracinating impact of commercial mediation. The reinstatement of Puerto Ricans onto the historical map of hip hop need not be nostalgic or retrospective

in this way, nor compensatory in aiming at granting a people just recognition for services rendered. But with all the renovations and reinventions of rap that have constituted its most familiar trajectory, the fact is that the past does not just go away, and traces of its initial articulation continue to resonate, explicitly or covertly, at every twist and turn of the historical course. The practice of sampling and the continual recycling of old-school fashion provide ample space for this kind of percolating influence, which is expressed thematically as a recurrent reference to cultural community and historical memory.

The point, then, is not that "it's a Puerto Rican thing too," or even, "yo, we were here from jump," though contentions for turf or pieces of the pie are integral to the conventional grammar of toasting and boasting, and obviously germane to any geography of rap as public discourse. The revision called for, rather than merely additive, is actually conjunctive, such that the emergence of rap may be seen as testimony to the cultural interaction between the black and Puerto Rican communities, especially as evident among the young people. Of course it is possible to identify specifically Puerto Rican ingredients that went into the original brew of hip hop, that formative contribution being even more apparent in breakdance and graffiti than in rap. But this line of analysis usually leads to the notion of the "tinge," or the touches of salsa thrown in to add zest to the recipe. The beginnings of rap are connective not so much because they link black traditions and Puerto Rican traditions, but because they mark off one more step in a long and intricate black-and-Puerto-Rican tradition of popular culture, based primarily in the long-standing black-and-Puerto-Rican neighborhoods of New York City.

Seen in this way, rap and hip hop can be understood to have not only identifiable social origins, but a prehistory as well. For long before there was any talk of rap as a mode of public performance, or for that matter of cultural "fusions," "crossovers" or "hybridization," blacks and Puerto Ricans were already busy jamming, partying, struggling or just hanging together in all aspects of everyday life, all the while building a new cultural tradition which is more and different from the sum of its component parts. Latin jazz, doo-wop, the Last Poets and the Third World Revelationists, bugalú, Latin soul and many other movements and styles are all examples of this meshing and increasingly seamless tradition. This emergent tradition attests at an artistic level to the African foundations of both cultural backgrounds, and to the close confines of their common social placement— shared tenement buildings, shared workplaces and welfare lines, shared classrooms and playgrounds, shared and coalescing political causes. And it is this joining of expressive forces, this construction of a new cultural memory in common, that comprises the most immediate source of hip hop.

Early Puerto Rican participation in graffiti has been noted all along, since the insightful writings of Craig Castleman, in his book *Getting Up*, and of Herbert Kohl.[3] Such recognition is all but obligatory in the case of breakdance, what with the overwhelmingly Puerto Rican composition of Rock Steady Crew and its obvious choreographic reliance on rumba,

mambo and Latin hustle movements. Pioneering hip hop films like *Wild Style* and *Style Wars* would be unthinkable without the preponderant casting and underlying social experience of New York Puerto Ricans. By comparison, rap is generally regarded as the most uniformly African-American form within hip hop, the main "outside" influence being not Puerto Rican but West Indian, as when writers like David Toop and Dick Hebdige accent the importance of the dub and reggae backgrounds of founding practitioners like Kool Herc and Grand Master Flash.[4] Though much can be made of this Jamaican link to Caribbean models and sources, the tendency of this kind of emphasis is to lend the story a decidedly "African roots" inflection, an image which has been fueled in more recent constructions with the infusion of dancehall and neo-Rasta modalities. Without denying the catalytic and enduring presence of West Indians in Harlem and other African-American communities, or the lively interplay between rhythm and blues and reggae traditions, it is Puerto Ricans who most directly shared with young African-Americans the demographic base and creative stage of hip hop in its origins.

The Puerto Rican participation in rap falls into three main periods or historical constellations: the formative years, through the later 1970s and early 1980s, prior to and including the first recordings; the breakthrough, since about 1984, when rap first achieved its immense popularity and commercial success; and the period of "Latino rap," beginning at the end of the 1980s. To this sequence we might add the "prehistory" already mentioned, those many antecedents of rap in the gathering black-and-Puerto-Rican tradition of the preceding decades, and a coda or fourth stage of the past few years, as rap has arrived and taken hold among popular music styles in Puerto Rico. A brief overview of this history, with all of its uniqueness to the Puerto Rican case, suggests a cultural dynamic of a more general kind, a process of exclusion, negotiation and reassertion that has to do with larger social determinations than those most directly impinging on the Nuyorican hip hoppers themselves. The net effect of the process, that there has still not been one Nuyorican rap superstar or best-selling record, is of course astounding, but should not blind us to the changes and, indeed, the progress toward recognition and the projection of a distinctive voice.

Rap in the early days was "a street thing." That is the consensus phrase which emerges from conversations with some of the Puerto Rican participants of that time, "veterans" (now in their early thirties) like Charlie Chase of the Cold Crush Brothers, Rubie Dee of the Fearless Four, TNT (Tomás Robles) and KMX Assault (Jenaro Díaz).[5] When it was still in the streets, rap was marked off not so much racially but in terms of class, geography, age and, though they tend to make little reference to it, of course gender. The original B-boys were inner-city teenagers from the poorest neighborhoods, which in New York means overwhelmingly black and Puerto Rican. Going beyond rap's embryonic forms of stylized talking and improvised drumbeats, the first crews and performance groups grew out of

the prevailing gang structures. The turn to rhyming and music served, consciously in the case of Afrikka Bambaataa's Zulu Nation, to channel youth energy and anger away from the internecine street violence running rampant in the South Bronx neighborhoods.

This story of the brewing of rap discourse is already a familiar one, and there is no sense going back over ground adequately covered, with some sociological attention, by chroniclers like Steven Hager and Peter Toop.[6] But though they make mention of the presence of Puerto Ricans on the scene, nowhere do these accounts nearly approximate the magnitude of that involvement, much less probe the perspective of the Puerto Rocks themselves. For one thing, as in graffiti and breakdancing, Puerto Ricans were everywhere in rap, and in substantial numbers—a large, integral part of practicing groups, security and set-up crews, supportive sidekicks and, of course, audiences. As for what it was like for the young Puerto Ricans involved, testimonial recollections describe an abiding sense of community, of inclusiveness and familiarity sometimes bordering on the familial. The word tribe suggests itself, and were it not for its primitivist overtones, the cultural progeny of Zulu Nation might be considered to evidence a "tribal" degree of organic bonding. In everyday street life and in the heat of rap practice, black and Puerto Rican B-boys and B-girls were virtually interchangeable; whether you were one or the other or, as was often the case, some combination of the two, was for practical purposes a matter of relative indifference.

But within this framework of cohesion and mutuality there were of course differences, just as there are always those areas of contention and distrust among groups of different backgrounds sharing the bottom. The overriding, ideologically buttressed attitudes of white racism and hostility toward foreigners, especially immigrants from the colonial backwaters, inevitably get played out among and between the most direct victims, sometimes with a tragic vengeance. Among young blacks and Puerto Ricans, hip hop has generally been a mortar of remarkable intensity, probably unmatched in the interracial war zone of contemporary U.S. society; its unifying potential has certainly been one of its strongest legacies and sources of appeal among youth in countless settings around the world. But another attraction of hip hop, equally a part of its underlying ethos, is that it shows how to draw boundaries, mark off terrain, face up to differences and call them by their name. Here again the interaction of black and Puerto Rican youth in the incubation of rap sets the stage for the momentous act to follow.

As Charlie Chase and many others recall, Puerto Rican rappers always knew that they were operating in a "black world." However "down" they felt and were made to feel with the homies, however much they loved the music, the angry question: What the fuck are you doing here, Porto Rican? still resonates in their memory. Charlie tells vividly of the times when he barely escaped an ass-kicking if he dared venture behind the ropes at the early jams, and when the black rappers and fans simply would not believe that he was actually responsible for the sounds and rhythms he came up with as DJ with Cold Crush.

"No way, it can't be, you're not even black, you're Porto Rican." At the same time, a lot of the early Puerto Rocks remember how in the privacy of the family they were warned to stay away from "los morenos," or at least to watch out for them, words which were often accompanied by the silent grimace of racial prejudice. Whatever their "tribal" solidarity with the brothers and sisters, the Puerto Rocks could not be deaf to such influences, as some of their accounts betray, and as is evident in the strong "Spanish" and "Indian" inflections they sometimes give to their ancestral lineage. Cultural baggage and black-white racial antinomies in the U.S. thus conspire to perpetuate a construction of Puerto Rican identity as non-black.

As a result of these conflicting pressures, the situation of Puerto Ricans in early rap contexts was typically one of camouflage. Belonging and not belonging, owning and not owning this cultural domain, Puerto Ricans had to test the waters with due caution, and know how far they could tread. Timing was of the essence, as Charlie Chase stresses when asked about the use of Spanish in rhymes or the splicing of Latin rhythms into the more accepted registers. At a musical level it was a fascinating kind of intercultural poaching, with the mostly black audiences usually not even knowing where the samples were coming from, but loving them. As for self-presentation, while not directly denying that they were Puerto Rican, they could never be obtrusive about it, and would predictably brandish all the trappings of street blackness. This adaptation has long been obvious in Puerto Ricans' English speech practices, and became paramount when it came to taking on rap nomenclature. Individuals, groups and song lyrics carefully avoided all suggestions of Spanish usage or references to anything Puerto Rican. How Charlie Chase arrived at his name is a particularly rich example:

> I made up my name because of Grand Master Flash. Flash is a friend of mine. I first saw Flash doing this, cutting and all of this, and I says, aw, man, I can do this. I'll rock this, you know. And I practiced, I broke turntables, needles, everything. Now Chase came because I'm like, damn, you need a good name, man. And Flash was on top and I'm down here. So I was chasing that nigger. I wanted to be up where he was. So I said, let's go with Charlie Chase.[7]

As interesting as it is, Carlos Mandes's choice of a new name was anything but unique: Who ever knew Rubie D., TNT or Prince Whipple Whip by their "Spanish" names, anyway?

Once rap began to be recorded for commercial distribution the scramble was on, and proprietary considerations at many levels served only to reinforce the patrols over language and musical taste. An early exception, but indicative of the rules, was the record "Disco Dream" by the Mean Machine, which came out in 1981. Often referred to by later, bilingual

rappers like Mellow Man Ace and Latin Empire as an inspiration, "Disco Dream" did dare to include rhymes in Puerto Rican Spanish; but as they are quick to point out, it was limited to a few unobtrusive party exhortations that nobody even noticed, and besides, neither "Disco Dream" nor the Mean Machine ever got anywhere. When rap went big-time around the mid-1980s any signs of Puerto Rican presence were all but erased. Of course they were there, even in high-profile groups like the Fat Boys and Master Don and the Def Committee, but their invisibility and anonymity as Puerto Ricans were complete; nobody, that is only a fraction of the public, had any idea of their background. Needless to say, they were still very much there in the streets, and continued to contribute to the history of the genre under its rapidly changing conditions. But in the public eye, trained as it was on commercial film, video and concert fare, they were hidden in the woodwork, their historical role as cocreators totally occluded.

As mentioned, the effect of mass distribution on the ethnic and racial image of rap moved in two directions: it was simultaneously particularized as "African" and generalized as "multicultural" both versions the rather transparent result of marketing and ideological strategies. In neither, of course, was there any place for Puerto Ricans, much less for any sense of their intricate cultural conjunction with African-Americans in the very formation of rap. It was either a "black thing," which you could only "understand" by mimicking or diluting it, or it was an all-purpose thing, of equal utility and relevance to anyone, anywhere, as long as you're "with it." The disappearing of Puerto Ricans from the public representation of rap was thus part of a larger process aimed at its disengagement from the concrete social context in which it arose. The fatalities of this process were of course many, having as much to do with gender, class and regional considerations as with ethnic and racial interaction. But it is the Puerto Ricans, as a group and as co-creators of new forms of cultural expression, whose reality was most manifestly elided.

Then, when "Latino rap" burst onto the scene in 1990, the whole situation changed, or so it seemed. Mellow Man Ace went gold with "Mentirosa" in the summer of that year, Kid Frost's debut album *Hispanic Causing Panic* became the rap anthem of La Raza, Gerardo ("Rico Suave") took his place as the inevitable Latin rap sex symbol, and El General established the immense popularity of Spanish-language reggae-rap in barrios here and all over Latin America and the Caribbean. Suddenly Spanish and the "Latin" sound were "in," and it wasn't long before high-profile performers like Queen Latifah and Nice & Smooth began sprinkling in some salsa and Spanglish. The door opened in the other direction, too, as Latin groups as diverse as El Gran Combo, Wilfredo Vargas, Manny Oquendo's Libre and Los Pleneros de la 21 started to let their guard down and add a rap number or two into their acts. The breakthrough was so intense and so far-reaching that, by late 1991, the Village Voice was already referring to Latino rap as the "Next Big Thing," marking off "a defining moment in the creation of a nationwide Latino/Americano hip hop aesthetic."[8]

Such hyperbole aside, the pop emergence of bilingual rap has signalled a major opening, as the "multicultural" generalization of rap's reference and idiom finally extended to the Latino population. Rap thus goes on record as the first major style of popular music to have effected this musical and especially linguistic crossover, even more extensively than the Latin jazz and Latin R & B fusions of earlier generations. And coming as it did in times of loud public alarm over "America's fastest growing minority" and a burgeoning "English Only Movement," Latino rap assumes a crucial political role as well. Not only does bilingual usage become common practice in rap vocabulary, but Spanglish rhyming and the interlingual encounter have even become a theme in some of the best-known rap lyrics, like Kid Frost's "Ya estuvo," Cypress Hill's "Funky Bi-lingo" and Latin Empire's "Palabras."

For the Puerto Rocks, though, for whom hip hop had long been a way of life, this victory has turned out to be Pyrrhic at best. Most obviously, none of the Latino rap superstars are Puerto Ricans from New York: Mellow Man was born in Cuba and raised in Los Angeles, Kid Frost is a Chicano from East L.A., Gerardo is from Ecuador, El General is Panamanian, and Vico C and Lisa M are Puerto Ricans from the Island. What Puerto Ricans there are, even in breakthrough Latino acts like those in the Latin Alliance, are still backgrounding their Puerto Rican identity in deference to some larger, more diluted ethnic construction. Cypress Hill, which gives the impression of Puerto Rican participation, is actually a combination of Cuban, Mexican and Italian in its ethnic composition.[9] One thing that KT of Latin Empire is seeing a lot of these days is—to expand on his own phrase— that when you don't get lost in the sauce you can still get lost in the "salsa."

Yet when it came to the need for public exposure and a broader social claim, KT and Puerto Rock did go with "Latin" rather than, say, "Rican Empire." The name "Latin Empire" was intended to resonate with "Zulu Nation" and to suggest the "Empire State," thus placing the group's historical and geographical roots. It was a big step from their old name, "Solid Gold," when they were just fitting in with the Superfly trend: KT stood for karat and Rick was Ricky D, Ricky Rock, Rickski, whatever. In their new identity as Latin Empire, KT came to mean "Krazy Taino," and in settling on "Puerto Rock" Rick was also appealing to historical roots, though of a less ancestral kind.

> And then I wound up coming up with Puerto Rock, and I like that one. That's the one that clicked the most. The Puerto Ricans that are into the trend of hip hop and all that, they call them "Puerto Rocks." They used to see the Hispanics dressing up with the hat to the side and all hip hop down, and some assumed that we're supposed to just stick to our own style of music and friends. They thought rap music was only a Black thing, and it wasn't. So that's what they used to call the Puerto Ricans when they would see them with the hats to the side, "Yo, look at that Puerto Rock, like he's trying to be down." They used to call us Puerto Rocks, so that was a nickname, and I said, "I'm going to stick with that. Shut everybody up."[10]

With the affirmation of "Puerto Rock," the present-day identity of "Latino rap" is re-connected with the original placement of Latinos in rap, characterized as it was by an intense, close-up negotiation with African-American cultural boundaries. The sidestepping of Puerto Ricans in the media construction of Latino rap has thus involved not only the absence of Nuyorican rap superstars or obliviousness toward things specifically Puerto Rican. Most significantly, it has meant the obscuring of this formative cultural context. National and ethnic authentication in this case, beyond the claim of "being here first," is a call to ground, or continually reground, popular cultural expression in the dynamic of lived social experience. Despite all the spurious overtones surrounding notions of cultural authenticity, in the trenches of our "culture wars" such a historically retributive call is also evidently and eminently political. For the creative coauthorship of popular cultural style expresses a history of social proximity and interaction which forms a solid foundation for unifying projects of political contestation. Of course, umbrella catchphrases like "Latino" or even "Hispanic" may take on significant semantic power in identifying social movements, and can be expressive of historically grounded cultural interactions.[11] But in the commercially overdetermined world of rap nomenclature, the demographics of marketing assumes priority over the need to identify allies in the social struggle, or even real neighbors in the real world.

With their claim to "ownership" of rap, the Puerto Rocks are thus confronting not only the selective vagaries of commercial expropriation but also, at an ideological level, the dogmas of "multiculturalism" in its official, accommodationist version. For rather than "inclusion" by way of some conveniently manageable, and marketable, aggregate, what they are after is historical focus and specificity. Their answer to the "sauce" of multicultural pop, whether represented by Vanilla Ice, MC Hammer or Rico Suave, is an insistent reference to their own national and ethnic position as Puerto Ricans raised in the streets with young black people: "We're Puerto Rican and proud, boyee!"

Notes

1. *The Americans*, part 10 of *Americas*, produced by Peter Bull and Joseph Tavares for WGBH Boston, 1993. For an introduction to Latin Empire see my interview, "Latin Empire: Puerto Rap," *Centro* (Bulletin of the Center for Puerto Rican Studies) III:2 (Spring 1991), pp. 77–85.

2. For an earlier look at the role of Puerto Ricans in the beginnings of hip hop, see my "Rappin', Writin' and Breakin': Black and Puerto Rican Street Culture in New York City," *Centro* II:3 (Spring 1988), pp. 34–41.

3. Craig Castleman, *Getting Up: Subway Graffiti in New York* (Cambridge: MIT Press, 1982); Herbert Kohl, *Golden Boy as Anthony Cool: A Photo Essay on Naming and Graffiti* (New York: Dial, 1972).

4. David Toop, *The Rap Attack: African Jive to New York Hip Hop* (Boston: South End, 1984); Dick Hebdige, *Cut 'n' Mix: Culture, Identity and Caribbean Music* (London: Routledge, 1987).

5. For a closer look at the experiences of the early Puerto Rican rappers, see my interview with Charlie Chase, "It's a Street Thing!" *Callaloo* 15:4 (1992), pp. 999–1021. See also my essays "Rappin', Writin' and Breakin' "; and "Puerto Rocks: New York Ricans Stake Their Claim," in *Droppin' Science: Critical Essays on Rap Music and Hip Hop Culture*, Eric Perkins, ed., (Philadelphia: Temple University Press, forthcoming 1994), and the interview with KMX Assault, *Centro* 5:1 (Winter, 1992–93), pp. 40–51.

6. Toop, *The Rap Attack*; Hager, *Hip-Hop: The Illustrated History of Break Dancing, Rap Music and Graffiti* (New York: St. Martin's, 1984).

7. See "It's a Street Thing!"

8. Ed Morales, "How Ya Like Nosotros Now?" *Village Voice*, (November 26, 1991), p. 91.

9. In his article "The Cypress Hill Experience" in *The Source* (July 1993), Michael Gonzales mentions that Sen (Mellow Man Ace's brother) is Cuban and Muggs is Italian, but does not identify B-Real's background. It was in a friendly follow-up phone conversation that Gonzales informed me that B-Real is part Cuban, part Mexican.

10. See "Latin Empire: Puerto Rap."

11. For a discussion of "Latino" as concept and theory in social and political contestation, see Juan Flores and George Yúdice, "Living Borders/Buscando América: Languages of Latino Self-Formation," *Social Text* 24 (Fall 1990), pp. 57–84.

The State of Rap
Time and Place in Hip Hop Nationalism

Jeffrey Louis Decker

"We're gonna treat you like a king," threatens a white cop from the LAPD on the "Death Side" of Ice Cube's 1991 album, *Death Certificate*. "What goddamn king?" snaps the indignant rapper from South Central Los Angeles. "Rodney King! Martin Luther King! And all the other goddamn kings from Africa!"[1] As the premier "gangsta rapper" in hip hop, Ice Cube emerges on the "Life Side" of this album, to the astonishment of many, as a born-again black nationalist. On the sleeve of *Death Certificate*, Ice Cube makes his transformation explicit:

> We have limited knowledge of self, so it leads to a nigga mentality. The best place for
> a young black male or female is the Nation of Islam. Soon as we as a people use our
> knowledge of self to our advantage we will then be able to become and be called blacks.

How can the recent and widespread emergence of black nationalism within rap music be accounted for? The words of Ice Cube's cop offers some clues. As an enforcer of a system of state control and repression within the African-American community, the cop conflates all black kings as criminal suspects. His statement also draws attention to three distinct inflections of the meaning of "king" for black nationalism today: "Rodney King" signifies both police brutality toward blacks in America and black consciousness around official racism in the 1990s; the name "Martin Luther King" marks the sixties as a time of both broken civil rights promises and black power militancy; and, finally, "kings from Africa" conjures the memory of glorious ancient African empires (and the loss of these empires due to the Western slave trade) which inspire those involved in building the new black nation.

Following the Rodney King-Martin Luther King-African king continuum generated by Ice Cube, I want to suggest that today's nation-conscious rappers draw their inspiration primarily from the Black Power movements of the 1960s and the Afrocentric notion that the original site of African-American cultural heritage is ancient Egypt. Hence, there exist two corresponding tendencies within nation-conscious rap: what I will call "sixties-inspired

hip hop nationalism" and "Afrocentric hip hop nationalism." Although rap groups espousing a black nationalist sound, image and message draw from both "sixties-inspired" and "Afrocentric" tendencies, this paper examines each category independently in order to unpack the logic specific to each. Both tendencies within rap imply a particular strategy for coding black nationalism. While the notion of *time* is central to sixties-inspired nationalism, the idea of *place* has heightened importance for Afrocentric nationalism. Sixties-inspired hip hop, espoused by rap groups such as Public Enemy, is time-conscious to the degree that it appropriates the language of organized black revolts from the 1960s around the concept of "nation time." Afrocentric rap, which can be found in the music of X-Clan, reclaims the ancient Egyptian empire as the African origin in order to generate racial pride and awareness in the struggle over injustice in America.

I am interested in the ways in which rap music uses the language of nation to rearticulate a history of racial oppression and struggle which can energize the movement toward black empowerment and independence. Rap groups espousing a black nationalist sound, image and message draw both from recent struggles that anticipate the coming of the black nation (nation time), and from a mythical attitude toward an immemorial African nation (nation place). Nationalism, as Tom Nairn argues, is defined by the ambivalent relationship between these two tendencies—that is, a simultaneous looking forward and backward.[2] In order for a nation to justify its existence, and to speak the language of progress and development to its people, it feels compelled to fabricate a myth of national origins, and at the same time to use these myths to propel itself forward toward national goals. Similarly, hip hop nationalism nostalgically looks toward ancient Egypt as the African-American motherland while it simultaneously imagines an alternative future based on the rise of the anticipated black nation.

This essay analyzes rap music's explicit engagement with the discourse of nation—and, more specifically, the black nationalist continuum within America—in the form of hip hop nationalism.[3] Members of the hip hop nation form an "imagined community" that is based less on its realization through state formation than on a collective challenge to the consensus logic of the U.S. nationalism.[4] The language of nation is appropriated by the hip hop community as a vehicle for contesting the changing discursive and institutional structures of racism in America. For instance, the consensus discourses of cultural pluralism and the ethnic melting pot in the U.S. threaten the black community with the loss of a collective identity. As rapper Daddy-O puts it: if you're not careful, "you get mapped, or should I say [taken] off the map, like a laundry stain in the laundromat."[5] Hip hop nationalism, like black nationalism generally, provides an imaginative map and inspirational territory for African-Americans who wish both to end the institutionalized legacy of slavery and to create self-sufficient, organically based organizations such as black businesses and Afrocentric school curriculums. As I will demonstrate below, only community-based hip hop nationalists create the basis for a more critical and conscious struggle.

In an effort to empower the present struggle for black liberation, hip hop nationalism's rethinking of the past exhibits productive if limiting contradictions. I am less concerned with judging the "truth" (that is, the accuracy or inaccuracy) of any particular historical claim made by hip hop nationalism than in attempting to describe and interpret the *logic* behind its use of the contemporary language of nation. I want to ask, implicitly if not always explicitly: What are the conditions for the emergence of these particular narratives of nationalism at this particular historical moment? What makes the specific truth claims of hip hop nationalism more or less culturally relevant, meaningful and effective in today's political climate? What kinds of contradictions are embedded in the logic of hip hop nationalism's representation of ancient African civilizations, the sixties struggles for racial empowerment in the U.S., and the promise of a black nation to come?

Homeboys Meet Gramsci, or Organic Cultural Intellectuals

While most nation-conscious rappers are not activists in the conventional sense, they do occupy a place between entertainers and politicians within the black community. When the Los Angeles riots of 1992 erupted after a nearly-all-white jury acquitted white officers of the LAPD of the charge police brutality toward Rodney King, ABC New's *Nightline* called Ice Cube for an interview. As the *Village Voice* reported, Cube declined to make the television appearance because "he was desperately looking through the South Central rubble for family and friends he hadn't heard from since the shit started."[6] Unlike most entertainers and politicians in the United States, many nation-conscious rappers sustain their organic ties to the black community from which they came and of which their music is a part. As the racial antagonisms that produced the recent riots in L.A. make clear, no cultural expression and neighborhood are as linked as rap music and South Central.

It is not uncommon to find rap artists, especially those with explicit political messages in their music and videos, participating in grass-roots events which are organized around the dogged but changing structures of racism in the United States. Rappers are conspicuous at public demonstrations, and frequently speak at rallies, schools and prisons. For example, the 1989 murder of Yusuf Hawkins in Brooklyn's Bensonhurst by a mob of angry white teens prompted a protest march under the slogan "A Day of Outrage." The rally was organized by community activists with the assistance of the rap group X-Clan, and memorialized on their debut album. While hip hop nationalists are not politicians, they are involved in the production of cultural politics—its creation, its circulation and its interpretation—which is tied to the everyday struggles of working-class blacks and the urban poor. Perhaps more than most popular black musicians, hip hop nationalists follow Cornel West's assertion that

> [s]ince black musicians play such an important role in Afro-American life, they have a special mission and responsibility: to present beautiful music [or serious noise] which

both sustains and motivates black people and provides visions of what black people should aspire to.[7]

The social efficacy of nation-conscious rap ranges from unrevised imitation and misinformed representation of media-styled black militancy to historically informed and creatively transformative representations of oppositional politics for the 1990s. In their least innovative moments, nation-conscious rappers conjure the spirits of, say, sixties revolutionaries by borrowing the names, battle cries and costumes of the period without transforming this legacy to meet the needs of the nineties. Alternatively, militant rappers are most effective when they appropriate popular knowledge from within the black community and exploit its most progressive elements in the process of envisioning a new society. At these moments rappers function in a manner resembling what Antonio Gramsci calls "organic intellectuals."[8]

Hip hop nationalists are organic *cultural* intellectuals to the degree that their activities are directly linked to the everyday struggles of black folk and their music critically engages the popular knowledge of which they are a part. The music and video images of hip hop nationalists must do more than mirror the interests of their urban constituency. They must actively shape popular knowledge in a manner that contests U.S. nationalism from within the black community. The affectivity of hip hop nationalism is not grounded on a rap artist's ability, as a member of an elite avant-garde, to lead the backward black masses. Instead the cultural intellectual who is organically linked to the community begins from popular knowledge and appropriates its "healthy nucleus" in order to make "coherent the principles and the problems raised by the masses in their practical activity."[9]

Hip hop nationalist are the most recent in a long line of organic cultural workers who are situated between the intellectual activist and the commercialized entertainer. They tend to be most progressive when they use their music, videos, and public appearances to make relevant their constituency's "commonsense" understanding of black militancy past for today's struggles against racism.

The Time of Sixties-inspired Hip Hop Nationalism

Nineteen eighty-eight was a landmark year in rap music for two reasons. On the popular front, MTV inaugurated its first regular hip hop program, called *Yo, MTV Raps!* to unprecedented network ratings. In the same year, Public Enemy released its second album, *It Takes a Nation of Millions to Hold Us Back*, giving black nationalism in the United States its first widely publicized expression in nearly two decades. Hip hop nationalism's immediate precursor in the black arts was the Black Aesthetic movement of the 1960s and early 1970s which, broadly conceived, included artists such as Amiri Baraka, Larry Neal, Haki R. Madhubuti, Sonia Sanchez, Gil Scott-Heron, and the Last Poets. Black Aestheticians

were predictably technophobic (not unlike the white New Left of the same period) in their firm rejection of mass media and commodity culture in favor of the community identity provided by the recovery of precolonial African oral and musical traditions. The Black Aesthetic movement's most powerful statement was, perhaps, formulated in the music of Gil Scott-Heron, who proclaimed: "The revolution will not be televised, will not be televised, will not be televised/ The revolution will be no re-run brothers/ The revolution will be live."[10]

By the mid-1970s, however, black cultural nationalists of the sixties emerged largely defeated, due to both state repression and internal contradictions. Many Black Aestheticians understood that, given the changing face of American culture, they had failed to respond organically to their own constituencies' needs and desires. In his 1973 book entitled *From Plan to Planet*, Haki Madhubuti recognized the "failure" of sixties black nationalism to give young African-Americans cultural and political alternatives in their own language.

> Black writers, as other black creators, deal in images. They understand the uses and manipulation of the image. One of the main reasons that our young so readily latch on to capsule form ideologies from outside the community is that black writers and others have failed. We have failed to give young brothers and sisters a workable and practical alternative in the language and style to which they can relate. We've failed to direct or set up and help operate constructive programs dealing with the *real* life issues on this planet.[11]

Madhubuti goes on to say that the black artist's "first allegiance is to the black media"— magazines, newspapers and, of course, radio. It is in the mass media, especially as it is situated within the black community, that a practical language of black nationalism can be produced by organic cultural intellectuals.

A fundamental difference between hip hop nationalism and black nationalism of the sixties is manifested in the way in which nation-conscious rap music embraces and exploits postmodern information technologies in order to produce a new black nationalist sound for the nineties and beyond. "Technology," Chuck D asserts, "we have to take advantage of it, and these black businessmen, instead of backing Coca-Cola all the time, they can get together and create a B.E.T.I. [Black Entertainment Television and Information] to inform us."[12] In the absence of a black CNN, rap records are an invisible network that can inform and mobilize the black community. Time and again, Chuck D has stated.

> Rap is black America's TV station. It gives a whole perspective of what exists and what black life is about. And black life doesn't get the total spectrum of information through anything else.[13]

Music videos, such as "Night of the Living Baseheads" (which critiques racism within the contemporary discourse of the "war" on drugs), produce a dynamic fusion of sound

and sight meant to move the audience's consciousness. The "Night of the Living Base-heads" video even creates its own television network, called PETV, to combat a media-saturated culture where there exist few minority-controlled radio stations and even fewer minority-owned television stations. Other Public Enemy rap songs, such as "Don't Believe the Hype," "911 Is A Joke," "Can't Truss It," and "More News At 11," express the group's desire to broadcast to their hip hop constituency news and information not readily available on and through mainstream channels. Sustaining the gains made by the Black Power revolt is especially important because, for nationalists, these efforts work against mainstream efforts to the contrary. As Sister Souljah of Public Enemy states, "the media tr[ies] to move people's minds out of the consciousness of the 60s and into some type of black backwardness."[14] The sixties-inspired hip hop nation understands that, today, control over the media means the ability to control representations of the real as well.

Hip hop's sixties-inspired nationalist groups—such as San Francisco Bay area's Paris, Queens's Intelligent Hoodlum, Los Angeles's Laquan, as well as Long Island's Public Enemy—make extensive use of the highly publicized and media-styled black militancy of the 1960s. The packaging of rap albums, CDs and cassettes provides many illustrations of hip hop nationalism's historical borrowings. Aside from more obscure references, such as Public Enemy's third album, *Fear of a Black Planet*, which recalls Madhubuti's aforementioned *From Plan to Planet*, there are numerous explicit examples of this tendency. A recent *Spin* article on Public Enemy, for instance, displayed a full-page photo of Chuck D seated between two members of PE's paramilitary outfit, the S1Ws (an acronym for Security of the First World). Upon Chuck D's request, the magazine agreed to restage the trademark photograph of Black Panther leader Huey Newton sitting in a regal wicker chair with spear and automatic rifle in hand. This time, however, Chuck D is decked out in "homeboy fashion": high-top, brand-named, leather basketball sneakers, black baseball jacket and cap with PE insignia and logo. By taking on and yet revising Panther imagery, Public Enemy creatively updates the most media-conscious iconography of sixties black radicalism for a 1990s constituency.

Broadly speaking, this revision of a historical image is generated by means of what is referred to within rap music itself as sampling. Sampling occurs in rap when previously recorded materials are appropriated, often without regard for copyright laws. The speeches and TV images of black political leaders of the sixties—especially Malcolm X, Martin Luther King, and Huey Newton—are cited by Public Enemy in raps and videos in the same manner that, for example, Motown hits are sampled. Hip hop nationalists are most effective when, by sampling the voices and images of political leaders from this period, they move beyond romanticizing media images of sixties Black Power. They perform this task when, as organic cultural intellectuals, nation-conscious rappers recontextualize and thus make black militancy of the 1960s meaningful for the 1990s.

Musically and historically speaking, Public Enemy's nationalist sounds and historical

references are time-conscious. Chuck D explains that the difference between the revolutionary black music of yesterday and of today is the latter's ability to move the masses through a musical timing that translates into rap's danceability.

> The thing about the Last Poets and Gil Scott-Heron is that they were into a jazz-type approach, doing poetry over a beat. When rap music came along, it was poetry over a beat too, but *in time*. More important than the Last Poets and Gil Scott-Heron, to us, was James Brown. His record, "Say It Loud, I'm Black and I'm Proud" had the most impact because it was danceable and yet you still thought about it . . . the groove was funk and soul, which was different from jazz.

Chuck D continues by explaining how, in response to the short history of rap music in the mid-1980s, Public Enemy first went about altering musical time.

> See, rap comes from the idea of a deejay working a party. A lot of our decisions are still based on that structure. We figure the thing that makes people really respond is changes in beats-per-minute. At one time, most rap music coming out was around 99 to 102 beats per minute, and that's what made us do "Bring the Noise" [from *It Takes a Nation . . .*], where we jetted it up to 109.[15]

By increasing the sonic speed of the beat—as well as the sampling of high-pitched horns, police sirens, automatic weapon fire and breaking glass—rap reproduces sounds that conjure experiences ranging from an ordinary summer's day in the ghetto to an urban riot. It is the everyday urgency of Public Enemy's sound that is largely responsible for its widespread appeal.

Public Enemy's time-consciousness goes beyond musical technique in its ability to conjure a particular history of struggle within the black community. On "Don't Believe the Hype,"[16] for example, high-energy rapper Flavor Flav exclaims: "Yo Terminator X, step up on the stand and show these people what *time* it is, boyeee." By mixing, sampling and scratching, Terminator X is the group's timekeeper, its time-consciousness. Immediately after stating that he's a "time bomb," Chuck D, the group's deep-voiced lead rapper, boasts:

> In the daytime the radio's scared of me
> 'Cause I'm mad, plus I'm the enemy
> They can't c'mon and play with me in primetime
> Cause I know the time, plus I'm gettin' mine.

These lyrics point to the fact that marginalized groups are often excluded from "prime" or mainstream time. Hip hop nationalism, like contemporary black nationalism generally,

responds to this crisis of exclusion by advocating the creation of self-sufficient institutions that can empower the African-American community through its own form of disciplinary time. As Chuck D once told an interviewer, "The black race needs order and discipline if it's going to prosper."[17]

If Chuck D's editorializing fails to reach the audience, the S1W's deliberate visual message is a very readable sign of black power. In PE's concert performance the S1Ws, outfitted in military fatigues, respond to Terminator X's commands by stepping in time to the music. The S1Ws move their bodies with precision and in unison, producing an impressive display of masculine muscle and order. The synchronic and syncopated moves are embedded not only in the military imperative of most nationalisms, but also specifically in the tradition of black fraternity step shows. Even Flavor Flav's playful and disorderly conduct—which balances the straightforward rhyming and stepping of Chuck D and the S1Ws—can be attributed to what is called "freaking" in step shows, where an individual deviates from what is otherwise a spectacle of group solidarity.[18]

Hip hop nationalism draws from a wide range of militant styles from the sixties, often with less regard for the conflicts between black radicals during the period than for the fact that they fit the time of sixties militancy. Chuck D and Public Enemy draw inspiration not only from the Nation of Islam but also from the vanguardist Black Panther Party. The Black Panthers were Black Left Internationalists who generally followed the ideas of Marx, Lenin and Mao. The Panthers not only attempted to build political coalitions with other Left organizations, regardless of racial identity, but challenged the romantic nationalism promoted by certain prominent black nationalist organizations and leaders.[19] PE has expressed a genuine interest in forging both musical coalitions with white rock bands (such as Anthrax) and cross-cultural alliances. Not surprisingly, in rap music forums such as *The Source* magazine, more militant black nationalists have openly criticized members of PE for their nonseparatist tendencies. PE is remarkable for their ability to maintain their organic ties to the black community while challenging blind allegiance to racial solidarity. On a rap such as "Welcome To the Terrordome," they remind their black nationalist brethren that:

> Every brother ain't a brother
> Cause a Black hand
> Squeezed on Malcolm X the man
> The shootin' of Huey Newton
> From a hand of a Nig who pulled the trig.[20]

Terminator X helps PE reformulate the sixties-inspired identity politics for the nineties. In one sense, Terminator X is rap music's cyborg. Part human, part machine, he is an anonymous subject whose identity is claimed only through musical technology. An assault technician, Terminator X not only works to precision the technique of cutting and mixing,

he also recalls the futuristic film by the same name. Masculine, indestructible, and always on the edge of violence, Terminator X, although his voice is silent, sounds "louder than a bomb" by "yellin' with his hands"[21] (by scratching and sampling). He conjures the sound from the black historical memory, sets the sound in time and in motion, and brings the noise to the hip hop constituency.

A Woman's Place: Mother Africa

Not unlike the hypermasculine figure of Terminator X, much of hip hop nationalism is unabashedly patriarchal. While their musical and visual performances incite a politics of disbelief ("Don't Believe the Hype") Public Enemy simultaneously reproduces a particular form of sexism common to counternationalisms of the sixties. Compare the lyrics of PE's 1988 "She Watch Channel Zero?!" to a passage from Malcolm X's description of black women in his 1965 *The Autobiography of Malcolm X*:

> [Malcolm X:] I don't know how many marriage breakups are caused by these movie- and television-addicted women expecting some bouquets and kissing and hugging and being swept out like Cinderella for dinner and dancing—then gets mad when a poor, scraggly husband comes in tired and sweaty from working like a dog all day, looking for some food.[22]

> [Public Enemy:] There's a 5-letter word
> To describe her character
> But her brains being washed by an actor
> And every real man that tries to approach
> Come the closer he comes
> He gets dissed like a roach
> [Refrain:] I don't think I can handle
> She goes channel to channel
> Cold lookin' for that hero
> She watch channel zero.[23]

While it is accurate to describe sexism in rap music as a symptom of American culture in general, the above descriptions of African-American women are specific to the language of black nationalism. Hip hop nationalism follows in the steps of sixties black militancy by positioning black women who do not conform to the ideals of the patriarchal family structure as ungrateful wives or gold-digging lovers. Chuck D reiterated his concern for the disabling effect of the mass media on black women in a recent interview: "if she has no man she has to hold on to something like television."[24] Much was made of Public Enemy's attempt to revise their sexism with pro-black-woman tracks on their 1990 album *Fear of a Black*

Planet. On "Revolutionary Generation,"[25] for example, PE evokes Aretha Franklin by rhyming, "R-E-S-P-E-C-T/ My sister's not the enemy." Yet they can rap on the same cut, in conventional black nationalist tone: "It takes a man to take a stand/ Understand it takes a/ Woman to make a stronger man." As they rap "I'm tired of America dissin' my sisters," it becomes clear that sexism is PE's concern only in so far as it is connected to white supremacy in the United States. The inability of even the most progressive forms of nation-conscious rap to confront sexism suggests that the historical conditions for new thinking on gender relations has yet to be realized by the largely male-dominated organic intelligentsia of the African-American community.

For a brief while between 1990 and 1992 PE added a female member, Sister Souljah, to the group. An activist in the black community prior to her entrance into hip hop, Souljah has taken the role of "Sister of Instruction" and "Director of Attitude." One might assume that the introduction of an outspoken, pro-black-woman rapper to nation-conscious rap's most successful group would transform Public Enemy's attitudes concerning sexual politics. This has simply not been the case. Instead, Sister Souljah deflects gender-based criticism away from PE through her repeated affirmation that the war against racial oppression should be fought primarily on the terms set by men. Her presence thus seems to have tempered the group's potential for progressive critique in this area by allowing them to sustain an unrevised concept of sexual politics.

Black America, insists Souljah, is in the midst of a war—and she is a revolutionary. Like Public Enemy, Sister Souljah urges her audience to pay close attention to time. The connection between her sixties-inspired political posture and the hip hop pseudonym, Sister Souljah, recalls the title character of Sonia Sanchez's militant 1969 play, *Sister Sonji*. Sanchez was the most prominent female Black Aesthetician in a movement dominated by men. Produced on stage in 1972, the one-woman play opens with an elderly Sister Sonji— a Harriet Tubman figure according to Sanchez[26]—asking: "Ain't time and i made a truce so that i am time a blk/ version of past/ ago & now/ time."[27] As Sonji is transformed from a teenager to a young adult, she exemplifies the black revolutionary female self: "The time for blk/ nationhood is here." At a Black Power conference, Sonji learns a great deal about her role in building the new nation:

> this morning i heard a sister talk about blk
> women supporting their blk
> men, listening to their men, sacrificing, working while blk
> men take care of bizness, having warriors and young sisters.[28]

During revolutionary times, according to the play, black women make sacrifices to the patriarchal hierarchy by both supporting black men and taking care of private, domestic concerns such as bearing children.

Twenty years later we see and hear Sister Souljah—who has stated that Harriet Tubman is her primary source of inspiration and her principle model for leadership[29]—echoing Sanchez's Sonji in the rap music video "Buck Whylin'."[30] The video is from the 1991 album *Terminator X & the Valley of the Jeep Beets*, upon which Souljah makes her first recorded appearance with Public Enemy. "Buck Whylin' " begins with a sample from PE's "Bring the Noise." The listener is immediately assaulted by Sister Souljah's powerful and preacherly voice. Her topic is "the black man," and she exclaims: "We are at war! Black man, where is your army?" Souljah's presence is felt not only in the beginning, but also in middle and at the end of the otherwise male-centered video. At a break in Chuck D's rap, Sister Souljah roars:

> What is America's beef with the black man? It's the way that you walk, it's the way that you talk. Every brother and sister has got to be a soldier in the war against the black man.

At the music video's conclusion the listener hears the words: "Sister Souljah speaking. Sisters say 'Where are all the good black men?' They're missing in action because we are at war!"

Like her foremother, Sister Sonji, Souljah's voice is that of a visionary or prophet. Her message, too, is nationalist to the core. On her 1992 debut solo album, *360 Degrees of Power*, she raps "Turn all your talents and skills to a Black business/ Which helps to build the African community."[31] Souljah, in line with Chuck D, claims: "The number one thing we must do is rebuild the Black Man."[32] Black nationalism's primary focus is the actualization of black men's political agency in the struggle for liberation. The high rate of black male mortality is understood as American genocide; it is the principle cause for action. Black women and men, according to Souljah, must fight together as soldiers in the battle for the survival of the black man. The struggle is thus defined purely in terms of the remasculinization of black men: "When you are a Black Man in America you are automatically hunted."[33] In line with PE, Sister Souljah never uses sexual politics to contest the contradictions in black nationalism's concept of liberation. On the one hand, she stereotypes both white women (for their desire for black men) and white feminists (as man-hating lesbians in global sisterhood clothing).[34] On the other hand, she constructs an alibi for the stereotypical hypermasculinity of black men: "White people try to make black women uncomfortable with black manhood . . . a lot of times sisters don't understand the amount of pressure that black men are under."[35] While Souljah's remarks implicitly raise some pertinent issues concerning the uneasy relationship between, for example, liberal feminism and black sisterhood, the shortcomings of Souljah's sexual politics are aggravated by the logic of black nationalism. Agendas not based exclusively on racial politics are essentially foreclosed. All problems within the black community—including gender antagonisms—are reduced to

the omnipresent menace of white supremacy. While this brand of hip hop nationalism expresses only part of a far more complex story, it ironically serves to show the limits of black nationalism as a language of liberation for African-American women.

The tendency to objectify the black woman as the sign "Mother Africa" is fully entrenched in Afrocentric hip hop nationalism. This objectification is a consequence of the Afrocentric interest in fabricating ancient Egypt as a mythical homeland for the black nation to come. Black woman rapper Isis, a member of the Afrocentric hip hop group X-Clan, functions as the sign "Africa" within nationalist rap. According to Frances Cress Welsing,[36] in ancient Egyptian mythology Isis is the goddess of fertility, and second only to her brother/husband, the god Osiris, in status. One myth tells of the murder and dismemberment of Osiris, Isis' discovery of the crime, her recovery of the pieces of his body, and, finally, her successful effort to restore not only his existence, but his supreme power as "Lord of the perfect Black." As the wife of Osiris and the mother of Horus, Isis is worshipped as the goddess of fertility and the mother of Africa.

Not surprisingly, within the Afrocentric hip hop group X-Clan, rapper Isis takes on the role of her mythological namesake. For example, in Isis's debut music video, "The Power of Myself is Moving,"[37] she plays the part of fertility goddess along the Nile: "I am a self coming forth/ A creature bearing life, a renaissance, a rebirth." Throughout the song, Isis speaks primarily about "love" and "blackness," "birth" and the "Motherland." Her visual and audio narrative are conspicuously framed by Professor X's righteous rapping. While he opens the rap by claiming that "We, who write . . . summons the goddess Isis," he closes the song with his recitation of X-Clan's trademark proselytizing as Isis silently crosses her arms. This representation of the venerated black woman within Afrocentric hip hop nationalism strongly suggests that black men control black women's messages by framing their voices and images. Professor X, speaking in an interview on X-Clan's production of solo albums for two of its female members (Queen Mother Rage as well as Isis) states:

> It's important that [X-Clan's] point of view can be expressed in different tones and in different ways, but all with the same message, but with different angles.[38]

The key is that the message remains the same despite the potentially conflicting sexual interests of different Afrocentric rappers.

Afrocentric hip hop nationalism tends to limit the range of representations of black women to a set of rigidly coded sexist oppositions. Black women are either good or bad, mothers or whores, wives or gold-digging lovers. Poor Righteous Teachers, another Afrocentric rap group, use this binary logic in their veneration of the ideal African woman on their music video titled "Shakiyla."[39] The video opens with the image of an uppity black woman, dressed in a business suit, who deliberately ignores the friendly advancements

from two black men on the street. As this image dissolves, rapper Wise Intelligent of Poor Righteous Teachers states: "This is not a love ballad." Instead, he raps, "I've come to pay tribute to Shakiyla," who is described as "the mother of civilization" and "the black woman." As the chorus repeats the lyrics "The black queen is mine," a map of Africa is superimposed on the screen, implying not only the possession but also the objectification of Shakiyla, the revered queen of the black nation, as the sign "Africa." Isis is mapped with a similar effect on X-Clan's music video "Heed the Word of a Brother."[40] On the screen, her primary function is to silently strike a Cleopatra pose in front of a painting of Egyptian monuments (the pyramids and the sphinx). The queen of the Nile, X-Clan's Isis is exploited at this moment as the sign "Egypt." Isis and Shakiyla thus function as the black woman who stands in for a romanticized notion of Africa as the nurturing mother of all prior civilizations and as the inspirational source for the emerging black nation. However, by representing the black woman in this way, Afrocentric rap affirms her objectification while constraining the possibility for black women's autonomy and agency.

The Place of Afrocentric Hip Hop Nationalism

Many hip hop nationalists labor under a version of the ensign "Afrocentricity." According to its leading proponent, Molefi Kete Asante, an Afrocentric perspective "means, literally, placing African ideals at the center of any analysis that involves African culture and behavior." Asante, like Afrocentric hip hop nationalists, maintains that members of the African diaspora can never reach their full potential as individuals or as a group unless they "place Africans and the interest of Africa at the center of [their] approach to problem solving." Afrocentricity attempts to reverse a history of Western economic dependency and cultural imperialism by placing a distinctly African value system—found in "deep [spiritual and psychological] structures" of the African being—at the center of the black American worldview.[41] Asante goes to great lengths to avoid making arguments for racial difference that are motivated by biological essentialism, but many black nationalists, including those of the hip hop variety, do not. Afrocentric rapper Wise Intelligent, for example, remarks: "You have to understand that the potency of melanin in the black man makes him naturally rhythmic. . . . This is our blood."[42]

All historical thinking, to a large extent, is a remembering of the past in terms of the present. As a popular culture form, rap music—and hip hop nationalism in specific—is a powerful vehicle which allows today's black youth to gain a better understanding of their heritage and their present identities when official channels of remembering and identity formation continually fail to meet their needs. As such, I am more interested in the productive and contradictory logic which underwrites this revision of the past.

Afrocentric nationalism places Africa at the core of its value system by attempting to find—through spiritual and psychological transcendence—freedom from Western oppres-

sion. On their rap "Grand Verbalizer, What Time Is It?"[43] X-Clan focuses much less on temporality than on imagining a transcendent origin for the black nation. The rap immediately transports the listener to an unmistakable place: "African, very African/ Come and step in Brother's temple and see what's happenin'." At the conclusion of X-Clan's music video "Funkin' Lesson,"[44] the viewer is shown a map of the Atlantic. A pink Cadillac is superimposed on the map, and a line is drawn which begins in New York City and ends in Africa. As Professor X stated in an interview, the pink Caddy is a "time-travelling machine,"[45] one which presumably links black Americans with Africa. It is also a machine for rewriting the history of Western and non-Western civilization at a moment of world-historical transition.

In "Funkin' Lesson," contemporary black Americans are transported back to Africa "at the crossroads," as much in spirit as in reality, not on Garvey's Black Steamship Line but while driving on Aretha Franklin's funky "freeway of love." The '59 Caddy is one of X-Clan's trademarks: a complex symbol both of black consumer culture in the U.S. ("what Detroit Red went through to become Malcolm X") and of the dawning of the contemporary civil rights struggle ("[t]hat kind of attitude that had to come out of that era that led into the 60s").[46] This image is placed in tension with the group's excessive and serious display of Afrocentric garb, such as black leathered crowns, African handcrafted staffs and heavy African jewelry, beads, chains, medallions, ankhs and nose rings. As the Caddy makes its transcendent journey across the Atlantic and to the east, the viewer cannot help but notice its apparent final destination: North Africa or, perhaps, Mecca.

Rappers such as X-Clan and Lakim Shabazz are among a growing handful of hip hop nationalists who are committed, in one form or another, to a militant Afrocentric value-system. Lakim, unlike X-Clan, is an active member of a Nation of Islam splinter sect called the Five Percenters, which includes Afrocentric hip hop nationalists such as Rakim (of Eric B. and Rakim), Poor Righteous Teachers, Brand Nubian, Movement Ex and King Sun.[47] The Five Percenters' belief system is similar to that of the NOI in that Five Percenters essentially follow the teachings of Elijah Muhammad. Although Lakim goes so far as to insist that "[t]he only difference between the Nation of Islam and the Five Percent Nation is that they're always dressed nicely with a suit and tie and we figure you can wear anything,"[48] other Five Percenters might disagree. In fact, the Five Percent Nation follows the rival teachings of Clarence 13X, who claimed in the 1960s that god was to be found not in some external or monolithic force (Allah) but within the Asiatic black man himself. Five Percenters thus believe themselves to be "the poor righteous teachers": that is, those who know that the "original Black Man" is god. Another distinction between the NOI and the Five Percenters is that the latter insist that any corrupt person—black as well as white—is the "devil." Yet, as a publicized roundtable discussion among Five Percenters revealed, there is less than a consensus among them about the differences between their group and the NOI.[49]

Despite the philosophical and religious differences between Five Percenters and other Black Muslims in America, Louis Farrakhan, the present head of the NOI, is the closest the Five Percenters have to a spiritual leader. Perhaps most important is the appropriation by Five Percenters, in their music and videos, of the NOI's declaration of Islamic origins for members of the African diaspora presently residing in the United States. According to the teachings of Elijah Muhammad,[50] who founded the Nation of Islam sixty years ago, blacks in North America are the "original people," and were originally from the Holy City of Mecca. They are members of the lost tribe of Shabazz. NOI doctrine states that the black man must strive to regain his original religion (Islam), language (Arabic), and culture (astronomy and mathematics).

Afrocentric hip hoppers such as X-Clan, in an effort to create a vital counternationalism, look "to the east, blackwards" for a collective racial identity. Their gaze is, like the NOI's, based on a combination of mythical and historical revisionings of the origins of civilization against dominant Western culture's narration of the same. In the interest of locating a more original and even superior civilization which can be attributed to the ancestors of Africans and the African diaspora, hip hop nationalists focus on ancient Egypt. For this and other reasons, they rarely show an interest in exploring the language or customs of precolonial, African, sub-Saharan empires or tribals. The important exception to this rule is the widespread appropriation of West African drumming in rap music. In X-Clan's "Funkin' Lesson" video, for example, we observe tribal drummers and dancers in an open field while Brother J. raps "African, call it black man . . ." to the sampled screams of James Brown over African drum beats. In an interview, Professor X states the importance of drumming to nation-conscious rap in biological or racially essentialist terms:

> We found that coming back to the drum was the most important move that a black man can make. . . . Because, via the drum it connects our African genes whether we are conscious of our connections or not. It is natural . . . that we talk through the drum.[51]

While X-Clan takes a symbolic journey to North Africa, Lakim Shabazz convinced his small and independent record label actually to send him there (specifically, to Cairo, Luxor and Aswan) to shoot "The Lost Tribe of Shabazz" video from his 1989 debut album, *Pure Righteousness*.[52] In the resulting music video, Lakim is filmed making his pilgrimage through the Islamic world. With the pyramids along the Nile as his backdrop, Lakim raps both five percent lessons concerning knowledge, wisdom and understanding and his refrain—"Our people will survive America"—over Mark "The 45 King" beats. Of his journey to the Islamic world, Lakim states:

> I always wanted to go to the Motherland. I couldn't think of a more righteous place to make my video than in Egypt. . . . I wanted to show that our people were the builders of the pyramids, that our people invented science and mathematics.[53]

"Afrocentricity," according to Asante, "reorganizes our frame of reference so that we become the center of analysis and synthesis. . . . Indeed, this movement recaptures the collective will responsible for ancient Egypt and Nubia."[54] Afrocentric hip hop nationalists valorize the great ancient civilizations of North Africa as both the origin of all Western civilization and the inspirational glue that binds the diverse black American community together. Recent non-Afrocentric scholarship supports the Afrocentric claim of Egypt as an effaced source of Western civilization. This effacement was a result of two centuries of European scholars' systematic erasure of the influence of ancient Egypt on Greece.[55] Afrocentric hip hop nationalists counter this historical erasure by laying claim to the artifacts of ancient Egypt as a marker of the cultural superiority of precolonial Africans relative to Europe during the same period. X-Clan raps:

> I am an African, I don't wear Greek
> Must I be reminded of a legendary thief?
> Who tried to make Greece in comparison to Egypt
> But they got gypped 'cause their mind's not equipped.[56]

In X-Clan's music video "Head the Word of a Brother," as Brother J. raps "Jealous of what are we/ Becomes tendency for their thievery," the busts of the Greek philosophers Aristotle, Plato and Socrates are flashed upon the television screen, only to be quickly dismissed. Poor Righteous Teachers' Wise Intelligent explains:

> We're teaching black youth that their history goes beyond slavery . . . beyond Africa. Black people are the mothers and fathers of the highest forms of civilization ever built on this planet . . . Plato, Socrates, and so forth, they learned from black masters of Egypt.[57]

The contemporary deployment of the word "civilization" extends only as far back as the late eighteenth century. As a modern concept, civilization comes to be associated with developments in Europe since the Enlightenment, including the birth of modern forms of nationalism and imperialism. Throughout the nineteenth-century, European "civilization" was rigidly contrasted with the "savagery" of non-Western cultures (including those found throughout Africa). For instance, when in 1871 Karl Mauch came across the ruins of an ancient civilization in Zimbabwe, no European believed that they had been built by sub-Saharan Africans. Instead, Europeans advanced the idea that this was King Solomon's Golden Ophir—ruins attributable only to the creative genius of a superior race. It was not until 1906 that archaeologists began the slow process of overturning the myth of "King Solomon's Mines."[58] The point is that the civilizing mission of Europe could only see the

African subcontinent as Other: hence, Europe had to invent "savage" Africa to rationalize colonization.

Afrocentric hip hop nationalists contest the Western notion that precolonial Africa was barbaric. They make ancient Africa civilized by uncovering incontrovertible evidence for a thriving Egyptian empire that preexisted Greece. Yet this important assertion is limited in its political scope in as much as it only provides a reversal—and not a displacement—of the modern opposition between civilization and savagery. In order to challenge the binary logic of the civilized/barbaric opposition, Afrocentric rappers would do well to turn their gaze from Egypt and toward the largely ignored precolonial, African sub-Sahara. Prior to the fateful appearance of the Portuguese on the western coast of Africa in the mid-fifteenth century, three great African empires thrived to the south of the Sahara. These empires, based in Ghana (700 to 1200 A.D.), Mali (1200 to 1500 A.D.), and Songhai (1350 to 1600 A.D.),[59] provide a possible way for black nationalists to explode the European concept of civilization without reproducing its logic.

The Afrocentric assertion that Egypt is not only the origin of the black nation to come but the cradle of all civilization empowers hip hop nationalists in their struggle against a history of white supremacy. The logic of this claim (based, as it is, on Western notions of "civilization") is nonetheless contradictory. Exploiting Egypt as an alternative frame of reference does not necessarily allow nationalists to break with European notions of civilization but, rather, allows blacks to occupy a category previously reserved for whites. As a result, Afrocentric hip hop nationalists advocate a notion of civilization which still has its conspicuous origins in the slave cultures of the ancient Mediterranean. The great monuments which testify to the glory of these fallen empires—whether Greek, Roman or Egyptian—were built with slave labor. Given that black militants in the U.S. have always struggled against colonial forms of slavery and its legacy in the Americas, it is a sad irony that Afrocentric hip hop nationalists embrace an ancient empire whose enduring monuments are also markers of slavery during antiquity.

Women's Time: On the Front Line

Within Afrocentric hip hop nationalism, a rapper such as Isis is assigned the role of black woman to the extent that she passively mirrors the monuments of Egypt which signify the glories of an African empire. Thus in X-Clan's "Funkin' Lesson" video, Isis silently stands in front of a mural of pyramids and the sphinx as Brother J. raps over the beat. In a strikingly different pose, rapper Queen Latifah, in her 1989 music video debut "Ladies First," stands over and above a map of southern Africa. Instead of becoming a sign for ancient empire, Latifah exploits the language of black nationalism in order to engage contemporary struggles in and around South Africa. Unlike Isis, whose voice is authoritatively framed by Professor X's voice, Latifah's "Ladies First" is simultaneously woman-

centered and pro-black, feminist and Afrocentric. And unlike Sister Souljah, whose allegiance is primarily to the male leadership of the NOI and PE,[60] Latifah creates alliances which are less dependent on traditional hierarchies imposed by black nationalism.

While Latifah has been aligned with a loosely organized, Afrocentric, rap collective called the Native Tongues, she has also had membership in other hip hop posses, such as the Breakfast Club and the Flavor Unit. Even when the Native Tongues (which has consisted of rap groups such as De La Soul, A Tribe Called Quest and Jungle Brothers, among others) speak the language of black nationalism, it is hardly militant or masculinist, and always playful. The fact that Latifah maintains her status as a solo artist allows her both real and symbolic autonomy that sets her apart from most other women rappers within the hip hop nation. Paradoxically, this affords Latifah a heightened capacity for collaborative work with other rap artists of varying backgrounds. Latifah's Afrocentric expression is remarkable not only because it is devoid of the concomitant sexism of nationalism, but because it challenges the masculinist logic of nation as well.

In her commentary on an interview conducted with the Queen of the hip hop nation, Tricia Rose suggests that Latifah is "uncomfortable with the term 'feminist.' "[61] Latifah's pro-black-woman stance, which both refuses the category of white feminism and is energized by sixties-inspired black nationalism, can be explained, I believe, by the concept of the organic cultural intellectual. Black women rappers, within and outside of nationalism, are *gendered* agents of social struggle not to the degree that they publicly embrace a feminist identity. Instead their political agency, as organically based women rappers, is grounded in their ability to articulate and elaborate upon competing interests between men and women within the black community. A rap video such as "Ladies First" illustrates Latifah extracting a kernel of "good sense" embedded in popular or "common sense" notions of a black woman's place within the hip hop nation. Latifah explains her use of newsreel footage of black women fighting alongside men in national liberation struggles in the video as follows:

> I wanted to show the strength of black women in history. Strong black women. . . .
> Sisters have been in the midst of these things for a long time, but we just don't get to
> see it that much.[62]

The music video for "Ladies First"[63] opens by sampling snapshots of women of color who were involved in black liberation struggles—such as Sojourner Truth, Angela Davis and Winnie Mandela—but who have, until recently, been marginalized in or even censored from the official memories of black liberation struggles. The camera pans to Latifah at her command post in a darkly lit war room with her dancers, the Safari Sisters, flanking her. Latifah dons commando military garb while she smashes pawn statues of corporate

multinational businessmen and replaces them with figures of Black Power fists on a map of southern Africa. The fact that Latifah not only inhabits but is also the commander of the war room symbolizes her leadership role within the imaginary nation. Latifah, and all the "ladies" of the hip hop nation, are involved in the black nationalist liberation struggle against oppressive, white regimes. As a member of the African diaspora, Latifah's nationalism is based not on a romantic return to an archaic past but on her engagement with contemporary forms of racism. "Ladies First" suggests the reciprocal relationship between national liberation struggles at home and abroad over the last thirty years. Her strategic use of a Black Power sign system, for example, makes sixties-inspired black nationalism relevant to the continuing struggles in countries such as South Africa (where self-determination is still denied to the majority population) while reminding her audience of the inspiration provided by Third World national liberation movements to Black Power militants during the sixties.

It should come as no surprise that Latifah's image and music exceed nation-conscious rap and often go beyond the sanctioned limits of black nationalism of any sort. The fact that she is something of an anomaly *within* hip hop nationalism suggests the degree to which the discourse of nation in the black community, as elsewhere, remains masculinist. Latifah not only reveals the severe limitations of nationalism as a language of equality for women in general; she also clears a space within hip hop nationalism for the empowerment of black women. For both these reasons, her contribution to building the hip hop nation is particularly important.

Like many other nation-conscious rappers, Latifah's performance testifies to the vital work being done by community-based intellectual musicians within rap music today. Hip hop nationalists are particularly skillful in generating fresh understandings of the ill-mapped history of racism at home and abroad, while challenging the claims of the New World Order. As organic cultural intellectuals, they can transform "commonsense" knowledge of oppression into a new critical awareness that is attentive not only to racial but also to class and sexual contradictions.

Hip hop nationalism is particularly adept at interpreting the past in a manner that develops black consciousness about alternatives to the hegemony of U.S. nationalism. Yet for black nationalism to be a sustained vehicle of social change, its conservative tendencies need to be addressed and transformed. Within nation-conscious rap "a certain sort of regression" (as Nairn puts it) that manifests itself in a nostalgia for ancient Egypt or a romanticization of sixties Black Power is not the only available form for reimagining the time and place of a new black militancy. Rather, as Ice Cube's lineage of "kings" demonstrates, the most effective nationalist rappers have a consciousness of the *present* which blasts apart the stale historical continuum.[64] In nineties-based militant rap, the apocalyptic noise of the racial crisis in America shatters a mythic past of the nation.

Notes

For their comments, criticisms and encouragement on earlier versions of this paper, I am indebted to Tricia Rose and Jenny Sharpe. This essay is an abridged version of that which has been previously published in *Social Text* vol. 34 1993.

1. This exchange between Ice Cube and the LAPD provides an interlude between "My Summer Vacation" and "Steady Mobbin' " on *Death Certificate* (Priority Records, 1991).

2. Tom Nairn, *The Break-Up of Britain*, 2nd ed. (London: Verso, 1981), pp. 348–49. Drawing partly on the work of Nairn, Benedict Anderson makes a similar point: "If nation-states are widely conceded to be 'new' and 'historical,' the nations to which they give political expression always loom out of an immemorial past, and . . . glide into a limitless future." See Anderson's *Imagined Communities: Reflection on the Origin and Spread of Nationalism* (London: Verso, 1983), p. 19.

3. It should be noted that within rap music and hip hop culture there exist a number of distinct agendas, some intersecting, and many of which have little or nothing in common with nationalist politics of any sort.

4. The term "hip hop nation" was first used in print as the title of a *Village Voice* special section on this topic from 19 January, 1988. More recently, the music industry's weekly publication, *Billboard*, titled its 23 November, 1991 cover story "State of Rap: Triumph of the Hip-Hop Nation." The use of the phrase "hip hop nation" is now commonplace in discussions of rap music, and almost always refers to an "imagined" community of hip hoppers, regardless of their relationship to the legacy of black nationalism in America. My usage of the term is more exclusive to the degree that I focus on the various forms that *nationalism* takes within hip hop culture.

5. Daddy-O, quoted by Sister Souljah in *Nation Conscious Rap*, Joseph D. Eure and James G. Spady, eds., (New York: PC International Press, 1991), p. 242. This book, of which I make extensive use throughout this piece, is primarily a collection of interviews.

6. "Rockbeat," *Village Voice* 37 (May 12, 1992), p. 80.

7. Cornel West, "The Paradox of the Afro-American Rebellion" in *The Sixties Without Apology*, eds. Sonya Sayres *et al.* (Minneapolis: University of Minnesota Press, 1984), p. 56.

8. Antonio Gramsci maintains that every social group generates intellectuals who are organically tied to their community of origin and who "function not only in the economic but in the social and political fields." See Gramsci, "The Formation of the Intellectuals," in *Selections from the Prison Notebooks*, trans. Quintin Hoare and Geoffrey Nowell Smith (New York: International Publishers, 1971), p. 5.

9. *Ibid.*, pp. 328, 330.

10. Gil Scott-Heron, "The Revolution Will Not Be Televised" (Flying Dutchman Records, 1974). In a brief interview in *The Source*, 32 (May 1992), p. 59, Gil Scott-Heron betrays his hostility to

rap music by suggesting that it is too commercialized, and that rappers are not musicians because they rely on sampling techniques rather than playing instruments.

11. Don L. Lee (Haki R. Madhubuti), *From Plan to Planet* (Detroit: Broadside Press, 1973), p. 96.

12. *Nation Conscious Rap*, p. 336.

13. Chuck D, quoted in an interview with John Leland; see "Armageddon in Effect," *Spin* 4 (November 1988), p. 48.

14. *Nation Conscious Rap*, p. 247.

15. Mark Dery, "Public Enemy Confrontation," *Keyboard* 16 (September 1990), p. 88 (Chuck D's emphasis).

16. Public Enemy, "Don't Believe the Hype," *It Takes a Nation of Millions to Hold Us Back* (Def Jam Records, 1988).

17. Frank Owen, "Public Service," *Spin* 5 (March 1990), p. 57. More recently, responding to a question from Robert Christgau, Chuck D insisted that "because business is family . . . [black] self-sufficiency is the best program." See Robert Christgau and Greg Tate, "Chuck D. All Over the Map," *Village Voice Rock & Roll Quarterly* (Fall 1991), p. 16.

18. For a discussion of black fraternity step shows, see Elizabeth C. Fine's "Stepping, Cracking, and Freaking: The Cultural Politics of African-American Step Shows," *Drama Review* 35 (Summer 1991), pp. 39–59.

19. The ideological distance between the Left Internationalism of the Black Panthers and black nationalism was tragically illustrated in the alleged murders in southern California of four Panthers by members of Ron Karenga's rival black nationalist U.S. organization.

20. Public Enemy, "Welcome To the Terrordome," *Fear of a Black Planet* (Def Jam Records, 1990).

21. Public Enemy, "Louder Than a Bomb" and "Terminator X to the Edge of Panic," *It Takes a Nation of Millions to Hold Us Back.*

22. Malcolm X with Alex Haley, *The Autobiography of Malcolm X* (New York: Grove, 1965), p. 231.

23. Public Enemy, "She Watch Channel Zero?!" *It Takes a Nation of Millions to Hold Us Back.*

24. *Nation Conscious Rap*, p. 354.

25. Public Enemy, "Revolutionary Generation," *Fear of a Black Planet.*

26. Sonia Sanchez, in an interview with Claudia Tate, states: "In *Sister Son-ji* I portray a woman who ages on stage, but her spirit is ageless. She is Harriet Tubman, a woman." See *Black Women Writers at Work*, Claudia Tate, ed., (New York: Continuum, 1983), p. 148.

27. Sonia Sanchez, *Sister Son-ji*, in *New Plays from the Black Theatre*, Ed Bullins, ed., (New York: Bantam, 1969), p. 99. Elsewhere Sanchez comments that *Sister Son-ji* is about "the concept of time"; see "Ruminations/Reflections," in *Black Women Writers (1950–1980): A Critical Evaluation*, Mari Evans, ed., (Garden City, NY: Doubleday, 1984), p. 416.

28. *Ibid.*, p. 102.

29. *Nation Conscious Rap*, pp. 251–52.

30. Terminator X, "Buck Whylin'," *Terminator X & the Valley of the Jeep Beets* (Def Jam Records, 1991).

31. Sister Souljah, "Survival Handbook vs. Global Extinction," *360 Degrees of Power* (Epic Records, 1992).

32. *Nation Conscious Rap*, p. 378.

33. *Ibid.*, p. 247.

34. Sister Souljah, "Brainteasers And Doubtbusters," *360 Degrees of Power*.

35. *Nation Conscious Rap*, p. 247.

36. See Frances Cress Welsing, *The Isis Papers* (Chicago: Third World Press, 1991).

37. Isis, "The Power of Myself Is Moving," *Rebel Soul* (4th & B'Way Records, 1990).

38. *Nation Conscious Rap*, p. 194.

39. Poor Righteous Teachers, "Shakiyla," *Holy Intellect* (Profile Records, 1990).

40. X-Clan, "Heed the Word of a Brother," *To the East, Blackwards* (4th & B'Way Records, 1990).

41. Molefi Kete Asante, *The Afrocentric Idea* (Philadelphia: Temple University Press, 1987), pp. 6, 198n.3, 172.

42. *Nation Conscious Rap*, p. 74. It is interesting to note that Asante, despite his vigilance against essentialism in describing the relation between an Afrocentric perspective and the people of the African diaspora, nevertheless betrays this tendency in the "naturalizing" analogies upon which he relies. In his book *Afrocentricity*, rev. ed. (Trenton, N.J.: Africa World Press, 1988), p. 43, Asante explains that, for people of African descent, embracing an Afrocentric spirituality "is like a fish swimming in water, it cannot escape the water. Its choice is whether to swim or not, that is, to activate. There is nothing the fish can do about the existence [and biological necessity?] of the water."

43. X-Clan, "Grand Verbalizer, What Time Is It?," *To the East, Blackwards*.

44. X-Clan, "Funkin' Lesson," *To the East, Blackwards*.

45. Professor X, quoted in an interview with Louis Romain; see "Roots and Boots," *The Source* 32 (May 1992), p. 35.

46. *Ibid.*

47. While I include rappers with Islamic beliefs as part of the Afrocentric tendency in hip hop nationalism, Islam lies outside the the concept of Afrocentricity according to Asante's definition. In the opening pages of his book *Afrocentricity*, Asante argues that an Islamic belief system goes against the Afrocentric idea because the former is based on an Arab (as opposed to an

African) heritage. Islamic religion is thus, like European forms of Christianity, a non-African spiritual practice.

48. Lakim Shabazz, quoted in an interview with Charlie Ahearn; see "The Five Percent Solution," *Spin 6* (February 1991), p. 76.

49. The lack of consensus among Five Percenters about what it means to be a member of the Five Percent Nation is revealed in a 1991 "Islamic Summit" sponsored by the hip hop magazine, *The Source*. The transcript of the roundtable discussion, put together by Harry Allen, was later printed under the title of "Righteous Indignation," *The Source* 19 (March/April, 1991), pp. 48–53.

50. Elijah Muhammad, *Message to the Black Man* (Chicago: Muhammad's Temple No. 2, 1965), pp. 31–2.

51. *Nation Conscious Rap*, p. 191.

52. Lakim Shabazz, "The Lost Tribe of Shabazz," *Pure Righteousness* (Tuff City Records, 1989).

53. Ahearn, "The Five Percent Solution," p. 57.

54. Asante, *Afrocentricity*, p. 39.

55. See, for example, Martin Bernal, *Black Athena, vol. 1, The Fabrication of Ancient Greece, 1785–1985* (London: Free Association Books, 1987).

56. X-Clan, "In the Ways of the Scales," *To the East, Blackwards*.

57. *Nation Conscious Rap*, p. 68.

58. For a discussion of the European debate over the origins of King Solomon's Golden Ophir, see Patrick Brantlinger, *Rule of Darkness: British Literature and Imperialism, 1830–1914* (Ithaca: Cornell University Press, 1988), p. 195.

59. L. S. Stavrianos comments on these three African sub-Saharan empires in his book *Global Rift: The Third World Comes of Age* (New York: William Morrow, 1981), pp. 103ff.

60. See Nelson George, "She Has a Dream," *Village Voice* 35 (October 2, 1990), p. 28.

61. Tricia Rose, "Never Trust a Big Butt and a Smile," *Camera Obscura* 23 (May 1990), p. 127. For a discussion of African-American women scholars who have attempted to combine black nationalism and feminism, see E. Frances White, "Africa on My Mind: Gender, Counter Discourse and African-American Nationalism," *Journal of Women's History* 2 (Spring 1990), pp. 90–4.

62. Queen Latifah, quoted in an interview with Tricia Rose; see "Never Trust a Big Butt and a Smile," p. 123.

63. Queen Latifah, "Ladies First," *All Hail the Queen* (Tommy Boy Records, 1989).

64. My formulation is inspired by the antihistoricist thinking of Walter Benjamin. See, for example, Benjamin's "Theses on the Philosophy of History" (in *Illuminations*, trans. Harry Zohn [New York: Schocken, 1969], p. 261) where he states: "The awareness that they are about to make the continuum of history explode is characteristic of the revolutionary classes at the moment of their action."

Contracting Rap
An Interview with Carmen Ashhurst-Watson

Tricia Rose

Carmen Ashhurst-Watson has been involved in media, film and television organization-building and production for twenty years. She began working with "hip hop impressario" Russell Simmons in the mid-1980s, and as of 1990 became president of Def Jam Recordings. Since 1991, Ashhurst-Watson has been president of Rush Communications, the parent company of Simmons' media empire and the second largest black-owned entertainment company in the United States, which has—in addition to music—three major subdivisions for film, television and fashion. In my animated conversation with Ashhurst-Watson, she dropped science on rap artists' contracts, black radio, capitalism, sexism in the music business and more. Here it is . . . hardcore.

Tricia Rose: Before I turned the recorder on, I asked what I thought would be a throw-away question—your answer will probably shock folks as it shocked me. So let's begin there: how many rap demo tapes do you receive and how many of those would you be interested in?

Carmen Ashurst-Watson: Out of about a thousand tapes, we might be interested in one or two.

TR: Given that, describe the process of discovering a band.

CAW: First of all, it is extremely rare for a group to come to the attention of a record company just off the street, and it's very rare that any such group that would come to the attention of a record company wouldn't have a large body of work. By the time a record company is interested in a group, they've already been tried and tested somewhere. They have a local following, or a friend who's an artist who brought them to the label, or they used to DJ for an established artist. It is very, very rare that somebody came up with one song idea, did a tape in their basement, and then brought it to somebody. Usually, a rapper has done several hundred songs and picked three of the sev-

122

eral hundred that somebody likes before he's even in the league of being commercially viable. The most recent discovery story that people mention is Kris Kross. It's this great story of two kids who were found in a shopping mall by an agent or manager. By the time they were in this mall, they had already been performing there and in other local places for two years, and had a body of songs from which this guy could choose. So, yes, he did see them in this environment, but he didn't actually discover them performing for the first time.

Most of Def Jam's new groups are actually brought to our attention by our artists. Onyx, the most recent find, was brought in by Jam Master Jay who knew them and had seen them perform. They had been struggling together for some time—Onyx had a different kind of music, but when Jay got his own label, he remembered them. We found L.L. Cool J because he lived in the same neighborhood with Run-DMC.

TR: Nowadays, the markets for performing are not that great. You're saying that Kris Kross performed in the mall. Where would Onyx perform without a label, without a record contract? Why would a small club owner allow them to perform given their rough and rugged image and explicit lyrics?

CAW: Well, for the most part they're allowed to perform because they perform for free or real cheap. They do local club dates, they might be the DJ at a party in their neighborhood or something like that. There are local amateur shows or talent shows which feature competition amongst rappers. They get their experience by freestyling and battling other rappers in jam sessions. Freestyling is the primary mode of competition for rappers before they come to a label. Freestyling is not really a commercially viable style of rap—it is more of a training ground. There might be some tapes of freestyling that would make it on to underground radio, but that's a precommercial market. It is very important in terms of their development as artists; it certainly would be important to be able to have that skill for live concerts once they start touring, but nobody's going to put out a record of freestylers at the moment.

TR: Not yet! [Laughs] So by the time you get a viable demo from a band, the group is fairly seasoned, and because of their experience they already understand themselves in terms of marketing categories?

CAW: They may think so. What most groups think of themselves, and what the record business requires or expects of them, are often very far apart. Helping the group to understand that their idea of what's marketable might not be really marketable in the year that they get the record deal is the job of the A & R department (artist and repertoire) and/or the management. But they at least have a sense of themselves as a

group, they have a sense of who has the best lyrics, who has the best style, who is going to be the lead, whatever. Sometimes, though, the record company might say, "That guy really isn't the lead. This other one has more personality." But, generally speaking, and certainly with Def Jam and Russell Simmons, he pretty much tries to work with the personalities as the group established them. His contribution might be, "This is the kind of music that's selling. Can you add two songs to your repertoire that fit this?" For example, right now gangsta rappers are the big thing. If they look like the kind of group that has the capacity to do that, then he might suggest they do some gangsta-style songs. With Nikki D as an example, she was not really as hardcore when she came to Def Jam. Then hardcore women rappers became popular. He knew that she had the capacity to do that, and he told her that she could and should work some of it into her repertoire, so she went back and worked on some hardcore raps.

TR: Let's diverge there for a moment. That's actually something I find disturbing and problematic about the way the market works in relationship to rap. I bought Yo-Yo's and MC Lyte's new records, and they're basically both coming off as hardcore female rappers. I'm not suggesting that their initial image wasn't also a performance, but it certainly wasn't as market-driven. But now, it seems as if all these women have to come out superhard to even remain in the game, whereas there still seems to be a much wider range of personae for male rappers. How much do you think this trend is about shaping the market or following a lead set by fans? When someone makes two or three gangsta cuts, is that following the gangsta style or is that perpetuating the gangsta style?

CAW: It's a little bit of both. The trick with marketing is that you have to do something that the market is already comfortable with, but you have to do something that's a little ahead at the same time. It's finding that balance which is the mark of a good marketer. [realizes pun & laughs] Sometimes a group cannot carry what the market is used to. When De La Soul first came out, there wasn't anything even remotely related to daisy rap; that just wasn't even happening. There was no way to think of what De La Soul are doing as gangsta rap, or hard or street rap, or militant rap—they just didn't fit. If they don't fit but they have good music, they have a good stage presence, and we can do something with it, then we'll just market them as new, or different, and work that. You have to find what makes the group unique. The underlying decision about Nikki D was that, whatever her original image, it wasn't so distinct or unique that it could be pushed as a separate entity. In those cases we look at her strong suits. She really is good at delivering fast lyrics, and she's very clever with her wording. There were a lot of people who did that, but she can, in fact, deliver stronger lyrics than most.

TR: *It'll be interesting to see how Salt-N-Pepa respond to this trend. I heard their new album is coming out pretty soon, so it'll be really interesting to see what direction they take, since they're not as easily fit into the hardcore image.*

CAW: They have an additional problem, in terms of marketing, and that is longevity, which is very difficult to achieve. The audience for all youth music, not just rap, has a very short attention span. A record is hot for three or four months maximum, and then it becomes an oldie, right? So then the key becomes how you can make the old record have the sustenance of an oldie. . . . There are a lot of old records that just die, and there are old records that you want to hear next year. There's some mental connection you have to them. Kids today remember all the words, just like we remember all the words to Motown songs. They even have that same relationship to the music, but not to every song. To become an act whose records have that kind of relationship to the fans, so that you end up having a body of material that has a long sales life, is the difference between a professional music group and a flash-in-the-pan music group.

TR: *Most rap-derived independent labels havn't been around long enough to have these "professional," top-shelf bands. Most rappers haven't been around long enough to really have multiple records until recently.*

CAW: In terms of the conversation we're having, that's important, because a record company can't survive without groups that have *catalogue* and *future*. That's how record companies survive. Most rap labels, or independent labels, were presumed to be short-term business deals, because rap was not perceived as something with a history, and its future was highly questionable, according to music business executives. It's only now that rap labels—and there are really only four—who are in a position to do this survive this transition, who have acts with catalogue and future, and these are: Def Jam, Tommy Boy, Uptown and Profile. Ruffhouse is getting there, but their big-name promising acts like Kris Kross and Cypress Hill are new. Priority is profitable because they have N.W.A.

TR: *They have Young MC and Yo-Yo, too.*

CAW: Right. The difference between a flash-in-the-pan label and a label that has longstanding groups is that the latter have more money to give to other groups, are able to take a risk on younger groups. It's like having the rap equivalent of Bruce Springsteen or Paul Simon. Those guys on those big labels—they provide the support base for the record company because they make sure that you have basic sales, which helps you cut deals with retailers, helps you get records on the radio, and provides money that

you can use to support other groups. So, for a record label to survive, it has to have groups with both past and future.

TR: Let's talk about this notion that rap has changed the rules about black music and the historical legacy of black musicians softening or diluting the blackness of the music in order to cross over to a white (and much larger) audience. There is a commonly held belief that rap has been "accepted by the mainstream on its own terms," that is, without compromise. It seems to me that what is really interesting about rap is that the notion of crossover doesn't emerge until long after rap has a prominent commercial presence. Run-DMC was accused of trying to cross over with rock samples, but frankly that was a misinterpretation of what they were doing. You had your first commercial successes like "Rapper's Delight," . . .

CAW: Kurtis Blow with "The Breaks."

TR: Yeah, Kurtis Blow, but I'm not sure he was a crossover attempt, because in effect, he was still very much in line with what rap was up to—he just happened to cross over with what he was already doing. He wasn't quite like the groups who were polished up and made to look like what a mainstream American audience would want/expect them to look like. So why is it, and how is it, that Def Jam or Russell had the confidence, or vision to promote rap as a hardcore black music? What was the logic behind that, and why did he think it would work?

CAW: Russell Simmons thought it would work because he saw it working on a smaller scale. He would go to clubs, and while the white kids didn't necessarily understand the music, they liked the style. The idea of wearing sneakers all the time was something that white rebellious kids could do. They might have a different kind of sneaker [laughs], but they liked the idea of being able to go to a party and wear sneakers and jeans as opposed to getting dressed up. In fact, this "slumming" was actually more comfortable for white kids than it was for many middle-class black kids. Middle-class black kids thought that when you went out on a Friday night you were supposed to get dressed up. White kids liked to dress down. So the rapper's image looked a lot more like . . .

TR: . . . like Saturday night for white kids . . .

CAW: . . . right, and Russell observed that from hanging out with Rick Rubin and other guys. So he figured that he could sell it, that it was something that he could get them to appreciate just on the rebellious tip, as opposed to understanding rap or music

aesthetically. He sold rap music as a style. He felt that, if he could sell it as a stylistic package, then the music and stuff would come later. The core audience would be street kids who knew the music, who would actually imitate rappers, which is something white kids would not feel they could do. White kids would feel that they could imitate the look—the sneakers, the hats, whatever, and look cool. So Russell reasoned that, if he could combine those two, then he had a hit.

TR: Doesn't that sound a lot like early rock and roll?

CAW: It's exactly like early rock and roll.

TR: But what makes rap different, then? It seems to me that the marketing history is somewhat different; the music seems to have retained a black edge to it for a much longer period of time. Fifteen years into recorded rock 'n' roll history and we had to remind folks that black musicians were the core inventors. Now, fifteen years into rap's recording history we've got Snoop Doggy Dogg and Onyx.

CAW: Because white people really can't do it very well, or it has taken them a very, very long time. Singing was different; you could go to school and learn to sing. [Laughs] Or you were already crooning. For Pat Boone to move from Andy Williams-type songs to black songs was not such a leap; the lyrical line was somewhat familiar. Rapping is a much harder skill to develop from the ground up. Certainly scratching is a different thing; people didn't even believe it was a skill. For a long time, they thought it was something that you threw together. Like breakdancing, rapping and scratching is something that you really have to master. It isn't like anybody could just flop down and spin around on their back.

TR: Also rock 'n' roll was in many ways more of a mixture of white country music genres with black blues and R & B. These sounds were more closely related to one another. What about consumption, though? Even though there are not many white rappers, there are plenty of white B-boys and B-girls. They wear the clothes, and they're buying the black versions of the music. In other words, what white kids would do in rock 'n' roll is buy Pat Boone, rather than buy Chuck Berry, but now they're buying Chuck D.

CAW: But for a long time, there was no equivalent Pat Boone in rap. It wasn't until the Beastie Boys that you had a white group who was trying to rap. In fact, they were the biggest-selling rap act ever! Until Vanilla Ice came along—now he's the closest thing to Pat Boone in rap.

TR: Why is that?

CAW: Same thing. White kids bought Pat Boone, so they bought Beastie Boys! And then Vanilla Ice. The way I see it, the Beastie Boys, to their credit, did not attempt to pretend to be black. Their rap was pretty much the idiotic, rebellious, middle-class, "I don't like my parents" kind of rap. They didn't try to be urban. They were just rap kids who rapped rather than sang. For example, *License to Ill*, their 1986 record, they had a real ill image, and they sold it to white kids. At that point, white kids in general thought that the only real difference between rap and R & B was that for one you spoke and for the other you sang. It was a while before they caught on that there was a skill involved in rapping.

TR: But I think that a lot of white kids thought of the Beastie Boys as real rappers— as in—they rapped like black kids—even though most black rap fans could hear major stylistic differences. But, let's go back to the question of crossover. Even though the marketing wasn't intended that way, basically what you're saying is that white people buy white people's music more regularly. Beastie Boys were a little bit different be- cause they in fact weren't trying to imitate black artists completely—they brought a kind of rock/punk style to their rapping. Whereas Vanilla Ice, who was obviously trying to be a white Negro, clearly couldn't really rap that well, but he still outsold everybody. How do you explain that?

CAW: By the time Vanilla Ice appeared, rap was a very familiar sound. When the Beastie Boys came out, black kids knew about rap, and black kids on the East Coast knew a lot about rap. Even though it was popular, it was still fairly limited. The Beastie Boys were essentially introducing a lot of the rest of the country to this music. By the time Vanilla Ice came out, rap was already fairly well known. There had been some rap movies, there were some rap lyrics on commericals, and L.L. Cool was big, so there were other "safe" black rappers around. There was a body of work that white kids could feel comfortable with, and then Vanilla Ice came along and attempted to be the Elvis Presley of rap. He sold more records—eight million, I think—than anybody else.

TR: He outsold Hammer and Tone-Loc.

CAW: Hammer is first; then there's Vanilla Ice, and then there's Beastie Boys. So the three rap artists with the greatest sales are the black guy who's rap was like a white im- itation of a black rapper and the two white groups who imitated black rappers. [Laugh- ter] Those are the three lead sales, to this day.

TR: You've said before that early rap frightened mainstream record companies. Exactly what was it that frightened them?

CAW: Record companies say that the early rappers—with the exception of a Kurtis Blow or a Dougie Fresh—most of them like Afrikka Bambaataa or Grand Master Flash or the Sugar Hill Gang—had pretty rough management. The people who were involved on the business end of early rap music were people who were, in fact, frightening, whether they were just sort-of frightening, or pretty rough-looking guys, or very tough. They also found the images of the artists frightening. Rappers were not tuxedo-wearing black guys, they dressed like working-class kids—which translated into looking like the black guys you feared would mug you on the street. The management and the rappers frightened black industry people, much less white people. But record companies also have their own thugs, too—and Dannen's book *Hit Men* is testimony to all of that. The difference is more of a matter of criminal style. Record company criminals are more accustomed to doing you out of your money, and telling you that they're going to buy you a whole bunch of Rolls-Royces, and then use up all of your money and own you. But, in rap, the criminal process is different. People literally have shot people, and have been shot—it was a new phenomenon for these people! [Laughs] Gun fights were not a part of regular business practices—they were more accustomed to drugs, laundering money, that kind of criminal element, not 'round-the-way, straight-up street hoods.

TR: So they were afraid both of the music and of the people that they felt they had to work with in order to sell it.

CAW: They were afraid of the people they had to work with, and that's why they were afraid of the music. The music was a little difficult to embrace because they couldn't be sure how long people would listen to songs that were not sung. That would be something they would think of as more of a novelty, but that's a different kind of fear. They might be afraid to put a whole bunch of money into that act. . . . But that's similar to any other kind of novelty in the mind of a record company executive. A couple of the independent labels started one or two acts that they believed in, and they started a label as part of the process of getting a distribution deal for the group or for the record. But they did not expect the label to remain viable. They were just trying to develop a way to sell their particular rapper. So it was a while before the bigger record companies, the Sonys and Warner Brothers, began taking rap seriously as a genre with longevity. So the big guys really left to the independent labels the job of finding the new rap acts and putting all the energy into working with them. That meant that rap acts had smaller budgets and much fewer resources, generally. This eventually contributed to sampling problems. If a rap producer had a choice between paying legal fees to

clear samples or cleaning up your last demo in the studio to make the music better, they will put the money into the record. It was a while before people even started chasing rappers for sample clearance. Since they had so little money to work with, they couldn't see investing it in sample clearances, especially five or seven years ago when it seemed a small and distant problem. But having less money also limited rappers' ability to produce music with a lot of a complexity or depth to the cuts, because they just did not have that much time to spend in the studio. It's not until Public Enemy's *Nation of Millions* (1988) that the music begins to have elaborate musical layering.

TR: That's true, but you are referring to a certain kind of musical complexity, because there was a different kind of complexity, rhythmically and sonically, going on even when there were limited production funds. Say, Eric B. and Rakim's first album, Paid In Full (1986), which precedes Public Enemy's Nation of Millions, is pretty extraordinary in its sonic and rhythmic arrangements.

CAW: Right, but I'm pretty sure that Hank Shocklee was the first rap producer to make a conscious decision to put a lot of money into production. It is a difficult decision to make—it is also a gamble. The money used to produce the record comes from the record company's advance to the artist against royalties. So, it is really your money that you're using to make the record, (something that a lot of artists don't realize). Artists get a check for one hundred fifty thousand dollars and that's the first time they've ever seen a check with that many zeros and their name on it. From that money they have to produce the record and they have to live off that money for months, sometimes a year or longer, until they get royalty payments.

TR: And they have to sell enough records so that the first one hundred fifty thousand dollars worth of royalties which they have already spent can be recouperated by the record company. After that, they see payment number one. It could be years before they see any money, right?

CAW: That's correct. Because of that, a lot of groups get crazy because they have all of this money, and then really in order to survive they have to tour. They have to be able to have a performance career in order to live once they've cut the first record. Actually, you could cut the first record and then not have it released for quite a while, so there's potentially a large time gap. So you have to know to take your cut off the hundred and fifty grand, take your thirty thousand dollars, which is all you're going to get to live on, and God help you if you've got a group of five! If you've got a group of two, that's fine; if you've got a big group, then you're cutting it up five ways and still have to make the record.

TR: You've got to get a day job.

CAW: Right, or tour. Once your record comes out, you have to do a lot of touring, which is basically free promotion stuff. You've got to go around and talk to radio stations, talk to the retailers, and so on. You don't really get paid for that; your expenses might get covered, but you don't really get paid. And then touring becomes a problem for rappers after 1985—after the Long Beach, California Arena gang melee. The mainstream press, which had already begun to presume that rap concerts are dangerous, really went to town. This is a serious problem because their capacity to make money diminishes dramatically when they are frozen out of the largest arenas. The cost of putting on a rap show increased phenomenally after that because the insurance rates went up. . . . So the ticket prices went up. Before, you could have a show that only had two groups; now you have to have a show that's going to have five groups lined up to cover expenses. Each group gets less money, the ticket price is higher, and moving the groups around costs more. So now, the touring options for rappers are fewer and their need to tour for income is as great as ever.

Who's Zoomin' Who? Rights, Contracts and Ownership

TR: Let's talk about the question of publishing rights. Why is it important for artists to have the publishing rights to their lyrics and songs, and why have so many artists relinquished these rights? Do rappers, as compared with other artists, tend to have more of their publishing rights, or less?

CAW: There are three profitable areas for artists. The first is when you record the music and you sell records. You get some money off the direct sale of the record—this is called royalties. The second is if somebody else records your record, or if your record gets used in something other than the original song that you recorded, like a commercial, or on a sound track—this is called publishing. The third is if it gets played on radio—this is performance. So you get money from your royalties on records sold from your record company, you get licensing fees from the publisher, and you get money from performance from ASCAP or BMI, or now SESAC, which is a smaller version of ASCAP or BMI. Most of the time, when new groups are starting out and come to the record company, the publishing rights don't seem like a big deal to them. They're really focused on royalties and getting a record made. The other thing they might be interested in is touring opportunities—going out and performing live—getting some money for that. So record companies have a tendency to say, "Well, give me those publishing rights," and that becomes something that the record companies get from the group, and the group gets fifty percent and the record company keeps fifty percent of the publishing rights. The group can say,

"No, I'm not going to give up my publishing, I want to keep my publishing" and then become a publisher of themselves. Keeping one's publishing rights is a major undertaking and it's also a major contract negotiation item. But the average new group doesn't even think about publishing.

TR: Even today? Even today they still don't know that publishing is a major source of income?

CAW: No. And it isn't necessarily so, unless you produce a catalogue of material. If you're only going to be a flash-in-the-pan group, fighting over publishing doesn't really make that much sense anyway. It only makes sense if you're going to have a body of work, because you're not going to make a killing on each and every song. It's when you have a body of well-known work that publishing rights matter. People might want that Public Enemy sound, and they might go through your catalogue to use it. But generally speaking, rap catalogues have not had a whole lot of revenue strength, because they were so lyric-driven rather than tune-driven. The music is important to rap, but not as valuable in terms of publishing rights. Often the rap tune wasn't original with the rap song. They relied heavily on samples from somebody else, so it was James Brown who would make the money rather than Eric B. and Rakim, because rappers' tunes are not completely original—most of the songs are comprised of samples. So, they have to pay the other publishers for the right to use that material.

TR: So the publishing rights, then, become important with the larger acts that have what you're calling a history or catalogue. Since most bands sign those standard multiyear contracts before they expect to have a history, the ones that become successful don't necessarily have any publishing rights.

CAW: Publishing is often an area for renegotiation. They often start out with a fifty-fifty split, then they might move to seventy-five-twenty-five. Sometimes they move to eighty-five-fifteen. A super-large group might get all the publishing rights back. As they get more successful you review your contract for things to give the group.

TR: How long are these contracts, generally speaking?

CAW: They're not set by years, they are set by album, so usually bands are signed for six to eight albums.

TR: Most rappers haven't even gotten through half of their first contract—they can't even think about renegotiating!

CAW: That's right. Most acts—not just rappers—do not make it through the first contract. So the record company locks you up for a significant portion of your career, because the average pop group barely makes it through half of an average contract. If a pop group makes three records, that's a successful act!

TR: *So the record companies lock the artist up for six to eight albums so that they can be sure to cash in on the acts that might get big after the first few album attempts. I suppose that, from their vantage point, it's the second three records that have the potential to make the big money—if they get made at all.*

CAW: That's correct. So when you come to them, you come as a new act with not much negotiating power, because the record company is going to have to lay out all this money, and it's a lot of money. I don't want to understate how much it costs. To get the record distributed nationally—to get twenty copies of every record into every record store in the country—is a big financial undertaking. To get radio stations to play this record—every radio station has a forty-song cap on its three-week play list—to get your record to be one of those forty costs money.

TR: *Forty out of how many songs?*

CAW: About five thousand. [Notes shocked look on my face] It's a lot of songs. And some of those spaces get snapped up automatically by established groups. If a Janet Jackson record comes out, they'll make space for it, so that's one less space that you can compete for. And then there are different formats—black radio has one format, adult contemporary has another, so you've got to pick which stations will carry this record. For rap, you have to put a lot of energy into underground stuff—making sure that DJs get it and play it in clubs so that people will start demanding it. You might have to put a lot of money into getting the video done so that it will be on TV and people will start demanding it. There are lots of other monies that you have to expend in order to put pressure on radio to play this record. Radio has to get a sense that people want to hear the record.

TR: *What kind of investment is this? Let's just talk numbers. Let's say I'm a new rapper—Sweet Tricia, and I get my one hundred fifty thousand dollars advance from my royalties to make the record and so on. Where are all the rest of these expenses coming from?*

CAW: Some of it also comes out of your royalties. Some of the marketing money wouldn't, that would be another point of negotiation. Certainly a portion of the music video and publicity costs comes out the artist's percentage. Promotion, for example, sending the group around on a tour to convince radio to love them, that might not come out. Selling

the record to radio—that wouldn't come out of royalties. Neither might the artwork for your posters. Some of it might, some of it might not. If you wanted any special packaging, that would certainly come out of the royalties, but if you just had standard packaging, the label pays for that. Distribution costs are covered by the label.

TR: Those distribution costs are factored into the price of the CD and the number of records and CDs that you choose to press. The vast majority of the expenses are coming out of the musician's pocket in the long haul, and yet record companies still consider it expensive to front the money. Since they've got the next ten years of the artist's productivity to draw on for profit, they can recoup one way or another. So, what's the big expense? Why do record companies cry the "it cost so much" blues?

CAW: From a record company's position, I'd have to say, "Gee, this is pretty much a win-win situation."

TR: Even you have to admit that!

CAW: Oh, without question! But the only spot where that doesn't work is if the record bombs, and a significant portion of the records bomb. So that every Public Enemy album is covering for No Face [laughs], BWP and so on. So you've got to cover for failures. And you also have to decide when you're going to cut your losses. You have the option to release them from the contract if you don't think they're going to be productive.

TR: So what's the minimum sales figure that would save a group from being released from their contract?

CAW: Mmm, about two hundred thousand.

TR: But that seems like a pretty solid initial fan base.

CAW: Yeah. If they sold two hundred thousand on the first record, you would keep them; if they sold two hundred thousand over the course of three records, no.

TR: So, Def Jam's ability to market certain artists may have an effect on sales?

CAW: That's right. In that kind of case, you can get stuck because the artist can really get a lot of advances. . . .

TR: But that's a negotiation problem. The record company is going to basically fight as hard as it can to lower its advance to the artist, unless they feel a band is a total smash and they just know it.

CAW: That's right. But that's a rarity.

TR: As I understand it, smaller record companies have distribution deals with larger record companies, and some have production and distribution deals. What are the differences between the two?

CAW: A distribution deal is where you, the independent label, are paying in advance for the cost of making the record, and you show up at the major label with a demo master tape ready to be pressed. A production/distribution deal is one in which the major label advances to you, the smaller label, the money to pay for the production of the record. So you give most of that, or a significant portion of that, to the artist to make a record. Then the record company becomes more involved with helping you pick the studio, figuring out who the engineer is and managing the costs. A joint venture deal is when the major label and the independent is splitting costs fifty-fifty including overhead. The larger company takes distribution costs and marketing costs off the top. So a distribution deal has the most uneven power relationship and a joint venture is much closer to partnership.

TR: How common are joint venture deals?

CAW: Distribution deals are more common than joint venture deals.

TR: In the same way that the artist is at a disadvantage negotiating with the record company, an independent record company is at a disadvantage negotiating with a major, right?

CAW: Even though an independent company can have great records and great artists, they have very limited distribution outlets; they have no way to get that record to everybody across the country. You cannot sit in New York and make sure that your record is being sold in Boise, Idaho unless you have some nationwide distribution system.

TR: Nationwide distribution is dominated and completely controlled by the six major labels, right?

CAW: Right. Warner Brothers, Sony, EMI, Polygram, MCA and BMG; only one of which—Time-Warner—is American-owned, by the way. (At this point, Japan owns Sony and MCA,

EMI is British-owned, Polygram is owned by a Dutch company and BMG is German-owned.) So, if you want your record distributed widely, if you want it on two hundred radio stations simultaneously, if you want it on all the video outlets at the same time, you've got to hook up with these six corporations. The small record companies are concerned about getting the record into every retail outlet, and making sure that the retailer puts the name tag on the record so that the artist is not just under the "F"s but under her name, right? They want to make sure that the record is selling at the front of the store when it first comes out, and that there's a picture of the group in the store. All of those things make a difference in sales. A small label doesn't have the money to do that, so the first deal you make with a major record company would be, "For every record that we sell, we'll give you twenty five points." (Points are percentages out of one hundred percent of how the royalties/profits get divided.) You, the small record label, then, have to go to an artist and say, "I'm going to give you fifteen points, and I keep ten." In reality, you don't tell the group you're going to keep ten, because you don't reveal how many points you have to distribute.

TR: That's really how it works? The independent label keeps less than what they give the artist?

CAW: Yes, but I'm taking ten percent of artist A and ten percent of artist B, so my ten percents add up. You're only getting this one fifteen percent. Michael Jackson's got a very lucrative deal. He's reputed to have the most lucrative deal in the industry, at thirty percent. But most artists do not expect to get anywhere near that. Some artists with big deals might get eighteen, twenty, twenty-two, twenty-four, percent. After the artist's cut, the independent label works with the remaining percentage. So, of course, the independent label tries to negotiate with the major label to pay some of these expenses. An independent label might say, "I don't want anything taken off my profits for distribution costs." Then the major label tells you how much they spent, and you basically have their word as proof. Who's to say that a company didn't keep your profits and called it distribution costs? So it can become sort of like a company town thing.

TR: As Chuck D has said, show business is five percent show and ninety-five percent business.

CAW: It's really, in its institutional design, a very plantation-like system. Not just for rappers, but across the board for all artists. The record industry is very plantation-like. Every rung down gets less and less of the pie, and the artists are at the bottom.

TR: *What does this mean about the possibility for creative control? What are your thoughts about this profoundly confining and unequal relationship?*

CAW: The primary issue in the music business is profit. So, even black record executives with a conscience are trapped by the rules of the institution. Artists on all labels get exploited, some get exploited less than others. Really big-name stars get exploited less, but what they get paid is not commensurate with the profits that they generate, and their creative control expands only as much as the company feels they can sell this new product. This is one of the reasons so many artists behave in temperamental ways that seem juvenile and irrational, and it explains why label executives accept artists' quirkiness and artists' negative behavior and so on. When record companies give them the limo, or the girls, or whatever else they give them, it's not out of some largess or because they think it is fair compensation. It's like . . .

TR: . . . *the European settlers giving tobacco and beads to Native Americans in exchange for land . . .*

CAW: Yeah, right. . . . It really is like that. It's very difficult for an artist to break out of these lengthy contracts. It's very rare for an artist to be able to be both an artist and a businessperson, and to get some control over their career at that level. That's very, very hard and frustrating.

TR: *Given that, then what is the significance of rapper-owned record companies like N.W.A's Ruthless Records, Luther Campbell's Skywalker Records, or Flavor Unit Records. Is this artist-owned label phenomena really something that could redistribute the power in the industry?*

CAW: I think it will be a very, very long time before power is actually redistributed in the industry, especially now that the industry is owned by these multinational conglomerates who are utilizing the entertainment industry to fuel much bigger enterprises. Sony bought Columbia records to help them sell hardware. It's not as if they had this burning desire to sell Public Enemy records. [Mutual laughter] They're trying to sell electronic equipment. Artists' work sells interactive television, it sells video games—each artist is a pindrop, a pinhead on this much bigger mosaic. The record industry is worried about its strategic positioning in relationship to the film industry or records versus television versus telecommunications versus phone companies; that's the kind of jockeying they're doing. They're not talking about Public Enemy versus Bruce Springsteen.

These artist-controlled labels are not really going to change the balance of power in the industry. What they can do is facilitate an artist getting more control of his or her own

individual career. Mind you, for the individual artist, this is a profound difference. Are you just going to be a slave that gets beat up? Or are you going to be an overseer, be someone who is higher up in the hierarchy? Those distinctions are real for you as a person. And these artist-owned companies gives them the institutional structure to produce and develop new talent. So, when a rapper brings in new talent, having a company can mean the difference between getting a flat fifty thousand dollars discovery fee and a thank-you from the larger record label, and being able to negotiate a long-term investment in that artist's career. Suppose that artist becomes a big seller . . .

TR: Like Jam Master Jay and his "discovery" of the rap group Onyx.

CAW: That's right. But for most acts who've brought a new hot group to the attention of a label, up until now, somebody would thank them, maybe give them some money, and they would have no relationship with that act whatsoever, nor would they see any profits for their efforts. Somebody as famous as Gladys Knight, who discovered the Jackson Five, didn't get money. She just got a thank-you from Berry Gordy.

TR: I'd go bald over that one.

CAW: This is an industry-wide phenomena, it's not just rap-related. But because rappers are such a small and insulated group, and because the labels that rap music profits helped found are few and highly visible, you can see this dynamic more clearly in this genre.

I Can Live Without My Radio

TR: One of the things that you alluded to at the Princeton conference was the significance of the major record labels and the entertainment industry at large realizing that rappers could sell products to white middle America. They seemed to have overcome their fear of B-boys. An image of some rapper selling Coke, they decided, was not going to traumatize the middle-American family gathered wholesomely around their living room television screen. In fact, rappers seemed to stimulate sales among the wannabe hip. This meant the rappers would soon become viable outlets for sales revenues in Hollywood and for general advertising. How was this fear overcome? What changed?

CAW: Well, the key is that the B-boy will never really come to your home, right? [Laughs] He can only appear on the screen. He can only come through that hamburger. He can only come through that sneaker style, whatever.

TR: *He's fully mediated by a commodity . . .*

CAW: . . . and so he's fully safe. The first big rapper who made this transition was Fresh Prince. When television producers selected a rapper for a white middle-class television audience, it was a light-skinned guy from Philadelphia from a middle-class background. Even when he was rapping full-time, Fresh Prince's raps were "Parents Just Don't Understand," and "Nightmare on My Street." He was as much a comedic poet as a rapper. Because of his image and talent, they were able to market him as a fresh-faced kid with a little ghetto flavor. He had a little edge to him because he used black slang. But that was as much as Hollywood or the mainstream television audience really saw. They found a rapper who would be safe but at the same time appear cutting-edge. The only other place you could see rap was on the Cosby Show. Theo, the Huxtable's son, grew up listening to rap in a very safe context. This was significant because these were black people whom middle-class White Americans know and understand, who are accepting this music in their lives and homes. Of course, in reality it wasn't true. Black middle-class adults have not been supportive of rap and black radio was refusing to play rap.

TR: *Why did black radio reject rap music?*

CAW: Advertising. All radio is local—even when they advertise nationally, the vast majority of things that they sell, even when they sell McDonalds ads, are being sold for the local outlet. McDonalds, the Cadillac dealership, the Seaman's furniture store and so on— they want to be assured that when they advertise to a radio station's listenership that this audience is not going to come to the store and steal from it or break it up. Radio station advertising salespeople censored themselves. They were sure—even before they were rejected—that local stores would not want to appear as if they were advertising to rap's core listening audience: young black teenagers.

TR: *The promotion and the advertising departments at black radio feel as if they have to convince the advertisers that their listeners are not hoodlums, but that they're upstanding black people?*

CAW: . . . who have money. . . . But rappers, or the rapper image, was an image that was frightening to your local store owners. They did not want to up the number of black kids who are coming into their store with baggy pants and their hats on backwards.

TR: *Do you think the radio stations are right about rap fans and correct in deciding to affirm advertiser's fears?*

CAW: I think black radio and the advertisers overreacted. I think that a lot of the products that they sell weren't going to be attractive to that audience anyway. A fourteen-year-old kid isn't really that interested in going to Seaman's furniture store and certainly isn't by definition a thief. And black radio really could have utilized rap music to expand its advertising base, because there are a lot of stores and companies who do want to sell to a young black audience as well as the other audiences who listen to black radio. But black radio has spent most of its time trying to "upgrade" its advertisers, that is, trying to get the more prestigious sponsors. They were trying to upgrade the image of their audience by courting advertisers who are associated with higher-class demographics. To be fair, black radio's attempts to upgrade its local advertising base is also related to its inability to reserve the big national advertising spots, since advertisers presume that black radio has a smaller audience which spends less money. Some of it is sheer numbers: there are a lot more white folks in this country than black folks. So a bigger part of black radio's advertising dollar comes from these local stores. Rock or pop stations can more easily get a national ad for McDonalds, a Colgate, Tide, and all of that. But black radio doesn't get that as easily, so their dependence on these smaller, local outlets is much more significant.

The main problem with black radio's response to rap music is that they didn't wait for Seaman's and so on, to reject the audience. The radio executives decided in advance, "Since we're afraid of these kids and think they are going to mug us, we know that Seaman's won't want them." And that was the beef that Russell Simmons has had with black radio. So black radio's rejection of rap, combined with the touring problems, really limits rap's media access. It has also led to rap's disproportionate dependence on video outlets for visibility. There was no other way—except for smaller club dates (which is a specialized market) for kids to hear or see rap performed. If you're trying to sell records to the kid who's not allowed to stay out on Friday night past midnight, [laughs] or who can only go to one party, you've got to get on radio, you've got to get on TV.

TR: *But I do hear some rappers on New York black radio stations. How did they get through?*

CAW: Since there are a number of rap groups that are considered "respectable," black radio has relaxed their silent rap ban. And at the same time, rap defines "cool" for this generation, and black radio doesn't want to be corny! On black radio, you can get rappers who have made the Top 10 or Top 20 rotation. The occasional big group gets played, like an L.L. Cool J, on white radio. But the bulk of rap's artists still depend on college radio, on listener-sponsored radio and on other alternative outlets.

TR: Who listens to black radio?

CAW: Black radio's audiences are actually considerably older than rap's audience. Rap music's audiences are twelve to thirty years old, while black radio's audiences are twenty four to forty years old. There's really a hole in the radio demographic for young black people.

TR: Since there is no real radio market for teenagers they rely on video culture, which explains why MTV's mining of rap video was so lucrative. But there were still advertiser's concerns for MTV and for BET (Black Entertainment Television). They also seem to contain rap programming to keep advertisers happy. What if someone started a twenty four-hour rap show? Could you find advertisers and make tons of money?

CAW: The question is, can you? And that's what we're trying to figure out.

Women in the Music Business

TR: Let's talk about the gender issues in rap and in the music business, in general. How and where do women function in the music business?

CAW: Well, it's good news and bad news. Women are a bigger presence than you would think at the executive level in the entertainment business in general, and in the music business specifically. At the *absolute top*; very few women run record labels, not one is running a major label. There are women who run particular departments, and Sylvia Rhone runs a label. But the bad news is that women do not make anywhere near the same salary for the same positions. These are not small salary differences, we're talking about at least a twenty thousand-dollar-a-year gap and more. And there are very few women who are at the level at which stock options or equity in the company are offered, those kind of things which are normal in the old boy network are not passed on to women, no matter how high up the corporate ladder they may be. This is true for women of any color. So the record business is not particularly different from other industries. What makes it especially noticeable in the music business is the fact that women are heavily relied upon for the nurturing of artists. Keeping your artists happy, keeping them in line, and keeping them working along with you is a key part of the record business. We talked about this whole plantation thing—well, if the slaves uprise, you're in a lot of trouble, so women are used to negotiate artist's emotional needs. You will notice that women will dominate publicity, artist development, product management—all those "keep the artist happy" departments. We do not dominate sales, we do not dominate business affairs, we do not dominate marketing.

TR: What about everyday work conditions for women? I've heard a number of horror stories.

CAW: It's a very macho industry across the board, not just with rappers. There's a lot of foul and sexist language that is routine. The things that Anita Hill said she heard from Clarence Thomas over a four-year period, I might hear in a morning. My boss, if he wants to tell me I did a good job, he'll call me up and say, "Carmen, I'm on your dick!" Should I say, "Look, this is sexual harassment, I shouldn't have to hear that," or do I take the props (praise)? That's the kind of decision that women have to make literally by the hour— not by the day, not by the week, but by the hour. It's at that level of conversation all the time. Rappers also use verbal disrespect, verbal abuse and constant sexual innuendo in their interaction with women employees. By contrast, rockers have groups of girls or groupies around them a lot more than rappers. So you, as a woman executive or woman in artist development in a rock division, might be asked to cover for the rocker who leaves some girl drunk and battered in the back of his car. Part of your job can require you to cover for really blatant sexism, sexual harassment and abuse. It's hard to fight because it is so routine for the rockers to abuse women on that level. In my experience, rappers are not often that physically abusive.

TR: Clearly, the culture of the music industry is profoundly sexist, and yet fully depends on women to manage their primary investments. Is it that they're more threatened by women's presence because the male executives are more dependent on women to keep things running smoothly? What do you think motivates their behavior?

CAW: There is a mutual love-hate relationship between the record company and the artist. For the record company, there's the basic: "We need these artists," but there's also the belief that "Artists come a dime a dozen." So the people who take care of the dime-a-dozens are treated as dime-a-dozens people, too. The sexism travels more like that.

TR: So the abusive logic of the industry has reverbatory effects going all the way up the ladder.

CAW: Right, and up in the upper eschelons of executive management, they consider women and girls one of the perks of their job.

TR: Let's bring it down to the rap context. You're saying that rappers are much more likely to be verbally abusive but not physically abusive. What about the day-to-day contact between rappers and women employees? I spoke to a black female video producer who

said that she sometimes has to speak to rappers through her male coworkers because she can't get these rappers to respect her role as a producer and do what she's asking them to do. They'll call her "sweetheart" throughout the video shoot, lick their lips at her, constantly undermine her authority.

CAW: There's no question that the reason rappers work with me is their sense that Russell thinks I protect his money, period. And I'm older. The fact that I have a body of professional skills is irrelevant, absolutely irrelevant to them. It's as if I am Russell's business wife, not his romantic woman. Their fear is that if they don't treat me with respect then Russell will be mad at them, not "Carmen deserves respect." There is no woman who's respected at Def Jam who does not have Russell to watch her back. This is true for most of the upper-level female executives in the music business.

TR: So what happens to the women who don't have that sort of patriarchal protection, women who are independent producers or work for very small labels?

CAW: The same thing that happens to the black female producer you mentioned earlier. You literally end up having to find the man who is going to front for you. Or you have the physical size and diva status to establish authority against the odds. Even then, all powerful women are at some point labeled a "bitch" for exercising their power—often they are called bitches to their faces. I had to put one artist out of the office because he told a woman staff person that he wanted her to suck his dick, straight up. I said, "You can't come back in here until you apologize to her." And we had to get Russell and Lyor Cohen to back us up, to agree to tell this artist that he couldn't come back in the building. But it was not an automatic decision.

TR: You had to persuade them that this was a legitimate reason to demand an apology?

CAW: No, in this case they backed me up immediately, but if the rapper had been somebody who had been selling a lot of records, I'm not sure that I would have won.

TR: What about women rappers and women music producers. You've described an environment in which women employees are treated in a consistant and extremely sexist manner. Are women rappers treated like their male counterparts, since they are potentially equal money-makers?

CAW: Women rappers have a special set of concerns: one, record companies have not yet found a sure-fire sales strategy for female rappers' work and two, female rappers have less business savvy and are less aggressive negotiators. They rarely come to negotiation

sessions with high-powered legal representation. I'm not quite sure why that is, but they generally hire lawyers for whom they are the first or second or third client. It's very rare to see a woman rapper walk in with seasoned counsel. The power of your counsel to represent and protect you has a serious effect on your image with the record label. Too often, women rappers' records are categorized as "We're waiting to see what's going to happen with this artist." They are not considered, "This is the breakout one." So oftentimes they don't get promoted as well, and the initial assessment becomes a self-fulfilling prophecy.

At the same time, women rappers as a group have some clout because everybody's waiting to see who's going to be the break-out woman rapper. People are trying to see who's going to be the Diana Ross of this music. And that person has not yet arrived.

The Dance Continuum

In the Empire of the Beat
Discipline and Disco

Walter Hughes

Few forms of popular culture receive the kind of opprobrium that has been lavished on disco music since its emergence in the seventies. Although innovations in American popular music, especially those associated with dancing, sex and African-Americans, usually provoke harsh criticism at first, most eventually achieve recognition and admiration. Jazz, rock 'n' roll, reggae and now rap all have not only devoted listeners but intellectual defenders; conspicuously missing from this canon, however, is disco. Even at the height of its popularity, it was widely condemned, most vociferously by the admirers and consumers of popular music themselves. Today, many years after its supposed "death" at the end of the seventies, the mere memory of disco provokes from many people a vehement dismissal of it as an affront and an embarassment; moreover, musical styles that suggest the vital continuity of disco into the present, such as house music, suffer from guilt by association.

The intensity of this hostility and its peculiar rhetoric result, I would like to argue, from the enduring association of disco with male homosexuality, a link best demonstrated by the terse and ubiquitous critique that appeared on T-shirts and bumper stickers during the late seventies: "DISCO SUCKS." But even the subtler critiques of disco implicitly echo homophobic accounts of a simultaneously emerging urban gay male minority: disco is "mindless," "repetitive," "synthetic," "technological" and "commercial," just as the men who dance to it with each other are "unnatural," "trivial," "decadent," "artificial" and "indistinguishable" "clones." Nor is the association of disco and gay men only a hostile construction; the rare apologist for this style of music, such as Richard Dyer in his 1979 essay "In Defense of Disco," likewise associated it with the gay "subculture" that alone seemed to regard it with unabashed affection.[1] The 1977 film *Saturday Night Fever*, the exception that proved the rule, was an overdetermined attempt to heterosexualize disco by showing that white working-class males who harass homosexuals and rape women could dance to it, as long as it was performed not by the African-American divas preferred by gay men, but by a trio of Australian falsetti.

147

Historically, disco music was one element in the post-Stonewall project of reconstituting those persons medically designated "homosexuals" as members of a "gay" minority group, and of rendering them individually and collectively visible. As such, it contributed to the construction of one specific but highly publicized sector of the developing "gay community," urban gay males, a construction assiduously pursued both by the mass media and by the urban gay males themselves. I would like to address the instrumentality of disco in this identifying process by posing the following question: just what is it about disco music that enables men to dance with each other and so represent their "sexual identity" to society? The answer I would like to propose is that disco is less a decadent indulgence than a disciplinary, regulatory discourse that paradoxically permits, even creates a form of freedom.

If disco is a form of discipline, it resembles many of the other salient aspects of urban gay male culture, such as bodybuilding, fashion, sadomasochism and safe sex. As it has developed in major American cities, gay male identity derives to a great extent from a series of practices that combine pleasure with the discipline of the self.[2] One significant moment of gay identification might therefore be the realization that the policing and regulation to which homosexuality is subject in our society are themselves erotic practices, practices that may be claimed for one's own pleasure rather than being left to parents, policemen, psychiatrists, fagbashers, priests and senators from North Carolina. This moment, when one seizes from these others the power of constructing homosexuality, and usurps the pleasure attendant on this exercise of power, is a moment staged in the disco nightly. By submitting to its insistent, disciplinary beat, one learns from disco how to be one kind of gay man; one accepts, with pleasure rather than suffering, the imposition of a version of gay identity.[3]

Disco, as I will speak of it today, is not only a genre of music and a kind of dancing, but the venue in which both are deployed; it is, as its name suggests, site-specific music, the music of the discotheque. The name also defines it as music that is technologically reproduced, "on disk," not performed. As long as people go out to clubs and dance to recorded music, therefore, disco lives, even if it is never "live." This definition dispels the rumors of disco's "death" in the early eighties; disco is electronic dance club music and as such it may be revived by infusions of rock, new wave, punk, Hi-NRG, hip hop, house, and techno-rave, but it nevertheless retains its generic continuity. Revival is both its project and its method. For urban gay men, "disco" is where you dance and what you dance to, regardless of the technicalities of musical innovation and evolution.

But these definitions also evoke the rhetoric of the critical attack on disco: dance music cannot be serious music because it speaks to our bodies, not to our minds or aesthetic sensibilities; it is commercially produced for consumption in an urban environment; it abandons the inspired composition or improvisation of the singer or instrumentalist in favor of a slick, overproduced studio product; all of which leads to what disco defender Brian

Chin calls "the classic lie" that "disco kill[ed] 'real' music."[4] Whatever aesthetic evaluation one makes of disco, one must understand that its importance to the formation of gay male identity lies precisely in those characteristics which are most often decried in this way as musically murderous.

Foremost among these is the beat. Disco foregrounds the beat, makes it consistent, simple, repetitive. The origins of disco music have been traced by house historian Anthony Thomas to late sixties DJs in mostly gay, black clubs, who spliced together the faster soul songs into a continuous dance "mix" that provided a predictable, unbroken rhythm conducive to a long spate of dancing.[5] As Vicki Sue Robinson says in an early hit, disco "turns the beat around, turns it upside down." This troping and inversion of the beat makes it the dominant element in the music, and attributes to it the irresistibility that is disco's recurrent theme. As the lyrics of disco songs make clear for us in a characteristically redundant way, the beat brooks no denial, but moves us, controls us, deprives us of our will. Dancing becomes a form of submission to this overmastering beat.

The oft-noted vacuity of the lyrics of disco songs is itself a part of the medium's message; they usually strive only to translate the rhetoric of the beat into simple imperatives: "Got to keep on dancing, got to keep on making me high"; "My body, your body, everybody work your body"; "Come on come on get busy, do it, I want to see you party." Often these lyrics become little but counting, a repetitive enumeration that signifies only a precipitancy of succession without teleology or terminus ("five, four, three, two, one, let's go" or "one, two, three, shake your body down"). Language is subjugated to the beat, and drained of its pretensions to meaning; almost all traces of syntax or structure are abandoned, reducing language to the simplest sequential repetition, a mere verbal echo of the beat itself.

This emptying out of language parallels the refusal of narrative structure in the song overall. There is rarely an identifiable direction, progression or climax in disco music; the prolongation of its own continuity is its only end. The mixing of the music by the producer and the remixing of it by the club DJ shatter, rebuild, and reshatter any architectonics a disco song might ever have possessed, making it difficult to identify its beginning or end. In the discotheque, the "disco-text" strives to shake off all remnants of its own textuality, to become pure, unconstructed, undifferentiated discourse, this purity being another expression of its unmediated power to stimulate dancing.

The process of dissolving musical, linguistic and narrative structures that disco dramatizes reflects a similar unmaking of the artist. Critics point out the hopelessness of identifying the actual creator of a disco song: is it the composer, the lyricist, the singer, the producer, the arranger or the DJ? To an unprecedented degree, disco mystifies its authorial origins, as we see in the obscure collective names given to disco "groups" (such as Hues Corporation, Machine, or Black Box) or in performers such as the Village People or Shannon, who are patently the "creations" of their producers. One is encouraged to entertain the alarming

fantasy that disco music is nothing but a beat generated, recorded and broadcast entirely by machines, a rhythmic signifying chain that may link any number of people on its way from the recording studio to the dance floor, but that originates with no one and arrives nowhere in particular.

These are some of the ways in which disco represents itself as literally disconcerting. It thereby allows the gay man's dissenting existence, precisely by enacting the destruction of the socialized self represented in conventional cultural products by language, narrative structure and authorial control. In their stead, it enthrones the tyrannical power of the beat. If disco seems at times to be deliberately trying to "kill real music," it also represents, for certain gay men, a form of violence done to a conventional self in order to refashion it, much in the manner of military, religious or sadomasochistic discipline (and it was of course appropriate that the songs of the Village People, such as "YMCA" and "In the Navy," tended to couch the open secret of their homoeroticism in the very language of recruitment and evangelism). Historically, the rhetoric of determinism has been necessary to most forms of militancy; in order to enlist people in the process of radical change one must first convince them that they have no choice, that some natural, divine or historical force compels them to do so. The destruction and re-creation of the self must be performed not, tautologically, by the self itself but by some power above and beyond it. The puritans, for example, cropped their hair, dressed alike, sundered the connections between nature and monarchy and created the modern state, all at the irresistible prompting of God's grace. Gay men, at the irresistible prompting of a disco diva such as Grace Jones, cropped their hair, dressed alike, and became what she calls "slaves to the rhythm."

The power of disco to re-create the self lies in the always implicit parallel between the beat and desire. Crucial to this analogy is the physical sensation of the disco bass line, described in the commonplace that one "feels" the throbbing beat of disco music inside one's body, rather than merely hearing it. The most common topos in disco lyrics, the exhortation to "get out on the floor" and "get down," suggests that the power of the beat to make us dance is commensurate with the power of desire to lead us into sexual acts, even those considered forbidden, unnatural, even unnameable by our culture. Desire, by way of this analogy, is more than either a physical sensation or an internal libidinal force; it becomes a reified external force that can penetrate and establish control over any number of individuals, drawing them into a community of submission to its power. Thus "love," in disco lyrics, tends to be described in hyperbolic terms as enslavement, insanity or addiction, a disease or a police state, as anything that rivals the despotism of the beat itself.

The power of music to master the individual has, of course, been regarded as, by turns, useful and dangerous in Western culture from Ancient Greece onward. Martial music can create a disciplinary order in which the individual falls into step with his fellows, while erotic music can induce a lapse into sensuality and indulgence; but both useful and dangerous

forms of music have roughly the same effect, as both are forces that overwhelm the will. Disco makes explicit the identity of the two seemingly opposed musical styles, which the Greeks distinguished as Dorian and Lydian: it takes the regular tattoo of the military march, and puts it to the sensual purposes of dance music. By combining martial music with erotic music, disco seeks to muster the "army of lovers" celebrated by Aristophanes in Plato's *Symposium* and by Whitman in "I Sing the Body Electric." Whether they are marching or boogieying, these comrades-in-arms have surrendered their autonomy and self-control to an overmastering beat that, in the case of disco, leads them into the arms of their comrades.

"If you're thinking you are too cool to boogie," A Taste of Honey admonishes us, "let me tell you you are no exception to the rule," the immutable law that "everybody here tonight must boogie." Technotronic ventriloquizes the beat that brooks no denial in still more insistent tones: "One, two: I'm a part of you/ Three, four: so get your butt on the floor." Allowing the beat to become a part of us disturbs the very foundations of conventional constructions of masculine selfhood; allowing ourselves to be penetrated and controlled by musical rhythm, by desire, or by another person is to relinquish the traditional conditions of full humanity and citizenship, and to embrace instead the traditional role of slave. Nowhere is this exchange of identity more forcefully articulated than in Grace Jones's use of the imagery of forced labor to describe the discipline of the disco in "Slave to the Rhythm." According to the song's lyric, the rhythm regulates every aspect of bodily existence, breathing, dancing, labor and sex, and so becomes a universalized disciplinary apparatus: "you learn to the rhythm and you live to the rhythm." But by submitting to it, the disco dancer begins to lose his social identity as a man; and he becomes recategorized alongside the black woman and the machine that together relentlessly draw him into the empire of the beat.

Somewhere between these images—the African-American woman who is the prototypical disco diva, and the complex synthesizer technology that provides disco's instrumentation—vibrates the new gay male identity that disco begins to fashion with its discourse. The frequent conflation of labor, dancing and sex in disco lyrics ("work your body," "work it to the bone," or "wanna see you sweat") makes subordination to the beat a form of enslavement, and offers three categories by which it can be represented: femininity, blackness and mechanization. We have already seen how the condemnation of disco as technologically synthesized and therefore "artificial" echoed the stereotyping of gay men as "clones" who rejected "natural" reproduction for some mysterious process of self-replication. But disco music, with what one song called its "electric body talk" insists that the gay man entertain this technological identification. By allowing the synthesized disco beat to move you, you surrender yourself to becoming an extension of the machine that generates the beat, and consequently what is variously called a "man-machine," a "dancing machine" or a "love machine." The fearful paradox of the technological age, that machines created as artificial slaves will somehow enslave and even mechanize human beings, is

ritually enacted at the discotheque; there gay men can experiment with the kind of cyborg identification that Donna Haraway recommends for women in her "Manifesto" as a means of freeing the self from the oppressive category of the "natural."[6] The transmission of the beat from disk to speaker, from speaker to dancer, from dancer to dancer, creates a kind of circuitry, an automatic community of technological communication that suggests an updating of Whitman's adhesive "body electric" as the gay body electronic.

The voice that sings this body electronic offers the gay man a different form of identification. Wayne Koestenbaum has explored some of the relations between gay identity and female vocalization in *The Queen's Throat*; the disco diva presents a related but special case.[7] The fact that a heterosexual woman singing about her desire for men can become a vehicle for gay male identification is clearly the foundation for the institution of the disco diva, but this possibility is complicated by the role of race. Disco music performed by black women often evokes the stereotypical constructions of the dominant culture, particularly those of the black woman's utter powerlessness. In the news media, she is blamed and pitied as the welfare queen, the addict, the teenage mother and the prostitute. In disco music, she is celebrated as what Donna Summer calls "the bad girl," the type of unabashed sexual expression, who freely vocalizes her powerlessness before her own desire. Disco music recirculates this racist construction to a different effect from, say, gangsta rap, by urging gay men to identify with rather than lust after or despise the "bad girl": "Now you and me are both the same/ But we call ourselves by a different name." In both the delirium of "It's Raining Men" and the desperation of "Don't Leave Me This Way" the black disco diva, offers a kind of dare; can a man, even or perhaps particularly a white one, possibly identify with this supposedly degraded subject position? Just as it coerces him to abandon the privileges attendant on masculine identity, the disciplinary beat compels him to occupy the position of the racial and sexual other, to accept, as an almost ascetic gesture, her "minority" status. As in the example of the machine, submission and identification are simultaneous, even synonymous in the discotheque.

The rhetoric of minority-group oppression and liberation was often explicitly incorporated into the lyrics of songs like "Ain't No Stopping Us Now" or "We are Family," as if implicitly offering the African-American liberationist model represented by the singer to her gay audience. Other songs made the parallel still more forcefully: Machine's "There but for the Grace of God" applied the upper-middle-class condescension of its titular phrase against the upper-middle class itself, who are represented as saying "Let's find a place that's safe/ Somewhere far away/ With no blacks, no Jews, and no gays." To this the chorus emphatically responds "there but for the grace of God go I." Minority status, like God's grace, can free us from being trapped in miserable, straight, white, Christian enclaves, just as the disco beat compels us to contemplate new forms of social and personal integration.

But the primary negotiation between gay men and straight black women in disco involved

the formation of identity through the representation of desire and pleasure. At their best, disco singers draw on the gospel music tradition, where vocal repetition empties out language in order to open the self to divine inspiration, expressed in heightened emotive renderings of the repeated phrase. This possession of the singer by the increasing passion of her own vocalization is given an explicitly erotic, rather than spiritual meaning in disco (although the distinction is usually lost in the escalating force of the singing). In Donna Summer's "I Feel Love," she whispers and moans amorous phrases like "it's so good, it's so good" and "I'm in love, I'm in love" against a particularly relentless beat generated by analogue synthesizers and sequencers. Her state of arousal is audibly represented, but remains ambiguous throughout: is she helpless before the unstoppable mechnical stimulation of the rhythm? or is she mastering it for her own pleasure? When she begins rhyming "falling free, falling free" with "you and me, you and me" she could be addressing a lover; but it is also possible that she is insisting on the solidarity between herself and her audience, who are participating, by dancing, in the precipitate liberation of her autoerotic ecstacy, "falling free" by surrendering to both the beat and her voice.

This performance, like that of her "Love to Love You Baby" or Diana Ross's "Love Hangover," made a significant link between disco, its gay audience and another source of 1970s anxiety: the female orgasm, which the popular media obsessively tried to represent even while uneasily acknowledging its unmappable progressions, its potentially limitless multiplicity, its mysterious sources and the possibility of its technological production. This language should be recognizable by now as similar to that applied to both disco and gay men. The seemingly endless cycles and plateaus that replace narrative structure in a disco mix; the seemingly limitless promiscuity of gay men's "multiple contacts" that "mix" them as effectively as the technology that splices songs together in the DJ booth; the increasingly unpaired, unchoreographed, improvisatory dancing that developed in the discotheque; these things are not unconnected to the inscrutable feminine "jouissance" that became the fascination of both popular and academic culture in the era of disco's emergence.

Implicit in early disco is the assumption that only a black woman can openly vocalize her sexuality, and that only a gay man would join her in a free-fall from rational self-mastery. But the evolution of disco is one of both appropriation and integration, both exploitation and empathy; the negotiation between usually straight black women and usually white gay men seemed to open up and make visible all the various subject positions between these previously polarized identities. Since the actual author and audience of any disco song are both indeterminate, disco's racial, sexual and gender identity cannot be finally fixed as "black music" "women's music" or "gay music." The violence I have argued it does to fixed indentity results in a doubling, slippage and transference of black and white, male and female, gay and straight subject positions. Grace Jones can sing of "feeling like a woman" and "looking like a man"; Donna Summer can plead with her lover (or her audience) to "turn my brown body white." In their wake, many permutations of disco singer can

appear: Jimmy Somerville, the gay white man as disco diva or Madonna, the omnisexual white woman as disco diva.

Most significant of all is Sylvester, whose particular identity as a gay black man stands at the origin of the disco tradition; he is nevertheless rendered invisible if not impossible by the dominant culture's potent alliance of homophobia and racism. Thus his perhaps the most successful use of gospel vocalization in disco, "You Make Me Feel (Mighty Real)" performs the representative hypostatization of his gay identity. His impassioned repetition becomes as orgasmic as Donna Summer's in "I Feel Love," insisting that, for the gay black man, the realization of the self can have the ecstatic force of a revelation. This is not the drag "realness" of the voguing houses, achieved through ironic mimicry of the icons of white fashion culture (and now an explicit presence in disco with the outrageous posturing of RuPaul). This is a "gay" realness that flickers into being with a "touch" and a "kiss"—at the moment of homosexual physical contact. According to Sylvester, we "feel" real the way Donna Summer claims we "feel" love, as a heightened erotic sensation, not as an essential state. The identity that disco offers is sustained by the beat and its twin, desire; it could conceivably go on forever, like our dancing, if the music is right, but it will never be permanent, fixed or naturalized. Therein lies the freedom disco constructs out of our subordination to it.

Just how long disco and its discourse could be sustained became an important question in the eighties; its "death" was being eagerly pronounced at the beginning of the decade, even as the first casualties of the AIDS epidemic were being reported and uneasily discussed. The onslaught of the disease made disco seem rife with proleptic ironies: for example, gay men and black women would soon be united outside the discourse of disco by the epidemiological rhetoric of "risk groups." The representation of both desire and the beat as things that enter our bodies from outside and take control of them had already given rise to a frequent metaphor of disease; but now the "night fever," the "boogie fever" the "tainted love" and the "love hangover" all seemed to be passing into literalism. Even the technological aspect of disco became vulnerable and ominous; computers could be infected with viruses, after all, and the human immunological virus itself was frequently represented as a nonliving, automatically self-replicating machine. Re-Flex's 1983 song, prophetically entitled "The Politics of Dancing," gave presumably unintentional expression to the emerging link between the transmission of music and AIDS: "the broadcast was spreading, station to station/ like an infection, across the nation."

In spite of this frightening parallel, the discourse of disco was still loudly proclaimed in the mid-eighties, almost in an effort to conceal the threat, to envelop it in a double consciousness that made it possible to ignore the risk of which one was constantly aware. Miguel Brown's "So Many Men, So Little Time" captures this refracted denial: a brash paean to promiscuity, it nevertheless acknowledges a relation of inverse proportion between "men" and "time." Behind the diva's carefree vocals, stern male voices intone a

version of disco's familiar "counting": "twenty-five . . . thirty-five . . . forty-five . . . fifty-five . . ." and so on. What was ostensibly a rising number of "sexual contacts," as they were then being called, could just as easily be heard as a mounting death toll, as inevitable in its accumulation as the beat itself. But surely the most devastatingly clear in its implications was the uncannily blithe lyric of the Pointer Sisters' 1983 song "Automatic," (Planet Records), which described desire as an all too familiar series of symptoms. The lyric offers the discourse of disco in perhaps its purest form: the self, as sung by a black woman, is unmade by the determinist force of desire, becoming, even in a state of emotional and physical debilitation, a machine, a robot or computer, subservient to another, a camera or perhaps a virus-carrying modem. The description, typically, also evokes disco music itself (language is "lost in the circuity" and replaced by the mindless, repetitive "stream of absurdity"). But in its historical context, the submission described here evokes desire and the beat less than it does the ravages of HIV infection: the spiking temperatures, the night sweats, the dementia, the collapse of the various bodily "systems." The song offers ample evidence of why the discourse of disco finally became intolerable, even to those whose identities it had partially refashioned. For a few years in the late eighties, therefore, it seemed as if disco would die of its own disease.

Urban gay men could not, however, be permanently divorced from the institution and rituals they had fostered and that had fostered them. So in the late 1980s, disco music became a series of strategies for its own revival. The Pet Shop Boys, for example, offer the same disciplinary beat, but the familiar bass line is sheathed and numbed by a prophylactic irony. The irresistible force of desire is domesticated within the venally calculating scenarios of a new gay monogamy: "I love you; you pay my rent" or "I've got the brains, you've got the brawn; let's make lots of money." Their bland insouciance seduces us with the promise of low-risk disco, but the Pet Shop Boys like to confront us nevertheless with a return of our repressed anxieties. If the nursery rhyme "ring around the rosie" turned the symptoms and inevitable prognosis of the Black Death into a macabre childhood dance, a song like "Domino Dancing" similarly introduces the escalating mortality rate of the latest pandemic into the ritual of the disco. The falling dominoes that are a popular emblem of the inevitability of a chain reaction here bind the beat and the dance, desire and sex into a inevitable sequence culminating now in death. With a self-consciousness absent from earlier songs like "So Many Men, So Little Time," they replay the tabulating beat of their dance tunes as a recurrent echo of the actuarial accounting that punctuates the lives of their audience: the computing of sexual contacts, the counting of T-cells, the calculation of casualties that are all suggested when urban gay men speak today of their "numbers." The disciplinary determinism of disco has become fatality, if not fatalism.

And so it is not surprising that disco in this period brings back its earlier standards in a new guise. In many cases, the description of erotic desperation becomes, without a

single change of lyrics, an account of grief. 1970s songs like "Don't Leave Me This Way" and "Never Can Say Good-bye" become, in the 1980s, part of the work of mourning. They can make this transition so easily because disco's representation of desire always included the element of loss, the loss of a prior self easily conflated with the departure of a lover, now made to resemble the loss of everything and everyone disco had come to represent. The lyrics remind us that grief can control us as tyrannically as desire, and so our submission to the beat is still a necessary practice, while the revival of the songs gives the lie to the hostile criticism that dismisses disco as ephemera, and its gay adherents as short-lived.

Thus, if the AIDS epidemic almost killed disco in the late 1980s, the same crisis seems to have brought about its determined resurgence in the early 1990s. The revival is not simply nostalgia, but an application of the discourse of disco to a new end. Recent songs celebrate the pleasurable discipline of self-exhaustion with the all brashness of early disco, unintimidated by the inevitable resonances set off by the epidemic. Pat and Mick, for example, urge us to "Use It Up, Wear It Out." Using it up and wearing it out on the dance floor, at the bidding of disco music, may seem uncannily like submitting to the debilitation wrought by the virus; "shaking our bodies down" at a disco is pleasurable, while being shaken down by the health care system is not. But surrender to the beat can briefly vaccinate us against the fear of the virus's depredations. Once again gay men can defiantly appropriate and inoculate their society's most ruthless disciplines as their own means of survival. A 1991 song by the resonantly named Army of Lovers described this homeopathic immolation of the self in grandiose but inevitable terms as redemption: "I'm crucified, crucified like my savior . . ."

The music that once taught some men to be gay can now teach them what all gay men must learn: how to live with AIDS. Like safe sex or ACT UP or the concept of sexual identity itself, this indispensible discipline enables them to submit without acquiescing. Disco now looks forward to a moment when gay men can once again, vocally and unequivocally, say of their sexuality what a disco diva once sang about her "love hangover": neither the "doctor" nor the "preacher" is needed, because "if there's a cure for this, I don't want it."

Notes

1. Richard Dyer's 1979 essay, "In Defense of Disco," can be found in *Gay Left* 8, and in Simon Frith's and Andrew Goodwin's collection *On Record: Rock, Pop & the Written Word* (New York: Pantheon 1989) pp. 410–418.

2. I am indebted, here and throughout, to Leo Bersani's contention that gay sexual practices, particularly anal sex, are themselves a form of "ascesis," of ascetic discipline, by which "the

masculine ideal . . . of proud subjectivity" is destroyed. See "Is the Rectum a Grave?" in *October* 34, pp. 222ff.

3. I am making use here of Michel Foucault's theory of sexuality as a regulatory discourse, expounded in *The History of Sexuality, Volume I: An Introduction*, trans. R. Hurley (New York: Vintage, 1980). I am stressing, however, that the pleasure inherent in such regulation is what draws gay men to participate in the very discourse that labeled and policed them; and I am suggesting that indulgence in the pleasure of self-inflicted discipline can also become a form of resistance.

4. Brian Chin, liner notes to *Dance! Dance! Dance! The Very Best of RCA's All Time Greatest Dance Music*, BMG Music, New York, 1988.

5. See Anthony Thomas, "The House the Kids Built," *Outlook* 5, Summer 1989, pp. 24–35.

6. See Donna Haraway, "A Manifesto for Cyborgs: Science, Technology, and Socialist Feminism in the 1980s" in L. J. Nicholson, ed., *Feminism/Postmodernism* (New York: Routledge, 1990), pp. 190–233.

7. Wayne Koestenbaum, *The Queen's Throat: Opera, Homosexuality, and the Mystery of Desire* (New York: Poseidon Press, 1993); see, in particular, pp. 84–154.

Hello

Lady Kier Kirby

You can count on dance music when there's nothing else to count on. Two thousand kids who come together, children of all colors—we are collective. This is the one place we can congregate to feel the humanitarian spirit that lives through the bass running through us all on the dance floor. A hop and a dip with the same kick. For every no there is a yes. For every nothing there is something. For every star there is a black hole. The dance community is not living in a fantasy world.

The dance community is not living in a fantasy world. AIDS, homelessness, poverty. The poverty level in 1972 was eleven thousand dollars a year. In 1992, the poor live on four thousand dollars a year. We are not feeling for this: gentrification and drugs pumped into the neighborhood by businessmen from faraway wealthy places; racist employers, racist realtors, racist bank lenders, racist justice system; the environment, women's rights. The dance community is not living in a fantasy world, because we deal with these problems every day. The music selector is the soul reflector. It's the club DJ who decides his own play list, which is why it is so free.

The music selector is the soul reflector. When they phased out vinyl they had no understanding of scratching, mixing or the nature of the club DJ. They didn't know that wax tracks is hot, but is it really stopped? Sam Goody don't got it. The rave has got it. Ten thousand people gathered together in a field and the event is free. Ravestock. This is the real alternative. Summer solstice rave, full moon rave, resuscitate the natural rituals from the pagan era. Defuse our dissatisfaction. Celebrate life.

Like the New Orleans funeral, when someone dies, through the sorrow we use music and dance to celebrate the living. We Will Survive. Sylvester's songs survived the disco era and many others also endured that fizzled-out revolution. House is not disco, but there are some deep roots. "Last Night a DJ Saved My Life." "Funky Sensation." "I Will Survive." "Love is the Message." "You Brought the Sunshine." These are a few of the classics that trickled down into house.

The seventies frustration that led to the punk and new wave bands, like Kraftwerk, Psychic TV, also trickled into the stream, merging. A rhythm evolved. Techno, rave, little

acid house on the prairie, deep house, rare groove, raggatech, jazz house, hip house, ambient, break beat. Call it whatever you want. Do we need categories?

Whatever the category, the nature of the artist is to break the format or structure that tries to confine the energy. And we will. That is why we love music and change. The I Ching DJ of Changes. The DJ is the guru.

The music selector is the soul reflector. The sampler changed production. When the piano first arrived on the scene, they said: Oh, it's not soulful, if the musician isn't touching the strings, then he's playing through a box. The electric guitar was devil music. But the sampler is here to stay. And I just wish credit was given where it's due. No one's ignorance about a new instrument should cast discredit upon today's original composers. Little Louie Vega, Kenny Dope Gonzales, Todd Terry, Larry Levan (may he rest in peace). There are hundreds more.

The kids that embraced modern technology in dance music have come from inner-city schools that not only had no computers, but often no books. They embraced the technology and created a new art form. The remixer is the writer. The music selector is the soul reflector. And he will pump our ass on the dance floor, and give us strength for our aspirations for better days. Thank you.

Not a Mutant Turtle

Willi Ninja

Hi, everybody. My name is Willi Ninja, and I am not a mutant turtle. I had the name before they did. Here's a brief history of who and what I am and my brief claim to fame. As you know, in 1990, Madonna made voguing famous. She was not the inventor. I and others have been doing it for about twelve years. The dance originated in the Black and Latin, but primarily the black, gay balls in Harlem. Two other things I want to clear up. No, I am not from Harlem. Yes, I did go to college for a year—I couldn't take it, though. In 1980, I formed a house and came up with the name "Ninja" because I lived in a mostly Asian neighborhood and my best friends were Asian, so I took the idea of the "Ninja," which is an invisible assassin. They come, they strike hard, and then they dash. You never see them again. You don't know when they're coming back. So hopefully you'll remember me after this.

In the fifties, the drag balls, which were mixed at the time—both white and black—staged competitions for trophies and sometimes cash prizes, where the drag queens competed in categories such as costume, or best body. The black drag queens found that they were not winning, so they took their balls up to Harlem and competed amongst their own, to avoid discrimination. Up through the end of the sixties, the scene was primarily black, and mostly drag queens, at which point the balls started to include, along with femme drag queens, butch queens, like the everyday boy that passes you on the street. And you'd be surprised! Anyway, the butch queens that went to the balls decided they would like some categories of their own because they wanted to have their little claim to fame. It's like winning an Oscar for us. Since we couldn't compete in the so-called "real world," this was our chance to kind of live out our fantasy for one evening, for real, for us. Just like acting out a play and competing, and, if you win, being important for one night, at least among your friends. So the butch queens got their categories, and voguing came into being, basically, when the drag queens would walk down the runways with their giant fans, and the hand movement was strategically placed so—I'm not sure, actually, who created the movements. No dance form is entirely new, of course. And they basically came up with the name "vogue" because some of the movements were similar to what you see in the fashion magazines, except exaggerated. In the seventies, stretch movements,

including splits, were added to the posing with hand movements. When I came in I learned from, God bless his soul, Hector Extravaganza, the creator of the House of Extravaganza, who taught me my movements, and I just went on from there and added some fluidity, which accounts for all the contorted movements that the kids now do. And now we have Madonna doing it, or trying to do it, for which I will give credit where credit is due: she did go into our life, and took two young men, José and Luis, who did not get credit until everything was over. Vince Paterson was choreographer for the "Vogue" video, but it was José and Luis that taught everybody in it how to vogue. I want to make that clear.

As for myself, I did get the chance to put the dance out in public before Madonna but, of course, not in such a visible way. In 1988, I did a song with Malcolm McLaren called "Deep in Vogue," and that was my start in the music industry. At about the same time, I took the dance into the fashion industry itself by working with Thierry Mugler, but I didn't let people forget the black and Latin and gay roots of the dance. It was a challenge to do it among people that you didn't particularly care for. Instead of fighting, you competed on the dance floor, for trophies and for money. The same was true of breaking, where the gangs didn't want to fight, so they danced it out. As you probably know from the film *Paris is Burning*, the dance takes on many forms. It combines a little technical dance, from, say, jazz and ballet, with acrobatics. As for my own form, it has as much to do with watching Indian and martial arts movies and fashion shows and putting bits and pieces together. There's a Latin base, which is the flowing movements, and then there's the African base, which is the hard, strong, blocking and clicking. As in the film, I had this dream of wanting to go to Paris, and wanting to go to Japan, and I did it all. But most of all, I wanted to show people what we can do, even though we have such a hard time in our life, struggling to get someplace against all the racism in this world. I hate bringing up the issue of color myself, but when you're black, you have one strike against you. When you're gay, you have another strike against you. So a black, gay male has just, like, no chance in hell of being a corporate exec, or of being anything legitimate in the "real world." In our balls we could be executives for an evening. We could be the best dancers in the world, for an evening.

But I actually took my fantasy and made it succeed. With Mugler, my dream of walking the runways of Paris came true in 1989, where I worked with the legendary Iman, the only woman that could turn me straight, I swear. I told her, I hate Bowie right now, I used to love Bowie. Since then, I've worked with different designers, choreographing shows in other countries. As you can imagine, the dance lost a lot of its "street element." No matter how original you are, when you get into the music or the fashion industry, they will have another version for you to dance—"We want to see it this way, it looks better for our camera angles." They will try to tell you how to do what you know. I don't tell them how to design clothes, but they did try to tell me how to do my dance. Now I've gotten to the point where I can have more say—"This is how it should be done. This is where it

came from. Let's show the real version." There was no problem about this with the Queen Latifah video ("Come Into My House"). This amazing woman fights for everybody, and fought for us to do this video right. Of course, there was a little shade on the set, between us voguers and the homeboy rappers, but she set it straight, "Just watch the boy dance." They watched, they shut up.

Now when Fred Astaire danced with Ginger Rogers, the camera was pulled full back, to get the full dance. If you want us to dance, show us dancing. If you don't want us to dance, hire a model to stand there. Remember Janet Jackson's "Escapade" video? OK, there were three tired—I'm going to be blunt—three tired queens doing the video who had no idea what the hell vogue was all about. I had sent an audition tape to—I won't name the company—Squeak Productions in L.A.—showing me and six other people doing what we do best. And they took the tape and tried to teach dancers from the tape—which was a quick edit to begin with, so that there would only be glimpses of what we do. Well, whatever the hell they were trying to do in that video, they weren't getting it. Before the video appeared, they did the routine on the American Music Awards. My phone was ringing off the hook with "Did you see those three tired queens trying to vogue?" And I was upset, because what I saw were the signature movements of me and my friends. The same thing has happened to people in breaking, like Crazy Legs and Wiggles from the Rock Steady crew, who were all ripped off in the same way through use of their audition tapes. If they want to sell to a mainstream public, they like to show a white face. Even when I did the video with Malcolm McLaren, I had to fight for the people in my video. Since I had a girlfriend that was white and knew how to vogue, the compromise was to use her in the video. I really dislike the music industry. I dislike the fashion industry. But that's my money, so . . .

I have no technical background in dance. Never went to school for ballet, jazz or anything. Everything I learned was from PBS. Thank God for PBS and "Dance in America." My mother took me to the Apollo, to see all of the Motown acts, and Radio City Music Hall, to see the legs of the Rockettes. I learned everything by watching. There's no rule that says you cannot learn how to dance and get a technique. They said I had no technique. Although I didn't go to school, I do have a technique because all dance is technique, no matter where you learn it from. If you do it well, and you train every day, you do have a technique. Besides, at one time, ballet was not considered a technique, and look at it now.

It won't be long before voguing is a respected art form, which I believe it should be. It is dance. It will always be dance, however much it changes in the years to come, just as it has changed since the sixties. So whoever dances out there, whatever dance you do, whatever dance you do well, it doesn't matter if you didn't learn it in a school. It doesn't matter if somebody tells you that it's not technique. Just ask them if they can do what you can do. That's technique.

Nobody Wants a Part-Time Mother
An Interview with Willi Ninja

Tricia Rose

Willi Ninja and I sat at a quiet window table of Dosanko's, a Japanese restaurant in Flushing, Queens. The restaurant was almost empty because at 3:30 p.m. it was after the lunch folks and before the dinner crowd. Between intense moments of pedestrian people-gazing and devouring platters filled with grilled eel, spiced rice, makki and california rolls, Willi Ninja talked with me about his childhood in New York City, dance, sexuality and, of course, voguing. Like a carefully sliced makki roll, here are the fresh parts of our conversation.

Tricia Rose: Tell me about your childhood.

Ninja: I was born in New Hide Park, right on the border of Nassau and Queens at Long Island Jewish medical center on April 12, 1961. I was born in a Jewish hospital; my mother—who was a pioneer—was one of the first three black people to work in that hospital and was one of the first black students in the University of St. Louis. She left there and came to New York because she got tired of being called nigger in school. I was always raised in Queens, my junior high and high school years were spent in South Jamaica, Queens, but we eventually came back to our home base—Flushing, Queens. We wound up in South Jamaica because after moving to the Rockaway Beach area for a year, and deciding that we couldn't deal with the isolation and winters on the Atlantic Ocean, we moved back inland, but my mother could only find an apartment in South Jamaica. South Jamaica was my first experience with an all-black neighborhood; up until then, I had always been raised in ethnically mixed areas. So, during my junior high and high school years I became kind of a loner because the kids in the neighborhood tried to tell me what types of friends I should have. It was kind of a culture shock for me. The school and the area were totally black. My building, which was in the Baisley projects, had mostly Five Percenters in it. My peers put a lot of pressure on me to hang out only with black kids.

R: So what did you do?

N: I just took to myself, had very few friends, did everything basically by myself until I got to high school. In junior high school I did everything—travel, went to the movies—by myself. If my mother wasn't with me, I was solo. Always loved to dance, always . . .

R: Did you go out dancing as a kid?

N: At the house parties I would always dominate, 'cause I could do whatever the new dance was and I would try to go one up on it. Nobody told me that I couldn't. My mother took me to a lot of cultural events. I always went to Radio City Music Hall. We went to every Motown act that ever performed at the Apollo—I *lived* at the Apollo and Radio City Music Hall.

R: You always went to these events with your mom; where was your dad?

N: He was around somewhere . . . on and off.

R: So you wouldn't say you spent any time with him.

N: Hell no. Twice a year if I was lucky, birthday and Christmas. That was it. I wouldn't call that parenting. My mother was both a mother and father. My father showed up when he felt like it, when he was sober.

R: In high school you began having more friends?

N: Yeah, but they really didn't come to my house and it depressed me.

R: Why's that?

N: Well, because I was afraid that they would get hurt if I brought them to my neighborhood. I was listening to people at Bailey projects constantly saying "You shouldn't be hanging with white people, you shouldn't be hanging with this group or that group." But since they knew my family was mixed (I have Irish, Cherokee, and Asian ancestry in my family) I just started using excuses—saying that my non-black friends were cousins. By the time I got to my junior/senior year in high school I was just like "Screw them" and I just started hanging out with whomever I pleased, and they got used to it. Eventually we moved back over to the Flushing/Bayside area, where most of my friends lived, thank God! And it was great. I started getting out of my closet more, not meaning as

far as my sexual awareness, but as far as just being myself. Without worrying about other people telling me what type of friends I should have, what race they should be, so I started to blossom.

R: You didn't know you were gay at this point?

N: Uh-huh. Oh, child, I knew this since I was a kid.

R: How old would you say, do you remember?

N: About ten years old. At that point nobody discussed it—didn't say it was right or wrong. You see, nobody really discussed these things when you were a kid. The only thing they may have said was, "sissy sissy sissy" because maybe you had feminine characteristics, but that never went towards my way. I didn't know that you could not be with another boy. I didn't know—I liked girls and I liked boys so I just liked whoever happened to be there at the moment. So I kind of grew into a relationship with one of my best friends. It was interesting but I always had girlfriends, too.

R: You seemed worried about your white friends feeling safe in your neighborhood. Were you equally worried about anyone finding out about your relationship with your best friend?

N: I was more worried about racial tension than I was worried about sexuality, until I got to high school—that's when I started worrying. It became an added worry, so I began covering up.

R: When did you tell your mom you were gay?

N: No, she told me.

R: What did she say?

N: She said she always knew; I was beating around the bush, and she finally came out and told me. This was after I dropped out of college.

R: After you dropped out, what did you do?

N: I did what almost every gay American does. I went to beauty school. [Mutual laughter] I went to Robert Fiance School of Beauty and then started doing hair, makeup. Can you believe it?

R: Did you feel like it was a cliché at the time?

N: No, I look back at it now that way—at the time I wasn't aware of it. I just like messin' with hair and makeup. Not for myself but for other people. In order to do it seriously, you've got to get a license. So I did that for a while until that got on my nerves. I got tired of smelling like perms.

R: Did you work in a salon?

N: A little bit, and then I was working out of my apartment, too. You make more money that way. The only way you make lots of money is if you get into the big-name salons. But there you have to do an apprenticeship for a year—for little or no money at all. If you stay in the small neighborhood salons around here you stagnate—you do the same haircuts on the same people. You don't grow creatively.

R: How long did you do hair? And then what was next?

N: About three years, then that got on my nerves. But while I was in beauty school all hell really broke loose. I started hanging in the Village—I always snuck out to the Village even when I was in high school. While I was in beauty school I began going to parties at after-hour clubs and I started meeting the kids from the house scene, and hanging out with them and developing a reputation. I danced in this club called Crisco's. It was an after-hours gay club and the DJ's booth was a huge Crisco's oil can. It was called Crisco's disco. That club was a scandal. You got your five-dollar's-worth. Around this time my best friends, Archie Burnett and Tyrone Proctor, and some others and I started a group. We called ourselves the Video Pretenders, because we used to go to any club that had video capabilities; we would do the exact dance routine in the videos that were out at the time. They would book us to mimic live the routine that was on the video. So it was fun for a while, then we said, "Well why do we have to copy everybody's else's routine? Let's come up with our own choreography." And we were still getting bookings. Soon after that, I left the group to focus on some personal things. Then about a year later, they asked me to come back, but now they had changed the name to Breed of Motion. At that point we performed our own routines,

and did our own choreography. Tyrone, who used to be a *Soul Train* dancer, took a dance video of us performing in the Cat Club and showed it to his friend Jody Watley and Jeffrey Daniels of the now defunct R & B group Shalimar, and they encouraged us to add vocals, so we tried to do some singing, too. In fact, Breed of Motion is still in existence as a recording group in the house music scene.

R: As your group got more established, did you start doing more dance routines?

N: More dance routines, more singing, and I also started hanging in the house scene meeting more dancers.

Strike the Pose

R: Describe vogue dancing.

N: When it first started it was mostly posing, striking poses like runway models. Hand movements, posture, attitude and presence were most important. Then people started doing splits, and Hector and I started dislocating our arms and doing what they now call "arm clicking," where you're dislocating the arms and doing cartwheels and aerials. And then I began combining martial arts moves.

R: What are vogue houses?

N: Vogue houses are based on the high fashion houses, like House of Chanel, House of St. Laurent and so on. Each vogue house develops a style and an image. They raise money to throw balls, which consist of various competitions, voguing being the most prestigious. But it's also a family unit. House members stick together like family because some of these kids can't face their parents, can't live with them once they tell them they are gay. Many of these kids are thrown out of the house by their parents. So they look up to the older members to give advice and support to the younger members in the group. So the fashion house is also just like a real home—a family unit—it's not just a dance group. Also you could say it's a social clique, or posse.

R: How did you start House of Ninja?

N: When I was dancing and hanging out at clubs, I began to develop a style in which I used my arms and hands a lot when I danced. A few days after one particular night, I ran into this guy who was at the club and he said: "Why were you so "shady" to me last week?" (At that time the slang wasn't "shady" but I can't remember what the word for

attitude was.) I didn't know what he was talking about. He said: "Why were you voguing me? Why were you going against me? What did I do to you?" I was totally confused. He said: "At the club last week, you were looking dead at me." Basically he was saying that I was challenging him to competition with the moves I was doing, but I didn't know it at the time. I didn't know what voguing was. I was in my own little world. My hand and arm movements were just similar to voguing. So I asked him to explain it to me. He said; "It's better if I show you." So we went to this club called Peter Rabbits and watched these people battle. I saw a battle between a butch and a boy, and they were going at it, but they weren't very good dancers. So I thought it was cute, but I said to myself; "Oh please, I could take them out in two seconds flat." Then everybody kept telling me about this boy named Hector. Hector this, Hector that, Hector is so incredible. When I finally met Hector I pounced on him so badly to show me his moves, and when he showed me I was floored. He was incredible. So then Hector started showing me the basic moves, and I just went on and created my own style from there. Normally, in order to create a house you have to have been a member of a house, or have three grand prize trophies from ball competitions. But I didn't do that. I had been dancing and battling in the clubs but I didn't compete for trophies, I just created my own house and went. Which was really a taboo and a no-no . . .

R: So how did you get respect if you didn't get established the right way?

N: Because we racked up the trophies at the first ball we went to, and got more from then on.

R: So describe House of Ninja style. And what happened at that first competition?

N: I live mostly in an Asian neighborhood so I always take everything, even my form, from martial arts and kung fu hand movements. So when we were trying to decide a name for the group we considered and rejected all the fashion names, and finally hit on the idea to use Ninja—there were so many ninja flicks out at the time, and it fit our reputation. My friend Archie and I decided that House of Ninja suited us, because nobody knew who we were since we didn't hang out in the ball scene, we seemed to come out of nowhere and we struck hard. A Ninja is like an invisible assassin, he completes his assignment and leaves. That's exactly what we did when we went to the first ball. We won and we left. Everybody was like, who the hell are they? The name really took on meaning after that.

R: What is the ball scene like now?

N: It's still hot and heavy. It calmed down for a while and got very commercialized, kind of toned down. Now it's just gotten back to what it used to be, but even a little bit

wilder than before. You don't know what scandal—and I do mean scandal—might go on sometimes. The imagination is still very creative. That's one thing I give these house children, they always come up with something new.

R: What are house children? Are they usually young?

N: Well, that's what you call the house members: "house children"—and then there are the house mothers and house fathers who run the houses. There are a lot of young children, though. You'd be surprised. They are as young as thirteen; every once in a while you might see a twelve-year-old. That's when I say, "What are you doing out?" As *Paris is Burning* pointed out, the majority of these kids are poor. But there are also some middle-class kids hanging in there, too. They are there for the emotional support. But there are also a lot of college kids and adults. The film, though, primarily emphasized the poor kids who need the houses the most. House children or ball children are competitors and spectators within the ballroom circuit. The house competitions have different categories, like dance, fashion, style—and whatever mad categories that the house which is throwing the ball at the moment can come up with. Of course, these are not "children" only; ball or house children range from thirteen to forty years old. If you're not the house mother or father, then you're usually considered one of the house children, no matter what your age is.

R: Do you still run House of Ninja?

N: No, I stopped it in 1988, tried it again in '89, when I was still performing but stopped it because then I got too busy. Nobody wants a part-time mother. And then, too, I didn't want my name out there associated with folks who might be doing stupid things, like getting trashed on drugs, or stealing or whatever under House of Ninja. So I just closed it.

R: Was the house a separate physical place?

N: Oh no.

R: It's like a community based on social relationships but it doesn't have a place? So that means they would just call you at your apartment?

N: My apartment would be the physical place. We sometimes worked out of a community center on 13th Street in Manhattan which was the meeting hall. The House of Ninja stuck for a while; it had a reputation for being multiracial.

R: Most of the others were all-black or all-Latin?

N: Yes. Most of them were all-black. House of Extravaganza was the all-Latin house, and my house was the first ones to have white men walk and compete.

R: What are the competition categories?

N: Early on, the gay male categories were: Overall Performance Vogue, Pop Dip and Spin (the judges call the next move and you have to execute it), Vogue the Old Fashion Way, which is mostly hand movements, or Vogue the New Fashion Way, which is more stretching and acrobatic in performance. Big Boys Runway Models Effect for boys 250 pounds and over. At that time there were only two categories for straight females: Best Face for Girls and Best Dressed Woman. Then there were the lesbian categories for women: Looking Like a Man, Looking Like a Boy, Best Dressed Butch in Executive Wear. The categories change all the time, and often relate to current issues. So, during the Gulf War there were military categories like Ground Wars versus Aerial Wars. If you were in the Ground Wars category, then all your movements had to be on the floor, if you were in Aerial Wars, then your moves were confined to upright hand-oriented movements.

R: Are there houses in other cities?

N: Oh yeah. There are some in Chicago, a few in London, maybe fifteen or so in DC, There are maybe four in Miami. But it started in New York. It spread out rapidly after *Paris is Burning* was released.

R: What was the music of choice during the balls?

N: In the houses it was always R & B music, since the beginning, thirty or so years ago. Songs like "Doctor Love" by First Choice, "Love Hangover," by Diana Ross, which were favorites, were R & B songs; this was not considered house music at the time. Another R & B song, "Love is the Message" by MFSB is the vogue category ball competition anthem.

R: There is a part in "Paris is Burning" where you are showing straight women how to walk in more graceful, "feminine" ways.

N: [Laughter . . .]

R: *Here you were, teaching these women how to walk and posture more like "women."*
What is that like?

N: Well, I started doing this basically in my neighborhood. There was this woman that used to produce these little around-the-town fashion shows. The models have to sell ten tickets, and then your parents and your family come and watch you model. She and this leather designer asked me to walk in the show, but after a few shows, the choreography got tired. Long before this, I was always into fashion shows, and went to Bloomingdale's and watched them on video. I was always fascinated with Iman, I lived for that woman since the first time she started modeling. So, since I was familiar with the moves, I began helping them choreograph the neighborhood shows. And then I started training girls. I began training some really good girls, some fierce ones. After a while I got frustrated with the setting and I started training girls on my own. We started doing beauty pageants and teaching girls how to walk.

It's like going back to the old Emily Post days of charm school, and that's all it is. One of the unfortunate by-products of the feminist movement (which I totally support) was the idea that you have to act like a man to get a man's job. You don't have to. Let's take Diahann Carroll—I mean she gets what she wants, and Diana Ross, too. They are both feminine beyond belief; you do not see any hard edges. As the saying goes, "You attract more bees with honey than with vinegar." Femininity and grace is needed in the world. Since men can't provide that grace and femininity without getting the shit beat out of them, then who's left? I'm not trying to teach a woman how to be a woman, I'm just trying to teach her how to have correct body posture, how to be feminine again. In such a large and tough city like New York sometimes you have to have that outer shell to protect yourself, so the roughness is understandable. But some women forget how to loosen it up, so when they're at home or on a date they still have that rough exterior. I'm trying to break through that shell. You can keep that shell when you need it, but you have to learn when to come out of it.

R: *At the conference you seemed to apologize about bringing up race and racism.*

N: You can't help but bring it up. People keep saying we gotta stop talking about race and sex. But the day this world stops dealing in race and sex will be the day we stop talking about it. People say: "I'm tired of hearing it." Sure, I say: "Do something about it. Then maybe we won't have to say it again." But you're right, I do apologize because I know people are tired of hearing it.

R: Yeah so let's talk about it. What have been your experiences with homophobia in general and within black communities in particular.

N: I've had a lot of minor instances like name-calling, and so on. That sort of stuff you just get used to. But on two occasions, I had to deal with more heavy discrimination at my job, and I went to my boss, who was really supportive of gay people and unafraid to voice it. This guy came in and said in my direction, "why do you have this faggot working here in this restaurant. Don't you know he can give you AIDS?" I usually ignored stuff like that, but this caught me off guard, because it was the first time somebody associated me with AIDS. I was so angry the tears came to my eyes. A whole bunch of people turned around in the restaurant and just lit this man up. And my boss came out of her office, took the food out of his hand, and she said: "You can take your business somewhere else" She said: "I will not have that in my restaurant. I make enough money to throw you out. Get out." If it were to happen now, I wouldn't be as hurt. I guess now I have a better protective shell.

R: You were very lucky to have such a supportive boss. What about homophobia in the black community?

N: For the most part, the black community denies homosexuality. It's a "white thing" as far as they're concerned. The majority deny it, and among some there is a lot of direct hostility toward us. Some express the same sentiments of a Shabba Ranks or Butu Banton: "Boom, Boom, Bye Bye," kill all the gay people, and so on.

R: What about black women? Are they as hostile as black men?

N: Generally, black women are a lot less hostile than the men.

R: Let's get back to your dancing. If you had to name the five major influences on your dancing, who would they be?

N: Fred Astaire, of course. The Nicolas Brothers, Eleanor Powell. I loved her grace. Dance Theater of Harlem, I loved to see them dance. There was a lead dancer with DTH who danced the Firebird. I can't remember her name but she was just flaw-less. A friend of mine and Hector's named Melvin was another influence. This boy was un-real. Ballet, freestyle, hustle, he did everything. The boy made me cry one day watching him do the hustle at a ball. His partner didn't know the dance that well, but Melvin covered for him so gracefully. It made me cry. I get emotional when I see great performances, especially when someone overcomes an obstacle and still comes off.

R: What about James Brown or Michael Jackson? Everyone seems to mention them as dance influences.

N: Yeah, that's true, everybody references James Brown. I used to think he was fierce when I saw him at the Apollo as a kid, but not as an influence on me. Well, I'm gonna have to be shady, but not intentionally. There's nothing graceful about James Brown to me, I thought he was energetic, extremely high voltage. But I wouldn't say graceful. The people I mentioned had grace. That's what influenced me. Michael, we're about the same age so, he didn't influence me as much.

R: There is a myth of egalitarianism that seems prevalent in dance. It is as if "anyone can dance, we all have bodies" and so on. But there are important hierarchies among dancers. For instance, you asked people to dance with you at the conference party, as if you were just like the rest of us "regular" dancers. I mean get real now—who is gonna just dance with Willi Ninja!?

N: Nobody would . . . other than Dmitri from Deee-Lite! What I said at the conference holds true here: never be ashamed of what you can do. Because you'll never know what you can do with your body if you keep letting people say you can't dance. I don't care if you're the worst dancer—go on, just do it. I've seen bad dancers who sometimes come up with a move. And then I've seen experienced dancers try to use the move and it won't work for them.

R: So you don't consider yourself in competition with other people?

N: I'm always competitive. But, that doesn't contradict what I said before about working with what you've got. Everybody has an ego and everybody is competitive. If I deny that I'm competitive I'd be full of shit. When I see somebody who's a really good dancer sometimes I'll sit there with a little smirk on my face wondering if I should get up and compete, to see how good they *really* are. But the majority of the time I won't do it, because I hate when people do that to me, especially when I'm having a good time on the dance floor. But, if they come for me and I'm in that mood and they started first, that's when I'll answer it. They started it, so let's see if they can finish it. If I'm in a competitive mood I have to let the music take me over. Now, there are days when I just can't get it together. And there are days when I know I'm so flawless that I wish there was a camera there because I doubt it'll happen that way again for a long time. How the DJ clips the music—certain combinations—can totally inspire you. Sometimes people think I'm on major drugs because when a song clicks, I am *gone*. I mean I don't *see, hear, smell* or

taste no one. I get such a high from dancing. If both my legs break and they can't heal? You better kill me.

R: *That's how important it is?*

N: That's how important it is to me. If I don't have a lover, if I don't have somebody close to me, then dancing is my lover. So far it hasn't let me down . . . it's taken me all around the world.

R: *Where do you think voguing is gonna go?*

N: It will continue to evolve as we take everyday life and incorporate it into adapted runway movements. I think it will become more abstract, like modern dance. There are so many different variations of the dance which you haven't even seen yet. I saw a video of this boy named Adrian who dances like a hip hop version of vogue, real street, real hardcore. My style is what you call the runway version. Right on the beat he'll go down the floor, balancing on his hands, do backflips and walkovers. He does very African-inspired movements, some inspired by Brazilian capoeira dance moves. He'll backkick his leg straight up while his torso is bent down, but instead of following through, he'll hold the pose—to make the move more like vogue's use of stationary or freeze posing. Vogue will continue to change by taking up different moves and bringing them into vogue's style, attitude and presentation.

R: *Before we go, define "throw shade" for me.*

N: [Laughter.] Shade is basically a nonverbal response to verbal or nonverbal abuse. Shade is about using certain mannerisms in battle. If you said something nasty to me, I would just turn to you, and give you a look like: "Bitch please, you're not even worth my time, go on." All with a facial expression and body posture, that's throwing shade. If I want to be a little extra nasty I might throw in a little cough, but not so loud, just a little bit like: "You're making me choke."

R: *It's definitely a challenge.*

N: Definitely. You're looking for trouble when you're throwing shade. It's like watching Joan Collins going against Linda Evans on *Dynasty*. Or Jasmine Guy on *A Different World*, going against Diahann Carroll who plays her mother . . .
Or when Bush ran against Clinton, they were throwing shade. Who got the bigger shade? Bush did because Clinton won. Bush threw some good verbal daggers, but Clinton just

paid him dust. Clinton threw the biggest shade when he looked at him with a little smirk on his face as if to say: "That did not even work." When they had that town meeting debate and Clinton walked toward and addressed the audience with his back to Bush, he was saying that he did not need to address Bush, that Bush was beneath him and the audience. He was saying: "You're out of the circle." *That's* throwing shade. Everybody does it.

R: Um-hmm. Even academics.

N: Absolutely.

Moral Panic, the Media and British Rave Culture[1]

Sarah Thornton

The idea that authentic culture is somehow outside media and commerce is a resilient one. In its full-blown romantic form, the belief imagines that grass-roots cultures resist and struggle with a colonizing mass-mediated corporate world. At other times, the perspective lurks between the lines, inconspicuously informing parameters of research, definitions of culture and judgments of value. Either way, scholars of youth and music culture are among the most tenacious holders of the idea. One explanation for this is undoubtedly that their studies reproduce the anti-mass-media discourses of the youth formations they study. While youth celebrate the "underground," academics venerate "subcultures"; where one group denounces the "commercial," the other criticizes "hegemony"; where one laments "selling out," the other theorizes "incorporation."

Every music scene has its own specific set of media relations. "Acid house," a dance club culture which, after sensational media coverage about drug use, mutated into "rave," a movement said to be bigger than punk and akin to the hippie "revolution," offers a particularly revealing case. In exploring this case, this article finds no opposition between subcultures and the media, except for a dogged ideological one. It uncovers no pure origins or organic homologies of sound, style and ritual, nor does it vilify a vague monolith called "*the* media." Instead, it examines how various media are integral to youth's social and ideological formations. *Micro*media like flyers and listings are means by which club organizers bring the *crowd* together; *niche* media like the music press construct as much as they document *subcultures*; while *mass* media like the tabloids develop as much as distort youth *movements*. Contrary to youth discourses, then, subcultures do not germinate from a seed and grow by force of their own energy into mysterious movements to be belatedly digested by *the* media. Rather, media are there and effective right from the start. They are integral to the processes by which, in Bourdieu's terms, we "create groups with words."[2]

To understand the relations between youth subcultures and the media, one needs to pose and differentiate two questions. On the one hand, how do youth's subcultural dis-

176

courses position the media? On the other, how are the media instrumental in the congregation of youth and the formation of subcultures? The two questions are entwined but distinct.

Youth's "underground" ideologies infer a lot but understand little about cultural production. Their views of the media have other agendas to fill. They are a means by which youth imagine their own and other social groups, assert their distinctive character, and affirm that they are not just "attention spans" to be bought and sold by advertisers, nor faceless members of an undifferentiated mass.

Even the most *political subcultures* are also *taste cultures*. Given that the vast majority of British youth subcultures, past and present, do not espouse overt political projects, nor even constitute "subcultures" in more stable sociological senses of the term,[3] issues of taste and distinction deserve attention. Rather than depoliticizing youth subcultures, this move actually gives fuller representation to the complex and not always progressive politics of popular culture. While difference is not necessarily resistant, it is always caught up in systems of distinction.

Similarly, the second question about how the media do not just represent, but mediate within, subculture can only be fully understood in relation to subcultural ideologies. For the positioning of various media outlets—prime-time chart shows versus late-night narrowcasts, BBC versus pirate radio, the music press versus the tabloids, flyers versus fanzines—as well as discourses about "hipness," "selling out" and "moral panic," are crucial to the ways young people receive these media and, consequently, to the ways that media shape subcultures.

The "Subcultural Capitals" of the "Underground"

The term "underground" is the expression by which clubbers refer to things subcultural. More than fashionable or trendy, underground sounds and styles are "authentic," and pitted against the mass-produced and mass-consumed. Undergrounds denote exclusive worlds whose main point is not elitism, but whose parameters often relate to particular crowds. They delight in parental incomprehension, negative newspaper coverage and that best blessing in disguise, the BBC ban. More than anything else, then, undergrounds define themselves against the mass media.

Undergrounds are nebulous constructions;[4] their crowds shun definitive social categorization. Mostly they are said to be "mixed" and, although the subcultural discourses cross lines of class, race and sexuality, the people who hold these ideas are less likely to physically traverse the relevant thresholds.[5] Generally, underground crowds are attached to sounds. As one label manager put it: "There are records out there that are more radical and, at this moment, have a more radical audience—a smaller, more selective audience—but the sounds in that area will be the next generation of sounds we're all used to. . . . That's what I mean by underground."[6]

Undergrounds define themselves most clearly by what they're not—that is, "main-stream." Although there is variation, the oft-repeated expression by which they refer to mainstream clubs is that these are places where "Sharon and Tracy dance around their handbags." This mainstream is decried as passive, indiscriminate and uncommitted to dance culture; it is ridiculed for its "herd instinct" and "bandwagon mentality." Undoubtedly a residual version of the mass, this mainstream points to the relevance of Andreas Huys-sen's "mass culture as woman" thesis, but here the traditional divide between virile high art and feminized low entertainment is replayed within popular culture itself.[7]

Though the discourses of the underground are anti-mass culture, one should not confuse them with those of the art world. Certainly, both criticize mass culture for being derivative, commercial, shallow and *femme*. But they differ insofar as subcultures romanticize "the street" and the crowd, not artists' studios and individual genius. Moreover, rather than the dreaded "trickle down," the problem for *under*ground *sub*culture is popularization by a gushing up to the mainstream. These metaphors are not arbitrary, for they betray a sense of social place. Subcultural discourses implicitly give alternative interpretations and values to young people's, particularly young men's, subordinate status; they reread the social world.

The main currency of the underground might be called "subcultural capital." Pierre Bourdieu's distinction model, from which the term is borrowed and amended, describes a total system which concentrates on the tastes of the middle-aged.[8] Perhaps more than gender, race or ethnicity, age differences and aging in time throw a spanner into the workings of class-based distinctions.[9] This may be because youth, whatever their class, enjoy a momentary reprieve from "necessity."[10] In other words, youth are exempt from adult commitments to the accumulation of economic capital. They temporarily enjoy what Bourdieu argues is normally reserved for the bourgeoisie; that is, a "taste of liberty or luxury."

Subcultural capital can be accumulated, but not over a lifetime. It is a capital with built-in obsolescence, which either gets converted into cultural capital proper (for example, jazz was turned into "Ph.D. music")[11] or depreciates in subcultural value (sometimes not without a fight; for example, Bob Dylan). Of course, "adult" cultural capital is also subject to obsolescence, but it isn't built in, so to speak. Bourdieu characterizes the *avant-garde* as the young bourgeois producing knowledges that eventually become "classic." But subcultural capital is different from this nascent cultural capital, insofar as its main antagonist is not established art culture but mass culture, and graduating up is not its standard route. *Subcultural* capital deteriorates with age and in this way, maintains its position as the prerogative of the young.

As a result, clubber subcultural capital is not as class-bound as cultural capital. After age, the social difference along which it aligns most systematically is, in fact, gender. Girls and women often opt out of the game of "hipness," refusing to compete, and conceding

defeat. They are inclined to identify their favorite music as "chartpop" rather than specialist genres, then defend their taste with expressions like "It's crap but I like it." In so doing, they acknowledge the subcultural hierarchy, and accept their position within it. Although many British girls and women refuse this defeatism, they tend to do so by distancing themselves from the culture of "Sharon and Tracey."[12]

Despite its fleeting contents, "hipness" is a long-standing form of subcultural capital. In the late forties, Howard Becker investigated the culture of jazz musicians, who saw themselves as possessing a mysterious attitude called "hip" and disdained others as ignorant "squares."[13] In the early 1960s, Ned Polsky researched "the cool world" of Greenwich Village beatniks, finding that the beats distinguished not only between the hip and the square, but added a third category of the "hipster" who shared the beatnik's fondness for drugs and jazz, but was said to be a "mannered show off regarding his hipness."[14] Club versions of hipness follow this logic, down to affiliations with black culture, associations with drugs and a division of labels (uncool ravers were called "Acid Teds" and "Techno Traceys.")[15]

One way that club ideology diverges from previous manifestations of hipness is that it is indifferent, if not hostile, to "live" music. Club culture is a record-based culture to the extent that the underground ethos is aptly symbolized by its attitude to two product types. Its distinctive format is the "white label"—a twelve-inch single produced in limited edition without the colorful graphics that accompany most retailed music, distributed to leading disc jockeys for club play and to specialist dance record shops for commercial sale. The rarity of white labels guarantees their underground status. At the other end of the spectrum, the format with the least credibility is the TV-advertised compilation album of already charted dance hits. One fanzine writer ranted against amateur ravers who buy such albums: "Wise up sucker, get hip to musical freedom, stop investing in K-Tel compilations with titles like *Nonstop Mental Mega Chart Busting Ravey Rip Off Hits Vol 234516*."[16] While these hit compilations may contain music that was on a white label only six months earlier, the sounds are corrupted by being accumulated and packaged.

The underground espouses a fashion system that is highly relative; it is all about position, context and timing. It imagines itself as an outlaw culture, as forbidden just because it's unauthorized, and as illicit even though it's not illegal. But its main antagonists are not the police who *imprison*, but the media who continually threaten to *release* their cultural knowledge to other social groups.

The Betrayals of Broadcasting

Most British homes receive only four television channels (cable penetration is one percent and satellite's market share is less than ten percent). Of these, two stations—the public service BBC 1 and commercial ITV—account for about seventy five percent of all television

viewed. TV in Britain is therefore a mass medium in the old sense of word: there is little regional or local programming; niche targeting is new and tends to operate only well outside prime time. As a result, the only regular prime-time music show occupies a key position within the symbology of the underground.

Having been on the air for over twenty-five years, *Top of the Pops* is an institution with close to universal brand recognition, and is the unrivalled nemesis of the underground. This half-hour program combines "live vocal" performances attended by a free-standing studio audience with video clips—both of which are introduced according to their current position in the week's Top 40.[17] As the show is considered domestic, familial and tame, the ultimate put down of a club event is to say it was "more *Top of the Pops* on 'E' [ecstasy] than a warehouse rave."[18] Moreover, it is assumed that "for dance music to stay vital, to mean more than the media crap we're fed from all angles, it has to keep *Top of the Pops* running scared."[19]

Top of the Pops is seen as the main gateway to mass culture, and as a key point of so-called "selling out." For example, a member of a techno dance act with a single in the charts warned, "don't expect to see us on *Top of the Pops*. We might let them show the video, but we [won't] have people pointing at us, regarding us as sell-outs."[20] If one were to take this discourse about selling out at face value, one could interpret it as anticommerce or resistant. Dick Hebdige theorizes selling out as a process of "incorporation" into the hegemony. He describes this recuperative "commercialization" as an aesthetic metamorphosis, an ideological rather than a material process whereby previously subversive subcultural signs (that is, music and clothing) are "converted" or "translated" into mass-produced commodities.[21] But given that the popular rhetoric of selling out postulates that records with low sales aren't "commercial" (even though they are obviously products of commerce), and validates the proliferating distinctions of consumer society, this fusion of populist and Marxist discourses is wistful.

Within club undergrounds, it seems to me that "to sell" means "to betray," and "selling out" refers to the process by which artists or songs sell beyond their initial market, which, in turn, loses its sense of possession, exclusive ownership and familiar belonging. In other words, selling out means *selling* to *out*siders, which in the case of *Top of the Pops* means those younger and older than club-going sixteen to twenty-four-year-olds (who do not form the bulk of the program's audience partly because they watch less TV than any other age group.)

Despite many academic arguments about the opposition between youth and TV,[22] British youth subcultures aren't "antitelevision" as much as they are against a few key segments of TV that expose subcultural materials to everybody else. The general accessibility of broadcasting (as opposed to narrowcasting) is at odds with the esotericisms and exclusivities of club and rave culture. It too widely distributes the raw material of youth's subcultural capitals. Other music-oriented television programs which tie into club culture (like ITV's

Chart Show or MTV Europe) have not accrued the connotations of *Top of the Pops*. Firstly, these programs are sufficiently narrowcast to escape negative symbolization as the overground. Secondly, they have high video content—a form which is somehow seen to maintain the autonomy of music culture.[23]

The techno artist quoted above differentiates between appearing on *Top of the Pops* in person (which amounts to selling out) and appearing on video (which is considered a legitimate promotion). This is a frequent distinction; underground dance acts seem to believe that videos help them resist the "mainstream." First, videos allow the band to present itself (with the help and hindrance of the marketing and promotions departments of its record company) in a controlled manner closer to its own terms. Second, with videos, the band avoids being tainted by the uncool context of *Top of the Pops*; the artists protect their "aura" by not making a physical appearance.[24] Third, the practice of acting out songs which have no "live" existence undermines the creative credibility of these artists. With few lyrics and few performers *per se*, much contemporary dance music (particularly house and techno) is still in the process of developing an effective style of "live" presentation. Videos are an appropriate visual accompaniment to a music that is quintessentially re-corded. (It is now often forgotten that the music video had its debut in discos in the 1970s and is still a feature of many clubs.)

Setting Up the Censors

Youth resent approving mass mediation of their culture, but relish the attention conferred by media condemnation. What better way to turn difference into defiance, life-style into social upheaval, leisure into revolt? Moral panics can be seen as a culmination and fulfillment of youth cultural agendas, insofar as negative news coverage baptizes transgression. Whether the underground espouses an overt politics or not, it is set on being culturally radical. In Britain, the best guarantee of radicality is rejection by one or both of the disparate institutions seen to represent the cultural *status quo*: the tempered, state-sponsored BBC (particularly pop music's Radio One) and the sensational, sales-dependent tabloids (particularly the Tory-supporting *Sun*).

As a national public station to which thirty percent of the British population tune each week, Radio One represents the accessible and safe mainstream. Being "banned" from Radio One is therefore a desirable prospect. It acts as expert testimony to the music's violation of national sensibilities, and as circumstantial evidence of its transgression. Being banned is consequently the most reliable way to gain what is in theory a contradiction in terms, but in practice a relatively common occurrence—namely an underground smash hit. The Beatles' "Day in the Life" (1967), Donna Summer's "Love to Love You Baby" (1976), the Sex Pistols' "God Save The Queen" (1977), Frankie Goes to Hollywood's "Relax" (1984) and George Michael's "I Want Your Sex" (1987) were all banned, and

became hit singles or spearheaded hit albums. In the case of dance singles featuring the word "acid," several climbed from the Bottom 40 to the Top 40 as a result of rumors alone.

In October 1988, the first acid track to enter the Top 20, D-Mob's "We call it Acieeed," caused controversy. Radio One denied allegations, which emerged from the artist's record company, of having banned the single, explaining that it was not on the playlist because "it wasn't right for the mood of programs such as the breakfast show." However, as their playlist functioned only at peak times, the single had received more plays from individual producers outside the playlist system than the Whitney Houston track that was number one that week. In other words, Radio One insisted that they had imposed no ban on acid house in the strict sense of the word; that is, they were *not censoring* acid house, whereas the record company kept suggesting that the music was "banned" in the conveniently loose sense of the word; that is, acid house was *not playlisted*.

Conscious of the curiosity generated by anything said to be censored, the BBC tries to keep its gatekeeping low-profile, and if that fails it actively plays down the offending issues. A BBC spokesman stated that the station understood the lyrics of the D-Mob single to be antidrugs: "it expresses the ideal sentiments of our forthcoming Drug Alert campaign."[25] Radio One's morning DJ gave interviews asserting that "Acid is all about bass line in the music and nothing to do with drugs."[26]

Back in January 1988, however, London Records had successfully launched acid house as a genre on the coattails of drug-oriented potential for scandal. The sleeve notes to *The House Sound of Chicago Volume III: Acid Tracks* described the new music as "drug-induced," "psychedelic," "sky high" and "ecstatic," and concluded with a prediction of moral panic: "The sound of acid tracking will undoubtedly become one of the most controversial sounds of 1988, provoking a split between those who adhere to its underground creed and those who decry the glamorization of drug culture." In retrospect, this seems remarkably prescient, but the statement is best understood as hopeful. Moral panics are one of the few marketing strategies open to relatively anonymous instrumental dance music.

Marketing Moral Outrage

While the BBC conducts its "bans," the logic of "moral panic" operates most conspicuously within the purview of the tabloids. Britons have a choice of eleven national daily newspapers, which range between "quality" broadsheets and "popular" tabloids. Unlike papers like *USA Today*, the national tabloids in Britain are read by over half the British population every day. They cover political issues in dramatic and personal terms, and take a regular interest in youth culture, which they tend to treat as either a moral outrage or a terrific entertainment. Most importantly, the tabloids have an incredible domino effect;

their "Shock! Horror!" headlines frequently make the news themselves, get relayed by TV and radio, and generate much word-of-mouth interest.

Mods, hippies, punks and new romantics have all had their tabloid front pages, so there is always the anticipation—the mixed dread and hope—that a youthful scene will be the subject of media outrage. Disapproving tabloid coverage legitimates and authenticates youth cultures. Without tabloid intervention, it is hard to imagine a British youth "movement." For in turning youth into news, the tabloids both frame subcultures as major events and disseminate them. A tabloid front page, however distorted, is frequently a self-fulfilling prophecy; it can turn the most ephemeral fad into a lasting development.

Following London Records' sleeve notes, the subcultural press repeatedly predicted that a moral panic about acid house was "inevitable."[27] Of course, the very magazines that embraced the company's inaugural discourses later excluded record company involvement from their histories of acid house, positioning the industry as "bandwagon jumpers" producing last-minute acid remixes. Contrary to underground ideology, culture industries do not just co-opt and incorporate, but generate ideas and incite culture. The record and publishing industries, in particular, have sectors which specialize in the production of "anticommercial" culture. Cultural studies have tended to overstate the homogeneity and conformity of cultural industry output and, as a consequence, exaggerate the presence of resistance.

Innuendo, then full-blown exposés about Ecstasy use in British clubs appeared in the music press for months before the story was picked up by the tabloids. Although it admitted that it was "hardly a matter for public broadcast," *New Music Express* was the first explicitly to explain the appeals of the drug and offer proof of its prevalence.[28] *Melody Maker* followed with, among other stories, "Ecstasy: a Consumer's Guide," which rated batches of MDMA.[29] By the end of August, most of the subcultural consumer press were wondering why the tabloids were ignoring the issue. Some complained that crack had received much more "gutter press" attention, despite its limited use. Others, confident of eventual moral panic, imagined possible headlines like "London Gripped by Ecstasy!" or "Drug Crazed New Hippies in Street Riot."[30]

When the "inevitable" moral panic ensued, the subcultural press were ready. They tracked the tabloids' every move, reprinted whole front pages, analysed their copy, and decried the misrepresentation of acid house. Even after the tabloid coverage had subsided, fanzines continued to compile Top 10 charts of "ridiculous" headlines: "Killer Cult," "In the grip of E," "Rave to the Grave."[31] In late 1991, however, when the negative stories had lost their news value, the tabloids started publishing positive articles with headlines such as "Bop to Burn: Raving is the Perfect Way to Lose Weight" and "High on Life." The music press attacked these affirmative tabloid stories with unprecedented virulence. For example, *Touch* magazine wrote: "the *Sun* knows absolutely fuck all about what's happening on the Rave scene, just as they knew fuck all in 1988 and 1989. The truth is

that the *Sun* is run and staffed by a bunch of hypocritical, no good, Tory, band-wagon jumping wankers." [32]

Although negative reporting is disparaged, it is subject to anticipation, even aspiration. Affirmative tabloid coverage, on the other hand, is the kiss of death. Cultural studies and sociologies of moral panic have tended to position youth cultures as innocent victims of negative stigmatization. But mass media misunderstanding is often a goal, not just an effect, of youth's cultural pursuits. Moral panic is therefore a form of routinized hype orchestrated by the culture industries that target that market. Moralizing denunciations are, to quote one music monthly, a "priceless PR campaign." [33] They render a subculture attractively subversive as no other promotional ploy can.

Perhaps the first publicity campaign intentionally to court moral outrage was conducted by Andrew Loog Oldman who, back in the 1960s, promoted the Rolling Stones as dirty, irascible, rebellious and threatening. [34] Rather than some fundamental innovation, then, Malcolm McLaren's management of the image of the Sex Pistols in the 1970s followed an already well-trodden promotional path. In the 1980s and 1990s, acts as disparate as Madonna, Ice-T and the Shamen play with these marketing strategies, for moral panic fosters widespread exposure at the same time as mitigating against accusations of selling out.

"Moral panic" is a metaphor which depicts a complex society as a single person who experiences sudden groundless fear about its virtue. Although the term serves the purposes of the record industry and the music press well by inflating the threat posed by subcultures, as an academic concept, its anthropomorphism and totalization mystifies more than it reveals. It fails to acknowledge competing media, let alone their disparate reception by diverse audiences. And its conception of morals overlooks the youthful ethics of abandon. [35]

Popular music is in perpetual search of significance. Associations with sex, death and drugs imbue it with a "real-life" gravity that moves it beyond lightweight entertainment into the realm of, at the very least, serious hedonism. Acid house came to be hailed as a movement bigger than punk and akin to the hippie revolution precisely because its drug connections made it newsworthy beyond the confines of youth culture. While subcultural studies have tended to argue that youth subcultures are subversive until the very moment they are represented by the mass media, here it is argued that these kinds of taste cultures (not to be confused with activist organizations) become politically relevant only when they are framed as such. In other words, disparaging media coverage is not the verdict but the vehicle of their resistance.

The Controlled Flow of Subterranean Media

So far my discussion has focused on mass media such as prime-time television, national radio and tabloid newspapers, whose audiences, aesthetics and agendas are generally

contrary to underground discourses. What about those micro- and niche media that are more directly involved in the congregation of dance crowds and the formation of youth subcultures?

Word-of-mouth is considered the consummate medium of the underground. But conversations between friends about clubs often involve flyers seen, radio heard and features read. Rather than unadulterated grass-roots medium, word-of-mouth is extended by or an extension of other communications. Similarly, romantic notions of "the street" forget that it is a space of advertising which is subject to market research that gives ratings called "OTS" or "opportunities to see."[36] Outdoor advertising reaches large, non-TV audiences with a young, male, upmarket bias. This is one reason why record companies allot budgets to what they call "street marketing" and why flyposting and spray-painting are effective means for rave organizations to gain a higher profile and draw a crowd.

More than any other medium, fanzines have been celebrated as grass roots—as the active voice of the consumer and the quintessence of subcultural communications. But while rave fanzines (which are full of first-person narratives and local slang) are important outlets for clubber debate, they are not, as is often assumed, necessarily emergent. Most of the rave fanzines appeared in the aftermath of the tabloid "moral panic," long after British acid house had been converted into a "scene" by the subcultural consumer press. Professional media are generally faster off the mark, working to monthly, weekly and daily deadlines rather than the slow productions and erratic schedules of amateur media. Moreover, free from the constraints of maintaining readerships, fanzines do not have to worry about being identified with a scene that has become passé. Much fanzine copy therefore wallows in nostalgia. Writers reminisce about the legendary raves and hanker after the original "vibe."

"Crowd" is the colloquialism used by clubbers to describe the collections of people who go out dancing. Unlike mobs, club crowds are local and fragmented. Compared to scenes, they are explicit and concrete, but unlike communities, they are transitory and disorderly. Club crowds are not organic formations which respond mysteriously to some class-based collective unconscious. They are tied together by networks of communications, and actively assembled by club organizers whose job it is to deliver a crowd to a specified venue on a given night.

Flyers are considered the most effective means of building a crowd, insofar as they are a relatively inexpensive way to target fine audience segments. For their distribution, they can be mailed directly to clubbers in the form of invitations (the medium of the private party) or distributed to pubs, clothing and record shops, and handed to people in the street "who look like they belong" (methods which trace young people's routes through the city, exhibiting an understanding of what Michel de Certeau would call their "practices of space").[37] Though celebrated by some as "semiotic guerilla warfare," flyers are more accurately seen as advertising rather than cultural combat.[38] In Britain, "direct marketing"

(as the industry calls it) is the subject of more advertising investment than either magazines or radio, but because it targets tightly, it often feels more intimate and less "commercial."[39]

Key recipients of flyers are local listings magazines, who relay their information (along with that of accompanying press releases) to preview clubs for their readers. Listings magazines contain at least three gradations of exposure: the relative obscurity of the listings themselves, the discreet disclosure of a column mention and the open exhibition of a feature in the front pages. The listings themselves are written in a kind of shorthand which is often indecipherable to those who are not already familiar with clubbing. (For example, American students at the London School of Economics for a semester told me that after scouring *Time Out*'s London club listings, they still had no idea where to go.)

Published listings need to be negotiated carefully, as they can stimulate or stifle interest, under- or overexpose. While a crowd needs to be assembled, too much or the wrong kind of coverage can close a club down in a matter of weeks. Just enough and the right kind of publicity, on the other hand, can reserve a place in the annals of club folklore. "Shoom," the club retrospectively hailed as the origin of acid house culture, offers a telling case of the cultural logics involved. Its listing promoted the club by withholding its address.[40] Like marketing campaigns that revolve around banning and moral panic, the practice of advertising the inaccessible plays a media game which is in harmony with the underground. It doesn't betray, so much as reveal a mask. It doesn't sell "out," so much as identify the people and places that are "in."

Flyers and listings are not marginal representations, but principal mediators in subculture. They rely on being "in the know" and in the "right place at the right time" and are actively involved in the social organization of youth. For this reason, postmodern accounts of the city as an endless mediascape are as unsatisfying as the cultural studies which segregate authentic culture from the media. When we are said to have screens for eyes and headphones for ears, then communication is automatic, indiscriminate and total.[41] But access to information is restricted at every turn. Being "hip" or "in the know" is testimony to the very selective nature of contemporary communications.

The Editorial Discovery and Development of Subcultures

Britain saw a remarkable seventy three percent increase in magazine titles in the 1980s—the result of more detailed market research, tighter target marketing and new technologies like computer mailing and desktop publishing.[42] By the end of the decade, about thirty magazines addressed youth, featured music and style editorial, and drew advertising from the record, fashion, beverage and tobacco industries. While flyers and listings deal in the corporeal world of *crowds*, and tabloids handle the sweeping and scandalous impact of *movements*, consumer magazines operate in *subcultures*. They categorize social groups,

arrange sounds, itemize attire and label everything. They baptize scenes and generate the self-consciousness required to maintain cultural distinctions.

Although the phrase "subcultural consumer magazines" may at first seem to be a contradiction in terms, it accurately describes the editorial and market position of many youth-oriented magazines. The key reason for the magazines' interest in subcultures is their need to target and maintain readerships. The fortunes of the youth press have tended to fluctuate with the popularity of the scenes with which they're affiliated, so the monitoring of subcultures has become a financial necessity. For instance, *New Musical Express* peaked in circulation in 1980 when punk and postpunk rock held sway, then experienced steady decline until 1989, when its association with the Manchester scene gave it a new lease on life. Similarly, *The Face* was an integral part of the new wave club scene in the early eighties. Its contributors roamed around "clubland," celebrated posing and elaborated clubber discourse. By 1988, however, the magazine had lost touch with club culture, it dismissed acid house as a passing fad and its circulation, already in decline since 1986, worsened.[43]

In early 1988, acid house was little more than an imported type of music with drug associations. It didn't have a definite crowd, a telltale wardrobe or a unique blend of dance styles. It didn't even have a suitable British home. When the music was eventually anchored at Shoom, it was not because the club had any special affiliation to the sound *per se*, but because they identified with the drug discourses in which the music had been enveloped. Rather than being an organic part of the scene, then, acid house "simply gave them a musical identity that . . . these particular hippies could relate to, man."[44] So admitted the article that conclusively united the music with a club, drug and crowd, and fixed the parameters of acid house as a London subculture.

In 1988, the established magazine closest to clubland was *i-D*. Since its inception in 1980, the mission of *i-D* has been to excavate the youth cultural landscape, to find and formulate subcultures. Twenty years after 1968, hippie attitudes and attire were in revival among many disparate groups of youth, to diverse sound tracks, with different ideologies. And *i-D* was busy picking scenes out of the cultural morass and labeling them as subcultures. In their June 1988 issue, they ran an article which wove these disparate hippie themes through an account of Shoom, and effectively transformed a club *crowd* into a full-fledged *subculture*. Called "The Amnesiacs," the article reiterated the much-vaunted "realignment of club attitudes"—the "return to fun"—but combined it with the revelation of subculture—the "core crowd had adopted its own language and fashion codes."[45] Rendered fully newsworthy, it then proceeded to tabulate, in four Top 10 lists, the clothing, sounds, sites and slang of this scene. In so doing, the article gave the subculture a certain shape, marked its core and reified its borders.

Magazines like *i-D* produced acid house subculture as much as the participating dancers and drug-takers. The subcultural consumer press regularly pull together and reify the

disparate materials that subculturalists might turn around and interpret as revealing socio-symbolic homologies.[46] While not random, the distinct combination of rituals that came to be acid house was certainly not an unmediated reflection of the social structure. Media and commerce do not just *cover* but help *construct* music subcultures.

Conclusion[47]

Although acid house and rave are unique phenomena, several general theoretical points about youth, cultural distinctions and the media emerge from their case study. Firstly, diverse media are inextricably involved in the meaning and organization of subcultures. Youth subcultures are not organic, unmediated social formations, nor autonomous, grass-roots cultures which only meet the media upon "selling out" or at moments of "moral panic." Micro-, niche and mass media are crucial to the assembly, demarcation and development of subcultures. They do not just represent but actively participate in the processes of music culture.

Secondly, the reason for the oft-repeated notion of an absolute and essentialist ideological opposition between subcultures and media is, at one level, easy to understand. The stories that subcultural youth tell about media and commerce are not meant to give accurate accounts of media production processes, but are part of the way youth articulate their negotiation of issues of cultural capital and social structure. In this case, "*the* media" stand in for the masses—the greater discursive distance from which is a measure of their greater cultural worth.

Thirdly, academics have perpetuated this obscuration. Their segregation of subcultures from the media derives, in part, from an intellectual project in which *popular* culture was excavated out from under *mass* culture (that is, authentic people's culture was sequestered from mediated, corporate culture). In this way, the *popular* was defended against the disparagement of "mass society" and other theorists; youth could be seen as unambiguously active rather than passive, creative rather than manipulated. In practice, however, music subcultures and the media—popular and mass culture—are inextricable. In consumer societies, where sundry media work simultaneously and global industries are local businesses, the analytical division eclipses as much as it explains.

Finally, over the past two decades, there has been much productive inquiry into the divide between high and popular culture and many studies of the "resistances" of the popular to "dominant" culture. Comparatively little attention has been paid to hierarchies *within* popular culture. Although judgments of value are made as a matter of course, few scholars have examined the systems of cultural distinction that divide and demarcate youth music culture.[48] In examining youth's cultural hierarchies, one finds that they operate in symbiotic relation to a diversity of media. Media not only act as symbolic goods or marks of distinction, but as institutions. They are crucial to the creation, classification and distribu-

tion of cultural knowledge. To this degree, subcultural capital is itself, in no small part, a phenomenon of the media.

Notes

1. I would like to thank José Arroyo, Brian Austin, Andrew Goodwin, Larry Grossberg, Keith Negus and Leslie Felperin Sharman for their comments on the chapter of my Ph.D. from which this abridged article is derived. Special thanks go to Simon Frith, Angela McRobbie, Richard Ohmann, Andrew Ross and Jeremy Silver for their advice and support.

2. Pierre Bourdieu, *In Other Words: Essays Towards a Reflexive Sociology* (London: Polity, 1990), p. 139.

3. See David O. Arnold, ed., *Subcultures* (Berkeley: The Glendessary Press, 1970).

4. The "subcultures," defined and explored by the Centre for Contemporary Cultural Studies at University of Birmingham and subsequent studies in this tradition, are also nebulous constructions. These studies tend to position the media and its associated processes in opposition to and after the fact of subculture. In so doing, they omit precisely that which clearly delineates a "subculture," for labeling is crucial to insider and outsider senses of difference. These studies tend to consider previously labeled social types—"mods," "skinheads," "punks"—in a miraculously media-free moment. Moreover, they frequently position subcultures as transparent niches in an opaque world, as if subcultural life spoke an unmediated truth. These problems arise primarily from the fact that they were insufficiently critical of subcultural ideologies; first, because their attention was concentrated on the task of puncturing and contesting dominant ideology, and second, because their theories agreed with the anti-mass culture discourses of the youth music cultures they were studying. See, for example, Stuart Hall and Tony Jefferson, eds., *Resistance Through Rituals: Youth Subcultures in Post-war Britain* (London: Unwin Hyman, 1976); Paul Willis, *Profane Culture* (London: Routledge & Kegan Paul, 1978); Dick Hebdige, *Subculture: The Meaning of Style* (London: Methuen, 1979).

5. Although "underground" ideologies also operate in gay and lesbian club cultures, the alternative cultural capitals involved in exploring sex and sexuality complicate the situation beyond easy generalization. I therefore describe only their heterosexual manifestation. Moreover, "campness" rather than "hipness" is the prevailing subcultural discourse in these communities. See Susan Sontag, "Notes on Camp" *Against Interpretation and Other Essays* (New York: Farrar Straus Giroux, 1966).

6. *Select* (July 1990).

7. Andreas Huyssen, *After the Great Divide: Modernism, Mass Culture, Postmodernism* (Bloomington: Indiana University Press, 1986).

8. Pierre Bourdieu, *Distinction: A Social Critique of the Judgement of Taste* (Cambridge, MA: Harvard University Press, 1984).

9. Although youth subcultures are plainly within the field of "popular aesthetics," they do not display the concomitant "taste of necessity." They do not refuse formal experimentation nor distanciation. Moreover, problems of "legitimation" (cast as problems of authenticity and credibility) are a main concern.

10. Bourdieu argues that "as the objective distance from necessity grows, life-style increasingly becomes the product of what Weber calls a 'stylization of life', a systemic commitment which orients and organises the most diverse practices." Back in the 1950s, the first market researcher of British youth argued that the "teenage market" was characterized by "economic indiscipline." Without adult overheads like mortgages and insurance policies, young people were free to spend on goods which formed "the nexus of teenage gregariousness outside the home." See Bourdieu, *Distinction*, pp. 55–56; Mark Abrams, *The Teenage Consumer* (London: Press Exchange, 1959), p. 1.

11. For a seminal exploration of the meaning, uses and institutionalization of new cultural capitals in America, see Andrew Ross, *No Respect: Intellectuals and Popular Culture* (London: Routledge, 1989).

12. Girls spend less time and money on music, the music press and going out, and more on clothes and cosmetics. One might assume, therefore, that they are less sectarian and specialist in relation to music, because they literally and symbolically invest less in their taste in music and participation in music culture. See Euromonitor, *The Music and Video Buyers Survey* (London: Euromonitor, 1989); and Mintel, *Youth Lifestyles Special Report* (London: Mintel, 1988). For a more enthusiastic interpretation of femininity in rave culture, see Angela McRobbie, "Shut up and Dance: Youth culture and changing modes of femininity" *Young* 1:2 (May 1993).

13. Howard Becker, *Outsiders: Studies in the Sociology of Deviance* (New York: The Free Press, 1963).

14. Ned Polsky, *Hustlers, Beats and Others* (London: Penguin, 1967), pp. 151, 149.

15. This bifurcation of labels between original and imitator is perennial. The distinction is partly about age—the older connoisseur deplores the naive enthusiasm of the younger fan. It is also about class; the cultural identity has slid up- or down-market to that slice of the skilled working class positioned as the "mainstream." Either way, they tell of losing distinction and merging with the mass.

16. *Herb Garden* 1 (1991).

17. The Top 40 singles chart is a longstanding (and international) boundary of the musical underground. See David Riesman's 1950 discussion of the hit parade in "Listening to Popular Music," *On Record: Pop, Rock and the Written Word*, Simon Frith and Andrew Goodwin, eds., (London: Pantheon, 1990). The first British singles sales chart was published in *New Musical Express* in 1952, while the first album chart appeared in *Melody Maker* in 1958.

18. *i-D* (June 1990).

19. *Mixmag* (December 1991).

20. *New Musical Express* (July 28, 1990).

21. Hebdige, *Subculture The Meaning of Style*, pp. 94–97.

22. This is implicit in the Birmingham work (see Note 4) and explicitly argued by Paul Attalah's working paper "Music Television," (Montreal: McGill University, 1986) and Simon Frith's "Making Sense of Video: Pop into the Nineties" in *Music For Pleasure* (London: Polity, 1988).

23. MTV's brisk rotation of animated station identification sequences projects a dynamic and mischievous image that affiliates the station with the pleasures of "cool" youth. The relation of MTV Europe to British youth subcultures is also conditioned by the fact that the satellite station boasts a high ratio of out-of-home viewing in pubs and clubs. Called the "OOH factor," its nondomestic contexts and communal consumption contribute to MTV Europe's credibility. See *Broadcast* (14 May 1993); and *Marketing* (13 May 1993).

24. See Andrew Goodwin, "Sample and hold: pop music in the digital age of reproduction" in *On Record: Pop, Rock and the Written Word*, p. 269.

25. *New Musical Express* (October 29, 1988).

26. *Daily Mirror* interview with Simon Bates, quoted in *New Musical Express* (November 12, 1988).

27. See "New Acid Daze" *New Musical Express* (February 6, 1988); "Acid Daze" *Record Mirror* (February 20, 1988); "Acid Daze" *Melody Maker* (February 27, 1988); Darren Reynolds "Acid House" *Soul Underground* (April 1988). The repetition of the phrase "Acid Daze" suggests the stories were PR led.

28. *New Musical Express* (July 16, 1988).

29. *Melody Maker* (August 20, 1988).

30. *Time Out* (August 17–26, 1988).

31. *Herb Garden* 3 (no date).

32. *Touch* (December 1991).

33. *O* (January 1989).

34. See Philip Norman, *The Stones* (London: Penguin, 1993).

35. In Stanley Cohen's classic *Folk Devils and Moral Panics* (London: MacGibbon & Kee, 1980), for example, the media is synonymous with local and national newspapers, while magazines which might have been read by his subcultural subjects, like the mod girl's *Honey* or the mod boy's *Record Mirror*, are ignored. According to Cohen, "folk devils" are "unambiguously unfavorable" but a devil in the tabloids is often a hero or idiot in the youth press. Youth-oriented media demonstrate the appeal of moral panics, and suggest how they can be used as a means of marketing popular music.

36. The "OTS" rating specifies the demographic details of people who pass particular poster and billboard sites in cars or on foot, adjusting figures to take into account distractions such as rival sites and poor visibility.

37. Michel de Certeau, *The Practice of Everyday Life* (London: University of California Press, 1984).

38. Cynthia Rose, *Design After Dark: The Story of Dancefloor Style* (London: Thames and Hudson, 1991).

39. *Marketing* (August 13, 1992).

40. See *Time Out* (February 24–March 2, 1988).

41. Iain Chambers's cruise through "the communication membrane of the metropolis," for instance, does little to clarify the concrete relations between music cultures and their various media. Iain Chambers, *Popular Culture: The Urban Experience* (London: Methuen, 1986).

42. *Marketing* (August 13, 1992).

43. Not all youth-oriented magazines are in the business of discovering and developing subcultures. *Smash Hits* is a top-selling biweekly glossy that loves *Top of the Pops*, publishes poster pinups of the younger Radio One DJs and reiterates tabloid gossip with exclamations like "Really?!!!" With a target readership of girls aged twelve to twenty-two, *Smash Hits* covers dance music but rarely discusses club culture or celebrates undergrounds. While not subcultural in any current sense of the word, these magazines certainly cater to niches subject to fad and fashion.

44. *i-D* (June 1988).

45. *i-D* (June 1988).

46. The Birmingham scholarship (see Note 4) ignored the *development* of subcultures, considering them only when they were ripe for critical interpretation. This was an admitted shortcoming of the methodology: "Homological analysis of a cultural relation is synchronic. It is not equipped to account for changes over time, or to account for the creation or disintegration, of homologies: it records the complex qualitative state of a cultural relation as it is observed in one quantum of time." Willis, *Profane Culture*, p. 191.

47. My survey attempts to be holistic but not exhaustive. For a more detailed discussion, see Sarah Thornton, "Record Hops to Raves: Cultural Distinctions in Youth, Music and Media," Ph.D. dissertation (Glasgow: The John Logie Baird Centre, Strathclyde University, 1993).

48. Feminist analyses are an important exception, but they tend to restrict their critique of popular hierarchies to the devaluation of the feminine; see Angela McRobbie, *Feminism and Youth Culture* (London: MacMillan, 1991). For an interesting discussion of value judgment and popular music, see Simon Frith, "Towards an Aesthetic of Popular Music," *Music and Society*, Richard Leppert and Susan McClary, eds., (Cambridge: Cambridge University Press, 1987).

The Funkification of Rio[1]

George Yúdice

For Hermano Vianna, Jr.

Claustrofobia[2]

Ah! meu samba
Se tu es nosso, o nosso é samba
Se o nosso é o samba, o samba é
 nosso
Pra que prisões vais tu
Sa, meu samba
Porque sei que tu tens claustrofobia

É tua a noite, a noite e o dia
Vai te espalhar pelo pais

Vai, meu samba
Sem fatiga, estafa o stress
não precisa te rezar, kermis
ou passaporte do juiz
Já se abriu a janela do mundo
E agora não podes parar
Tu tens que conquistar
Tu tens que encantar
e te fazer cantar
com teu la-la, la, la
com teu la-la, la, la
com teu la-la, la, la

Claustrophobia

Ah! My samba
If you are ours, then ours is the samba
If ours is the samba, then the samba is
 ours
Why prisons within yourself?
Go out, my samba
Because I know you have claustro-
 phobia
The night is yours, the night and day
Go spread yourself throughout the
 nation
Go out, my samba
Without fatigue, weariness or stress
There's no need for prayer, kermis
or a judge's passport
The window to the world is already open
And now you can't stop
You have to conquer
You have to enchant
And make yourself sing
with your la-la, la, la
with your la-la, la, la
with your la-la, la, la

Rio 40 Graus[3]

rio 40 graus
cidade maravilha
purgatório da beleza e do caos

capital do sangue quente do brasil
capital do sangue quente
do melhor e do pior do Brasil

cidade sangue quente
maravilha mutante
.

quem é dono desse beco?
quem é dono dessa rua?
de quem é esse edificio?
de quem é esse lugar?

é meu esse lugar
sou carioca, pô
eu quero meu crachá
sou carioca
.

a novidade cultural da garotada
favelada, suburbana, classe média mar-
 ginal
é informática metralha
sub-uzi equipadinha com cartucho mu-
 sical
de batucada digital
.

de marcação invocação
pra gritaria de torcida da galera funk
de marcação invocação
pra gritaria de torcida da galera samba
de marcação invocação
pra gritaria de torcida da galera tiroteio

de gatilho digital
de sub-uzi equipadinha

Rio 104 Degrees

Rio 104 degrees
marvelous city
purgatory of beauty and chaos

hot-blooded capital of Brazil
hot-blooded capital
of the best and worst of Brazil

hot-blooded city
mutating marvel
.

who does that corner belong to?
who does that street belong to?
who does that building belong to?
who does that place belong to?

that place is mine
I'm carioca, damn
I want my I.D.
I'm carioca
.

the cultural novelty of the homies
slumdwellers, suburban, marginal middle
 class
is the informational machine gun
sub-uzi equipped with a music cartridge

with a digital drum beat
.

a demarcation [beat] invocation
for the cheering dancers at a funk club
a demarcation [beat] invocation
for the cheering dancers at a samba club
a demarcation [beat] invocation
for the cheering dancers at a shooting
 spree
with digital triggers
on a sub-uzi equipped

com cartucho musica; *with music cartridges*
de contrabando militar *smuggled in by the military*

.

Introduction: Youth Culture and the Waning of Brazilian National Identity

"Claustrofobia" and "Rio 40 Graus," juxtaposed, give contrasting characterizations of Rio de Janeiro's urban landscape, although they traverse the same terrain. The difference is in the manner of moving through space. The first, a samba, is a mellow, metapoetic composition whose sound is thematized as permeating the world through its open-ended structure and ethos. Its composer, Martinho da Vila, a highly popular *sambista* associated since the mid-eighties with a festival of black heritage in Rio, has interpreted the lyrics in an interview with Gary Robinson, the host of the television show *Sounds Brazilian*:

> Claustrophobia: everyone knows what that is. Here it's a conversation I'm having with samba. It shouldn't stay in the backyards, interiors and shantytowns; it needs to go out and "spread throughout the world." And that's happening. "The window has been opened," that is, the world is now open to receive samba. And now it's everywhere.[4]

For Martinho, as for many other enthusiasts, samba is a cultural form emanating from "the people" that permeates everything and everyone, blending all into one national identity ("Go spread yourself throughout the nation"). On the same show, Beth Carvalho and Paulinho da Viola emphasize the togetherness that samba inspires, and the resistance of "the people" and the culture to the hardships of everyday life. This resistance is born of samba's propensity to appropriate and mix everything in its way, thus undermining, it is argued, hierarchies of all kinds. *National Geographic*'s documentary, *Samba: Rhythm of Life*, about the efforts of the favela Mangueira's *escola de samba* to win the annual carnival competition, gathers every commonplace imaginable about samba: it is what makes life worth living, even in the worst of circumstances; the people may be poor in material goods but they are rich in spirit; through it they express their social and political aspirations; and, the clincher, in it the people speak with one voice.[5] Samba has, of course, meant these things to many people. As Brazilian music historians Chris McGowan and Ricardo Pessanha write, "In Brazil, millions of people make, sing, dance or just enjoy samba. Its importance in the maintenance of a relative social peace in Brazil is hard to measure, but it is clear. One doesn't need to wait for Carnaval to see how samba brings people from all social classes and races together and keeps them in harmony. . . . After all, in Brazil everything sooner or later ends up in samba."[6]

I would like to suggest, however, that the circumstances have changed, and that not

everything will "sooner or later end up in samba" or any other celebration of Brazilian identity that "keeps all social classes and races together in harmony." The transition to an ever distant democracy in the eighties and nineties has brought to the surface the unworkability of social and political enfranchisement through cultural practices that formed part of a "consensus" that dealt material wealth to elites and ever greater hardship to subalterns. Today, the cultural scene is rapidly changing, reflecting the growing dissatisfaction with the nation, as the events that I shall narrate here confirm. The breakdown in Brazilian national identity has taken place politically as well as racially and culturally. As Howard Winant argues: "Today, blacks are beginning to challenge the racial 'common sense,' both mainstream and radical, that race and racism are of limited political significance in the Brazilian context."[7] Given the importance of representations of blacks and mulattos and their cultural practices in the struggles to define Brazilianness, the challenge to racial common sense must focus on the social and economic status of non-whites and on how the "consensus culture" has symbolized such practices as samba, *pagode* (a neighborhood gathering where samba is played), *capoeira* (an Afro-Brazilian martial arts dance form brought by slaves from Angola), *candomblé* and *umbanda* (Afro-Brazilian religions), and so on. It should be stressed that the critique implicit in "opting out" of the "consensus culture" does not mean that the above-mentioned practices are somehow alienating, or always co-optable as binding elements of a social homeostasis that benefits elites. The point, rather, is that *since the 1930s* they have been mobilized by the media, business (particularly tourism), politics (including the manipulation of carnival), and other mediating instances for the symbolic reproduction of a "cordial" Brazil, with the result that elites reap the lion's share of material benefits. How to disengage these practices at this point from these mediations is a question that is not being asked, because the cultural-political negotiations have already yielded something for each party.

Perhaps more than any other sector, including the black and other social movements, which continue to invest their cultural-political capital in Brazil *as a nation*, youth, especially subaltern youth, are leading the way to new experiences, often crisscrossed by transnational cultural forms that confound the "consensus culture," and often seem to instill fear in the elite and middle classes, and suspicion among the leadership of the social movements. The new reality of street gangs, riots, narcotrafficking "commandos," *meninos de rua* or homeless street kids, vigilantism, and so on, have replaced the old myth of conviviality with a premonition of "social explosion," the term used by Brazil's president, Itamar Franco, in setting aside over two billion U.S. dollars for food for nine million poor families.[8]

This new urban landscape is what Fernanda Abreu's funk-rap "Rio 40 Graus" is about. While "Claustrofobia" projects a sense of free access to space, of no constraints on samba's "permeation" of space, the youths sung about in "Rio 40 Graus" must take possession of it through violence, through the display of force that inheres in the machine-gun-like assault of the black U.S. urban rhythms. Brazilian funk occupies the *same physical*

space as that of the more traditional samba, but it questions, as does the song, the fantasy of access to social space. Its adherents consistute a new cultural sector—*a novidade cultural*—that does not identify with their *sambista* elders, although they are equally a *garotada favelada, suburbana, classe média marginal* [homies, slumdwellers, marginal middle class]. The youths challenge the ownership by the "nonmarginal" middle classes of the city's space, claiming it as their own. Through the new, nontraditional musics such as funk and rap, they seek to establish new forms of identity, but not those premised on Brazil's much-heralded self-understanding as a nation of nonconflictual diversity. On the contrary, the song is about the *disarticulation of national identity and local citizenship*.

The cultural glue of this country of 150 million people has been quickly eroding in the wake of the demise of an authoritarian military dictatorship in the late seventies, and the never-ending "transition to democracy" in the eighties and nineties, made even more difficult by a substantial decrease in productivity and per capita income.[9] The most telling indicator of this shift is the diversification of youth cultures, almost none of which are holding to the cultural practices that supposedly bound their parents and grandparents in a community imagined through the *mise-en-scène* of popular culture forms like carnival, samba, soccer, and so on. Not only have the middle classes veered in a more "modern" direction, away from the celebratory consensus provided by plaza public culture (of the kind celebrated by Bakhtin and numerous Brazilian mythifiers of carnival), the working classes and the poor have also sought out new cultural forms or transformed more traditional ones like popular music in keeping with the pervasive mass mediation of Brazilian society. If Brazil was once imagined by its national bourgeoisie (and many complicit popular sectors, such as those associated with carnival) as a convivial meeting ground for the diverse groups that inhabit it, most notably the descendants of European immigrants and of African slaves, today its cultural critics are increasingly speaking of "balkanization."

"Cordiality," "racial democracy," and other similar terms have been used since the first decades of the twentieth century as the key words in the mythic projection of Brazil as a nonconflictual society. Brazilian intellectuals and artists cultivated this myth as a means to recognize the miscegenation that characterized Brazil, warding off, at the same time, the anxiety that it produced in elites and middle sectors.[10] *Mestiçagem* [miscegenation] was purged of its threatening connotations and dressed up in an aesthetic camouflage that transformed the anxiety into national pride. Gilberto Freyre, who coined the term "racial democracy," an apt catchphrase that evokes a society without "violent racial prejudice," saw in this "tropical *mestiçagem*" a "softening effect" that "tended to dissolve prejudice."[11] He went so far as to attribute to the *mestiço*, actually, to the *mestiça*, a new political function that derives from the aesthetic plasticity that she represents: "One may even suggest that mestizos are, perhaps, becoming the decisive force, political and cultural, in a considerable part of the world; and that human aesthetic tastes in regard to human form and particularly to feminine beauty are being greatly affected by the increasing racial

mixture."[12] [It should be said, at least parenthetically, that in Brazil, Cuba and other Ibero-American countries characterized by racial miscegenation between whites and blacks, the "positive" racist valuation is gendered feminine: the *mulata* is eroticized to mythic proportions, the reverse of Anglo-American mythification of black male eroticism.[13]] In projecting *mestiços* as the "plastic mediators between extremes," Freyre was in effect making more palatable the black element that Brazilian elite culture found "repulsive." "Racial democracy," based as it is in *mestiçagem*, thus leads to the related myth of *embranquecimento*, that is, the belief that the new national culture can be purged, through a process of "whitening," of its "cacogenic, mongrel, repulsive aspect."[14]

So long as Brazilian subaltern groups accommodate to this image, whereby even social injustice is thought to be better endured and even negotiated through the cultural forms of *mestiçagem* (for example, carnival) or the political practices typical of a patriarchal society (patronage and clientelism), they will be tolerated and even imagined as partaking in the rights of citizenship. This is what the *favelados* of today are rejecting. But Brazil as a whole also seems to be rejecting this "consensus," if recent events are any indication.

The Contradictions of Democracy, à Brasileira

In less than three weeks, between September 30 and October 18, 1992, three events took place that catapulted Brazil into a politics of representations unprecedented in its history. In using the word "unprecedented" I am referring to the peculiar mix of representations, not to the *persistent* social and political asymmetries to which these representations point.

The first event: on September 30, Parliament voted 441 to 38 to impeach President Fernando Collor, capping a five-month process of political jockeying after evidence of corruption was, in a fitting telenovelesque melodrama, presented by the president's brother, who was among other things taking revenge for the president's attempt to seduce his wife. Brazil thus became the first country ever to impeach its president, and the frenzied rush to the streets by more than a million demonstrators outdid Nixon's relatively spineless teledisplay of crocodile tears and the U.S. public's comparatively tepid sigh of relief. The *Jornal do Brasil* described the event as follows:

> The Brazilian people exploded. Throughout the entire country multitudes released the tension of the last two months. . . . In an unprecedented demonstration, the crowds, ever attentive to the news of the impeachment, frenziedly commemorated the vote against Collor by the greatest "traitor" of the government and the most celebrated hero of the opposition, deputy Onaireves Moura (PTB-PR), host of the *feast of curses [jantar dos palavrões]*. . . .
>
> In Brasilia the people stopped mourning, cast down the black and held aloft the yellow-

green [colors of the Brazilian flag]. One hundred thousand demonstrators gave an indescribable spectacle. [An official] set his immense black flag on fire. "Enough of mourning. The yellow-green belongs to the people," he cried. And hundreds of people repeated his gesture, burning their black flags and transforming the lawn outside Congress into a stage illuminated by fire. Thousands of yellow-green flags became visible among the people who danced, laughed and wept.

Fireworks and rockets lit up the sky. Everyone sang, in unison, the National Anthem. Then the Hymn of Independence. . . .[15]

This and other articles describe the festivities in good national tradition as a carnival. Not only were there fireworks and chanting, there were music, dancing and masquerade, the celebrated *caras pintadas* or painted faces of the students, most of them of high school age. Brazil had not seen demonstrations like these since the political heyday of the sixties. Brazil seemed to be a nation united again.

I would like to ask the reader to hold this image of national celebration in your mind—fireworks, national anthem, samba, carnival, restoration of democracy and so on—as I now turn, for the sake of contrast, to the other two epochal events.

The second event: just two days after the impeachment celebrations, on October 2, the Military Police invaded the House of Detention in Carandiru, São Paulo, and massacred at least 111 prisoners (some estimates run as high as 280). The police turned machine guns on the prisoners, lining them up against the walls St. Valentine's Day-style or shot them with their hands tied behind their backs, and those who were not killed by bullets were attacked by dogs specially trained to go for the genitals.[16] Prisoners reported being forced to drag the cadavers through puddles of blood because the military police were afraid of contracting AIDS. In fact, it was suggested that the military police took licence to massacre the protesting prisoners as a means to decrease the risk of contamination by continued contact with them.

The tenor of the reports was subdued in comparison to those of Collor's impeachment. Most were descriptive, resorting to sensationalist photographs of mutilated, naked corpses piled on top of each other, holocaust-style, an image that was explicitly evoked by several witnesses. The *Folha de São Paulo* reported:

> "It was worse than World War II. Hitler doesn't compare with this massacre!" cried a woman on Saturday night at the door of the IML (Legal-Medical Institute) in São Paulo. . . .
>
> Quite noticeable were the number of perforations in each cadaver: five or six. In at least two the wounds in the back were visible. Many showed large blood stains—even 24 hours after their death. The majority seemed to be under 30 years of age. The long and coarse stitchwork that traversed the corpses, made by the undertakers, put the final touch on the indigence in which they had died.[17]

Although the newspapers carried denunciations by intellectuals, politicians and clergy, accusing the state of terrorism, there were many in the population at large who endorsed the massacre, if polls are to be believed. The celebrations of just two days before were succeeded by a substantial show of support for the military police. The *Folha de São Paulo* reported that in a telephone survey it conducted, one third of the population of São Paulo supported the action.[18] Another newspaper, *O Estado de São Paulo*, found that support to be even higher: forty-four percent.[19] The interviewees repudiated the dénunciation by the OAS and Americas Watch,[20] defending the military police as the "moral reserve of São Paulo,"[21] and condemned human rights activists as abettors of murderers and rapists. Joanna Wechsler of Americas Watch received insults from many quarters. "I reject the presence of that *gringa*. She's an observer of nothing. Let her deal with the results of the racial conflict between whites and blacks in L.A."; *"Energumens*, tricksters and clumsy fools. Those communists want the corpses for their political proselytizing"; "Useless, vulgar bitch. Go teach your son not to be a thief."[22] The irony, as political philosopher José Arthur Giannotti and urban anthropologist Gilberto Velho explained, is that the mistrust of the justice system leads people to seek violence as a means to ensure security.[23] Some have even argued that vigilantism and the belief that it is better to kill off criminals is an internalization of a state of terror, in both senses of the phrase.

This display of violence, reproduced in many other spheres throughout Brazilian society (for example, the killing of *meninos de rua*, the widespread narcotraffic, vigilantism, and so on) is not proof, of course, that the prodemocracy movement, which has been a complex consensus-building phenomenon cutting across racial, class and ideological lines, is in any way bankrupt. It is a reminder, however, that talk of democracy in purely political terms is otiose when social rights are weak and then not even enforced.[24]

The third event, which I shall examine more closely in this essay, occurred on October 18. I first found out about it when the mother of the friend at whose house I was staying came running in off the street, alarmed about a riot on the beach (my friend lives where Copacabana turns into Ipanema). It was an *arrastão* or a looting "rampage"[25] conducted by *"uma negrada dos subúrbios da Zona Norte,"* (hordes of dark kids from the slums in the Northern suburbs). The event was registered hysterically by television news shows and newspapers throughout Brazil, as if it were a replay of the L.A. riots. In fact, the television shots of kids running wild on the beach and crowding into overstuffed buses through the windows, were clearly meant to provoke such fear. The *Jornal do Brasil* reported:

> Yesterday the *Zona Sul* [south end] of Rio became a battle zone, with *arrastões* carried out by gangs of adolescents from the slums of the suburbs of Baixada Fluminense, armed with sticks. The Military Police, with 110 guards armed with revolvers, machine guns and rifles, had difficulty in putting down the violence of the various groups involved

in the attack. Even a parallel police force, constituted by the Guardian Angels—a voluntary group aiming to defend the population—entered the fray.

Panicked beachgoers and inhabitants of the area had to take refuge in bars, bakeries and street stands. The attack began about midday, on Arpoador Beach [between Copacabana and Ipanema], where several bus lines from the periphery make their final stop. As the gangs got off, they began to form *arrastões*, spilling over into Copacabana, Ipanema and Leblon. Angry inhabitants demanded the death sentence and Army patrols on the streets.[26]

Fear of Funk

It didn't take long before the main offenders were identified as *funkeiros* or the youths from the slums of the North and West ends of Rio who on weekends frequent the dance clubs that play funk music, mostly from the U.S. The *Jornal do Brasil*'s Sunday edition carried an article titled *"Movimento funk leva desesperança"* (Funk Movement Breeds Despair) and emphasized the contrast with the student *caras pintadas* who had engaged in a very different public spectacle on behalf of democracy:

> They do not have their faces painted with the colors of the Brazilian flag and much less are they any cause for pride, as were the youths who resurrected the student movement in the struggle to impeach president Collor. With no paint on their faces, last Sunday these *caras pintadas* of the periphery took to the *Zona Sul* the battle of one of the wars that they have faced since birth—the war between communities. They thus became a cause for shame, directly linked to the terror on the beach: the *arrastões* that sowed panic.
>
> From Leme to Barra da Tijuca, the beaches were partitioned according to gang membership. This army was drawn from the two million frequenters of funk—[which could be described as]—a rhythm, a movement, or a force.[27]

This report plays ironically with the two kinds of "painted faces": the middle-class youths who went out into the streets to support "democracy" and the "naturally" painted faces (that is, with no need for paint) of the black and mulatto youths who took to the beach to cause panic. Their dark skin, in fact, was emphasized in many other reports, such as that by *Veja*, a news magazine comparable to a combination of *Time* and *Der Spiegel*. It carried statements made by middle-class beach-goers who remarked on the dark skin, poverty and dirty clothing of the kids, some of whom it also interviewed, if for no other reason than to sensationalize them and add to the panic. In a special section of the report, entitled *"Baile só é bom se tiver briga"* (A dance is only good if it ends in a brawl), it states:

> The tribes that terrorized the beaches of Rio de Janeiro can be compared to English hooligans or the perverse Mancha Verde gang of the Palmeiras suburb in São Paulo. They are youths who band together to go on rioting sprees wherever and whenever the occasion arises. The name *"galera"* [dance club][28] was coined in the funk dance clubs of the Rio suburbs, where gangs from the slums and *favelas* gather in multitudes of up to 4,000. . . . The aficionados of rioting call themselves *funkeiros* and they cultivate frequent showdowns as a leisure activity.[29]

Not all of the reports pinned the blame exclusively on the *funkeiros*; in the ensuing days, interviews with them and with youths from the *favelas* in the *Zona Sul* itself presented a more ambiguous picture. Yes, the gangs from the funk clubs did engage in commotions on the beach; yes, the beach-goers were scared shitless; yes, there were youths who stole some things from the blankets, although it could not have amounted to much since no *carioca* (resident of Rio de Janeiro) or tourist in his or her right mind would take anything of value to the beach. As it turns out, what the cameras captured were rival gangs skirmishing on the beach and kids jumping through windows into the few and overstuffed buses that would take them back to their neighborhoods in the North and West ends. Reports from the Guardian Angels and the surfers also suggested that what robberies were committed were probably carried out by the *favelados* of the *Zona Sul*. But never mind, the *funkeiros* seem to have been permanently stigmatized by the media and the hysteria of the middle classes of South Rio: a hysteria that was quite productive. The hoopla around the *arrastão* took place less than a month before the most important election in Rio's history. The *favela*-bred and self-taught daughter of a cleaning woman, the black candidate on the Workers' Party (PT) ticket, Benedita Souza da Silva, who is representative of the above-mentioned cross-class, race and ideology coalition of the prodemocracy movement, was up against a white, middle-class economist from the *Zona Sul*. Benê, as she is called in Brazil, won a plurality of the votes in the general election but, failing to get a majority, she faced the runner-up, César Maia, in the run-off election on November 15. Samba and the other cultural practices that are supposed to create social solidarity were not sufficient to brake the racial polarization that overtook the city. The upshot is that Benê lost the runoff by three percentage points as many ambivalent middle-class voters, fearing an increase in violence, voted for the "law and order" man.

This event took place while I was conducting interviews with people knowledgeable about music in Rio. I was interested in the reception of rap. Just the day before the *arrastão*, I had interviewed an anthropologist who had written a book on the funk dance clubs. He explained that rap, at least as Rio was concerned, was of minor interest. Brazilian youth were basically interested in rock, especially heavy metal, and most of it from the U.S. and England. These were the middle classes. The youths from the suburban slums and *favelas* of Rio, on the other hand, most of whom were black or mulatto and poor,

preferred funk, although rap is on the rise, especially in São Paulo. Reggae, too, is already a permanent fixture in São Luis de Maranhão and Bahia. (It should be said, parenthetically at least, that Brazil is a country of many musics, and that one cannot generalize about music loyalty from one city or region to another. If Brazil as a nation could ever have been characterized by samba, that is no longer the case. What is popular in Bahia or Porto Alegre is not necessarily popular elsewhere, and may not even get national radio and TV projection. I shall return to the question of distribution.)

Before the *arrastão* took place, even the anthropologist was at pains to explain why these youths would be interested in a music that they couldn't understand, that was not available in stores, and until recently didn't even get airplay. The *arrastão*, however, made it patently clear that the allegiance to funk implied *opting out* of other musics, particularly those most identified with Brazilian nationalism, or, more locally, cultural citizenship in Rio de Janeiro. A *Jornal do Brasil* article that carried interviews with an influential *funkeiro* DJ and the above-mentioned anthropologist brought this point home.

> According to DJ Marlboro (Fernando Luiz), who since the end of the seventies has promoted these dances, the *funkeiros* are not the source but the victims of everyday violence. They go to the dance clubs—*galeras* named after the hillside slums (*morros*) and *favelas*—seeking the homeland that they do not otherwise know.[30]

This DJ has already cowritten with other founders of the funk movement—Ademir Lemos and Nirto—a song titled *Rap do arrastão* [Riot Rap] which deals with this everyday violence.

Eu gosto de música americana	*I like American music*
e vou pro baile curtir todo	*and I go dancing every weekend*
fim-de-semana	*to have a good time*
Só que na hora de voltar pra	*But on the way home*
casa é o maior sufoco pegar condução	*it's impossible to catch a bus*
E de repente pinta até um arrastão	*And all of a sudden an arrastão . . .*
Esconde a grana, o relógio e o cordão	*Hide your money, watch or chain*
Cuidado, vai passar o arrastão	*Careful, the arrastão's coming your way*
Batalho todo dia dando um	*I work my ass off all day*
duro danado mas no fim-de-semana	*and on the weekend*
sempre fico na mão, esconden-	*I always run into problems*
do minha grana para entrar	*I have to hide my money*
na condução[31]	*for when I catch the bus . . .*

This song emphasizes the problems of everyday violence encountered by the youths who attend funk dances. In Rio, as in other major Latin American urban centers, poor

black and mulatto youth have no citizenship rights to speak of. They are not protected by the police; on the contrary, the police, often in cahoots with *justiçeiros* or vigilantes, harass them in the best of cases, and in the worst, murder them and leave their corpses on the street to serve as a warning to others. Human rights organizations' records show that in 1991 in São Paulo alone, the military police killed 876 "street youth." That number was expected to increase to 1,350 in 1992.[32] In comparison, twenty-three youth were killed in similar circumstances in New York, a city about the same size as São Paulo.[33] The point is not so much that in São Paulo the police kill thirty-eight times as many youth as in New York (although that in itself is a telling statistic) but rather that the method of dealing with unemployment, lack of educational opportunity, hunger, and racism is death to the poor. During the mammoth environment summit—Eco 92—in June of 1992, the military police combed the *Zona Sul* and downtown areas, removing poor youth (most of them black and mulatto) in order to make the streets safe for the visiting dignitaries. They were taken and held in outlying areas, such as the nearby bedroom community of Niteroi.

Youths from the slums are detested by the righteous middle classes as polluting elements. Not only geographical but, even more importantly, social space is clearly demarcated in Rio and other Brazilian cities. The beaches and the leisure that they represent are considered the patrimony of the *Zona Sul* middle classes and of tourists. Youths from the slums have no patrimony, except that which they stake out for themselves, as evidenced in the *arrastão*, which became a struggle over space, as the Afro-Brazilian geographer Milton Santos explains. When asked by an interviewer how he assessed the demand by some middle-class *cariocas* to cut off bus service to the beaches of the *Zona Sul* from the northern suburbs, he answered that the multiple spaces of the new megacities of the world are not traversable by everyone, and that the poor tend to be prisoners in their own neighborhoods. Multiplicity and heterogeneity do not translate into access.[34] Those without the "right" to cross over into a space "not their own" will be stopped by the state on behalf of those who enjoy "citizenship." It should also be added that traversability also depends on the purpose for which one moves from one area to another. In the wake of the *arrastão*, for example, many middle-class people had called for the elimination of bus service from the *Zona Norte* to the *Zona Sul*. However, they found themselves having to back out of this position when they realized that many of their *empregadas* (maids) lived in the *Zona Norte*, and would not be able to come to cook and clean their houses under such a restriction.

The *funkeiros*, then, can only be seen by the "citizenry" as a menace. There were reports that guards hired by the tourist agency Riotur were stopping youths, frisking them, and holding them for the police.[35] And to add insult to injury, even the narcotraffickers declared that they were going to rid the *Zona Sul* of these youths, for they brought more police to the area and that, as in the tourist trade, was bad for business. In contrast to

the image of chaos associated with the *funkeiros*, the narcotrafficking *comandos* came off as the mirror image of the forces of order, that is, the military and security forces.

Funkeiro culture is both reactive and proactive. On the one hand, *funkeiros* reject the spectacle of democracy in which the *caras pintadas* participated. *Funkeiros* had no cause for celebration. The upper and middle classes have at their disposal the new simulation of democracy, staged by the impeachment of president Collor, and the projection of the poor and the slum dwellers as criminals and lazy parasites. There was a time when the cultural politics of Rio made it possible for these marginal classes to imagine themselves as part of the nation but, as São Paulo sociologist Alba Zaluar explained in an article in the *Jornal do Brasil*:

> Rio can no longer be reduced to *blocos de carnaval* or *escolas de samba*, soccer teams and street corner society, the bar hangout or the bohemian boite, all of them creating the cultural politics that always characterized this city that communicated and differentiated itself through music.[36]

She goes on to explain that this construction of a national image is no longer viable. What characterizes Rio and other urban centers in Brazil is a process of differentiation that renders commonality difficult if not impossible to achieve.

> Since the funk clubs do no show any signs of withering away, this still musical city, more consumerist than productive today, will have to learn to deal with the *roqueiros, funkeiros, carecas* [skinheads], *motoqueiros* [motorcycle gangs] that make of small differences signs of an identity to be defended at any cost, even death. Patently narcissistic and without any clear political project or social conscience that might allow us to speak of them as revolutionary in any sense, these groups should gain the attention of the social movements, particularly those of blacks, women and neighborhood societies.

I agree with Zaluar and shall return to these problems. At this point, however, I would like to describe the activities of the *funkeiros*.

The World of Carioca Funk

Funk culture in Rio de Janeiro implies a total reconfiguration of social space. On the one hand, the million-plus youth who attend the *galeras funk* or funk dance clubs on weekends live in the ghetto suburbs of the *Zona Norte* and *Zona Oeste* of Rio de Janeiro. On the other hand, the DJs who play funk—which in Rio includes several black U.S. genres such as soul, rhythm and blues, Motown, hip hop—engage in a dizzying transnational traffic in

records, tapes and CDs. Since almost all the music they play is not available in record stores, and until about 1990 was not played on the radio, the DJs rely on a network of couriers who fly periodically to New York and Miami to buy the music. These couriers may be employees of travel agencies and airlines, or even DJs themselves from the *Zona Norte* who arrive in New York in the morning, make their contacts, and return to Rio on the evening flight. In Rio they sell their merchandise to resellers from whom other DJs get their music. There is stiff competition over the tapes and records, since the quality of the music—gauged in terms of danceability, what makes the *funkeiros* feel most like dancing—is what gives the DJs their place in world of funk culture.

A bit of history: funk culture got its start in the early seventies in the *Zona Sul*, specifically at the *Canecão*, which is the principal show stage in Rio for pop music. Today it is devoted predominantly to rock, and national and international pop. But back in the seventies several DJs, among them Ademir Lemos and Big Boy, began to give preference to soul artists like James Brown, Wilson Pickett and Kool and the Gang in the Sunday "Bailes da Pesada" (literally "heavy" or rowdy, that is, "hip" dances), attended by five thousand youth. When the *Canecão*'s administration shifted attention to MPB (Brazilian Popular Music, a rough equivalent of folk-rock "incorporating elements of bossa nova, jazz, bolero, sertaneja music, rock, northeastern music, reggae, and other genres"),[37] the *Bailes da Pesada* were taken to the *Zona Norte*, where the dancers most interested in this kind of music resided. In order to put on the large dances, which sometimes counted over ten thousand youth at a given club, some enterprising individuals put together huge sound systems, *equipes*, comprising in some cases over one hundred speakers piled on top of each other like a wall. These *equipes* had names like *"Revolução da Mente,"* after James Brown's *"Revolution of the Mind"* or *"Soul Grand Prix,"* or *"Black Power."*

It was Soul Grand Prix that initiated a new phase in Rio funk culture in 1975, a phase which the press labeled "Black Rio." Their dances took on a didactic format, introducing black culture through figures who were already familiar to the dancers—music and sports celebrities. Soul Grand Prix's dances actually used mixed media—slides, films, photos, posters and so on—to inculcate the "Black is Beautiful" style of the period. The fact that the youth from the *Zona Norte* were engaging black culture mediated by a U.S. culture industry met with many arguments against their susceptibility to cultural colonization. However, as some of Bahia's most important intellectuals on issues of "Africanization" have argued, soul and funk were important sites for the revitalization of traditional Afro-Brazilian forms such as the Bahian *afoxé* (a rhythm derived from the ritual music of the Afro-Brazilian religion *candomblé*) and the birth of the first *bloco afro* (an Afro-Brazilian Carnival group), *Ilê Aiyê*. One of the founders, Jorge Watusi, did impugn the commercial character of soul in Rio, but also argued that the engagement with black U.S. music could be put to good use in the recuperation of Brazil's own black roots.[38]

The passage from the seventies to the eighties, which saw the reinvention of Brazilian

rock and the transition to democracy, also spelled the waning of the black consciousness of the *galeras funk* in Rio's *Zona Norte*. While it is true that they have maintained their exclusive preference for black U.S. music as a marker of difference from rock, Brazil's most popular music among middle-class youth (who assume "whiteness" in its Brazilian version), the *galeras funk* no longer make any reference to black pride.[39] According to Hermano Vianna, "the militants of the various tendencies of the Brazilian black movement seem to have forgotten these dances, no longer considered as proper spaces for *conscientização*.[40] Some analysts of the black movement, such as Emília Viotti da Costa, concur with this view, holding that the movement "has remained mostly a middle-class phenomenon and has found little echo among poor blacks."[41] It is understandable, then, that some groups of poor youth may turn to cultural forms that are not inscribed within the black movement's counterhegemonic project.

However, these observations, which were made in the mid-eighties, may need revising after the middle-class panic caused by the *arrastão* and the increasing harassment experienced by the *funkeiros* and other poor youth. Subaltern youth are responding, particularly those involved with rap, the majority of whom are in São Paulo although there is significant activity in Rio. The rap movement is becoming more visible, and it carries a clear ideological message against racism and the state's complicity with it.[42] Rap and hip hop organizations have formed in São Paulo and Rio with the sanction of Workers' Party government officials, particularly the Department of Culture in São Bernardo do Campo, one of several industrial centers on the periphery of São Paulo which subvened the *Projeto de Ação Cultural "Movimento de Rua"* (Cultural Action Project "Street Movement") and its book of rap lyrics and poetry, *ABC RAP: Coletânea de poesia rap*. The editors and contributors defined their demands around issues of "negritude (the majority of the youths are black) and racism, urban violence, poverty (the majority of the youths live at or below the poverty line), the rap movement and ecology."[43] The group *Esquadrão urbano* (Urban Squadron, suggesting an inversion of the violent connotation that death squads have in Brazil) protests the hypocrisy of the notion of security, which is one thing for the elites and another for the poor:

a segurança que a cidade nos oferece
já não se vê no dia, então quando escurece
parece que a corajosa polícia some
policias otários nosso dinheiro consomem
circulando em confortáveis viaturas
enquanto nós pobres descalços circulamos nas ruas[44]

*the security that the city offers us
you can't even see in the day, so when it gets dark
it seems the brave police disappear
stupid cops spend our money*

*cruising in comfortable cars
while we poor trudge along barefoot*

Several groups, like Panthers The Night, advocate nonviolence;[45] others, like MC Blacks, claim their rights as black citizens;[46] and some, like NEPS, even defend feminism:

homens machistas	*machista men*
nos humilham, não querem saber	*humiliate us, they don't want to know*
insistem em incitar	*they insist upon inciting*
dizem donos do poder	*they call themselves owners of power*
.	*.*
só pensam em clamar	*they only think about making claims*
para a violência	*for violence*
inconformados	*disturbed*
por estarmos progredindo[47]	*by our progress*

These uses of rap tend to have a political-intellectual backing from progressive elements in the state, such as São Paulo's municipal Secretary of Education, which sponsored the project *Rap nas Escolas—Rap . . . pensando a Educação* (Rap in the Schools—Rap . . . thinking Education)[48] or Rio's *Ceap* (*Centro de articulação das populações marginais—* Center for the Articulation of Marginal Populations), which sponsored the *Associação hip-hop Attitude Consciente* (hip hop Association for a Conscious Attitude).[49] The aim of these projects is to "construct a citizenship of the subaltern." *Funkeiro* culture, on the other hand, from the late seventies to the present has rejected the promise of citizenship by politicians and intellectuals, whether populists of the left or right, or even of the black movement. It has resisted the terms of participation—cultural representation without access to social and material goods and services—typical of the clientelist relationship accepted by carnival and samba culture. The political significance of *funkeiro* culture, if any, must be construed otherwise.

In Rio, cultural critics have generally seen *funkeiros* as nonpolitical and alienated. Rappers endorse that view, and have even launched a project to "convert the *funkeiro* tribe."[50] For Hermano Vianna, however, this opting out of politics does not mean that they are alienated. Taking the lead from critics of the idea that, in contrast to elites who live with one eye on the international scene, popular sectors maintain the "authentic roots of national culture," Vianna, somewhat in the spirit of Dick Hebdige's claims about subcultural groups, sees *funkeiro* culture as resisting "official or dominant culture," but *not* through group or ethnic identity, nor any other worthwhile cause.[51] His ethnographic work and participant observation in the *galeras funk* of the *Zona Norte* lead him to characterize them as "orgiastic feast-like" dances in the spirit of a Batailleian *dépense*.[52] Resistance is at best a kind of "poaching," in the sense that de Certeau gives the word: a nomadic despoiling of the existing cultural capital.[53] *Funkeiros* dress like the middle-class *surfistas* of the *Zona Sul*;

appropriate U.S. black music; piggyback on existing networks that serve other purposes (tourism) to get their music, which is then pirated, thus offering no commercial value to the recording industry; and make use of the spaces designated for samba and sports. These appropriations produce little value for the dominant order: the clothes do not distinguish them from other youth (although Nikes and Reeboks do produce profit for shoe manufacturers); and U.S. black culture as disseminated through funk does not translate into Afro-Brazilian consciousness. In fact, the lyrics of U.S. black music, which might make reference to racial and cultural politics, are not even understood; *funkeiros* relexicalize the English on the basis of homophony: "you talk too much" and "I'll be all you ever need" become the nonsense Portuguese *taca tomate* (tomato beat) and *ravioli eu comi* (I ate ravioli).[54] With the exception of rap and the music of pop stars like Michael Jackson, U.S. black music is not sold in Brazil, therefore producing no profit for record companies, although the sound system *equipes* make their living from the dances; and the use of the spaces of samba and sports do not suture them into the national culture.

Poaching, *dépense* and Dionysian orgiastic dancing, while necessary correctives to the stereotypes of media consumers as the dupes of the culture industry and cultural imperialism, are not, however, the only ways of interpreting the practices of these youths. The poaching model takes to an extreme a gesture of contemporary critical theory which projects all kinds of everyday people, and particularly subaltern groups in charge of the representations that constitute their world, as "active producers and manipulators of meanings."[55] The depiction of *funkeiro* culture that I have provided here certainly recognizes the active role of these youths in staking out their own territory, and constructing their own means of pleasure, often against the grain of national or regional cultural identity. I characterize the poaching model as an extreme, however, because in attempting to overturn one stereotype, it fails to give sufficient attention to the *negotiated character of reception*, which is never squarely in the hands of any one person or group.

Funkeiros, whether they wanted to or not, have found themselves in the center of public sphere debates about culture. The *arrastão*, if nothing else, put them in the middle of an ongoing conflict about the place of the poor, their access to the goods and services of citizenship and their vulnerability to vigilantism and state violence, so pointed in the case of the *meninos de rua* or street youth. *Funkeiros* have now become part of a new urban lore, projected as a polluting menace. Television and the press show them as have-nots seeking to take what belongs to the elite and middle classes in exchange for a fear that "justifies" their repression. In fact, images of violence in the *arrastão* have served to fix the spatial fluidity of *funkeiros'* nomadic poaching, thus demarcating in a Manichaean way the differences between *Zona Sul* and *Zona Norte*. Images of violence have demonized and thus to a degree controlled them, making funk productive of the culture at large, a productivity that it sought to opt out of.

Funkeiros are only one sector of Brazilian youth whose representations are transforming the traditional mediascape. Youth culture is highly differentiated, as we have seen. It consists of politicized rappers; the *caras pintadas* who celebrated the "democratic" triumph over President Collor, most of whom listen almost exclusively to rock and international pop; the *meninos de rua*, thousands of whom are brutally murdered throughout Brazil and who have recently organized a new social movement with their first international convention in Brasilia;[56] *surfistas;*[57] Guardian Angels;[58] and *funkeiros*; but also *metaleiros* (heavy metal aficionados); punks, skateboarders, *motoqueiros, neobeats, neohippies, carecas* or skin-heads;[59] neonazis and "nationalist" *whitepowers;*[60] Black Muslims;[61] not to speak of the rastas, reggae and calypso enthusiasts and other youth who cultivate the musics and cultural practices of the African diaspora, especially in Bahia and other cities of the North-east. Brazil, which has a land mass larger than that of the continental U.S., has never been a homogeneous country, although samba, carnival, bossa nova, MPB (Música Popular Brasileira) did represent it as more or less coherent. Today, however, a *new politics of representation* has emerged that places the emphasis on difference. The media, the new social movements, and the asymmetrical but pervasive consumer culture all engage in this politics of representation, making it impossible for any one group to maintain control of how it is imaged.

The newspaper accounts that I have cited throughout this essay are filled with accusations, contestations and recriminations about *funkeiros*. But the images that have been generated around them are not all negative; in the past two years, just like hip hop culture in the U.S., they have made their way from the periphery to prime time TV and chic boutiques in the Zona Sul: *O funk caminha das festas da periferia para novelas de TV e lojas da Zona Sul.*[62] New pop stars are beginning to gain recognition in Rio and other Brazilian cities as funk singers or by appropriating elements of funk. There is a tendency in U.S. cultural criticism to impugn white middle-class musicians and artists who appropriate elements from subaltern cultural practices: Elvis and rhythm and blues, Madonna and voguing, and so on. Similar charges could be made about Fernanda Abreu, whose "Rio 40 Graus" opens this essay, or some of the DJs who have begun to "mainstream" the Brazilian-composed funk, particularly DJ Marlboro, who has already been mentioned, and who has produced three *Funk Brasil* albums.[63] What is important to keep in mind, however, is that such artists and producers are helping to open up public spheres to which *funkeiros* had no access. If the *funkeiros* themselves have not politicized their dances and emergent music, they are now, in the wake of the *arrastão*, inevitably involved in a conflict of valuations that takes place in public spheres. And their contribution to *carioca* cultural politics has been to open up a space of taste, style and pleasure that is not permeated by national or regional identity, even though they may be using the same physical space of samba, soccer and carnival.

The Cultural Politics of Carioca Funk

How to evaluate the cultural politics of *funkeiro* culture? This, of course, cannot be an innocent enterprise. Contemporary cultural criticism, particularly in studies of reception and youth culture, tend to endow viewers and listeners with substantial political power as a corrective to the elitist attitude that mass culture only alienates its consumers. I would like to opt out of this kind of discussion, for it does not tell us very much about the larger institutional and transnational context of popular practices. I prefer to situate the question of *carioca* funk's cultural politics in the terrain of conflicting public spheres. In this regard, I think, on the one hand, that *funkeiro* practices offer a new cognitive mapping in which transnational culture and technology are used for their own purposes, which are clearly not political. This is a cultural mapping quite different, however, from the kind that Marxist theorists from Lukács, Adorno and Benjamin to Eagleton and Jameson differentially advocate: namely, that art works are heuristic devices through which the critic gains a knowledge of social reality otherwise unavailable. *Funkeiros* do not need the culture critic to tell them how their social reality is structured; they know it quite well and make use of that knowledge to further their own ends. We might call this a "cultural reconversion," after Néstor García Canclini's study of the strategies for "entering and exiting modernity" in a transnational world.[64] This kind of cognitive mapping is more a *practical* matter than an epistemological one.

On the other hand, the claims made for identity politics typical in U.S. cultural criticism make no sense whatsoever in Brazil. Many of the groups mentioned above have an ephemeral existence. Identity does not go very deep, especially in this age of denationalizing culture. Nor does the poaching model help to understand the political dimensions of practices that seem to be quite apolitical, but that have significant repercussions in the conflict of public spheres. Ultimately, I think that a public sphere approach to the conflict of styles and forms of pleasure goes further in accounting for why space is so hotly contested in Rio and other Brazilian cities. Certainly something of the poaching model is operative in this contestation of space, but it is the permeation of space by style and ethos that carries the political impact that the new funk artists are tapping in their songs. In an uncanny anticipation of the *arrastão* and the "law and order" reaction of the white candidate for mayor, César Maia, the title song on Fernanda Abreu's album *Be Sample* starts with a demagogic representative of the middle and upper classes who calls in the military police to remove *o povo* (the people, that is, the popular classes) so that the "marvelous folklore" of the nation can be presented with *melhor brilhantismo* (better brilliance).[65] This call for national pride is immediately undercut by the emphasis on the sampled character of culture in the voice that sings: "Play it again Sam/ Sampleia isso ai" (Play it again Sam/ Sample this here), an interlingual pun, by inversion, on the anglicism

sampleia (sample), which sounds in Portuguese like "Sam play." What follows is a kind of funk manifesto about sampling as opposed to any fixed national identity. The entire album, in fact, is a virtuoso performance of sampling, establishing interesting relations with the musics of U.S. blacks and Latinos, a kind of "transbarrio" sampling from one subaltern group to another. "Sigla Latina do Amor (SLA 2)" (Latin Initial of Love (SLA 2)) samples the voices of Puerto Rican youths in el barrio, among them a rap in Spanish by a woman who says: *"Hacerlos bailar es mi misión y Latin ACT UP es mi canción"*(To make them dance is my mission and Latin ACT UP is my song). The Puerto Rican rap group Latin Empire is also sampled making the kind of claim that *funkeiros* no doubt fully agree with: *"Yo tengo derecho de ser una estrella/ porque mis rimas son más bellas/ somos muchachos latinos y mi lenguaje es más fino/ porque yo soy latino activo"*(I have the right to be a star/ because my rhymes are more beautiful/ we are Latino boys and my language is finer/ because I am an active Latino). This is a claim to value, a claim that *funkeiros* make through their style, their pleasure, and above all their dancing. The popular funk hit "Dance" by Skowa and Tadeu Eliezer places identity and value in dance itself:

As minhas raízes são passos de dança	*My roots are dance steps*
Quando ouço um funk, nunca perco a esperança	*When I hear funk I never lose hope*
Dentro do salão não penso duas vezes	*In the dance hall I never think twice*
Eu danço com emoção e durante vários meses	*I dance with emotion and for several months*
Eu danço com raiva . . .[66]	*I dance with rage . . .*

Unlike Martinho da Vila's samba, there is no extension here of the emotion from the individual to a larger social formation, such as a social movement or the nation. This funk song expresses, rather, the desire to let go, to have the freedom to let go, which is continually denied whenever the *favelado* or *suburbano* steps off the dance floor. The emotion, which is experienced as rage in the act of dancing, is untapped for a "greater" social or political purpose. It is the manner in which poor youth construct their world, against the restrictions of space, and against the correctly deduced conviction that to channel the rage toward some social or political goal may only lead to being duped. And yet *funkeiro* culture is being heard, it is opening spheres of discussion on television and in the press, entering the market, creating new fashions, generating new music stars. This may not gain these youth greater material resources, it may not save them from violence; but then again, such expectations are not their specific hope, which is, rather, to clear a space of their own.

Notes

1. This essay has benefitted from the generous commentary of Rob Anderson, Idelber Avelar and Ana Lúcia Gazolla of Duke University, my comrade-in-criticism Juan Flores of the City University of New York, and Heloísa Buarque de Holanda, Patrícia Farias and Carlos Alberto Messeder Pereira of the Escola de Comunicação at the Universidade Federal do Rio de Janeiro. I am indebted, above all, to Hermano Vianna's pioneering work on *funkeiro* culture.

2. Martinho da Vila, "Claustrofobia," on *O Samba: Brazil Classics 2*, compiled by David Byrne (Luaka Bop/Sire Records) 9 26019–2 (1989), translation by Duncan Lindsay.

3. "Rio 40 Graus," written by Fernanda Abreu, Fausto Fawcett and Celso Laufer, on Fernanda Abreu, *SLA²—Be Sample* (Emi-Odeon Brasil) 368 780404 2 (1992).

4. *Sounds Brazilian: A Weekly Series of Brazilian Music.* Produced by Cândido Mendes and Maria Duha. New York: TV Brazil—Channel 31 (1989).

5. *National Geographic, Samba: Rhythm of Life.*

6. Chris McGowan and Ricardo Pessanha, *The Brazilian Sound: Samba, Bossa Nova and the Popular Music of Brazil* (New York: Billboard Books, 1991), p. 51.

7. Howard Winant, " 'The Other Side of the Process': Racial Formation in Contemporary Brazil," in George Yúdice, Jean Franco & Juan Flores, eds., *On Edge: The Crisis of Contemporary Latin American Culture* (Minneapolis: University of Minnesota Press, 1992), p. 87.

8. *"Risco de 'explosão social' preocupa Itamar"* (Risk of "social explosion" preoccupies Itamar), *Jornal do Brasil* (October 22, 1992), p. 3; *"Governo atenderá 9 milhões de famílias com Proalimentos"* (Government will assist 9 million families with Proalimentos—Brazilian Program of Nutritional Support), *Jornal do Brasil* (October 22, 1992), p. 1; *"El gobierno brasileño teme un estallido social por el hambre y la desocupación"* (The Brazilian government fears a social explosion on account of hunger and unemployment), *Clarín* (October 23, 1992), p. 24.

9. According to a *Los Angeles Times* report, "Industrial production is now 7 percent less than in 1980 and still dropping, while per capita income is 5 percent less and also dropping." The rate of decrease has accelerated in the 1990s: four percent in the first three years of the decade. "Inflation, despair reign as Brazilian confidence in new president wane," *The News and Observer* (March 18, 1993), p. 13A.

10. For a critique of the "limits of a racially based liberal nationalism" see Michael Hanchard, *Orpheus and Power; Afro-Brazilian Social Movements in Rio de Janeiro and São Paulo, Brazil 1945–1988* (Princeton: Princeton University Press, 1993).

11. Gilberto Freyre, *The Masters and the Slaves*, trans. Samuel Putnam (New York: Knopf, 1946), pp. xii–xiii.

12. "Toward a Mestizo Type," in *The Gilberto Freyre Reader*, trans. Barbara Shelby (New York: Knopf, 1974), p. 110. The essay originally appeared in *The Racial Factor in Contemporary*

Politics (Sussex U.K.: Research Unit for the Study of Multi-Racial Societies, University of Sussex, 1966).

13. The difference between Ibero- and Anglo-American sexual objectification of blacks may be explained, in part, by the fact that few Portuguese (and Spanish) women came to the "New World," while many U.S. colonies consisted of entire communities, including women and children. Brazil did not acquire a high percentage of whites until the end of the nineteenth and beginning of the twentieth centuries. Consequently, black and mulatto women were usually the sexual objects of white men's desire. In the U.S., where White women were more numerous (and puritan culture supposedly more repressed), White men's desire might have been inflected by the anxiety of "their" women being taken by the evidently more physical Black men.

14. *Ibid.*, 111. This brief discussion of the heritage of the cultural politics of race in Brazil is necessarily inadequate. To do justice to it, were it the central topic of this essay, I would have to lay out how the ideologemes of *mestiçagem* and "racial democracy" were important factors in the construction of a "modernized" Brazilian identity, from the twenties on, that imagined the largely "colored" working classes, especially those who were migrating from the economically declining northeast, as citizens with the responsibility of being productive. (This ideology made few claims about their rights.) One of the reasons that "people of color" (a term that means something very different in Brazil than in the U.S.) have had such a difficult time pushing forward an agenda of social justice is that the consensus culture included them as the basis of the nation, thus leading many "white" (again a term with different meanings in Brazil) elite and middle sectors to claim that there is no racial prejudice in Brazil and thus no need to make changes for this purpose. See Carlos Hasenbalg and Nelson do Valle Silva, *Estrutura Social, Mobilidade e Raça* (São Paulo/Rio de Janeiro: Vértice/IUPERJ, 1988) and Carlos Hasenbalg, "*Desigualdades raciais no Brasil e na América Latina: Respostas Tímidas ao Racismo Escamoteado (Notas Preliminares)*," [Racial inequalities in Brazil and Latin America: Timid Responses to Concealed Racism (Preliminary Notes)] conference paper presented at Seminario sobre *Derechos Humanos, Justicia y Sociedad*, Buenos Aires: October 22–24, 1992.

15. *Jornal do Brasil* (September 30, 1992), p. 17. The "feast of curses" refers to a dinner that Collor's ally Onaireves Moura gave for him. The press reported on Collor's use of foul language at that dinner. Everyone expected Moura to vote against the impeachment but, public pressure being so strong, he voted to oust Collor. Hence the celebration. (I owe this explanation to Ana Lúcia Gazolla.)

16. "*Rebelião em presídio de SP deixa 108 mortos*" (Rebellion in São Paulo Prison Leaves 108 Dead), *Folha de São Paulo* (October 4, 1992), p. 1–14; " *'Mortos estavam amarrados', dizem freiras*" (Dead Had Hands Tied, According to Nuns), *Folha de São Paulo* (October 4, 1992), p. 1–15; "*Mortos na Detenção podem superar 111*" (Dead in House of Detention Exceed 111), *Folha de São Paulo* (October 5, 1992), p. 1–1; "*Número de mortos na chacina pode crescer*" (Number of Dead in the Massacre May Be Higher), *Folha de São Paulo* (October 5, 1992), p. 1–9.

17. "*Equipe do IML chora entre pilha de corpos*" (Team from the Legal-Medical Institute Weeps On Seeing Pile of Bodies), *Folha de São Paulo* (October 5, 1992), p. 1–12.

18. *"Um terço apóia ação da polícia no Carandiru"* (One Third Supports Police Action in Carandiru), *Folha de São Paulo* (October 8, 1992), p. 1–12.

19. Cited in Teres Pires do Rio Caldeira, "Crime and Individual Rights: Reframing the Question of Violence in Latin America," paper presented at the Seminar on *"Derechos Humanos, Jusiticia y Sociedad,"* CEDES, Buenos Aires, October, 22–24, 1993, p. 2.

20. See *"OEA 'julga' invasão na penitenciária"* (OAS "Judges" the Invasion of the Penitentiary), *Folha de São Paulo* (October 8, 1992); p. 1–13; *Jornal do Brasil* (October 22, 1992), p. 1–1.

21. *"Assembléia aprova CEI em sessão tumultuada"* (Assembly Approves Investigative Commission in Tumultuous Session), *Folha de São Paulo* (October 9, 1992); p. 1–12.

22. *Ibid.*

23. *"Descrédito na Justiça traz apóio à violência"* (Lack of Trust in Justice Brings Support of Violence), *Folha de São Paulo* (October 8, 1992), p. 1–12.

24. I owe this qualification to Rob Anderson. On the unworkability of democratization without the enforcement of social rights, see T. Caldeira, "Crime and Individual Rights," paper presented at a conference on human rights at CEDES, Buenos Aires (October 1992).

25. *Arrastão* is derived from *arrastar*, the verb for net fishing. In a looting "rampage," youths from the *favela* line up shoulder to shoulder for distances as long as a quarter of a mile and run across the sand toward the water, taking whatever they can from the panic-stricken beach-goers.

26. *Jornal do Brasil* (October 19, 1992), pp. 1, 14.

27. *Jornal do Brasil* (October 23, 1992), p. 32.

28. This usage of the word *"galera"* is used metaphorically, by the youths themselves, to refer to the dense crowd that gathers in the dance clubs. *"Galera"* is the word for the hold of a ship, where the slaves were kept on the voyage from Africa to Brazil.

29. *Veja* (October 28, 1992), p. 22.

30. *Jornal do Brasil* (October 25, 1992), p. 32.

31. Cited in Pedro Só, *"Zunzunzum contra os bailes funk"* (Brouhaha Against Funk Dances), *Jornal do Brasil* (October 30, 1992), p. B1.

32. As this essay was being revised for publication, a massacre of street children in Rio by a death squad composed of military police in plain clothes was reported widely. See Human Rights Coordinator <hrcoord in igc:hr.child>," BRAZIL: CHILD MURDERS SHROUD RIO," newsdesk-@igc.apc.org in igc:ips.english (July 27, 1993).

33. Vasconcelo Quadros, *"Crise estimula o crime"* (Crisis Leads to Crime), *Jornal do Brasil* (November 8, 1992), p. 16.

34. Daniel Ulanovsky Sack, *"El día en que los marginados tomaron la ciudad"* (The Day the Marginals Took the City), *Clarín* (October 25, 1992), p. 20.

35. *Jornal do Brasil* (October 19, 1992), p. 1.

36. Alba Zaluar, *"Arrastão e cultura jovem"* (Arrastão and Youth Culture), *Jornal do Brasil* (October 30, 1992), p. 11.

37. McGowan and Pessanha, p. 78.

38. Hermano Vianna, *O Mundo Funk Carioca* (Rio de Janeiro: Jorge Zahar, 1988), p. 29.

39. *Ibid.*, p. 32.

40. *Ibid.*

41. See Michael Hanchard's discussion of this topic in *Orpheus and Power*.

42. Several reports and newspaper articles have drawn attention to the political focus of rap in the wake of the *arrastão*. See, for example, Elisabeth Orsini, *"Arrastão, estopim do preconceito"* (Arrasta; ato, the fuse of prejudice), *Jornal do Brasil* (November 8, 1992), p. B2.

43. Ronaldo de Oliveira, Neuza Pereira Borges and Carlos Bahdur Vieira, coords., *ABC RAP: Coletânea de poesia rap* (São Bernardo do Campo: Prefeitura do Município, 1992), p. 5.

44. *Ibid.*, p. 111.

45. *Ibid.*, pp. 115–16.

46. *Ibid.*, pp. 35–38.

47. *Ibid.*, p. 17.

48. See Evanildo Da Silveira, " *'Rap' em São Paulo dá lições de cidadania"* ("Rap" in São Paulo Gives Lessons in Citizenship), *Jornal do Brasil* (November 8, 1992), p. 16.

49. See Andréia Curry, *"O rap briga por dignidade urgente"* (Rap struggles for dignity urgently), *Jornal do Brasil* (January 9, 1993), p. 1B.

50. Curry, *"O rap briga por dignidade urgente."*

51. Vianna, p. 109.

52. Vianna, p. 54.

53. Michel de Certeau, *The Practice of Everyday Life* (Berkeley: University of California Press, 1984), p. 174.

54. Vianna, p. 82; and Caldeira, *"No embalo do subúrbio"* (Packaged (or "Swinging") in the Suburbs). See also a special *"Programa Legal"* on the *galeras funk* aired on Brazil's Manchete Network in 1991.

55. Henry Jenkins, *Textual Poachers: Television Fans and Participatory Culture* (New York: Routledge, 1992), p. 23.

56. Gilberto Nascimento, *"Jovens dizem ter sido torturados por policiais"* (Youths report having been tortured by the police), *Folha de São Paulo* (November 19, 1992), pp. 3–5; Edna Dantas, *"Meninos superlotam celas em Brasília"* (Children overcrowded in prison cells in Brasilia), *Folha de São Paulo* (November 18, 1992), pp. 3–3; Antônio José Mendes, *"População rejeita casas*

de apoio a menor" (Population rejects shelters for minors), *Jornal do Brasil* (January 17, 1993), p. 25; *"Encontro reúne 1,000 meninos de rua"* (Meeting gathers 1,000 street youths), *Jornal do Brasil* (November 19, 1992), p. 8.

57. *"Surfista do morro vai lutar"* (*Favela* surfers are going to battle), *Jornal do Brasil* (October 21, 1992), p. 12.

58. " 'Anjos' usam artes marciais" (Guardian 'Angels' use martial arts), *Jornal do Brasil* (October 22, 1992), p. 5; *"Anjos da Guarda nnegam versão da PM"* (Guardian Angels deny the PM's (Military Police's) version), *Folha de São Paulo* (October 20, 1992), p. 3.

59. A special section of *O Globo de São Paulo* (October 4, 1992), pp. 34–36, whose lead-in article is titled *"As tribus do Rio em pé de guerra"* (Rio's tribes are up in arms) and whose first line reads: *"A cidade está dividida em territórios—muitos deles minados—de gangues rivais"* (The city is divided into territories—many of them mined—held by rival gangs) included articles on several of these groups: *"Metaleiros invadem os cemitérios e violam túmulos"* (Heavy metal aficionados invade cemetery and violate graves); " *'Neohippies': viagem no túnel do tempo"* ("Neohippies": A trip in a time tunnel); " *'Funk' reproduz guerra de bandidos"* ("Funk" reproduces the battles among narcotraffickers); " *'Carecas': contra 'gays' e drogados"* ("Skinheads": Against "gays" and drug addicts).

60. *"Fanzines pregam morte a nordestino e judeu"* (Fanzines preach death to Northeasterners (most of whom are black or mulatto) and Jews), *Folha de São Paulo* (September 26, 1992), p. 3–3; *"São Paulo organiza frente antinazista"* (São Paulo organizes an Anti-Nazi Front), *Folha de São Paulo* (September 26, 1992), p. 3–1.

61. *"Ódio ao branco chega a São Paulo"* (Hatred toward whites comes to São Paulo) and *"Grupo negro declara guerra aos 'carecas' "* (Black group declares war on "skinheads"), *Folha de São Paulo* (October 18, 1992), pp. 4–1, 4–3.

62. Dulce Caldeira, *"No embalo do subúrbio"* (Packaged (or "Swinging") in the suburbs).

63. *Funk Brasil I*, (Polydor, 1989), *Funk Brasil II* (Polydor, 1990), *Funk Brasil III* (Polydor, 1991).

64. Néstor García Canclini, *Culturas híbridas: Estrategias para entrar y salir de la modermnidad* (Mexico: Grijalbo, 1990).

65. The text of the speech is: *Atenção, senhor, tenente comandante da patrulha da polícia militar do estado, pedimos o seu comparecimento para ver se retira o povo que invadiram, para que possamos e tenhamos qualidade de apresentar com melhor brilhantismo, com mais gesto, esta coisa maravilhosa que é o nosso folclore* (Attention, sir, lieutenant commander of the military police of the state, we request your presence to see if you can remove the people who have invaded, so that we can, and have the quality to, demonstrate with greater brilliance and more grace this marvelous thing that is our folklore).

66. "Dance," on Skowa e A Máfia, *La Famiglia* (EMI-Odeon) 064 792699 (1989).

Rock, Rituals & Rights

Rah, Rah, Sis-Boom-Bah
The Secret Relationship between College Rock and the Communist Party

Robert Christgau

When I was importuned to hold forth on the topic of "rock, rituals and rights," I found the rubric so broad and vaguely irritating that for a couple of weeks I could barely think about it. I've seen some two or three thousand rock shows, yet I haven't participated in a "ritual" I'd care to identify as such since I stopped taking communion thirty years ago. And I regard "rights" as a concept that either precedes or exists parallel to the kinds of satisfaction I associate with the music I've devoted my life to. That leaves "rock." One morning about a week ago I woke up worrying about this, and all of a sudden it dawned on me. Oh right—rock! You know, Bob—white people, especially white males. The sixties. Remember?

So I'll start with a few definitions. I call myself a rock critic because language isn't always logical and I'm normally not one for worrying terminology—I leave that to people with tenure, who get paid for it. But just by way of analogy, let me call your attention to garbage men for a moment. Despite the best efforts of mealymouthed bureaucrats on both sides of the management line—bosses who know words are cheap and union politicians who pretend respect can be conferred by fiat—it appears unlikely that the term sanitation worker will get out of the newspapers until our sanitation departments achieve as yet unimagined levels of sexual integration. The person who does that work has nothing to do with garbage, which my dictionary defines as "discarded animal and vegetable matter." What garbage men spend their working lives coping with is mostly trash.

But I digress—or do I? Garbage man, rock critic, what do they have in common? Well, I'm a rock critic, but I prefer to call the music I've devoted my life to rock and roll. Metal— it's rock and roll. Mbaqanga—it's rock and roll. Leonard Cohen chansons—rock and roll. Disco—rock and roll. I've devised various explanations for this over the years, but they all boil down to the same thing. Rock is a term that took hold in the sixties, and makes the sixties the focus of the story it implies, whereas rock and roll is rooted in the fifties, which just happens to be when I got interested in popular music. By insisting on a fifties

221

paradigm, I'm first of all positing popular music's Great Schism—which is one reason I'd no more use the Brit term for what I call rock and roll, which is pop, than I'd call a garbage can a dustbin. Pop in 1950 was very different from pop in 1960; as I recently described it in an appreciation of Nat King Cole:

> In the beginning, we believe, there was pop: leftover big-band singers crooning moon-June-spoon 'neath cloud of violins. And then Elvis—or Chuck Berry, or Bill Haley, or if you want to get fancy Jackie Brenston's "Rocket 88" or something—moved upon the face of the waters, and all was changed in what was suddenly an us-versus-them world. It was rock and rollers against grown-ups for control of the hit parade.

But I'm also insisting that the music I care about isn't the exclusive preserve of white people. In an effort to dispel a cultural-political nostalgia I don't think many people actually cherish, Larry Grossberg has attributed the integration of the pop charts in the fifties to "the limited repertoire of available music and the organization of the economics of production and distribution."[1] There may be something to that—the success of the Beastie Boys and Vanilla Ice and Marky Mark and the (East) German phenom J. have made clear once again that competent white imitations or extensions of black styles reach some white fans more readily than the music they ape, modify or elaborate. But this is to ignore the very real if extremely one-dimensional Romance of the Negro that ensued, at least in the North, both from the widely attractive stylistic innovations of postwar R & B and from *Brown v. Brown* in 1954. And it's also to ignore the unity of purpose that continued to animate the rock and roll mainstream, such as it was, well into the sixties—for in fact, the most frequently cited (and musically remarkable) black fifties rock and roll icons, Chuck Berry and Little Richard, sold nowhere near as many records as the Shirelles, who spearheaded the equally black girl-group style, which had its heyday in the early sixties, and Motown, which continued to claim that it was "The Music of Young America" long after the Beatles had awakened this nation's dormant Anglophilia and begun a British invasion that waxes and wanes but never seems to vanish altogether.

Nevertheless, it's obviously the Beatles who signal if not occasion the racial break, especially as they evolve from rock and roll cover band to songwriting powerhouse to cultural avatars. It's at some time in the middle sixties that rock and roll proves such an unavoidable subject of discourse that the contraction "rock" becomes an inevitable convenience, and then quickly accrues meanings that "rock and roll" never had. Quite literally, "rock" is rock and roll made conscious of itself, burdened with every vague association and responsibility that the era's ad hoc self-analysis could pile on. To me it seems likely in retrospect, though I certainly didn't notice at the time, that the development of the term itself contributed to the de facto resegregation of popular music, which I think

is primarily attributable not to backlash or market manipulation but to the diverging needs of the white and black artists and audiences.

What happens is this. Black artists take R & B, which first developed into an all-purpose party music and was then aimed at a newly defined youth market, and both African-Americanize it—harmonically-melodically, with the church chords and full-throated melismas of gospel-derived soul—and Africanize it—rhythmically, with the New Orleans-derived syncopations that James Brown came to realize could form the basis of an entire genre. The development is stylistic at first, but, as the civil rights movement and Black Power theory evolve, it soon becomes ideological as well—black artists and audiences become increasingly suspicious of the myth of integration, so that insular impulses begin to animate music that had at first striven to be ingratiating.

In theory, young whites are sympathetic to these developments, but in fact, they're intimidated by them. To an extent their response is simply the uneasiness white Americans always feel when black people act for themselves, but in general the intimidation is more stylistic than ideological. Soul they can appreciate, but funk they can't, and they also look askance when black artists try to meld in the developments going on in white music. Sly Stone and Jimi Hendrix, both certifiable geniuses, make the cut (though Sly loses status well before his music dries up), but Norman Whitfield and the Isley Brothers, who may not be geniuses but for damn sure have more going for them than Vanilla Fudge and Chicago, are dismissed as "commercial." Why do Vanilla Fudge and Chicago get respect? Not simply because they're white, though of course that helps, but because their whiteness enhances an illusion that to an extent they're taken in by themselves—that they *are* the sixties, that they embody the spirit of the counterculture, an almost entirely white mass Bohemian movement, which if it inheres in any one phenomenon inheres in what is by then called rock.

So it's clearly in the sixties that such hifalutin concepts as ritual and rights start accruing to popular music. I wish I could claim that rights are paramount, because my childhood experience with the sexual mores of evangelical Christianity left me with small thirst for religious emotion, and I'm of a basically literalistic cast of mind, which is why I've always been attracted to the popular as an aesthetic category—I value its ordinariness, something all too few rock and rollers care about. For all these reasons, the part of my consciousness that was raised in the sixties was the political part. But ritual is clearly foremost. Like the counterculture itself, rock conceives itself as spiritual first. The paradigmatic sixties experience isn't the demo, it's the rock concert—or the demolike festival megaconcerts that start with Woodstock in late 1969. It's in the concert that bands develop the expansive musical usages that distinguish rock from rock and roll—new instrumentation, looser song forms, solo space. But perhaps more important, it's also in the concert that these usages acquire the visual correlative that comes to define them in the audience's mind—the artist,

who is always male, hunched priestlike in simultaneous communion with his instrument, his audience and his soul, and the audience itself responding in ecstatic abandon.

Suggesting art, meaning, religion and (subsuming them all) seriousness, this image is far removed from a rock and roll that, no matter how momentous, was always fun. Rights are merely a subset of this seriousness. The rock of the sixties is supposed to be a very political music, but in fact what distinguishes it lyrically is an uprecedented weakness for personal obscurantism. Until the very end of the decade even the best-remembered explicitly political songs—Buffalo Springfield's "For What It's Worth," the Beatles' "Revolution," the Rolling Stones' "Street Fighting Man"—are ambiguous in an amazingly studied and deliberate way, not just to get them on the radio but because the artists are in fact ambivalent about politics. As Stephen Stills put it, "Something is happening here/ What it is ain't exactly clear."

It's worth noting that historically, the entry of explicit politics into American popular music has very little to do with rock or rock and roll. It results from a cultural strategy conceived by members of the Communist Party in the thirties, in which the "folk music" that up until then was defined primarily by academic eccentrics—affiliated with, of all things, the Modern Language Association—is bent to the assumptions of left populism. There's a direct line from John Lomax, a politically conservative banker, academic hustler and song collector, to Alan Lomax, his leftist son, to Pete Seeger, a young associate of Lomax's who is himself the son of a leftist composer-musicologist, to the Almanac Singers, who for all practical purposes constitute a CP front, to the Weavers, Seeger's canny attempt to polish the Almanacs for actual popular consumption. It's the Weavers who more than anyone else sow the seeds of the folk music movement that develops on a smaller scale, parallel to rock and roll, as the civil rights and ban the bomb movements slowly evolve into the New Left. And the folk music movement breeds a good many of the early American rock musicians, many of whom turn to rock at least partly to get away from the political correctness of folkiedom, but who retain varying degrees of political idealism anyway.

I've spent most of my career making fun of folkies, whose failure to comprehend ordinary pleasure has always exerted crippling limitations on both their political and their artistic acumen. But in this context I want to give them their due. Because if I'm not mistaken—and I live my life far enough from academia that I must be missing a nuance or two—the style of academic thought that makes a collection of this sort possible is unduly critical of its own political relevance. It romanticizes the inchoate political impulse as a means of reconceiving left populism at a higher level of theoretical sophistication. Yet, as I hope at least a few readers started muttering when I went off on the Weavers, this academic sensibility itself derives in part from the other isolable outside force that worked to politicize rock—that constellation of attitudes which in this context, for argument's and convenience's sake, we can call situationism. The extent of situationism's literal effect and for that matter literal existence is debatable, but without doubt something in its legendary

penchants for deconstruction and provocation takes musical form with punk, a far more explicitly political rock movement than psychedelia ever was—one that defines itself as antihippie at least partly because it believes the hippies betrayed their own promise.

But just as folk music isn't good enough for a more sophisticated if not cynical generation of leftists, punk isn't good enough either—like hippie before it, it waffles, it indulges itself, it says dumb things. The only true rock politics, some come to believe, arise more or less spontaneously from the oppressed themselves. If artists are gonna be dumb, let their dumbness be unmediated—let them create texts so transparent (or is it opaque?) that we smart people can infer meanings from them, meanings we will always attribute to them even if in fact we made them up ourselves. Thus we have the romance of metal, which almost twenty five years after the fact has proven itself the most faithful and uspoiled inheritor of the counterculture's "rock" tradition. It's in metal that the seriousness and ritualism of psychedelia continue to evolve and grow, surviving all manner of ridiculous sellouts and disguises to turn its inchoate quasi-nihilism to the service of both something approaching reasonable politics and something approaching apocalyptic (or perhaps cathartic) nihilism, as well as absorbing crucial influences such as punk itself. And also, of course, rap, which in addition is the subject of a romance of its own, defined by rockists who find themselves unaccountably attracted to these highly verbal males as the music of politicized other that isn't often called an underclass because that's become an unfashionable term, but is often thought of with all the exoticism and condescension such a term implies. And then there's the romance of disco, variously identified with the female principle, the destruction of gender, the subversiveness of pleasure, the nobility of the functional, the rhythms of the world and the music of the spheres.

For a rock and roller like myself, of course, rap is just one more rock and roll sect exfoliating from the schism—because it's more fun and has a better beat, I much prefer it to metal, which is rock. About dance music I'm more neutral. Functional music is best suited to people who encounter it regularly in the environment where it functions, and since I'm not interested enough or young enough to spend much time in dance clubs, I usually limit my enthusiasms to the irresistible pop flukes that have made the very best dance music some of the very best rock and roll, from "Do You Wanna Dance" to "Pump Up the Jam." But there is another subgenre, another sect, that's strangely underplayed in acdemias cultural studies subculture. Sometimes it's called postpunk, or "alternative," and I spend a lot of time making fun of it as well. But here I'd like to call it by its most shameful name, college rock—bands formed by a never-ending stream of moderately well-educated young quasi-Bohemians. And I'd like to give it its due. That's first of all because on my personal pleasure meter it ranks more or less equally with Afropop and rap and the musical musing of various over-forties and occasional over-seventies who still feel the rock and roll spirit, or one of the spirits that went into it. But it's also because its politics really aren't bad.

If you wanted to generalize about the politics of rock in the sixties sense, you could say that they reflect the way the rock mythos privileges ritual over rights—they're general, utopian and/or apocalyptic. And one of the things that assumes is a certain scale—the impulse most of these bands feel to convert their generation, and the commercial possibility of at least reaching it. You can talk about early British punk gigs having the force of ritual, and of course rituals in preurban cultures rarely involve more than a few hundred people. But rock ritual is massive, as are its political fantasies. Metal concerts still have that kind of scale, and as Sarah Thornton has explained, so do certain dance events. But what happens with college rock is that it loses this fantasy of scale. Stigmatizing the "commercial" and failing to gather all that many fans, they begin to conceive their subcultural subsistence-audience status as a virtue.

This can be very irritating, snobbish, elitist, *collegiate*, especially in a band that seems to you to be of small consequence, which due to their very profusion means most of them. But it has its political advantages. There's still plenty of personal obscurantism in this music, and plenty of that old staple, romantic love, though sometimes at a higher level of theoretical sophistication. But at the same time, the social and political subject takes on the weight of convention—it becomes inevitable, natural, in a strange way unmediated, rather than forced. As with folk music, college-rock politics can seem sentimental, programmatic, pro forma, on the surface and so forth. But also as with folk music, there's now a gratifying outpouring of what can best be designated as protest songs—protest songs that tend to be more musically and emotionally rooted and compelling than even the sharpest of the preaching-to-the-converted ditties of the sixties and the Popular Front era. There's no way to be certain how much good they do. But it's my perhaps literalistic belief that a music that includes Mofungo's "El Salvador" and Y Pants' "That's the Way Boys Are" and the Ramones' "Bonzo Goes to Bitburg" and Hüsker Dü's "Turn On the News" and Thelonious Monster's "Property Values" and Carmaig de Forest's "Crack's No Worse Than the Fascist Threat" and the Chills' "Submarine Bells" and the Mekons' "Funeral" and L7's "Wargasm" and Sonic Youth's "Youth Against Facism" and the collected works of the Minutemen is more useful politically than one that doesn't contain such songs. For damn sure it's more fun.

Notes

1. Lawrence Grossberg, *We Gotta Get Out of This Place* (New York: Routledge, 1991), p. 146.

Border Crossing in the U.S.A.

Donna Gaines

In post-Vietnam America, young people have experienced an erosion in their cultural prestige, their impact as a social force has diminished, they are losing ground in their rights and civil liberties. The nature of the nuclear family, the global economy and the world stage is in rapid transition. The American working class is disappearing as a a social entity. There now exists a permanent subclass of American citizens we call "the homeless." Half the kids in America don't go to college, and the ones who do spend six years getting degrees, after which they cannot find jobs, or afford housing, health care or cars.

As cultural radicals, we have a mission. We are activists, for whom social justice is expressed by defending cultural products and practices. Wherever the activities of young people are misinterpreted, misrepresented, exploited or devalued, our mission is to slam truth to power. We do that in our critiques of the hegemonic, in everyday life and in our social relations with young people. We are reflexive about our role in intergenerational politics and also about our various positions within the division of labor. Where possible, we sap power. We take practical action on behalf of young people, we seek to dignify and legitimate the aspirations of young people in the eyes of adults who have authority over them; parents, teachers, employers, the elders of community, church and the state. The repressive and coercive forces—if you like.

Teenage Wasteland, my book about teenage suicide in Bergenfield, New Jersey, offered a critique of social institutions that impose upon young people. The Bergenfield suicide pact moved me from case to cause. Some of my current activity is in response to other people's reaction to my testimony about the lives of young people I encountered on tour in teenage wasteland America. There are a variety of opportunities to intervene on behalf of young people. For example, the institutional church, the educational and criminal justice systems. We can offer pragmatic, concrete, social activism. Writing in itself will not transform the world.

In my research for *Teenage Wasteland*, I explored youth culture in order to demonstrate how kids fought back: for psychic space, autonomy, and for the right to articulate their truth. I examined youth subcults—insular enclaves with particular meanings, discreet styles, values, moods. I tried to show how these subcults offered community, asserted political

agendas and uplifted the race. Much of what I had to do was translated across borders. I worked on an as-needed basis. As you know, societal forces that impose upon young people are examined and resisted through cultural processes, expressed in cultural products—music, style, dance. Youth cultures do not exist in a vacuum. They are shaped by social, historical, political and economic facts. Much of their activity is hidden, esoteric, obscure. It takes place beyond the gaze of adult authority, outside the institutions and colonial protectorates organized by adults for young people. Let's try to keep it that way.

Our methods of critical and scientific analysis afford us an inside view of cultural activity. Because we have a radical agenda, we remain on guard. We do not wish to assist hegemonic interests in disrupting and undermining the psychic spaces young people have carved out for themselves. We can clarify, interpret and explain, but we must remember for whom we labor and why.

I

The 1980s were the worst years of our lives, the brutality years, a decade of repression. Young people were devalued, dismissed and degraded at every turn. Great, powerful music emerged, kids hid out in the margins, in their scenes, with their friends. They created their own explanations for what was going on.

We who have aged out of the statistical and sociological category of youth fought back in our own ways. Progressive-minded knowledge workers—"scholars, journalists, musicians"—challenged the Parents' Music Resource Center. We told them over and over again that songs like "Suicide Solution" were directed against alcoholism, not suicide. That "Fuck Tha Police" was a response, not a catalyst, to ongoing, relentless, street-based violence against young people on the basis of race and sex. We marched for reproductive rights, raised money for the rain forests, for the animals, and we spoke out against the oil war.

We remain outraged when kids are brutalized at home, in school, on the street and at shows. We have urged kids to stop the violence, the racism, sexism and homophobia. We remain haunted by suicide pacts, urban homicide rates, runaway/throwaway teenage prostitutes, date rapists, race wars, queer bashers, Satanic ritual slayers and parricides. We urged young people, from our own experience, to please say no to drugs, use condoms and rock the vote. Most of us have aged out of the statistic category of youth (fourteen to twenty-four) and are now working on the front lines of the culture war. In the confrontational words of Faith No More—"Its a dirty job but someone's gotta do it . . ." Thus far there have been great slogans, festive feel-good soirees, but not much to challenge the codified laws and social practices that make life hard for young people today. We can do a lot more.

II

Border crossing is a sociological experience. It is a practical, tactical maneuver. This is not school. Public intellectuals cross borders when they take information generated at the frontiers of knowledge—academic, esoteric—and apply it in the blooming, buzzing, dirty, social world. It is sort of po-mo to travel back and forth, tripping discourses, translating and presenting the social self where it usually fears to tread; in the mouth of the beast— in settings and situations we thought we had escaped when we decided to defect to the world of higher knowledge.

Kids are operating in different linguistic, sartorial and myth systems from adults. Sometimes we can translate. At best we seek to assess the power dynamic and try to humanize people. Method of destruction: cover my tattoos to look credible to a jury, expunge the obscenities from my sentences so as not to offend the faithful, keep my mouth shut in the face of incorrect thought and try to *verstehen*.

III

If you were born any time after 1964, here's a laundry list of the things that fucked you up.

HISTORICAL

The Declining Prestige of Youth as a Social Category

The harsh legacy of the Woodstock nation. Demographics—the lack of political and social impact on the adult authority structure. Living in the shadow of the baby boom. There were seventy-five million baby boomers, people born between the end of World War Two and 1964. In contrast, the baby bust, born between 1964 and the present, is under forty million. The baby boom had the cultural authority to make adults listen. They had a voice in the body social—kids today don't have that. They have fewer numbers, a weaker voice and the feeling that they missed the party.

ECONOMIC

The Poor Economic Prospects of Los Olvidados

Inflated expectations and diminished options. The American experience of decline. The loss of traditional working-class work; manufacturing, and the failure of small businesses. The forgotten half, kids of the service sector. Alternative, informal economies (drugs, sex work).

SOCIAL

The Negation of the Social Contract Between Young People and Adults

The breakdown in faith. Your parents, teachers and even the priests can rape you, rip you off and no one will believe you, if they do, they won't care, or do much about it. You're on your own. There is a lack of trust in caretakers. This mistrust is now an element of adequate reality-testing among young people.

Adolescents and the Peer Group

Once upon a time in America, we took young people out of the factories, made schooling mandatory, created a juvenile justice system, and sequestered young people in the protected status of adolescence. This is a limbo status, and it is growing obsolete. Adolescence was a time and place when adults actually did provide resources, time and space for young people. Adolescence was viewed as a preparatory stage for adulthood, when, under the guidance of concerned elders, young people would be groomed for their places in the social order. Increasingly, there are no supports, not even safety nets for kids. We give them latchkeys, tell them not to get into trouble, but do not offer any alternatives. We increasingly expect young people to fend for themselves in the world, to trust their own judgment. But we constantly devalue their contributions as "immature," "childish" and "silly."

Due to changes in the economy and society, the very definition of family and the nature of family life are in transition. In most families, both parents have to work, and so kids are on their own more than they have been in decades. Yet the concept of adolescence, our assumptions about young people's preparedness to handle life, and the laws we created to protect them, infantilize youth *at a time when they are increasingly called upon to care for themselves.* Increasingly, friends play the most significant quasi-parental roles in the kids' lives. Often it is the friend who assists in family planning, instructs on how to cope with school, love, family, and offers practical advice on cars, clothes and jobs.

LEGAL

The Collapse of The Adult Authority Structure

Kids are systematically excluded from the social order, ignored as a social and political entity, yet they are overregulated by ineffectual methods of social control. We forbid cruising, the purchase of beer and cigarettes, but deny access to safe and legal abortion, housing, education and proper nutrition; (that is, we don't know what we are doing but they have to obey us anyway.)

THE CULTURAL POLITICS OF YOUTH

Media Porn

The misrepresentation of young people's social activity. Popular images of kids as "thugs," "animals," drive-by shoot-outs, gangsters and teenage crack moms rocking in the free world, jock gang rapists, parricide perps, low math and science scorers, zombies without morals. Slime journalism feeds off youth atrocities, from Amy Fisher to Katie Beers.

More Than Racism: Youth Subcults, Cultural Fragmentation and Infighting

Young people are increasingly forced to rely upon their peers for support, yet lines of race, class, region and subcult tear them apart. Kids live for their bands, for hanging out, for their "scene." They turn to esoteric knowledges for answers because adults won't tell them the truth. They embrace antiheroes (Manson, Satan) because legitimate ones are openly corrupt.

The lyrical content of underground music reflects kids' attempt at understanding things adults won't talk about; suicide, alcoholism, incest, family violence, nuclear holocaust, alienation, street violence, police brutality. During the 1980s, thrash, rap and hardcore music expressed such themes, and opened them up for discussion. An examination of Slayer's *Decade of Aggression* live album, with songs like "War Ensemble," and "Expendable Youth," tells us just what it felt like to live in America during that time. Beyond the lyrics, the brutal form of the music releases tension. The community which forms around favorite "god bands" gives kids a sense of belonging, meaning and dignity. Most adult authorities get confused about the causal order of these things.

The Misinterpretation of their Cultural Processes and Products

Adults never get it. Young people may lack confidence in adults when they see them blaming Satan, Ozzy Osbourne's music and Spike Lee's films for youth atrocities and paying no attention to any of the real issues. This further erodes any confidence young people might have in their adult caretakers, and alienates them even more.

No Respect

The assumption that popular culture is trash, that youth culture is prefabricated and mass, that kids consume and participate in garbage culture without a critical eye (TV, junk food, grooming products, movies, cruising in cars, malls, video games, comics, virtual

reality and hacking, hanging out, music). Insisting that the everyday life of young people in 1992 is anything like life "when we were kids."

IV

If you were born between 1945 and 1963, here are some examples of fertile grounds for border crossings.

THE INSTITUTIONAL CHURCH

Judeo-Christian communities that are concerned with morality and spirituality sense that there is distinct loss of faith, reinforced by a rupture between generations. They want to help their kids live in the world, and they are trying to balance that with Christian values. They are really put off by youth culture—by popular culture. They feel overwhelmed by it. We can try to show them how elements of religion are expressed authentically in the kids' cultural practices, how their desire for community, meaning, truth and autonomous space are manifested.

The rupture between organized religions and young people is partially based on the dichotomy between the social-control functions of religion (normative, mandated behaviors, "sin," profanity, sexuality and so on) and the desire for the spiritual.

THE CRIMINAL JUSTICE SYSTEM

In some states kids are eligible for the death penalty as young as sixteen. I make the argument that we must oppose this on the grounds that society has failed to provide for young people, that the social contract between adults and youths is null and void. That the concept of adolescence is a social construction, obsolete and ideological—we no longer provide young people with the supports they need to "prepare" for adulthood. The interim period, where young people are groomed for independent living by concerned, involved adults, is now mere myth.

I began working with attorneys who defend kids in capital trials. They contacted me after reading *Teenage Wasteland* since it takes place in white, nonaffluent suburbia, turnpike suburbia, where the myth of classless homogeneity obscures recognition of negative social forces—social dislocation, inequality, poverty, family violence, substance abuse.

For example: How and why do white, suburban boys get involved with Satan? How do you explain a grisly crime to jury members who think they are looking at a kid who has "had everything handed to him"? The "Teenage Wasteland defense" humanizes a young person by showing how such activity may be motivated by a profound sense of power-lessness, blocked aspirations, hopelessness. The isolation and alienation of suburban life,

coupled with the need for individual autonomy and personal dignity, are expressed in forms as violent but far less comprehensible than "urban youth crime."

The average citizen-as-juror understands urban poverty, racial discrimination and parental neglect as "mitigating circumstances," but they go into deep, fuzzy denial when suburban decline, alienation, substance abuse, disenfranchisement and parental maltreatment are introduced. Americans typically hate bleeding hearts and do not understand kids. Lack of interaction at a cultural level between the generations is a cruel fact. Differences among generational experiences and mentalities must be articulated. We work to debunk media mythologies and confront popular stereotypes. This work involves extensive border crossing, since the community norms of jurors and young people are rarely the same. You have to know both.

EDUCATIONAL MALPRACTICE

Working-class and minority males who do not play the game at school are often labeled ED and dumped into special education programs. Parents are totally overwhelmed by the stigma, and intimidated by scientistic-sounding words. Some school districts are famous for doing this, and so I encourage parents there to talk, meet and organize, to bring a friend when they meet with the administrators. Related to this work is trying to explain to "helping professionals" why psychotherapy ends up being so useless to young people. Many kids would rather talk to a cop than have some dickhead fuck with their mind. Shrinks have a heavy social-control agenda that is transparent to young people, but which has an air of irreproachable legitimacy to adults.

V

Aside from the individual, localized actions on behalf of young people I have described above, there are collective activities available and well under way. Advocacy missions, for example, generally fall into three categories. First, challenging individual rights violations— such as involuntary hospitalization of teens in drug treatment programs. Second, taking formal, legal action against institutional malpractice: failing to provide mandated services for young people in custodial care. The pressure here is focused upon making institutions fulfill their mandates. Third, questioning the motivations behind "public safety" measures, those regulatory acts by the government upon youth behaviors and patterns of consumption. For example, "cruising laws" that ultimately curtail young people's freedom to drive, or loitering charges that violate their right to free assembly.

This third category has been harder to defeat through legislation. The ACLU has had some success in the first two, where civil liberties or rights of consumers of services are at stake, but repressive action in the name of "public safety" goes back to ideological

assumptions about young people's competence, and the menace they pose when they step outside the gaze of adult authority. For example, cruising laws are justified by arguing that they help police regulate the flow of traffic; curfew proposals are supposed to curb car-jacking. The laws conflate criminal behavior and status transgressions.

Ultimately, I believe that such attitudes, assumptions, laws and institutional coercion kill kids. "Teenage Wasteland" was my way of describing a malaise, a mood affecting kids across lines of race, sex, religion, region and class. It is the material and existential experience of living disillusioned, alienated, blocked. Maybe things will get better. The age of Clinton could be a good time to push youth back onto the national agenda in socially real terms. We will have more opportunities to intervene, to make new gains. I have no delusions about great future social movements, youthquakes and cultural revolutions. That was then, this is now. This time for real, we act every chance we get, everywhere we are, every day.

Highbrow, Lowbrow, Voodoo Aesthetics

Robert Walser

In his recent book on the emergence of cultural hierarchy in the United States, Lawrence Levine reminds us that when we use the terms "highbrow" and "lowbrow," we pay homage to the racist pseudoscience of phrenology.[1] Nineteenth-century phrenologists correlated moral and intellectual characteristics with brain size and skull shape, creating a hierarchy that conveniently placed themselves, white men, at the top. Subsequently, as "highbrow," "lowbrow" and "middlebrow" came into common usage to designate the relative worth of people and cultural activities, the social category of class was also mapped onto this hierarchy, and working-class culture acquired the aura of primitivity that nineteenth-century writers had projected onto non-white races. Levine's book is a valuable reminder that types such as "highbrow" and "lowbrow," or "classical" and "popular," do not simply reflect internal properties of texts or practices, but are, rather, invented categories that do cultural work. Like phrenology, cultural hierarchy functioned to naturalize social and cultural inequalities and deny the creative capacities of whole groups of people.

But Levine's topic does not belong to the nineteenth century alone; whether or not the same labels are used (and they often are), such essentializing categories are still at work at the end of the twentieth century, and they retain the power to affect millions of lives. People are constantly being typed by their cultural allegiances, respected or dismissed because of the music they like. Moreover, we internalize these categories; when I interviewed heavy metal fans, I found that while some of them regarded heavy metal music as the most important thing in their lives, they nonetheless completely accepted the conventional wisdom that classical music is categorically superior to any popular music. Many other people are similarly led to believe in their own inferiority because of the stories that are told about their culture. No one ever actually explains why classical music is better than all other musics, because no one ever has to explain; cultural hierarchy functions to naturalize social hierarchies through the circular reinscription of prestige—foreclosing dialogue, analysis and argument. Music historians are still writing textbooks of "Twentieth-Century Music" that omit popular musics entirely, without even explaining their exclusion

235

of most of the music that people have actually heard and cared about during the last hundred years.[2]

But not everyone abides by the rules of cultural hierarchy. In the liner notes for his 1988 album, *Odyssey*, heavy metal guitarist Yngwie J. Malmsteen claimed a musical genealogy that confounds the stability of conventional categorizations of music into classical and popular spheres. In his list of acknowledgments, along with the usual cast of agents and producers, suppliers of musical equipment, relatives and friends, Malmsteen expressed gratitude to J. S. Bach, Nicolo Paganini, Antonio Vivaldi, Ludwig van Beethoven, Jimi Hendrix and Ritchie Blackmore.[3] From the very beginnings of heavy metal in the late 1960s, guitar players had experimented with the musical materials of eighteenth- and nineteenth-century European composers. But the trend came to full fruition around the time of Malmsteen's debut in the early 1980s; a writer for the leading professional guitar magazine says flatly that the single most important development in rock guitar in the 1980s was "the turn to classical music for inspiration and form."[4]

Throughout heavy metal's history, its most influential musicians have been guitar players who have also studied some aspects of that assemblage of disparate musical styles known in the twentieth century as "classical music." Their appropriation and adaptation of classical models sparked the development of a new kind of guitar virtuosity, changes in the harmonic and melodic language of heavy metal, and new modes of musical pedagogy and analysis. Of course, the history of American popular music is replete with examples of appropriation "from below"—popular adaptations of classical music. But the classical influence on heavy metal marks a merger of what are generally regarded as the most and least prestigious musical discourses of our time. This influence thus seems an unlikely one, yet metal musicians and fans have found discursive fusions of rock and classical musics useful, invigorating and compelling. Moreover, the meeting took place on the terms established by heavy metal musicians, at their instigation. That is, their fusions were not motivated by the desire for "legitimacy" in classical terms; rather, they have participated in a process of cultural reformulation and recontextualization that has produced new meanings. To those blinkered by the assumptions of cultural hierarchy, such reformulations are impossible to trace or understand because they step outside the dominant logic of cultural production.

Heavy metal appropriations of classical music are in fact very specific and consistent: Bach not Mozart, Paganini rather than Liszt, Vivaldi and Albinoni instead of Telemann or Monteverdi. This selectivity is remarkable at a time when the historical and semiotic specificity of classical music, on its own turf, has all but vanished, when the classical canon is defined and marketed as a reliable set of equally great and ineffable collectibles. By finding new uses for old music, recycling the rhetoric of Bach and Vivaldi for their own purposes, metal musicians have reopened issues of signification in classical music. Their appropriation suggests that, despite the homogenization of that music in the literatures of "music appreciation" and commercial promotion, many listeners perceive and respond

to differences, to the musical specificity that reflects historical and social specificity. Thus the reasons behind heavy metal's classical turn reveal a great deal not only about heavy metal, but also about classical music. We must ask: if we don't understand his influence on the music of Ozzy Osbourne or Bon Jovi, do we really understand *Bach* as well as we thought we did?

Many rock guitarists have drawn upon classical techniques and procedures in their music; among the most important were Ritchie Blackmore in the late 1960s and 1970s, and Eddie Van Halen in the late 1970s and 1980s. Both had early classical training which familiarized them with that music; later, like most heavy metal guitarists, they turned to methodical study, emulation and adaptation. Blackmore took harmonic progressions, phrase patterns and figuration from Baroque models such as Vivaldi. As Blackmore himself has pointed out in numerous interviews, these classical features show up in many of the songs he recorded with Deep Purple: "For example, the chord progression in the "Highway Star" solo on *Machine Head* . . . is a Bach progression." And the solo is "just arpeggios based on Bach."[5]

Eddie Van Halen revolutionized rock guitar with his unprecedented virtuosity and the "tapping" technique he popularized in "Eruption" (1978), which demonstrated the possibility of playing speedy arpeggios on the guitar. Van Halen also participated in the technological developments that helped make Baroque models newly relevant to heavy metal guitar players.[6] The electrification of the guitar, begun in the 1920s, and subsequent developments in equipment and playing techniques, particularly the production of sophisticated distortion circuitry in the 1960s, acquired for the guitar the capabilities of the premier virtuosic instruments of the seventeenth and eighteenth centuries: the power and speed of the organ, the flexibility and nuance of the violin. Increases in sustain and volume made possible the conceptual and technical shifts that led players to explore Baroque models.

Two guitarists of the 1980s, Randy Rhoads and Yngwie Malmsteen, brought heavy metal neoclassicism to fruition and inspired a legion of imitators. Like Edward Van Halen, Rhoads grew up in a musical household; he enrolled as a student at his mother's music school at the age of six, studying guitar, piano and music theory, and a few years later began classical guitar lessons, which he would continue throughout his career. In 1980, he landed the guitar chair in a new band fronted by ex-Black Sabbath vocalist Ozzy Osbourne; during his brief tenure with Osbourne's band (ending with his death at age twenty-five in a plane crash), Rhoads became famous as the first guitar player of the 1980s to expand the classical influence, further adapting and integrating a harmonic and melodic vocabulary derived from classical music. Among his early musical influences, Rhoads cited the dark moods and drama of Alice Cooper, Ritchie Blackmore's fusion of rock and classical music, Van Halen's tapping technique, and his favorite classical composers, Vivaldi and Pachelbel.[7]

Rhoads's and Osbourne's "Mr. Crowley" (1981) begins with synthesized organ, playing a cyclical harmonic progression modelled on Vivaldi. The minor mode, the ominous organ and the fateful cyclicism, culminating in a suspension, are used to set up an affect of mystery and doom, supporting the mocking treatment of English satanist Aleister Crowley in the lyrics.[8] The progression that underpins Rhoads's "outro" (closing) solo at the end of the song is a straightforward Vivaldian circle of fifths progression: Dm | Gm7 | C | F | B♭ | Em7♭5 | Asus4 | A. Until classically influenced heavy metal, such cyclical progressions were unusual in rock music, which had been fundamentally blues-based. The classical influence contributed to a greater reliance on the power of harmonic progression to organize desire and narrative, as well as the turn toward virtuosic soloing. Rhoads's solo on the live recording of "Suicide Solution" (1981) makes even more extensive use of Baroque rhetoric, including diminished chords, trills, sliding chromatic figures, a gigue and a tapped section that focuses attention on the drama of harmonic progression.[9] Like the tapping in Van Halen's "Eruption," such figuration leads the listener along an aural adventure, as the guitarist continually sets up implied harmonic goals and then achieves, modifies, extends or subverts them.

Not only the classical materials in his music, but also Rhoads's study of academic music theory influenced many guitarists in the early 1980s. Throughout the decade, years after his death, Rhoads's picture appeared on the covers of guitar magazines, advertising articles that discussed his practicing and teaching methods and analyzed his music. The inner sleeve of the *Tribute* album (1987) reproduces a few pages from Rhoads's personal guitar notebook, showing his systematic exploration of classical music theory. One sheet is titled "Key of C♯"; on it, for each of the seven modes based on C♯ (Ionian, Dorian, Phrygian, and so on), Rhoads wrote out the diatonic chords for each scale degree, followed by secondary and substitute seventh chords. On another page, he composed exercises based on arpeggiated seventh and ninth chords.

Rhoads's interest in music theory was symptomatic of the increasing classical influence on heavy metal, but his success also helped promote classical study among metal guitarists. Winner of *Guitar Player's* "Best New Talent" Award in 1981, Rhoads brought to heavy metal guitar a new model of virtuosity which depended on patterns of discipline and consistency derived from classical models. Besides his classical allusions, and his methods of study and teaching, Rhoads's skill at double-tracking solos (recording them exactly the same way more than once, so that they could be layered on the record to add a sense of depth and space) was extremely influential on subsequent production techniques.[10] Rhoads's accomplishments also contributed to the growing tendency among guitarists to regard their virtuosic solos in terms of a division of labor long accepted in classical music, as opportunities for thoughtful composition and skillful execution, rather than spontaneous improvisation.

Classically influenced players such as Van Halen and Rhoads helped precipitate a shift

among guitar players towards a new model of professional excellence, with theory, analysis, pedagogy and technical rigor acquiring new importance. *Guitar for the Practicing Musician*, now the most widely read guitarists' magazine, began publication in 1983, attracting readers with transcriptions and analyses of guitar-based popular music. Its professional guitarist-transcribers developed a sophisticated set of special notations for representing the nuances of performance, rather like the elaborate ornament tables of Baroque music. Their transcriptions are usually accompanied by various kinds of analysis, such as modal (for example, "The next section alternates between the modalities of E♭ Lydian and F Mixolydian. . . ."), stylistic (relating new pieces to the history of discursive options available to guitar players) and technical (detailing the techniques used in particular performances).

Swedish guitar virtuoso Yngwie J. Malmsteen continued many of the trends explored by Blackmore, Van Halen, and Rhoads, and took some of them to unprecedented extremes. Malmsteen was exposed to classical music from the age of five; his mother wanted him to be a musician, and made sure he received classical training on several instruments. Yet he claims to have hated music until television brought him a pair of musical epiphanies that, taken together, started him on the path to becoming the most influential rock guitarist since Van Halen. "On the 18th of September, 1970, I saw a show on television with Jimi Hendrix, and I said, 'Wow!' I took the guitar off the wall, and I haven't stopped since."[11] Malmsteen's first exciting encounter with classical music—his exposure to the music of Paganini, the nineteenth-century violin virtuoso—also took place through the mediation of television.[12] Thus the mass mediation of classical music makes it available in contexts that cannot be conventionally policed, for uses that cannot be predicted.

Upon the release of his U.S. debut album in 1984, which won him *Guitar Player's* "Best New Talent" award that year and "Best Rock Guitarist" in 1985, Malmsteen quickly gained a reputation as the foremost of metal's neoclassicists. He adapted classical music with more thoroughness and intensity than any previous guitarist, and he expanded the melodic and harmonic language of metal while setting even higher standards of virtuosic precision. Not only do Malmsteen's solos recreate the rhetoric of his virtuosic heroes, Bach and Paganini, but he introduced further harmonic resources and advanced techniques such as sweep-picking, achieving the best impression yet of the nuance and agility of a virtuoso violinist. Moreover, as I will show below, Malmsteen embraced the ideological premises of classical music more openly than anyone before.

Guitar for the Practicing Musician published a detailed analysis of Malmsteen's "Black Star," from his first U.S. album, *Yngwie J. Malmsteen's Rising Force* (1984). Such analytical pieces are intended as guides to the music of important guitarists, facilitating the study and emulation practiced by the magazine's readers. The following excerpts from Wolf Marshall's commentary can serve both as a summary of some technical features of Malmsteen's music and as a sample of the critical discourse of the writers who theorize and analyze heavy metal in professional guitarists' magazines:

"Black Star" shows off the many facets of Yngwie's singular style. Whether he is playing subdued acoustic guitar or blazing pyrotechnics, he is unmistakably Yngwie— the newest and perhaps the most striking proponent of the Teutonic-Slavic *Weltsmerz* (as in Bach/Beethoven/Brahms Germanic brooding minor modality) School of Heavy Rock. . . . The opening guitar piece is a classical prelude (as one might expect) to the larger work. It is vaguely reminiscent of Bach's *Bourree* in Em, with its 3/4 rhythm and use of secondary dominant chords. . . . The passage at the close of the guitar's exposition is similar to the effect . . . [of the] spiccato ("bouncing bow") classical violin technique. It is the first of many references to classical violin mannerisms. . . . This is a diminished chord sequence, based on the classical relationship of C diminished: C D♯ F♯ A (chord) to B major in a Harmonic minor mode: E F♯ G A B C D♯. . . . The feeling of this is like some of Paganini's violin passages. . . . While these speedy arpeggio flurries are somewhat reminiscent of Blackmore's frenzied wide raking, they are actually quite measured and exact and require a tremendous amount of hand shifting and stretching as well as precision to accomplish. The concept is more related to virtuoso violin etudes than standard guitar vocabulary. . . . Notice the use of Harmonic minor (Mixolydian mode) in the B major sections and the Baroque Concerto Grosso (Handel/Bach/Vivaldi) style running bass line counterpoint as well.[13]

Marshall's analysis is quite musicological in tone and content; he deliberately compares Malmsteen's recorded performance to classical techniques, contextualizes it through style analysis, and translates certain features into the technical vocabulary of music theory. The style analysis situates "Black Star" with respect to two musical traditions: classical music (Bach, Paganini, Beethoven and so on) and rock guitar (Blackmore). Marshall simultaneously presents a detailed description of the music and links it to the classical tradition by employing the language of academic music theory: chords, modes, counterpoint, form. As rock guitarists have become increasingly interested in studying the history and theory of classical music, Marshall can safely assume that his audience is able to follow such analysis.[14]

Moreover, Marshall's analysis shows that metal guitarists and their pedagogues have not only adopted the trappings of academic discourse about music, but they have also internalized many of the values that underpin that discourse. Even as he carefully contextualizes Malmsteen's music, Marshall insists on its originality and uniqueness ("Yngwie's singular style," "unmistakably Yngwie"). The commentary emphasizes Malmsteen's precision of execution as well ("measured and exact," "tremendous . . . precision"). Most tellingly, Marshall implicitly accepts the categories and conceptions of academic music analysis, along with its terms. For apart from the comment about "arpeggio flurries," Marshall deals exclusively with pitch and form, the traditional concerns of musicological analysis. And just as the discipline of musicology has drawn fire from within and without for ignoring or marginalizing musical rhythm, timbre, gesture, rhetoric and other possible

categories of analysis, metal guitarists' own theorists and pedagogues could be criticized for the same restricted analytical vision.[15]

If they are to become effective musicians, metal guitarists must in fact learn to maneuver within musical parameters beyond pitch and form, just as their counterparts within conservatories and music schools must learn much that is not written down. In the academy, such learning is referred to as "musicality," and it is often the focal point of a mystification that covers up classical music's reliance on oral traditions. In both classical music and heavy metal, virtually the same aspects of music are far less theorized, codified and written; music students must learn by listening, emulating and watching the rhythm and gesture of bodily motion. Theorists of metal, like their academic counterparts, rarely deal with musical rhetoric and social meanings; one analysis of Van Halen's "Eruption" merely named the modes employed (E phrygian, A and E aeolian) and summed up with the blandness of a music appreciation text: "a well-balanced, thought-out guitar solo, which features a variety of techniques."[16]

Yngwie Malmsteen exemplifies the wholesale importation of classical music into heavy metal—the adoption of not only classical musical style and vocabulary, models of virtuosic rhetoric and modes of practice, pedagogy and analysis, but also the social values that underpin these activities. These values are a modern mixture of those that accompanied music-making of the seventeenth, eighteenth and nineteenth centuries, fused with the priorities of modernism. Along with virtuosity, the reigning values of metal guitar include a valorization of balance, planning and originality, a conservatory-style fetishization of technique and sometimes even a reactionary philosophy of culture—Malmsteen bemoans the lack of musicianship in today's popular music, and looks back on the "good old days" of the seventeenth century, when, he imagines, standards were much higher.[17] Malmsteen is particularly noted for his elitism, another value he derives from contemporary classical music, and which he justifies by emphasizing his connections with its greater prestige. In interviews, he constantly insists on his own genius, his links to the geniuses of the classical past, and his distance from virtually all contemporary popular musicians, whose music he regards as simple, trite and inept. Because he aspires to the universal status often claimed for classical music, he denounces the genre he is usually thought to inhabit, insisting "I do *not* play heavy metal!"[18]

While he has been known to claim that, as a genius, he never had to practice, Malmsteen also presents himself as one who has suffered for his art. A joint interview with bassist Billy Sheehan preserves an account of his early devotion to music, and its costs:

> Yngwie: I was extremely self-critical. I was possessed. For many years I wouldn't do anything else but play the guitar.
> Billy: I missed a lot of my youth. I missed the whole girl trip. I didn't start driving until I was 25.

Yngwie: I also sacrificed a lot of the social thing. I didn't care about my peers. To me, nothing else was even close in importance.[19]

Such statements undoubtedly reflect the tendency toward self-aggrandizement and self-pity that have made Malmsteen unloved by his peers in the guitar world. But they also further reflect his virtually total acceptance of the model of music-making promulgated in classical music. Malmsteen, along with many other musicians, sees a need for music to "evolve" toward greater complexity and "sophistication." The pursuit of virtuosic technique usually requires many thousands of hours of patient, private repetition of exercises. To this end, many young players pursue a fanatical practice regime, a pursuit of individual excellence that often leaves little room for communal experiences of music-making, just as is the case in the training of classical musicians.[20]

The extreme extension of this set of ideological values is the complete withdrawal of the musician from his or her public, in pursuit of complexity and private meanings. This strategy, which had earlier been championed by academic composers such as Milton Babbitt, can now be recognized in some virtuosic guitar players. Steve Vai boasts of his most recent album:

> What I did with *Passion and Warfare* is the ultimate statement: I *locked* myself into a room and said, "To hell with everything—I'm doing this and it's a complete expression of what I am. I'm not concerned about singles, I'm not concerned about megaplatinum success, I'm not concerned about record companies." It was a real special time. All too often kids and musicians and artists just have to conform to make a living. I'm one of the lucky few and believe me, I don't take it for granted.[21]

Vai is trying to claim "authenticity" here, trying to prove his autonomy as an artist who is free of the influences of the very social context that makes his artistic statements possible and meaningful. When he goes on to describe his fasting, his visions, his bleeding on the guitar—and his compositional process of painstaking and technologically sophisticated multitrack recording—he presents himself as an updated, self-torturing, Romantic artist, reaching beyond the known world for inspiration. This individualism and self-centeredness unites classical music and heavy metal, and stands in stark contrast to many other kinds of music. For example, a bit later in the same issue of *Musician*, B. B. King says,

> What I'm trying to get over to you is this: . . . when I'm on the stage, I am *trying* to entertain. I'm *not* just trying to amuse B. B. King. I'm trying to entertain the people that came to see me. . . . I think that's one of the things that's kind of kept me out here, trying to keep *pleasing* the audience. I think that's one of the mistakes that's happened in music as a whole: A lot of people forget that they got an audience.[22]

Malmsteen's work has convinced some that the classical influence is played out, even as it has been the leading inspiration for the eager experimentation of the avant-garde. He has helped turn many players to a fruitful engagement with the classical tradition, even as he has helped lead them toward the impoverishing regimes of practice and analysis that now dominate that tradition. Malmsteen's abrasive elitism contrasts with his attempt to forge links with the musical past and reinvigorate reified discourses for mass audiences. The new meritocracy of guitar technique he helped to create both encourages the fetishization of individual virtuosity and opens doors for female and African-American musicians, such as Jennifer Batten and Vernon Reid.[23] His music brings to light contradictions that add to our understanding of both heavy metal and classical music.

For heavy metal and classical music exist in the same social context: they are subject to similar structures of marketing and mediation, and they "belong to" and serve the needs of competing social groups whose power is linked to the prestige of their culture. The immense social and cultural distance that is normally assumed to separate classical music and heavy metal is in fact not a gap of musicality, but a more complex one constructed in the interests of cultural hierarchy. Since heavy metal and classical music are markers of social difference and enactments of social experience, their intersection affects the complex relations among those who depend on these musics to legitimate their values. Their discursive fusion provokes insights about the social interests that are powerfully served by invisible patterns of sound.

Heavy metal guitarists, like all other innovative musicians, create new sounds by drawing on the power of the old, and by fusing together their semiotic resources into compelling new combinations. They recognize affinities between their work and the tonal sequences of Vivaldi, the melodic imagination of Bach, the virtuosity of Liszt and Paganini. Metal musicians have revitalized eighteenth- and nineteenth-century music for their mass audience, in a striking demonstration of the ingenuity of popular culture. Although their audience's ability to decode such musical referents owes much to the effects of the ongoing appropriations of classical music by TV and movie composers, heavy metal musicians have accomplished their own adaptation of what has become the somber music of America's aristocracy, reworking it to speak for a different group's claims to power and artistry.

Metal musicians have appropriated the more prestigious discourses of classical music and reworked them into noisy articulations of pride, fear, longing, alienation, aggression and community. Their adaptations of classical music, while they might be seen as travesties by modern devotees of that music, are close in spirit to the eclectic fusions of J. S. Bach and other idols of that tradition. Metal appropriations are rarely parody or pastiche; they are usually a reanimation, a reclamation of signs that can be turned to new uses. Unlike art rock, the point is typically not to refer to a prestigious discourse and thus to bask in reflected glory. Rather, metal musicians adapt classical signs for their own purposes, to signify to their audience, to have real meanings in the present. This is the sort of process

to which the linguistic philosopher V. N. Volosinov referred when he wrote that the sign can become an arena of class struggle; Volosinov and the rest of the Bakhtin circle were interested in how signs not only reflect the interests of the social groups that use them, but are also "refracted" when the same signs are used by different groups to different ends.[24] Thus heavy metal musicians and "legitimate" musicians use Bach in drastically different ways.

Like classical musicians, heavy metal musicians draw upon the resources of the past that have been made available to them through mass mediation and their own historical study. But it is precisely such predations that the musical academy is supposed to prevent. Bach's contemporary meanings are produced jointly by musicologists, critics and the marketing departments of record companies and symphony orchestras, and the interpretation of Bach they construct has little to do with the dramatic, noisy meanings found by metal musicians and fans, and everything to do with aesthetics, order, hierarchy and cultural hegemony. The classical music world polices contemporary readings of the "masterworks"; the adaptations of Randy Rhoads and Bon Jovi are ignored, while the acceptability of Stokowski's orchestral transcriptions is debated. Malmsteen's inauthentic performances fall outside the permissable ideological boundaries that manage to contain Maurice André and Glenn Gould. The drive to enforce preferred ideological meanings is, as both Bakhtin and Volosinov put it, "nondialogic." It is oppressive, authoritative and absolute.

> The very same thing that makes the ideological sign vital and mutable is also, however, that which makes it a refracting and distorting medium. The ruling class strives to impart a supraclass, eternal character to the ideological sign, to extinguish or drive inward the struggle between social value judgements which occurs in it, to make the sign uniaccentual.[25]

The social function of distinctions such as "highbrow" and "lowbrow" is precisely to stabilize signs, prop up automatic dismissals, and quash dialogue and debate. But since cultural hegemony is never absolute, appropriations such as those by heavy metal musicians constantly appear on the field of social contestation we call "popular culture."[26] Such disruptions are rarely even acknowledged by academics. In the histories they write and the syllabi they teach, most musicologists continue to define "music" implicitly in terms of the European concert tradition, ignoring non-Western and popular musics, and treating contemporary academic composers such as Milton Babbitt as the heirs to the canon of great classical "masters."

But Babbitt's claim to inherit the mantle of Bach is perhaps more tenuous than that of Randy Rhoads, and not only because Bach and Rhoads utilize, to some extent, a common musical vocabulary. The institutional environment within which Babbitt has worked (and which he helped create and vigorously championed) rewards abstract complexity and often

regards listeners and their reactions with indifference or hostility; both Bach and Rhoads composed and performed for particular audiences, gauging their success by their rhetorical effectiveness. Babbitt's music demonstrates his braininess; Bach's and Rhoads's offer powerful, nuanced experiences of transcendence and communality. Despite their important differences, Bach and Rhoads have in common their love of virtuosic rhetoric and their willingness to seek to move people, to deploy shared musical codes of signification, to work in musical discourses that are widely intelligible, however complex.

In a recent journalistic defense of cultural hierarchy, Edward Rothstein begins by granting most of the usual objections to it—he admits that both high and low can be good or bad, simple or complex; that particular works of art cannot be considered innately high or low because they move up and down the ladder of cultural prestige as time passes; and that cultural categories are thus neither stable nor self-evident. In the end, though, Rothstein simply insists that the high/low distinction is necessary, falling back on some familiar mystical dogma about autonomy and timelessness, and implying that attacks on cultural hierarchy are attacks on culture. The idea seems to be that the worthy have high culture and the unworthy have popular culture and perhaps a bit of "music appreciation" to let them know what they're missing, a view I would characterize as "voodoo aesthetics" (after George Bush's derisive label for Reagan's trickle-down defense of economic hierarchy). Rothstein concludes by noting that classical composers have appropriated features of popular music, but seems unaware that the reverse has occured incessantly throughout the history of the split; he asserts that "while the high provides tools and perspectives which can comprehend the low, the low is powerless to comprehend the high."[27] Such a leap of faith, such imperial confidence, is prerequisite to voodoo aesthetics.

Rothstein's argument is of the sort that is common among those who know the fenced-in terrain of the so-called "high" much better than the vast, diverse spaces of the "low," for it depends upon denying the creative agency of those who inhabit the latter realm. Like musical phrenologists, critics such as Rothstein work to naturalize a hierarchy that privileges themselves and the culture they care about at the expense of everyone else. But heavy metal guitarists' creative appropriations of classical music rebut such attempts to ground cultural hierarchy in the inherent features of texts or practices. Metal musicians erupted across the Great Divide between "serious" and "popular" music, between "art" and "entertainment," and found that the gap was not as wide as we have been led to believe. As Christopher Small put it,

> The barrier between classical and vernacular music is opaque only when viewed from the point of view of the dominant group; when viewed from the other side it is often transparent, and to the vernacular musician there are not two musics but only one. . . . Bach and Beethoven and other "great composers" are not dead heroes but colleagues, ancestor figures even, who are alive in the present.[28]

Heavy metal musicians' appropriations of classical music help us to see "high culture" and "low culture" as categories that are socially constructed and maintained. Like "high-brow" and "lowbrow," the deployment of such terms benefits certain individuals and groups at the expense of others, and their power depends chiefly upon intimidation. By engaging directly with seventeenth-, eighteenth-, and nineteenth-century composers and performers, by claiming them as heroes and forebears despite contemporary boundaries that would keep them separate, and by mastering and recontextualizing the rhetoric and theoretical apparatus of "high" music, heavy metal musicians have accomplished a critical juxtaposition that undermines the apparent necessity and naturalness of cultural hierarchy. The specific meanings of metal's appropriations in their new contexts are of great importance, of course. But for cultural criticism, perhaps the most salient legacy of the classical influence on heavy metal is the fact that these musicians have "comprehended the high" without accepting its limitations, defying the division that has been such a crucial determinant of musical life in the twentieth century.

Notes

I am grateful to Andrew Ross for inviting me to participate in the "Youth Music, Youth Culture" conference, and to Tricia Rose for her excellent editorial suggestions.

1. Lawrence W. Levine, *Highbrow/Lowbrow: The Emergence of Cultural Hierarchy in America* (Cambridge: Harvard University Press, 1988), pp. 221–23. Theories of brows "scientifically" mapped onto the human body the more general concept of "high" and "low" culture, which had been most powerfully theorized earlier in the nineteenth century by German cultural nationalists. Sanna Pedersen has examined the extent to which the emergence of "autonomous" German instrumental music depended on the creation of a demonized other; see her "Enlightened and Romantic German Music Criticism, 1800–1850," Ph.D. dissertation, University of Pennsylvania, forthcoming.

2. See, for example, Robert P. Morgan, *Twentieth-Century Music: A History of Musical Style in Modern Europe and America* (New York: Norton, 1991); Robert P. Morgan, ed., *Anthology of Twentieth-Century Music* (New York: W. W. Norton, 1992); Glenn Watkins, *Soundings: Music in the Twentieth Century* (New York: Schirmer Books, 1988); and Bryan R. Simms, *Music of the Twentieth Century: Style and Structure* (New York: Schirmer Books, 1986). Of course, there is nothing wrong with writing about some kinds of music and not others; my point is that to use the grand title "Twentieth-Century Music" for a specialized repertoire is to make an implicit ideological argument that these authors neither admit nor defend.

3. Malmsteen's first U.S. album, *Yngwie J. Malmsteen's Rising Force* (1984), had offered "special thanks" to Bach and Paganini.

4. John Stix, "Yngwie Malmsteen and Billy Sheehan: Summit Meeting at Chops City," *Guitar for the Practicing Musician* (March 1986), p. 59. To be sure, heavy metal, like all forms of rock

music, owes its biggest debt to African-American blues. The harmonic progressions, vocal lines and guitar improvisations of metal all rely heavily on the pentatonic scales derived from blues music. The moans and screams of metal guitar playing, now performed with whammy bars and overdriven amplifiers, derive from the bottleneck playing of the Delta blues musicians, and ultimately from earlier African-American vocal styles. Many heavy metal musicians have testified that they learned to play by imitating urban blues guitarists such as B. B. King, Buddy Guy, and Muddy Waters, and those who did not study the blues directly learned it secondhand, from the British cover versions by Eric Clapton and Jimmy Page, or from the most conspicuous link between heavy metal and black blues and R & B, Jimi Hendrix. Glenn Tipton, guitarist with Judas Priest, offers a demonstration of the blues origins of heavy metal licks in J. D. Considine, "Purity and Power," *Musician* (September 1984), pp. 46–50.

5. Martin K. Webb, "Ritchie Blackmore with Deep Purple," in *Masters of Heavy Metal*, Jas Obrecht, ed., (New York: Quill, 1984), p. 54; and Steve Rosen, "Blackmore's Rainbow," in *Masters of Heavy Metal*, p. 62. Webb apparently misunderstood Blackmore's explanation, for what I have rendered as an ellipsis he transcribed as "Bm to a D♭ to a C to a G," a harmonic progression which is neither characteristic of Bach nor to be found anywhere in "Highway Star." Blackmore was probably referring to the progression that underpins the latter part of his solo, Dm | G | C | A. "Highway Star" was recorded in 1971 and released in 1972 on the album *Machine Head*.

6. This is described, among other places, in Jas Obrecht, "Van Halen Comes of Age," in *Masters of Heavy Metal*, Jas Obrecht, ed., (New York: Quill, 1984), p. 156.

7. See Wolf Marshall, "Randy Rhoads: A Musical Appreciation," *Guitar for the Practicing Musician* (June 1985), p. 57.

8. At the Princeton conference, I performed excerpts of Rhoads's solos on electric guitar, analyzing as I went. Since the printed format prevents me from using sounds and audience reactions as evidence for my arguments, my concern in this paper is more with the cultural significance of metal musicians' activities as appropriators rather than with the musical meanings of the resulting texts. For more on the latter, as well as theoretical discussions of how to ground musical analyses of affect, see my *Running with the Devil: Power, Gender, and Madness in Heavy Metal Music* (Hanover, NH: Wesleyan University Press, 1993); see also Susan McClary, *Feminine Endings: Music, Gender, and Sexuality* (Minneapolis: University of Minnesota Press, 1991), especially chs. one and seven.

9. By "Baroque rhetoric," I mean the kind of transgressive virtuosity to be found in, for example, the cadenza of Bach's Brandenburg Concerto No. 5, or his E minor Partita. See Susan McClary's analysis of this Brandenburg in "The Blasphemy of Talking Politics During Bach Year," in *Music and Society: The Politics of Composition, Performance, and Reception*, Richard Leppert and Susan McClary, eds., (Cambridge: Cambridge University Press, 1987), pp. 13–62. The live recording of "Suicide Solution" appears on Ozzy Osbourne/Randy Rhoads, *Tribute* (CBS, 1987 [recorded in 1981]). For a fuller discussion of the song, see my *Running with the Devil*, ch. five.

10. See Wolf Marshall, "Randy Rhoads," *Guitar for the Practicing Musician* (April 1986), p. 51.

11. Matt Resnicoff, "Flash of Two Worlds," *Musician* (September 1990), p. 76.

12. Joe Lalaina, "Yngwie, the One and Only," *Guitar School* (September 1989), p. 15.

13. Wolf Marshall, "Performance Notes: Black Star," *Guitar for the Practicing Musician Collector's Yearbook* (Winter 1990), pp. 26–27.

14. In fact, in my experience, many metal guitarists (most of whom, like Bach and Mozart, never attended college) have a much better grasp of harmonic theory and modal analysis than most university graduate students in music.

15. Compare Janet Levy's cautious but valuable exposé of the values implicit in the writings of academic musicologists, "Covert and Casual Values in Recent Writings About Music," *Journal of Musicology* 6:1 (Winter 1987), pp. 3–27.

16. Andy Aledort, "Performance Notes," *Guitar for the Practicing Musician Collector's Yearbook* (Winter 1990), p. 6.

17. John Stix, "Yngwie Malmsteen and Billy Sheehan," p. 59. On the other side of his lineage, Malmsteen cites early Deep Purple as another moment of high musicianship (p. 64).

18. FabioTesta, "Yngwie Malmsteen: In Search of a New Kingdom," *The Best of Metal Mania #2* (1987), p. 35.

19. Stix, "Yngwie Malmsteen and Billy Sheehan," p. 57. Heavy metal bass players have, for the most part, simply layed down a solid foundation for the music. Bassists had not attempted to transform their instrument into a vehicle for virtuosic soloing until the recent success of Sheehan, who, like Malmsteen, cites among his main influences Bach, Paganini, and Hendrix.

20. Guitar players who are members of bands, however, are usually the leading composers of their groups, and the collaborative experience of working out songs and arrangements in a rock band is a type of musical creativity seldom enjoyed by classical musicians.

21. Matt Resnicoff, "The Latest Temptation of Steve Vai," *Musician* (September 1990), p. 60. Compare Milton Babbitt's "Who Cares If You Listen?" *High Fidelity* (February 1958), pp. 38–40, 126–127.

22. *Musician* (September 1990), p. 112.

23. Jennifer Batten, who has toured with Michael Jackson and others, is also a columnist for *Guitar for the Practicing Musician*. Vernon Reid, of Living Colour, has been featured on the cover and in the analyses of the same magazine.

24. V. N. Volosinov, *Marxism and the Philosophy of Language* (Cambridge, MA: Harvard University Press, 1986). Some authorities believe that this work was actually written by M. M. Bakhtin.

25. Volosinov, *Marxism and the Philosophy of Language*, p. 23. See also M. M. Bakhtin, *The Dialogic Imagination: Four Essays* (Austin: University of Texas Press, 1981), and *Speech Genres and Other Late Essays* (Austin: University of Texas Press, 1986).

26. See Stuart Hall, "Notes On Deconstructing 'The Popular,' " in *People's History and Socialist Theory*, Raphael Samuel, ed., (London: Routledge and Kegan Paul, 1981), pp. 227–240.

27. Edward Rothstein, "Mr. Berry, Say Hello to Ludwig," *New York Times* (April 5, 1992), p. H31.

28. Christopher Small, *Music of the Common Tongue: Survival and Celebration in Afro-American Music* (New York: Riverrun, 1987), p. 126.

Smells Like Teen Spirit
Riot Grrrls, Revolution and Women in Independent Rock

Joanne Gottlieb and Gayle Wald

In the meteoric rise of quintessential Seattle grunge band Nirvana from indie obscurity to corporate rock fame, a rumor emerged among rock circles nationwide: that the cryptic title of their megahit "Smells Like Teen Spirit" was the invention not of Nirvana lead singer Kurt Cobain, but of his neighbor Kathleen Hanna, who jokingly scrawled it on the wall of Cobain's house prior to his ascension to rock stardom.[1] From this one gesture and its retelling ensue multiple ironies, dizzying in their cumulative effect. First, the anecdote hints at the creative invisibility of a woman behind what was to become a ubiquitous, industry-changing, Top 10 hit for a male rock group. The story additionally implies the male appropriation of Hanna's own ironic reference to a brand name deodorant marketed to teenage girls (Teen Spirit). While the pointedness of Hanna's reference gets lost in Nirvana's translation, she uses a brand name which itself conjures notions of female teenage identity, group activity and group solidarity; in short, in an ambiguous use of "teen" which actually refers specifically to female teens, "Teen Spirit" creates a marketable fantasy of female youth culture. Moreover, in contrast to her previous invisibility, Hanna now suddenly occupies a position of mass visibility as lead member of Bikini Kill, a band which has gained particular prominence, both within the independent music scene and in the corporate rock press, for its role in fostering the Riot Grrrl "movement" of young feminist women in underground rock. Given these origins, Hanna's slogan consolidates several themes that we propose to explore in this essay: namely, girl-specificity within commodity culture and youth subculture; the historical invisibility of women in rock; the newfound prominence of women bands; the relation between performance, gender and sexuality; and the possible links between women's musical production, feminist politics and feminist aesthetics.

We will examine these themes in the context of the recent explosion onto the independent or underground rock scene of all-women bands or individual women artists making loud, confrontational music in the ongoing tradition of punk rock.[2] The appearance of these bands and their widespread recognition in both the mainstream and alternative presses would seem to signal a heady change, one which situates the broadened access of girls

and women to the transgressive potentialities of rock, and especially punk, subculture within the larger narrative of gains made by women in the wake of feminism. At best, this change promises to expand the possibilities for women's public self-expression, individual or collective gender identifications, and transgressive behaviors—at least within the bounds of white, middle-class culture in which this scene is primarily staged.[3] The recent visibility of women in rock not only signals greater access for women to male-dominated realms of expression, but also specifically frames these expressions in terms of femininity and feminism. In part, our inquiry will examine the historical interaction of women in rock, to see both how this cultural mode has framed gender, and how gender has been enunciated within this cultural mode. One of our central concerns involves the reassessment of standard accounts of the subversive powers of subcultures: specifically, if rock and (especially) punk subcultures provide a language of rebellion, a vehicle, as Dick Hebdige writes, for "deformity, transformation, and Refusal,"[4] then women's appropriations of these already subversive cultural modes are potentially both promising and problematic.

The women rockers in question emerge from the independent music scene, a lasting outgrowth of the punk movement which has spawned numerous small, independent, record companies. As for terminology, "independent" refers to status of the record companies, "underground" to the movement at large; these terms replace outmoded descriptions like "punk" or "hardcore," which now refer more specifically to moments or genres within underground music. Independent record companies such as those that turn out the music by women rockers—labels that include Harriet in Cambridge, Massachusetts, and Kill Rock Stars in Olympia, Washington—are "independent" from huge, major-label corporations such as Warner, Sony, or Geffen. Independent labels are often tiny (run from someone's kitchen), have limited funds and minimal distribution (primarily through mail order), and have to choose the least expensive recording technologies and media—most often the 7-inch vinyl single or, more recently, cassette. Majors plunder indies for talent and trends, and are therefore viewed with skepticism and, frequently, loathing among the rock underground. Most recently, last year's phenomenal success of Nirvana after the band signed to Geffen has impelled majors to seek out more punk-influenced "belligerent hard rock."[5] Despite (or perhaps because of) the prestige and economic payoff of deals with the majors, the independent rock scene tends to cast aspersions upon bands that are perceived as "selling out" to gain broad popular visibility and commercial viability. Such major-label recognition can be construed as particularly threatening to the musical, stylistic and political integrity of women performers, who are simultaneously pressured to tone down their music (through "softer sounds," less guitar feedback, and more elaborate, even cosmetic production) and to dress up their image (through new hairstyles, makeup and clothing).

Perhaps ironically, then, the women-in-rock phenomenon is also marked by the movement of key, all-women, hardcore bands into "mainstream" mass market venues (such

as MTV and Top 40 or "modern rock" commercial radio) through deals with the major labels. In the cases of the bands Hole, Babes in Toyland and L7 (the last of which had a single, "Pretend We're Dead," in rotation on Top 40 radio stations during fall 1992), major-label contracts carry with them certain undeniable perks—like an audience of more than a few thousand people and enough money to concentrate exclusively on the production of new music. The boundaries between what constitutes "alternative" culture and what constitutes the "mainstream" are decidedly blurry in this discussion, in part because these terms are constantly being renegotiated. Both underground and mainstream cultures are continually reinventing themselves and even commenting upon one another—the mainstream through its imitations and appropriations of underground or street sounds and styles, the underground through its constant discourse of besiegement. Hebdige describes the mainstream recuperation of subculture as a commodity as a process by which the ideological challenge of subculture is "handled and contained."[6] Yet a hopeful reading might claim that the entrance of women bands, especially the so-called "angry" ones, into the mainstream resonates slightly differently from the standard narrative of evisceration which accompanies the movement of a band like Nirvana onto the Top 10, or the marketing of grunge at the mall. Despite real fears about the erosion of their integrity, or their reduction to a short-lived, gender-based fad, the signing of the three most recognizable "angry women bands" to major labels may signal mainstream commercial acceptance of a new role for women in rock and, most optimistically, the beginnings of a new role for women.

Our optimism is tempered, however, by two crucial observations: first, despite the advances of particular female performers, the ongoing tradition of rock is still deeply masculinist; and second, because of patriarchal restrictions, the youth cultures of girls historically have been defined by very different parameters from those of boys. As a result of this second circumstance, girls may have different access to the expression of, or different ways of expressing, nascent teenage sexuality and rebellion against parental (that is, patriarchal) control, two themes that predominate not only in rock music, but in the formation of Western teenage identity in general. The conjunction of these two terms intimates that the forms of resistance offered by rock culture are closely linked with the music's frank expressions of sexuality.

This means that rock 'n' roll is a potentially, though by no means an inherently, feminist form; indeed, among male punk and hardcore performers, there is a long tradition of this rebellion being acted out at the expense and over the bodies of women. The latest generation of women performers emerge from punk via American hardcore, the loudest, angriest, most violent (at least in imagery), and most disaffected music to date. Although hardcore is not monolithic, for our narrative, hardcore in its aggressively masculinist, mid-1980s incarnation stymies any easy historical progression from early women punk rockers to contemporary riot grrrls.[7] In her fanzine *Satan Wears a Bra*, Debby Wolfinsohn demon-

strates how all-male hardcore bands have often resorted to blatant misogyny. Among her examples, she cites the lyrics of a song by the band Fear: "I just wanna fuck some slut . . . piss on your warm embrace/ I just wanna come in your face/ I don't care if you're dead."[8] Hardcore has the potential to be not only antiromantic, but, as in this example, also downright ugly and violent, replacing conventional heterosexual rock 'n' roll romance with rape and murder. Insofar as hardcore reflects the desire of middle-class, white boys to shock their parents or other authority figures, its fascination for the repulsive and violent is sometimes less a kind of advocacy and more a kind of irony. However, this does not negate the significance of the fact that such desire is often, and not incidentally, articulated in terms of a desire to hurt or to degrade women.

Despite the fact that punk and hardcore have provided a forum for such misogyny, rock's, and especially punk's, foregrounding of a potent combination of sex and anger opens a fertile space both for women's feminist interventions and for the politicization of sexuality and female identity. Riot grrrl subculture, in particular, extends beyond the production and consumption of live or recorded music or the pleasures associated with the expression of subcultural styles, reaching into the realms of political strategizing and continually re-rehearsed self-definition through fanzine publication. Though the two are sometimes confused as synonymous, riot grrrls are instead a particular, self-conscious subset of the more generalized "women in rock" phenomenon. In other words, though riot grrrls are among the most recent additions to the ranks of female rockers, not all women in rock identify themselves as riot grrrls. By organizing around a certain musical style, riot grrrls seek to forge networks and communities of support to reject the forms of middle-class, white, youth culture they have inherited, and to break out of the patriarchal limitations on women's behavior, their access (to the street, to their own bodies, to rock music), and their everyday pleasures. Riot Grrrl—the name refers to the movement-at-large—has forged salient connections between musical subculture and explicitly feminist politics; these qualities in turn transform or revise previous paradigms of rock production and consumption.

In the past year rock journalism has had a significant role in molding and disseminating the belief that all-women bands and particular women artists represent a new and noteworthy presence in the rock music scene.[9] Depending on where you look, recent inventories have either confirmed the new emergence of women in rock as a real trend, or described the phenomenon as a journalistic construct—mere media hype, conceivably linked to the marketing interests of the music industry. In one of the first pieces to address the female rocker phenomenon as such, a February 1992 *New York Times* article by Simon Reynolds identified a new movement of women hard rockers, specifying two of the most visible all-women bands, Hole and Babes in Toyland, as well as Inger Lorres, the lead singer of the Nymphs, as notable for their unprecedented (and, to his mind, refreshingly "unfeminine")

expressions of rage.[10] Yet this account, like others that followed, partly worked to diminish the new phenomenon by attaching to it such global and inadequate monikers as "angry women."[11] In the same vein, Thurston Moore, guitarist and lead singer in the band Sonic Youth and one of the most influential men in the independent music scene, coined the pejorative term "foxcore" to describe the same phenomenon, implying that this brand of women's hardcore—the roughest, most abrasive end of the underground music spectrum—hinged on some version of female erotic performance. In short, although these journalistic treatments may have reflected, or continue to reflect, an important reality, they serve an ambivalent function in both defining a new trend and limiting it, and in diminishing the diversity of women's performance and musical styles under a single label. While such designations serve a descriptive function, they do so at the risk of essentializing women's punk or hardcore musical production, and hence of reifying and marginalizing it as "women's music." In particular, the epithet "angry girl bands" foregrounds the fact that in the history of rock 'n' roll, as well as in the dominant culture, anger has largely been understood as an all-male terrain. It is not surprising, therefore, to find popular journalistic accounts of the women rocker phenomenon groping for a vocabulary to describe the confrontational and rage-filled musical and performance styles of women without the descriptive modifier "angry."

Part of the naming dilemma emerges from the women performers themselves, who resist journalistic attempts to lump them together as an "interesting" new phenomenon. Particular bands—Hole, L7 and Scrawl included—have attempted publicly to distance themselves from the "angry women" label under the pretense (or, as is often the case, by taking the last available line of defense) that gender does not and should not figure in matters of artistic production or appreciation. For these women, such journalistic categorizations carry with them unwelcome baggage—of the trivializing model of the Phil Specter-type "girl groups," for one—and the danger that once identified and labeled, their music will become faddish, or worse, ultimately clichéd or passé.[12] In an interview in the riot grrrl fanzine *Girl Germs*, produced by Molly and Allison of the band Bratmobile, the members of 7-Year Bitch voice their frustration with gender-labels while also acknowledging their inevitability, and even their necessity. "We're helping open [male audience members'] minds," says lead singer Selene. "Like, 'Oh wow, you're women and you *can* play!' But it's like, No shit!" Adds drummer Valerie, "Just think about how many all-boy bands we sat through!"[13] In 7-Year Bitch's counternarrative to most journalistic descriptions, gender labels are a frustrating, limiting obstacle to respect and acceptance.

Punk spawned a tradition of male bands semi-ironically naming themselves after exaggerated phallic symbols (Sex Pistols, Revolting Cocks, Dickies, Meat Puppets, Prong, Fishbone), as well as bands that identified themselves with distanced and objectified references to women, women's genitals or women's sexuality (Mudhoney), from which they derive a certain self-conscious masculinity. Conversely, many of the new women's bands name

themselves in response to a ubiquitous and negative vocabulary for the female body, calling themselves Hole, Burning Bush, Thrush, Queen Meanie Puss, Snatch, Pop Smear, Ovarian Trolley and Dickless. Women bands have also employed names to communicate a succinct critique of masculinity, as in the names Pork, Thrust, Spitboy and Weenie Roast. In one particularly interesting example, a band that used to call itself PMS later adopted the name Cockpit, combining references to both sexes. Self-naming here becomes a tactic not only of reclaiming and recirculating masculinist terms (and thereby depleting their potency), but also of outing or enabling women's uses of vocabularies otherwise forbidden to "good" girls, who are never supposed to swear or speak to loudly in public, let alone refer explicitly to their genitals and what they do with them.

These bands find a precedent for their parodic self-naming in the example of the Slits, one of the greatest and earliest all-female punk bands of the late seventies. This brings us to another aspect of the "women in rock" phenomenon: despite its apparent novelty, its roots date back approximately fifteen years, with the emergence of women out of the 1970s punk movements in Britain and America. Women could participate in punk in part because the lack of musical experience—or even prejudicial beliefs about female musical incompetence—were relatively unimportant in punk, which rejected technical virtuosity and professionalism in favor of amateurishness, iconoclasm and a do-it-yourself aesthetic. This relatively high degree of active female participation in the early days of punk—not merely in roles that coded women as the pretty fronts for a producer's corporate musical venture—has prompted some critics to argue that the seemingly "new" entrance of women into rock culture, not unlike the Year of the Woman, had been seen before, and without lasting impact. According to this reading, the recent phenomenon seems to mirror an extended moment in the punk and postpunk era when brash women artists like Debbie Harry, Poly Styrene (of X-Ray Spex), Chrissie Hynde, Siouxsie Sioux, Exene Cervenka, Laurie Anderson, Grace Jones, Lydia Lunch, Nina Hagen, the Slits, the Raincoats, and the Go-Go's, among others, also seemed to herald a fundamental change in the roles available to women as performers.

As opposed to the above reading, which confines the entrance of women into rock culture to distinct and dramatic moments, and hence raises the suspicion that these moments are journalistic inventions, another narrative posits incremental, progressive change. For example, more and more women musicians—such as Georgia Hubley of Yo La Tengo or Kim Gordon of Sonic Youth—play in integrated (that is, mixed-gender) bands; functioning primarily as instrumentalists rather than lead singers, these women occupy a different role from the one that was previously available for women in rock bands, and thereby alter what Jean Smith of Mecca Normal (a one-man, one-woman band) calls "the standardized four guys in a band" formula of "what punk bands are supposed to be."[14] This standard formula underscores two major contradictions in this musical history. First, though punk was more open to the participation of women, its subsequent incarnations

reified both the all-male band structure and the use of punk musical style as a vehicle for the expression of a generalized male anger and rebellion. Second, though women bands were formed throughout the eighties, especially on the West Coast, they nevertheless received little recognition in the music press; as a result, the recent media hype belies the fact that some of these women bands have been around for more than a decade. Despite these qualifications, however, we seem nonetheless to have arrived at a new moment in this history, in which a number of factors coalesce, including the sheer number of women bands, the introduction of self-conscious feminism into rock discourse and activity (both in the promotion of outspoken girl culture on the part of the riot grrrls, and the political organizing of Rock for Choice and the Bohemian Women's Political Alliance[15]), and the (in part media-driven) increased visibility of women rockers in defiant and often outrageous performance and musical styles, which both defy and recast conventionally "feminine" erotic performance.

Before moving on to a specific consideration of the riot grrrl phenomenon, we want to explore the problematics of women in subculture, and specifically women in rock. To do so, we draw on two figures in British cultural studies: Simon Frith, who has written key texts on youth, music and politics; and Angela McRobbie, who has worked on the culture of girls, and who has attempted a feminist rereading of male-authored theories of subculture. The study of the gendering of subculture helps in part to explain why girls historically have not participated as actively as boys in rock culture—both because of the patriarchal restrictions on girls, and because their pleasure and identity-formation, in response, tend to take a different form from those of boys. Social restrictions on girls, their limited access to the street and their greater domestic role make the public spaces in which subcultures are acted out (clubs, the street, bars) prohibitive and exclusive for them. The street often poses a threat to girls and women, insofar as they are liable to male heckling, harrassment or assault. Though women historically have participated in street culture as prostitutes, such access is nevertheless regulated by patriarchal ideologies that designate women sex-industry workers "unfit" to occupy domestic roles. Therefore, while male youth culture is public, oriented around the street, girls' culture often takes forms that can be experienced within the home, such as dressing up, or engaging in the creative consumption of main-stream pop idols, including fan-oriented visual materials such as magazines, photographs and, most recently, videos.

The conclusions of Frith and McRobbie suggest that rock 'n' roll subculture is not the place to look for female participation, especially in terms of rock's production, and at first glance rock history seems to bear this out. In the past, when women have participated in rock culture, they have tended to do so as consumers and fans—their public roles limited to groupie, girlfriend or backup singer, their primary function to bolster male performance. When women performed, Frith writes, it was "almost always as singers, fronting a perfor-

mance or record, their musical abilities confused with their visual images and style." Frith accounts for the exclusion of women from rock production as part of an ideology of rock growing out of bohemian culture. Rock was a place for male friendship in a resistive, unregulated life-style, where women represented unwelcome demands for "routine living," for the provision of money for food and rent.[16] Moreover, rock culture, like other forms of oppositional culture that McRobbie describes, developed signifying systems that privileged masculinity, systems in which "[t]he meanings that have sedimented around other objects, like motorbikes or electronic musical equipment, have made them equally unavailable to women and girls."[17]

One of the most puzzling aspects of this whole history is the extent to which hardcore until recently seemed to have negated gains women made in the punk moment. The difficulties faced by girls wanting to participate in this scene are played out not only in terms of band composition and lyrical content, but also in live performances, where girls are often crowded out of the pit[18]—in other words, literally marginalized—by the aggressive jostling of the boys. Cathartic exercises in semilegitimized violence or visceral abandon in collective movement, slamdancing and stage-diving clearly have different implications for boys and for girls. While they might willingly take part in a crowd of human projectiles, girls operate at a disadvantage because of their generally smaller size and weight; moreover, for girls, the violence in the pit can quickly shade into violation. Or, as one writer put it, "Most of the girls didn't want to dance in the pit—it hurts your boobs."[19] In short, the performance setting is potentially experienced by women as an uncongenial or unsafe place. As one incensed male hardcore fan recently wrote to *Rolling Stone* magazine,

> As a direct result of her femaleness, [*Rolling Stone* staff writer] Kim Neely cannot possibly comprehend what moshing (skanking, slamming, et cetera) is all about. Moshing is not a feminine activity but a chance for a man to reach into himself, grab all of the anger and hatred that has built up and bash everybody around over the head with it. Women have their own ways of dealing with stress. . . .[20]

Given the parameters of the mostly antagonistic field in which women bands struggle for recognition and definition, the problem of female participation generates a series of questions: What does it mean for women to participate in rock? What specifically does it mean for *this* generation of women, at *this* point in the evolution of underground music (how are they different from their predecessors)? To what extent is music that is loud, hard, and fast ultimately a masculine kind of expression? Conversely, what place do women have in this kind of expression, except as one of the boys? What is the value of this kind of expression for women? How do women change the nature of this kind of expression, and how does this kind of expression change the nature of women? If the symbolic meaning of the lead guitar, signifying male power and virtuosity, the legitimate expression of phallic

sexuality, perversity (Jimi Hendrix) and violence (Pete Townshend), is tirelessly resurrected by generations of male rock performers, then something potentially radical happens when women appropriate this instrument, with all its ingrained connotations. What has changed to give women access to the pleasures of hard, fast, rock music?

The changes in rock, which has always been associated with sexuality, parallel changes in societal attitudes towards sexuality and romance. Frith writes that:

> Rock [in the sixties] was experienced as a new sort of sexual articulation by women as well as men. . . . At a time when girls were still being encouraged from all directions to interpret their sexuality in terms of romance . . . rock performers like the Rolling Stones were exhilarating because of their anti-romanticism, their concern for "the dark side of passion," their interest in sex as power and feeling.[21]

When the traditional association of love and romance with popular music (as well as the association of sex with pleasure) came apart in punk, women's voices began to emerge, "shrill, assertive, impure, individual voices, singer as subject not object."[22] As punk performers, participating in a new way, these women "brought with them new questions about sound and convention and image, about the sexuality of performance and the performance of sexuality. . . . [P]unks opened the possibility that rock could be *against* sexism."[23] What precisely are women punk rockers saying about the sexuality of performance and the performance of sexuality?

In order to answer this question, we need to look back to the what male rock performers have done—in other words, what male rock performance means. Women punk rockers emerged out of a decade of male rock experiments with gender, such as those of Gary Glitter or David Bowie. That is, the trajectory of (male) rock up through the late seventies was marked by increasing androgyny and gender ambiguity. The male gender bending of seventies glam-rock forms an important node in this history: breaking with the heterosexual romance paradigm of Elvis or the early Beatles, the glam-rocker elevated the erotics of performance to a high narcissism, alternately playing alien, outcast, deviant, prophet, high priest and messiah. This moment celebrated sexual deviance and connected it to the rock 'n' roll values of teenage rebellion and transcendent experience. Moreover, British punk had its immediate origins in the gender and sexual experimentation of the New York scene, notably in the sexually decadent Velvet Underground (originally invented as a concept band by Andy Warhol), the cross-dressing camp of the New York Dolls, and the deadpan androgyny of Patti Smith. The origins of women in punk at such a crucial moment points at a key set of tensions: as McRobbie argues, these overwhelmingly male experiments with gender and femininity may have opened a space for the greater acceptance of women in the rock scene, yet in general, "sexual ambiguity" in male subcultures does not automatically translate into greater freedom for women with regard to gender and sexual-

ity.[24] One reason for this might be precisely because male experiments with gender, however liberating or transgressive, are still uncomfortably fraught, constantly requiring reference to a stable femininity. In other words, the transparence of the concept of woman, the persistence of essential womanness, has facilitated male freedom to experiment, even with the terms of gender itself.

Glam-rock produced some freakish results in the form of heavy metal cockrock, which attempted to recoup this performance tradition for masculinity. In this genre, glam's camp and sexual ambiguity became cockrock's baroque staging of a peculiar form of long-haired, becostumed hypermasculinity—a phenomenon easily parodied, for instance, in the documentary spoof film *This is Spinal Tap*. The progression from glam-rock into cockrock (the masculinity of which is actually ambiguous and conflicted) suggests that within rock performance, there is a struggle with femininity that may stem from the feminine gendering of the performance position itself.[25] Two touchstones of white, male, rock performance, Elvis Presley and Mick Jagger, both created excitement in their performances by making sexuality explicit, in hip and lip movements which were uncomfortably unmasculine.[26] If early rock 'n' roll performers acquired their primary mass appeal as the objects of female heterosexual desire (for example, Beatlemania), the translation of rock performance into a predominantly male system relies on the performer's delicate posturings as both erotic and identificatory object. To the extent that the rock audience was male, the male performer generated anxiety around the erotics of the gaze. Rock masculinity is therefore not a transparent reflection of a patriarchal society and macho culture, but is itself fraught: the exaggerated masculinity of rock performance at crucial moments may attempt to recoup the gender discomfort that accompanies the open display of sexuality, and the assumption of the to-be-looked-at position, by men among men. Following this argument, the marginal, subservient and eroticized positions which women in rock long occupied served to deflect an implicitly homoerotic gaze.

This phenomenon has complex consequences for women rockers as performers: for one, women rockers have less freedom to experiment with transgressive performances of gender precisely because the stable femininity of women forms an important part of the dynamic. Conversely, Simon Frith defines the dilemma of women in rock in terms of its restriction on specifically feminine possibilities. With regard to women's attraction to rock via the antiromanticism of groups like the Rolling Stones, he writes:

> But the problem [was] not whether rock stars were sexist, but whether women could enter their discourse, appropriate their music, without having to become "one of the boys" (239).

Elsewhere he repeats the point:

> Women musicians obviously have made it—there are a number of female rock stars—
> but most of them have done it by working within a man-made notion of how women
> should sound, by becoming "one of the boys" (86).

Although exactly whom or what Frith means by female rock stars who have become "one
of the boys" is unclear, this formulation poses an essential question—what does/can
rock mean for women?—while at the same time foreclosing its answer. It achieves this
foreclosure by implying that women rock performers are limited to either of two, diametri-
cally opposed and equally unattractive options: the to-be-looked-at sex object, or the
woman with balls. It reifies the roles available to women, closes off the resistive possibilities
of rock for women, and ultimately begs the question of rock's masculine hegemony.

Frith's dilemma, however, alludes to underlying questions about the difficulties women
contend with in the rock performance position, and the various resonances of occupying
that position as a woman. Women performers go through complicated contortions as they
both appropriate and repudiate a traditionally masculine rock performance position which
is itself premised on the repression of femininity, while they simultaneously contend with
a feminine performance position defined primarily as the erotic object-to-be-looked-at.
These complexities are also played out historically. Although male experiments with gender
did not translate into an equal flexibility for women, glam and disco helped to erode the
necessary association of popular music with romance and heterosexuality, thereby prepar-
ing the way for female performance in punk rock. Introducing explicit homoerotics onto
the rock stage, male glam-rockers—like their female punk successors—revealed the
performativity of gender. Ironically, the same years which saw women emerge as punk
artists also witnessed the establishment of a new cultural form—MTV. The advent of
music video provided a space for women rockers based on traditional aspects of female
musical performance—the visual and emotive connotations of the female vocalist.[27] A
generation whose teenybop idols included for the first time women who displayed not only
sexuality but also some degree of independence and sexual power, Riot Grrrl emerged
from punk via Madonna.[28]

If MTV provided multiple images of women rockers, including Madonna's street smarts
and her easy assumption and rejection of various feminine roles, punk's staging of defiance
and impropriety allowed female punk performers to negotiate the paradox of femininity on
the rock stage by enacting transgressive forms of femininity, for instance, in frighteningly
unconventional hair, clothing styles and stage activities.[29] Punk featured an extreme degree
of bodily incontinence—beginning with the Sex Pistols' famous episode of spitting and
vomiting at Heathrow Airport[30]—although in general, blasphemous punk antics among
boys met with greater public tolerance than those among girls. Out of the whole range of
possible transgressive behaviors, spitting seems to rate particular attention with regard
to gender expectations. McRobbie writes that, "If the Sex Pistols had been an all-female

band spitting and swearing their way into the limelight, the response would have been more heated, the condemnation less tempered by indulgence." She adds that though girls are more visible in punk subculture than other subcultures, "I have yet to come across the sight of a girl 'gobbing'."[31] Similarly Gillian Gaar quotes the *Evening Standard* on Patti Smith: "She is the only girl singer I have ever seen spit onstage."[32] Yet transgressive bodily activity does provide a particular opportunity for women. In one of the most outrageous examples of the feminist appropriation and adaptation of male punk stage antics, one member of the band L7, in response to heckling from a male audience member at a concert in Boston in fall 1992, reportedly pulled down her pants, pulled out her tampon, and threw it at him. Aside from raising the question of what happens when women exercise their power in the form of an aggressive and confrontational expression of their sexuality, this act—a reverse rape?—takes the notion of a woman's being "on the rag" and literally hurls it back at patriarchy.

It's also interesting to place this instance of rock performance in the context of the collaboratively written liner notes from a 7-inch single released by the Los Angeles hardcore band named, appropriately, Spitboy. One of the band's members writes that "rape is inevitable in a society, as in western culture, where people are constantly taught and encouraged to be aggressive and dominant." Here the band's antirape, antiviolence discourse results in a peculiar irony—that of disavowing aggression within a musical form that celebrates it, yet has long denied its possibilities and pleasures to women. Poly Styrene, the lead singer of the punk band X-Ray Spex, puts it another way in the opening lines of the group's most memorable punk anthem: "Some people say little girls should be seen and not heard. But I say . . . OH BONDAGE, UP YOURS!" Such a speech-act conjoins the rebellious youthful anger of punk with the articulation of an expressly outlaw sexuality.

In one response to the complexities and contradictions of their performance positions, women rockers, from Yoko Ono and Tina Turner and continuing up to Bikini Kill, have resorted to the strategic use of the scream, a radically polysemous nonverbal articulation which can simultaneously and ambiguously evoke rage, terror, pleasure and/or primal self-assertion.[33] Screams work as linguistic signs having no particular referent outside of the context in which they are uttered; the scream can be read as a kind of jouissance, a female body language that evades the necessity to signify within male-defined conventions and meanings. But far from being a fluid signifier, screams are also emotional ejaculations bearing specific associations with highly charged events—like rape, orgasm or childbirth. Often associated with femininity at its most vulnerable, the scream in its punk context can effect a shocking juxtaposition of sex and rage, including the cultural terrors of the open expressions of female sexuality, or feminist rage at the sexual uses and abuses of women. If female screams are often associated with women's sexual violation and rape, then these examples seem to voice a collective outrage at such abuse. An attention-getting device, the scream publicizes private or internal experience. These girl screams, moreover, voice

not only rage, but rage as pleasure, the scream as orgasm. Taken together, they seem to be suggesting something new—not just that women are angry, but that there's pleasure in their performances of anger, or even just pleasure in performance; the scream thereby replaces the pleasant, melodious and ultimately tame emotionalism traditionally associated with the female vocalist. Conversely, these screams can communicate a profound ambiguousness about consent and coercion, a fine line between orgasm and rape, as when Kat Bjelland of Babes in Toyland chillingly apposes the chanted phrases "I'd love to/ I had to" and punctuates them by a piercing "Good God!" in the song "Blood." A form of expression both denied to women in public (screaming is unladylike) and devalued in private (women are so emotional), punk screams are a wordless protest against the overdetermined femininity that these female performers—performing *as* women—must occupy; the scream musters the energy of the whole body to burst these constrictions. Unruly and unexpected, these screams deploy punk values to violate the demand that women remain patient, uncomplaining and quiet.

> Girl's night will always be precious to me because, believe it or not, it was the first time I saw women stand on a stage as though they truly belonged there. The first time I had ever heard the voice of a sister proudly singing the rage so shamefully locked in my own heart. Until girl's night, I never knew that punk rock was anything but a phallic extension of the white middle class male's frustrations.
>
> Rebecca Basye, writing in the fanzine *Girl Germs*, on Girls' Night at the International Pop Underground Convention in Olympia, Washington, August 20, 1991.

Even before mainstream journalism "discovered" a recognizable, critical mass of women rock and punk bands, riot grrrls were emerging out of Olympia, Washington and Washington, DC, two cities with thriving underground punk/hardcore scenes and associated independent record labels ("K" in Olympia and Dischord in DC, for example). The history that follows is pieced together from accounts from the alternative presses, including "girlcore" zines. While there are multiple, even competing, accounts of the "origin" of Riot Grrrl, most riot grrrls themselves agree that the concept was spearheaded by women in and around the punk scene in Olympia. Out of this group of women emerged two bands, Bratmobile and Bikini Kill, the second of which published a two-page manifesto in 1990 preaching their own brand of feminist revolution—what they call "Revolution Girl-Style Now."[34] Under the banner of "envisioning and creating alternatives to the bullshit christian capitalist way of doing things," the manifesto urged girls to "resist psychic death," "cry in public," join bands, teach each other how to play instruments and produce fanzines, and generally fight back.[35] The Riot Grrrl "revolution" further took root in the summer of 1991 at the week-long International Pop Underground Convention in Olympia, a festival

of more than fifty bands put together by K records. A group of all-women bands and women artists—some of whom had never before played in public—made their own Punk Rock Dream Come True (in the words of one band) when they performed together on Girls' Night, organized by Molly Newman and Allison Wolfe of Bratmobile.[36] Now, nearly two years later, a small riot grrrl "network" has sprung up in places like New York, Chicago, Philadelphia and Richmond, Virginia, where high school and college-age girls meet regularly to plan riot grrrl festivals, share ideas, and support each other's efforts to make music. In the words of Sara, a member of Riot Grrrl New York, the girl-style revolution is "one that promotes women's intelligence, creativity and achievement . . . what makes Riot Grrrl special is that it is for women in the punk scene." Adds another member of Riot Grrrl NYC, "We support and encourage Grrrls to publish zines, create and show their artwork, start bands in a supportive and non-judgemental atmosphere, and do anything they want to do."[37] Driven by such an aggressive and insistent optimism, riot grrrls attempt to use female community as a way of combatting the forms of discrimination and abuse that limit women's power.

From its inception, Riot Grrrl emerges as a bona fide subculture, one which (to use McRobbie's terms) consolidates "a sense of oppositional sociality, an unambiguous pleasure in style, a disruptive public identity and a set of collective fantasies."[38] Riot grrrls not only have reconfigured punk's energy and rebelliousness in specifically female and feminist terms, but have also drawn upon punk's D.I.Y. tradition to blur the boundaries between musical production and consumption. If, according to Frith and McRobbie's models, girls have traditionally participated in rock as consumers (either active or passive), then riot grrrls pose a challenge to these models, insofar as they potentially allow all women—even the ones not up on stage playing guitar or drums—to assume the (masculine) role of subcultural producer. Moreover, by granting each other legitimacy as performers, regardless of musical experience, riot grrrls extend punk's early promise for women, which, though it provided precursors, did not eliminate girls' underconfidence in taking up punk performance. Here the idea of the female role model becomes *central*, not merely symbolic to the fostering of a female rock tradition; indeed, girls often form bands explicitly based upon the examples of other performers, or testify to the ways in which the experience of seeing women occupy otherwise "phallic" positions (such as lead guitarist) can indeed be transformative. Writes one contributor to *Girlymag*, a new zine out of Audubon, New Jersey:

> when i was seriously listening to hardcore, back whenever, there were no hc girl bands, at least none that i ever remember hearing on the radio. i remember thinking that girls couldnt do hardcore, because it wouldnt sound good—girls couldnt shout right, or something idiotic like that. i'm so glad that all these girlcore bands are proving me so wrong. Groups like Lunachicks and Bikini Kill really push the bare essential to the limits, and their anger is palpable, it blows away my memories of the most extreme 80's

hardcore boy bands. Listening to these bands and others . . . makes me feel like i can stomp every yucky thing i hate right into the tread of my boots like i can shout right after all.[39]

While riot grrrls share a punk aesthetic (minimalism, amateurism and rawness), the bands nevertheless vary widely in musical style; Bikini Kill, for example, makes music that is loud, fast and in-your-face. Heavens to Betsy, another riot grrrl band, put out a self-titled cassette last year with highly personal songs such as "My Red Self" (about menstruation) and "My Secret" (about incest) that are lyrical, sparse and sometimes loud, though without a lot of feedback. Kreviss, a band that performed at Girl's Night in Olympia, has an aggressive, overwhelming sound—the result of eight girls playing guitar. As influences, lead Bikini Kill singer Kathleen Hanna cites feminist writer Kathy Acker and performance artist Karen Finley, as well as the much-maligned (though highly influential) Yoko Ono. The recuperation of Ono is particularly important, since it exemplifies Riot Grrrl's attempts to define the rudiments of a female rock tradition (or to voice the ways in which women have been excluded or written out of rock culture) for their own musical projects. One issue of the *Bikini Kill* 'zine argues that "part of the revolution (GIRL STYLE NOW) is about rescuing our true heroines from obscurity, or in Yoko's case, from disgrace. . . . What your boyfriend teaches you is that Yoko Ono broke up the Beatles. . . . But besides being the victim of the girlfriend-is-distracting thing, Yoko was so fucking ahead of her time . . . in a lot of ways she is the first punk rock girl singer ever."[40] The writers of *Girlymag* perform a similar archeology of women in rock when they review a 1971 self-titled album by the all-female rock band Fanny: "I stole all my Mom's crackly LPs by these chicks. They are like Aerosmith's sistahs and they really kick. Maybe they hold a bit of nostalgic significance to me, being that i heard them throughout my twisted childhood."[41]

While music is central to riot grrrl subculture, it is also not exclusively responsible for defining its contours. In particular, the small "girlcore" fanzine network that has sprung up around Riot Grrrl allows women to participate actively in the ongoing perpetuation and (re)definition of the subculture. Most obviously, the 'zines foster girls' public self-expression, often understood as the ability to tell private stories (secrets) which are otherwise prohibited or repressed by the dominant culture. These include girls' descriptions of their experiences of coming out as lesbian (especially in the "queercore" 'zines, which as early as the mid-eighties took to protesting hardcore's heterosexism and homophobia); the disclosure of their traumas as rape or incest survivors, or as women struggling with eating disorders; and their gushy affirmations of girl-love and devotion to punk music. Thus publicized, such narratives often become the stuff of political commitment and an affirmation of girls' legitimacy within the realm of the political. "Music is a gigantic, humongus [sic] part of my life, playing and listening and seeing and feeling," writes *Chainsaw*. "I love girls, I love the power and beauty of women who are out to change the world. Being queer

is yet another important part of me."[42] Zines additionally serve a journalistic function, offering reviews of record releases and concerts, news about and interviews with favorite bands, addresses of other 'zines, information about riot grrrl organizations, recommendations for the best places to go "thrifting," responses to riot grrrl articles that appear in other print media, opinion about the politics of abortion, and individual laments about the disadvantages of growing up in a small town, where no one (certainly not the prom queen) has a tattoo. This last example demonstrates how zines help to construct both female community and subcultural identity. Named *Sister Nobody*, *Girl Germs*, *Bitch Nation*, and *Quit Whining*, zines provide a forum, outside (though not detached from) the music, in which the members of riot grrrl subculture can engage in their own self-naming, self-definition and self-critique—can comment, in other words, upon the very shape and representation of the subculture itself.

In their efforts to consolidate community, riot grrrls have had additional help from "mainstream," corporate sources, most notably *Sassy*, which attracts an enormous (three million by one estimate) readership, from teenyboppers to members of the so-called twentysomething generation. If some music critics have insisted that the riot grrrl "movement" does not "really" exist beyond "a hardcore hundred or so teen and college-age women exchanging letters like just-freed POW's,"[43] *Sassy* has nevertheless attempted to popularize Riot Grrrl, without ridiculing or demeaning its significance. The magazine has featured band/celebrity interviews, record reviews and a monthly feature of zine addresses (which has lead, for example, to a flood of mail at zines such as Bratmobile's *Girl Germs*). There are other connections, as well: Tobi Vail of Bikini Kill, for example, has dated Ian Svenonius, a member of the Washington DC-based band Nation of Ulysses who was once named *Sassy*'s "Sassiest Boy in America." In a sign of their involvement in riot grrrl culture, a group of *Sassy* editors recently formed their own all-woman band called Chia Pet, whose quirky, campy cover of Human League's new wave megahit "Don't You Want Me" appears on the *Freedom of Choice* compilation, which benefits organizations such as Planned Parenthood. (They also have released a 7-inch on the Kokopop label called "Hey Baby," which assembles and mocks the wide range of verbal harassment experienced by women in everyday life.) Perhaps because of *Sassy*'s respect and even commitment to riot grrrl ideology, many accounts have viewed the magazine as encouraging the dissemination, rather than the dilution, of riot grrrl subculture. Possibly, the riot grrrl movement would have been significantly diminished had it not been for its careful coverage in the magazine, which gave a mass audience of teenage girls access to a largely inaccessible phenomenon in the rock underground. This suggests a variation on Dick Hebdige's model of ideological incorporation in that—in this case—the media, beyond its function to control and contain this phenomenon, may also have helped to perpetuate it. *Sassy*'s role in publicizing and perpetuating the riot grrrl phenomenon may arise from a gendered division in the experience of youth culture, with girls' participation gravitating towards the forms,

often mass-market visual materials, that lend themselves toward consumption in the home. While it appropriates riot grrrl subculture as a marketing strategy, the magazine also enables riot grrrl culture to infiltrate the domestic spaces to which girls—particularly young teenagers—are typically confined.

Instead of tirelessly insisting on the right to be called "women," as mainstream feminism has long been advocating, riot grrrls foreground girl identity, in its simultaneous audacity and awkwardness—and not just girl, but a defiant "grrrl" identity that roars back at the dominant culture. Indeed, reclaiming the word "girl" and reinvesting it with new meaning within their own feminist punk vernacular has proved one of the most salient aspects of the riot grrrl revolution. Such a recuperation of patriarchal language in part reflects the subculture's celebration of preteen girlhood—indeed, precisely those years in girls' lives which Frith and McRobbie deem so crucial in understanding their ongoing relation to and participation within subculture, and the same years on which feminist theorists Carol Gilligan and Lyn Mikel Brown focus in terms of women's relation to society broadly defined.[44] In their song "Girl Germs," for example, Bratmobile revel in the idea of their toxicity to boys/men; in the age of AIDS, they ironically relate germs to girls' self-protection and their ability to repel unwanted sexual advances. "Germs" here also suggests "germi-nal," the potential girls have to develop into powerful women; alternatively, it refers to girl-specific culture in its embryonic stages. While parody and wordplay are central to the riot grrrl redefinition of "girl," there is also, admittedly, a crucial element of fantasy in their self-construction—a nostalgia for the apparently close relationships between girls prior to the intrusion of heterosexual romance and its spin-offs, sexual competition and sexual rivalry. (In Bikini Kill, for one, jealously is a favorite target of critique.) Bikini Kill's song "Rebel Girl" asserts the importance of such girl solidarity as a response to the sexual commodification, categorization and subsequent or resultant (self)-division of women: "They say she's a slut," they sing, "but i know she is my best friend." Most important in light of our earlier discussion of the journalistic labels that have come to define women in rock, the riot grrrls, in rewriting "girl" as "grrrl," also incorporate anger, defiance and rebellion into their own self-definition, construing female rage as essential and intrinsic to their collective punk identity.

Unlike some other women in the punk and postpunk alternative music scenes, riot grrrls draw upon their experiences of girlhood to emphasize female difference *in concert with* female equality. In other words, riot grrrls both assume women's equality and understand that it has not necessarily been efficacious in securing them recognition as "legitimate" rock musicians. By underscoring certain traditional paradigms of girl culture—such as the intensity of early female friendships, the centrality of menstruation as a sign of "woman-hood," the importance of secrets and secret-telling as forms of rebellion against parental control, even the early sexual play between girlfriends—and making them foundational to their political, social and musical interventions, riot grrrls foster an affirmative mode of public,

female self-expression that doesn't exclude, repress or delegitimize girls' experiences or their specific cultural formations. While self-consciously and ironically "putting on" the guises of conventional female sexuality and femininity (that is, by acting alternately or even simultaneously "girlish" and "slutty"), riot grrrls also express rage at violence against women (such as rape, incest, battering, as well as the self-inflicted violence of eating disorders), rage which ultimately challenges dominant vocabularies and ideologies.

The band Bikini Kill is in this regard both representative and exemplary. An essential part of their "Revolution Girl Style" is their attempt to encourage young, predominantly white, middle-class girls to contest capitalist-patriarchal racism and sexism, precisely through acts of individual transgression against the implicit or explicit norms of "ladylike" or "girlish" behavior. The band links these individual challenges to private (that is, domestic, local or familial) patriarchal authority to collective feminist resistance and struggle. McRobbie supports this notion in her suggestion that many middle-class girls' first political experiences involve escape "from the family and its pressures to act like a 'nice' girl" (32–33). Bikini Kill makes this connection between personal transgression and progressive feminist politics explicit in a song such as "Double Dare Ya," in which singer Hanna screams:

> You're a big girl now
> you've got no reason
> not to fight
> You've got to know
> what they are
> Fore you can stand up
> for your rights
> Rights rights Rights?
> you have them, you know

Performing against a backdrop that reads "ABORTION ON DEMAND AND WITHOUT APOLOGY," the band similarly encourages girls (and occasionally hostile male audience members) to speak up for women's reproductive rights and against various forms of sexual violation. In "Suck My Left One," a song about father-daughter incest, Hanna grabs her bared breast and taunts her audience. Ventriloquizing a maternal voice which speaks for patriarchy, she sings, "Show a little respect for your father/ Wait until your father gets home" and then ends the song with a line that consolidates rage, disobedience, sarcasm and (even ambiguously pleasurable) submission: "Fine fine Fine fine Fine fine Fine Fine." Father-daughter incest recurs as a theme in riot grrrl songs and zines not only as a reflection of reality, but also because it carries particular symbolic resonance as the quintessential form of patriarchal violation/exploitation of girls within the domestic sphere. On this symbolic level, incest contracts several key issues: it exemplifies patriarchal control within the home

as it is embodied in the father; the sexualization and objectification of girls (a theme taken up by female performers from Madonna to Courtney Love); and the subordination of girls and women to male power and authority.

Bikini Kill's adept manipulations of spectacle, exemplified by the audacious and even outrageous performance style of "Suck My Left One," bring us back to performance, as a crucial locus of gender issues in rock. Riot grrrls' engagement with performance may provide us a way to talk about the specific differences in and gains achieved by this generation of women rockers. Citing the examples of Bratmobile's baby doll dresses, sweaty boy dancers and bloody "Grrrl" flag, as well as Love's lace-dress parody of girlish "naughtiness"/innocence, White writes that riot grrrls have "learned from ACT UP and MTV to manipulate imagery."[45] Riot grrrls inherit the lesson of Madonna's constant self-recreation and combine it with lessons learned from work in the sex industry.[46] "If you can get up on stage and take your clothes off," says Hanna, "performing a punk show is nothing."[47] In concert, Hanna sometimes parodies Madonna, appearing on stage in a black bra and biker shorts, the word "SLUT" penned in across her abdomen. The ways in which riot grrrls perform on and through their bodies reaffirms the very themes articulated in their songs. The abuses of girls' and women's bodies are constantly represented by riot grrrls, both in their music and zines; since such abuses are generally associated with women's alienation from their bodies, the ability to *be* embodied—the deployment of the body in performance—provides an antidote to its previous violations. Not only do girls wield their bodies in performance, but they do so in such a way as to make their bodies highly visible: this visibility counteracts the (feelings of) erasure and invisibility produced by persistent degradation in a sexist society. Such performance recuperates to-be-looked-at-ness as something that constitutes, rather than erodes or impedes, female subjectivity.

In this respect riot grrrl performances build upon (and surpass?) the challenge to the male gaze that Hebdige describes when he writes that female punks of an earlier generation "turned being looked at into an aggressive act."[48] The current generation of riot grrrls derive their strategies from the first women punks, who put on

> the conventional iconography of fallen womanhood—the vamp, the prostitute, the slut, the waif, the stray, the sadistic mistress, the victim-in-bondage. Punk girls interrupt[ed] the flow of images, in a spirit of irony invert[ed] consensual definitions of attractiveness and desirability, playing back images of women as icons, women as the furies of classical mythology.[49]

The current generation work changes on the iconoclastic methods of early female punks, replacing punk's angry masochism with a deep sense of abuse and a stronger critique of patriarchy, and relating it ultimately to what happens, not only in the street, but also in the home. Rather than reducing the political to issues of self-esteem, riot grrrls make self-

esteem political. Using performance as a political forum to interrogate issues of gender, sexuality and patriarchal violence, riot grrrl performance creates a feminist praxis based on the transformation of the private into the public, consumption into production—or, rather than privileging the traditionally male side of these binaries, they create a new synthesis of both.

We need to conclude with a brief examination of the vexed relation of Riot Grrrl to the media, and our own conflicted place as participants and academic observers. This paper was developed in spring 1993, during a continuing period of media coverage of the Riot Grrrl movement, and equally continuous reaction by the participants. This resistance of Riot Grrrl to its perceived appropriation by various media forces needs to be included in any account of the movement. The resistance has various targets: certainly the mainstream press, but also the alternative and alternative music presses, and, to a great extent, any attempt by "outsiders" (including academics) to describe the movement. In this, Riot Grrrl's resistance to the media has been hard to distinguish from a more general resistance to definition and determination which comes out of its punk ethos. Although we began this study with the observation that media coverage of outrageous women might change the public discourse about gender—or participate in ongoing changes—Riot Grrrl groups have been engaged in contesting what they perceive to be the sexist, dismissive or inaccurate media coverage in many major American as well as British publications. The accelerated media coverage of the Riot Grrrl movement, starting in October 1992 and continuing through the spring, prompted a nationwide riot grrrl media blackout. Rejecting the mass media, in a gesture continuous with the underground rock scene's rejection of major-label recordings, riot grrrls propose instead to spread the revolution by word of mouth through a network of friends, through zines, mailing lists and events.

Yet Riot Grrrl's repudiation of the media has never been complete. In the ongoing coverage of Riot Grrrl in mainstream rock music venues, such as *Spin* and *Rolling Stone*, some members of the scene have been willing to talk to the press, while others have stayed away. Perhaps despite itself, Riot Grrrl has been very "media-friendly" in its ability to provoke through visual representations, and even because of the catchiness of its name.[50] Similarly the public reactions of riot grrrls against inaccurate coverage (in Letters to the Editor pages, for example) may be read as ambivalent gestures, seeking the kind of publicity they purport to reject. In March 1993 Courtney Love, by then a jaded observer, told Melody Maker that "Lately, I've been sickened by the media's handling of riot . . . and their handling of the 'media.' It's a mutually reciprocal sick relationship—and fascistic."[51] The inherent conflicts over the media risk creates dissension within the ranks of riot grrrl groups themselves, which the press is then quick to document. For example, in May 1993, *Seventeen* magazine interviewed one Jessica Hopper, a bona fide riot grrrl

defector, who complained about the criticism she received from other riot grrrls for talking to *Newsweek*. More recently *Rolling Stone* published an article titled "Grrrls at War."

Riot Grrrl is not only wary of recuperation in the mainstream music press, but also in the male-defined spaces of academia and academic discourse. Riot Grrrl NYC, to whom we showed this paper, responded variously; the dominant voices at one meeting articulated suspicion of and anger at our attempts to describe the movement (or even use the name in our title), and vehemently rejected our rather sanguine conclusions about the effects of riot grrrl coverage in *Sassy*, though to our surprise, the objections articulated turned less on the translation of a street culture into academia (a number of the women attending were college or graduate students themselves) and more on our content, approach and right to speak "for" them. A version of this essay that we delivered at a conference at the Whitney Museum in New York—a presentation which included slides as well as musical examples—provoked a related concern that the audience of intellectuals and museum-goers would be merely titillated by displays of women's rage. Riot grrrl vigilance about their misrepresentation involves questions not only of sexism but also of cultural authority. At the very least, unsanctioned accounts of the movement run the risks of exploitation, trivialization and tourism. Moreover, speaking about the movement, especially from a position of cultural centrality, risks appropriating Riot Grrrl's own ability, as a marginal group, to be heard, to speak for themselves, in a mode continuous with the silencing of girls' voices within patriarchal culture. For these reasons, some members of Riot Grrrl view with suspicion and even hostility any attempt to discuss the movement in an academic setting—even the left or feminist settings provided within intellectual discourses.

Riot Grrrl's vexed relation to mass-media/academic coverage takes us back to the question of the group's ability to broach the gendered separation of public and private. The contradictions of this relation to the media are themselves embedded in punk's own conflicted origins, in that its trademark rawness and crudeness were themselves both the pretext and the product of Malcolm McLaren's adept media manipulations. While Riot Grrrl may have learned from Madonna, McLaren and others how to manipulate imagery, the movement has not so readily adopted their strategy of engagement with the media— a strategy that has proved compatible with a radical agenda from Abbie Hoffman to ACT UP. While Riot Grrrl recognizes the inevitability of gender as a social construct, and attempts to disrupt ideologies of the feminine/femininity through counterrepresentations, the movement has been more reluctant to extend this critique to its interaction with mass culture generally. This is not to say that the movement has not recognized the power of inexpensive and easily reproducible forms to further their revolution; on the contrary, Riot Grrrl mobilizes xerox machines, 7-inch vinyl records and cassettes in the service of self-representation, a project inherently threatened by others' representations of them. Yet in pinning its resistance to the undifferentiated "mainstream," Riot Grrrl risks setting itself up in opposition to the culturally "popular," as well as to the political status quo; in this

they echo the collegiate erudition and elitism of independent music generally. Moreover, in rejecting the popular, Riot Grrrl may preclude the possibility of having a broad cultural or political impact. In any case, Riot Grrrl's relation to outside forms of representation will no doubt continue to be ambivalent—balancing a demand for cultural power with resistance to distortion or co-optation. At stake are familiar issues of cultural justice which are themselves tied to hierarchies of race, gender, sexuality and class—of who will speak for whom, and when, and under what conditions or circumstances. If Riot Grrrl wants to raise feminist consciousness on a large scale, then it will have to negotiate a relation to the mainstream that does not merely reify the opposition between mainstream and subculture. Like it or not, the Girl-Style Revolution is bound to be televised.

Notes

1. According to indie rock lore, Hanna wrote "Kurt Cobain smells like Teen Spirit." See Gina Arnold, "Bikini Kill: 'Revolution Girl-Style'," *Option*, No. 44 (May–June 1992), p. 46. Arnold adds that "[Hanna] wishes . . . this fact weren't known."

2. While we speak as feminist academics interested in both the roles of women and the various articulations of gender within musical culture, we also speak as the disc jockeys on a weekly college radio show that features the music of women artists and all-women bands, not only in rock or punk, but also in rap, soul, blues, jazz, worldbeat and spoken-word performance. Thus while we raise certain issues (such as the definition of "women bands") in their theoretical form, these issues also affect us on a very practical level in our radio work.

3. In this paper, we have specifically delimited our range of inquiry to include recent interventions of women in rock and punk, but not earlier precursors to rock (such as blues, jazz and R & B) in which women, especially African-American women, have played highly visible, musically and culturally influential roles. Indeed, many transgressive potentialities which we attribute to women's participation in rock and punk musical production may have been anticipated by women blues and jazz performers earlier in the century.

4. Dick Hebdige, *Subculture: The Meaning of Style* (London and New York: Methuen, 1979), p. 138.

5. Simon Reynolds, "Fuzzy Daydreams Replace the Grimness of Grunge," *New York Times* (November 22, 1992), Arts and Leisure section, p. 26. Reynolds characterizes grunge as a hybrid of punk and metal.

6. Hebdige, pp. 94–97.

7. One account describes American hardcore as emerging, not as a direct offshoot of British punk, but indirectly, as a reaction to punk's new wave successors. Although we focus on the hardcore of the mid-eighties, it still exists today, having gone through various changes and regional variations from its harder incarnations of five to ten years ago; politically it runs the gamut from neo-Nazi gang mentality to the sixties-influenced progressivism of Washington, DC's Fugazi

(Taehee Kim, "Capitalism Indie-Style," *Option*, No. 49 [March–April 1993], pp. 53, 57). At the present, both Fugazi and another DC band, Nation of Ulysses, are active friends, cohorts and supporters of riot grrrls.

8. Debby Wolfinsohn, *Satan Wears a Bra* (January 1993), p. 2.

9. As of February 1993, an article in *The Village Voice* tallied articles on "the Riot Grrrl movement" from *Newsweek, USA Today*, the *New Yorker*, the *New York Times*, the *Washington Post, Sassy* and *Seventeen*. Charles Aaron, "A Riot of the Mind," *The Village Voice* (February 2, 1993), p. 63.

10. Simon Reynolds, "Belting Out That Most Unfeminine Emotion," *New York Times* (February 9, 1992), Arts and Leisure p. 27. In contrast, a *Times* piece by Ann Powers, published just over a year later, in February 1993, offers a corrective to Reynolds' article by demonstrating how women in the alternative rock scene "have entered a new phase of [feminist] awareness and determination." Ann Powers, "No Longer Rock's Playthings," *New York Times* (February 14, 1993), Arts and Leisure p. 1.

11. Lorraine Ali provides a detailed account of the issues surrounding the "angry" label: "Foxcore My Ass: Grrrls, Guitars, & the Gender Dialectic," *Option*, No. 44 (May–June 1992), pp. 40–44.

12. Ali, p. 40–41.

13. *Girl Germs*: 18.

14. Interview with Jean Smith of Mecca Normal in *Mole* No. 5, p. 31.

15. Rock for Choice was originally organized by members of L7 and Sue Cummings, associate editor of *LA Weekly*, and subsequently adopted as a project of the Feminist Majority Foundation and Fund. Exene Cervenka of the group X and rock promoter Nicole Panter started the Bohemian Women's Political Alliance, the activities of which include "organizing voter registration, issuing candidate recommendations, and throwing benefits for a variety of causes" (Powers, p. 34).

16. Simon Frith, *Sound Effects: Youth, Leisure, and the Politics of Rock 'n' Role* (New York: Pantheon, 1981), pp. 85, 86–87.

17. Angela McRobbie, *Feminism and Youth Culture* (Houndsmills and London: Macmillan, 1981), p. 29.

18. The area directly in front of the stage.

19. Emily White, "Revolution Girl-Style Now: Notes From the Teenage Feminist Rock 'n' Roll Underground," *The Reader* (Chicago) (September 25, 1992), p. 9. White's article provides a graceful, complex and persuasive account of the riot grrrl phenomenon. Our copy comes originally from Riot Grrrl Chicago.

20. Lucas K. Sauer, "Correspondence, Love Letters & Advice," *Rolling Stone* (February 18, 1993). Quoted in *Option*, No. 49, p. 29.

21. Frith, p. 239.

22. Frith, pp. 243–44.

23. Frith, p. 244.

24. McRobbie, pp. 7, 26–27.

25. Arguably, this gendering originates in the display of sexuality and the manipulation of bodily artifice that have traditionally been associated with the feminine.

26. In the case of Elvis, these movements were explicitly borrowed from the body stylizations of black, male, R & B performers. Indeed, some accounts of Elvis's popularity and success suggest that as a white artist, he was able to perform for mainstream (white) audiences sexually sugges-tive movements that would have been taboo for black male performers. Such an imitation of black male performers suggests a related erotic identification with them. In other words, within this economy of imitation, a crucial homoerotic tension operates between differently-raced men. The homoerotic aspect of white, male, rock performance would further complicate the sexual dynamics of male performance in general.

27. Lisa Lewis, *Gender Politics and MTV: Voicing the Difference* (Philadelphia: Temple University Press, 1990), p. 69.

28. In a similar vein, Frith writes disparagingly that "the only sexual surprise of a self-conscious siren like Debbie Harry, for example, was that she became a teeny-bop idol for a generation of young girls" (Frith, p. 244).

29. Hebdige refers to this same phenomenon in "the minority of girls publicly affecting the punk style" in punk street subculture generally, in addition to the punk rock stage. Dick Hebdige, "Posing . . . Threats, Striking . . . Poses: Youth, Surveillance, and Display," *SubStance* 37–38 (1983), pp. 68–88.

30. Hebdige (1979), p. 92 and n. 4. See also Hebdige (1983), p. 85.

31. McRobbie, pp. 27, 29.

32. Gillian G. Gaar, *She's a Rebel* (Seattle, WA: Seal Press, 1992), p. 238.

33. In the examples of Ono and Turner, we link the female scream with two divergent musical traditions—the performance art tradition in which Ono was a germinal figure, and the R & B tradition embodied in Turner, especially in her role as a crossover artist. Gaar notes that "shouting and screaming" figured highly in the R & B tradition from which Turner's musical style emerged (Gaar, p. 89).

34. Bikini Kill is actually three women—Kathi Wilcox on bass, Tobi Vail on drums, and Kathleen Hanna on vocals—and one token man, guitarist Billy Boredom, whom the women call the "girliest boy" they know and who, incidentally, sometimes wears a skirt during performances. In 1992, the band came out with its first recording, an eight-song demo cassette jointly released by K and the Simple Machines label, which has been called the "first musical document of the Riot Grrrl Movement" (Kim, p. 53). Most of the songs from the cassette appear on a six-track vinyl

release put out by the Olympia-based Kill Rock Stars label. Bikini Kill's second vinyl release, recorded on four-track in 1992, is titled "Yeah Yeah Yeah Yeah," and appears as one side of a split LP with the British band Huggybear. The band also has a cut on at least two compilations: the *International Pop Underground Convention* (K) and *Kill Rock Stars* (Kill Rock Stars). Both vinyl recordings come with handwritten lyric sheets, in the style of the 'zines.

35. White, p. 8.

36. See White, p. 9. K has since released a compilation of live recordings from the convention, which includes many of the performances from Girls' Night.

37. "Riot Grrrl," *The New York Planet* (December 19, 1992), p. 19.

38. McRobbie, p. 33.

39. "Chickpunk," *Girlymag* 1 (1993), p. 7.

40. Quoted in Arnold, p. 45.

41. *Girlymag*: 4.

42. *Chainsaw* 3, p. 1.

43. Aaron, p. 63.

44. Carol Gilligan and Lyn Mikel Brown, *Meeting at the Crossroads: Women's Psychology and Girls' Development* (Cambridge: Harvard UP, 1992).

45. White, p. 20.

46. Citing examples from a range of women rock bands, Ashley Salisbury notes that "Courtney Love of Hole and Bjelland of Babes in Toyland formed a band after meeting at the strip bar where they both worked. The members of Frightwig [another all-women band] also used to strip. . . . Hanna left home and began stripping to pay her college tuition." See Salisbury's "Street Access and the Single Girl," *Nassau Weekly* (February 4, 1993), p. 12.

47. Quoted in Salisbury, p. 12.

48. Hebdige (1983), p. 85.

49. Hebdige (1983), p. 83.

50. We owe this observation to Sandra York.

51. Quoted in Kim France, "Grrrls at War" *Rolling Stone* (July 8–22, 1993), p. 24.

Contributor Notes

Carmen Ashhurst-Watson has been involved in media, film, and television management and production for twenty years. She is currently president of Rush Communications.

Robert Christgau has been a rock critic since 1967 and a senior editor of *The Village Voice* since 1974. He teaches at New York University and the New School for Social Research.

Jeffrey Louis Decker currently teaches at UCLA. He is the editor of *The Black Aesthetic Movement*. Articles of his have appeared in *Cultural Critique, New Literary History, Social Text,* and *Transition.*

Juan Flores is Professor of Latin American and Caribbean Studies at City College of the City University of New York, and Sociology and Cultural Studies at the Graduate School, CUNY. He is the author of *Divided Borders: Essays on Puerto Rican Identity*, and is a coeditor with Jean Franco and George Yúdice of *On Edge: The Crisis of Contemporary Latin American Culture.*

Donna Gaines is a sociologist, journalist, and New York State certified social worker. She is the author of *Teenage Wasteland: Suburbia's Deadend Kids* (HarperCollins) and a research professor at the Institute for Social Analysis at the State University of New York at Stonybrook. She lives on Long Island, and sings back-up vocals for The Slugs.

Joanne Gottlieb is a doctoral student in English at Princeton University, where she is researching cities of the future in the modern period.

Lawrence Grossberg is Professor of Speech Communication and Communications Research at the University of Illinois at Urbana-Champaign. He is the author of *We Gotta Get Out of this Place: Popular Conservatism and Postmodern Culture* and coeditor, with Cary Nelson and Paula Treichler, of *Cultural Studies.* He has also coedited *Sound and Vision* and *Rock and Popular Music: Politics, Policies, Institutions.*

Walter Hughes is Assistant Professor of English at Princeton University, where he teaches Early American literature and culture.

Lady Kier Kirby is the singer with *Deee-Lite*, crucial style interpreters and the leading crossover dance music ensemble of the 1990s.

Sarah Thornton is currently Lecturer in Media Studies at Sussex University.

George Lipsitz is Professor of Ethnic Studies at the University of California at San Diego. He is the author of *Rainbow at Midnight: Labor and Culture in the 1940s, Time Passages,* and *A Life in the Struggle: Ivory Perry and the Culture of Opposition.*

Susan McClary, Professor of Musicology at McGill University, is the author of *Feminine Endings: Music, Gender, and Sexuality* and *Georges Bizet: Carmen.* She has written and produced a music-theater piece, *Susanna Does the Elders.*

Willi Ninja is a pioneering vogue dancer, teacher and choreographer. He lives in New York City.

Andrew Ross is Director of the American Studies Program at New York University. His books include *Strange Weather: Culture, Science and Technology in the Age of Limits,* and *No Respect: Intellectuals and Popular Culture,* and most recently *The Chicago Gangster Theory of Life: Ecology, Culture, and Society.* He is the editor of *Universal Abandon? The Politics of Postmodernism* and coeditor of *Technoculture.*

Tricia Rose is Assistant Professor of History and Africana Studies at New York University, and author of *Black Noise: Rap Music and Black Culture in Contemporary America.*

Greg Tate is a staff writer for *The Village Voice* and a founding member of the Black Rock Coalition. He is the author of *Flyboy in the Buttermilk: Essays on Contemporary America.*

Gayle Wald will shortly be Assistant Professor in American Studies at Trinity College. She is completing her doctoral work on racial passing.

Robert Walser teaches in the Department of Music at Dartmouth College. He is the author of *Running with the Devil: Power, Gender, and Madness in Heavy Metal Music.*

George Yúdice teaches Latin American literature at Hunter College, and Cultural Studies at the Graduate Center of the City University of New York. His most recent book is *We are Not the World.*